The Materials of the Artist

and their use in painting with notes on
the techniques of the old masters

Max Doerner

PROFESSOR IN THE ACADEMY OF FINE ARTS, MUNICH

Translated by Eugen Neuhaus, Ph.D.h.c.
EMERITUS PROFESSOR OF ART AT THE
UNIVERSITY OF CALIFORNIA, BERKELEY

Revised edition

Hart-Davis, MacGibbon London

Granada Publishing Limited
First published in Great Britain 1963 by Rupert Hart-Davis Ltd
Revised edition 1969
Second impression 1970
Third impression 1973 by Hart-Davis, MacGibbon Ltd
Frogmore, St Albans, Hertfordshire AL2 2NF and
3 Upper James Street, London W1R 4BP
Fourth impression 1976

ISBN 0 246 63877 X
Printed in Great Britain by
Fletcher & Son Ltd,
Norwich, Norfolk

AUTHOR'S PREFACE

IN ITS general outline this book presents in condensed form the lectures which under the title, "The Materials of the Artist and Their Use in Painting," I have been giving for nearly twenty-five years at the Academy of Fine Arts at Munich. The results of my researches in the entire field of painting, as well as my practical experiences gathered over several decades, are laid down in this book.

The guiding thought of my lectures has always been *the closest relation to practice and the greatest possible agreement with the results of scientific research.*

There is much in the field of technique which even today remains unexplained. Art has abandoned the sound principles of craftsmanship and is therefore lacking in a dependable foundation. In a majority of cases recipes are being used without a knowledge of the materials involved and without critical judgment. To bring about a much-needed improvement it is necessary to become acquainted with the basic relationship of technical processes and to validate practice as far as possible by scientific proofs.

Science often speaks a language difficult for the artist to understand, and he is consequently unable to draw therefrom the conclusions which would enable him to solve his practical problems. The artist cannot be expected to be a chemist; he would only become the victim of a dilettantism more harmful than beneficial. Even more important to the painter than the chemistry of pigments and media is the question of their physical properties.

The problems of the technique of painting can be solved only by the coöperation of science with practice, but for such coöperation many of the basic conditions are today still lacking.

The laws which govern the materials of the artist are the same for all artists, to whatever schools they may belong. Whoever wishes to employ his materials correctly and to the best advantage

must know these laws and follow them, otherwise sooner or later he will pay dearly for his mistakes. Only a complete mastery of the materials will give that firm foundation on which the artist may develop an individual style and which at the same time will insure the durability and permanency of his creations. Without this basic understanding we are slaves of our materials or, as Böcklin said, adventurers as compared with the old masters and their sound tradition, whereby one stood on the shoulders of the other. When one considers how thoroughly Dürer, Leonardo, Rubens, Reynolds, and other masters studied their materials, one is tempted to smile at the fears of many painters of today who believe that their personalities would suffer if they should concern themselves too closely with the craftsmanship of their art. *Craftsmanship must again be made the solid foundation of art.* There is no other road to lead us out of chaos. This is increasingly becoming the opinion of present-day artists.

The sequence of the chapters follows the technical development of a painting. They are treated as individual entities, consequently occasional repetitions could not be avoided; but from my many years of experience as a teacher I have learned that certain basic facts cannot be repeated too often.

Stress has been laid upon the preparation of materials by the artist himself. The painter who prepares his own materials knows them in a very different way from one who buys them ready-made.

My lectures at the Academy are followed by practical experiments in which the members of my class may put to the test what they have heard and seen. Often after the lectures we have discussions of an hour or more regarding questions of technique and their clarification. The very live interest displayed by my students contradicts the often-expressed opinion that painters are not interested in craftsmanship; on the contrary, I have always found that students are genuinely interested if they are offered something worth their while. My own collection of teaching material contains a great many studies in which the technique of every historical school of painting is shown in its logical development; and visits to the public museums, where technical processes can be studied at first hand, often supplement the lectures.

This book obviously is without these aids. In their place, in a language familiar to the artist everything has been as thoroughly and as clearly discussed as is possible within the limitations of the printed page. This book is an attempt to communicate the dependable knowledge in the field of technique to the practicing artist. It is not intended as a course of instruction in painting, because it is no more possible to learn to paint from books than to learn to swim on a sofa.

<div align="right">MAX DOERNER</div>

TRANSLATOR'S PREFACE

AN APPRECIATION of the need for sound craftsmanship is today increasingly evident among artists everywhere, and since the first appearance of this book in 1921 it has enjoyed a deserved reputation with artists in many countries. It has become the accepted authority on questions of materials and technique, and it is being extensively used as a text by art schools and academies, and for reference by restorers, conservators, and collectors, not only in Germany but also in other countries. In addition to its extraordinary practical usefulness, moreover, many painters have even acknowledged its power to stimulate a desire toward creative painting. The realization of the spiritual and aesthetic values of his work is the problem of the painter, and Professor Doerner's book is a simple, direct, and clear exposition of the many and varied technical factors which enter into this problem.

As a final preparation toward the translation of this uniquely useful and authoritative book, I accepted an invitation from Professor Doerner to visit him at his country residence at Wessling in Upper Bavaria. The delightful days spent in the primitive environment of a small and picturesque village are among the most pleasant memories of my visit abroad during the summer of 1933. There in the cool shade of the beech forests of the Bavarian Uplands Professor Doerner and I discussed every phase of his book. In the evening several of his colleagues would join our conversation at the wooden tables under the great chestnut trees in front of the village inn. Later in the autumn, when his duties at the Academy called Professor Doerner back to Munich, these friendly informal gatherings were continued in one of the many typical Munich settings where painters meet in the evening to discuss their mutual problems over a stein of beer.

I trust that by means of this translation Professor Doerner's book will stimulate an increased interest in sound craftsmanship resulting in finer and more enduring works of art.

Four editions of Professor Doerner's book have so far appeared in German, and this translation is based upon the last, which was published in May, 1933. Professor Doerner very kindly put at my disposal many notes and additions which he contemplates using in a fifth German edition, and these have been incorporated into this book. Local and highly personal references which could have little or no interest to American or English readers have been omitted. In the interests of conciseness I have also taken the liberty of omitting some unessential details.

To my son Eugene, who prepared the first draft of the translation, I am indebted for much patient and painstaking preliminary work. In the final revision of the manuscript I have been assisted by Miss Leona Fassett, and my colleague, Professor C. W. Porter of the Department of Chemistry, has freely given me advice when I encountered difficulties in his field.

EUGEN NEUHAUS

POSTSCRIPT

PROFESSOR DOERNER was born in Burghausen in the Palatinate in 1870, the son of an army officer. He attended the public schools, and after his graduation from a classical Gymnasium, he entered the Royal Bavarian Academy at Munich, where he studied under Professors Johann Herterich and Wilhelm von Diez. His professional interests inevitably took him to Italy, where he came in contact with Arnold Böcklin and Hans von Marrées. The museums and art galleries of Italy, and particularly Pompeii, made a lasting impression upon him, and he revisited Italy frequently.

Early in his career as a painter he became associated with the *Deutsche Gesellschaft zur Förderung rationeller Malverfahren* (German Society for the Promotion of Rational Methods in Painting) and its founders, Adolf Wilhelm Keim, Franz von Lenbach, and Max von Pettenkofer. From 1910-1913 he was President of the Society, and he made numerous contributions to its official publication.

In 1911 he had been appointed instructor in technical methods at the Royal Bavarian Academy at Munich, where in 1921 he became Professor, a position which he held until his death.

When the Society for the Promotion of Rational Methods in Painting, associated with the Institute of Technology at Munich, ceased to function, a technical laboratory was established at the Academy to carry on the Society's program, and when, in 1938, the State Institute for Technical Tests and Research in the Field of Painting was founded as an affiliated institute of the State Art Academy, it was called the "Doerner Institute" to honor the man who had made such outstanding contributions in this field.

This institute was the crowning achievement of his career. His failing health, however, permitted him to work at the Institute for but a few months. Professor Doerner died on March 1, 1939.

The first German edition of his book, *Malmaterial und seine Verwendung im Bilde*, was published in 1921, and the present

xi

English edition, first published in 1934, is based upon his fourth and his projected fifth edition, his notes for which were placed at the disposal of the translator. His pupils since his death have continued his work at the Doerner Institute, and have published a sixth, seventh, and eighth edition of his book. The latest edition has been considerably expanded by the addition of a chapter on the restoration of medieval churches. This and other additions I have not seen fit to add to the English edition, since they would have changed the basic character of the book, the primary concern of which is with painting and its problems as they confront the American painter.

Numerous corrections, however, have been made in the present printing of errors which have from time to time been called to my attention, either in reviews of the book or by interested friends. I am particularly indebted to Mr. Henry Rusk, restorer at the California Palace of the Legion of Honor, for a number of suggestions, and am sorry that I have been able to take advantage of only a few of these in this new printing. Because of numerous complaints that the use of the metric system makes the book difficult to use from the standpoint of the American artist, I have also tried to alleviate this difficulty by adding an Appendix listing by chapter, page, and line the American equivalents of the measurements used in the text. This takes the place of the Conversion Tables used in earlier printings.

EUGEN NEUHAUS

Berkeley, California

CONTENTS

ILLUSTRATIONS

THE MATERIALS OF THE ARTIST

CHAPTER I

THE PREPARATION OF GROUNDS
FOR EASEL PICTURES

"The ground is of the utmost importance." DE MAYERNE.[1]

GROUNDS are applied to textile fabrics, woods, and the like
to make the surface tighter, less absorbent, and more luminous,
and so enable the artist better to realize his objective and give
durability to his work.

I. TEXTILE FABRICS AND THEIR PREPARATION FOR PAINTING

TEXTILE FABRICS consist of threads which are interlaced
at right angles and which are termed respectively the warp and
the woof.

In the case of the ordinary linen fabric most commonly used
for artist's canvas the threads are woven so that they cross one
another alternately at right angles. This method of weaving pro-
duces the tightest canvas because the threads are more closely
entwined. In the case of twills both warp and woof pass over a
varying number of threads in regular succession in such a way as
to form slanting or diagonal lines at the points of interlacing. In
the so-called herring-bone pattern a section of right twill and
a section of left twill alternate.

To insure a uniform quality in fabrics the threads must be spun
to a definite and standard length. Inferior fabrics show knots and
gaps.

Artist's canvas is woven from the fibers of flax, hemp, jute, and
cotton.

[1] Sir Théodore Turquet de Mayerne (1573-1655), physician, contempo-
rary and friend of Rubens (1577-1640). His leisure was occupied with
chemical and physical experiments, which he had begun in Paris. From 1620-
1646 he wrote a voluminous manuscript entitled *Pictoria, sculpturia et quae
subalternarum artium* (British Museum, No. 2052). [Translator's note.]

3

Hemp fiber is from about one to two meters long, and hence produces fabrics which are even and strong and especially adapted for larger canvases. The large easel paintings of the Venetian school, those by Tintoretto, Veronese, and others, are painted on coarse hemp canvas often woven with a twill or herring-bone pattern.

Flax produces a finer fabric, and is the material chiefly used for artist's canvas.

Cotton is suitable only for smaller canvases of not more than a meter square and must be closely woven, when, however, it serves its purpose very well.

Jute, Bengal hemp, concerns us only as it is used unbleached for coarse, inferior fabrics (sackcloth); it is also used, however, as the warp in cotton and linen fabrics. Jute turns brown when exposed to the air or dampness. The greater its luster or·sheen, the better it is.

When held against the light, linen shows threads of unequal strength; cotton, on the other hand, threads of equal strength and regularity. Caustic soda colors a linen canvas a brownish yellow, but cotton only a light yellow. If one snaps a single thread of a cotton fabric, the ends will curl and split, whereas a linen thread will remain smooth. Most commonly by far are natural, unbleached fabrics used for painting purposes; but bleached white linen or cotton also provides a good painting surface, whose brightness gives the picture from the outset an added effect of clearness and luminosity.

Canvases are usually dressed, that is, impregnated with some substance, such as a paste made of starch, which gives them a heavier, stronger, and smoother appearance. In addition they are often weighted with successive coatings of some mineral substance, such as clay, to simulate a still heavier quality.

In order to make the rough fibers of cheaper yarns smoother and easier to spin, it was formerly the custom to grease them with seal oil. Such canvases always turned dark, since the oil never dries. Fabrics treated in this way are also difficult to moisten; they absorb water unevenly and turn very dark when wet. Fabrics whose surfaces, when held against the light, show hair or down are not suitable for sizing, because experience has shown that,

through the gumming up of the hairs, small cracks are produced in the ground.

A serious disadvantage is the hygroscopic nature of fabrics. They draw moisture from the air and, upon drying, throw it off, and hence are in a sort of continual movement in which the successive layers of dried paint cannot participate. This is the cause of much damage. Fabrics shrink when dampened. The individual threads become thicker and shorter, and the intervening openings close. Many sorts lose 5 cm. or more to the meter. Upon drying they expand again. Textile fabrics which have been sized and primed or painted upon behave very differently in this respect, depending largely on the materials used. They will slacken in a warm temperature and in moist air. There is no advantage in dampening or scalding a canvas before sizing it, as is often advised, because such canvases when mounted after drying will stretch just as much as those which were not moistened. It is only for special purposes of restoring that this process is recommended. Another disadvantage of fabrics is their susceptibility to injury. An advantage, on the other hand, is that they are obtainable in all sizes and are easily transported, while they also possess a pleasing surface texture.

The strength of a linen canvas is very important, and it should not tear easily. When stretched, a canvas should give but little and spread smoothly and evenly in both directions and not form bumps. Hence all fabrics which are composed of different kinds of threads, for instance with a jute woof and a hemp warp, should be avoided. It should be possible to moisten fabrics evenly, that is, they should absorb water uniformly, otherwise the ground will not adhere well. Held against the light, they should be tight and not show sieve-like openings; such wide-meshed fabrics, however, are often used for sketching canvas.

ARTIST'S CANVAS. For the special purposes of artists the following kinds of canvas are manufactured:

Roman linen. The best canvas. A fabric of varying thickness and very even structure, both warp and woof of which are composed of several threads. The trade offers types especially suitable for sketching as well as heavy grades of extraordinary strength. It is obtainable in three qualities: heavy, medium, and fine.

There are also good thick linen fabrics with double threads in one direction only. These are likewise obtainable in the three qualities: heavy, medium, or fine.

Cheaper fabrics, such as the so-called oakum or tow linen, often show knots and defects and are not infrequently soaked in fish oil in order to make the coarse fibers lie down. Such greased canvas becomes very dark when wet.

Besides these there are many other fabrics suitable for sizing and priming, provided they are sufficiently strong and closely enough woven.

Sailcloth is a strong, firm fabric woven of hemp, flax, or cotton which makes an excellent canvas for painting purposes.

Domestic hand-woven linen, peasant linen, so-called *Swiss linen*, bleached or in their natural color, are firm fabrics with irregular threads, which, however, often give them a charming texture.

Gobelin linen, a very closely woven fabric of flax with especially heavy threads for the woof. Because of the conspicuousness of these threads they must run horizontally when the canvas is mounted for painting.

Half linen (Irish linen) is made with a cotton woof and is unsuitable as artist's canvas because of its uneven strength and lack of resistance to tearing.

Sackcloth, shoddy, are coarse, inferior fabrics of jute, hemp, or the left-overs of flax.

Ticking, twill, are very firm fabrics made of linen or flax, but sometimes also of half linen.

Cotton twill has but little strength.

Muslin is a thin cotton fabric with a linen warp, and is recommended only for small canvases, and then only in the heavier grades.

Cambric, handkerchief linen, cretonne, and *shirting* are very fine, uniform fabrics which, in the thicker and heavier grades, are suitable for small canvases and pencil work. There are works by Dürer on cambric.

THE MOUNTING OF THE CANVAS. In order to prepare a canvas for painting it must be mounted on a stretcher. In doing this one must take care that the threads run parallel with the

frame. The frame must be well beveled on the inside so that the inner margins cannot press through the canvas; otherwise damage may result which will be difficult to repair. The frame must be joined together at right angles, the accuracy of which can be determined by applying a right-angle to the corners. One must also take care that in the stretching of the canvas the frame does not lose its proper alignment. By paying attention to these apparently unimportant details one will save oneself much annoyance when the picture is later fitted into its frame. A stretcher should never be made of green wood, or it will shrink and the canvas become creased and out of shape. With larger frames of a meter or more in dimensions a cross-brace should be inserted so that the frame will not warp under tension. I have found very practical, especially for sketching trips, the machine-made patent stretcher bars whose ends are all mitered alike so that individual pieces can be used to make different frames of varied proportions. This is not possible with the ordinary handmade stretchers. Also, when large-sized canvases are being used, especially by the landscape painter, collapsible frames are very convenient.

The joined stretcher is next laid on the canvas, which must be about 2½ cm. larger on all sides, and fastened temporarily with a few thumbtacks, or tacks, on all four sides of the frame. With the canvas pliers, which should have a good grip, or with the hand, a middle section of the canvas is then pulled taut and even over one side and a short, broad-headed tack driven in, but not yet too firmly. [It is important that this be done on all four sides before proceeding further.] Still keeping within the span of the pliers, the next tack is then driven in [and this operation is again progressively carried out on all four sides of the stretcher]. While fastening the following tacks the canvas is given a slight pull with the hand or pliers toward the corner, so that folds are avoided.

With certain types of canvases which stretch unequally it is often necessary to give them a second tightening. Therefore it is advisable not to drive in the tacks too firmly in the beginning.

The corners are now turned over, and somewhat longer nails are used here, since tacks do not hold well in the miters. If the tacks are to be withdrawn, a screwdriver is best used, or a tack-

puller. If the canvas is to be removed from the stretcher when finished, much trouble will be avoided if thumbtacks have been used in the fastening.

If a canvas is to be applied to a stretcher which has been used before, it should first be taken apart and joined together again, particularly if it has been very tightly wedged. This also will save much annoyance.

The wedges are driven into the mitered corners after the stretching, or better still after the priming, but only very lightly. They are primarily intended for later use in tightening up a canvas which has become slack. Too powerful wedging may lead to a tearing of the ground and the layers of paint, because these, once they are dry, cannot follow the movement of the canvas under excessive wedging. Quite practical is the old method of boring a small hole through the wedges and fastening them with a string or thin wire to the stretcher bars, since the wedges otherwise may easily fall out and become lost.

GROUNDING A CANVAS. Unless specially treated, textile fabrics are porous, very absorbent, and swallow up much expensive paint, which sinks into the fabric. Thus the effect of the picture cannot be calculated, which makes work difficult. In addition, the fibers of a fabric soak up the oil from the paint and soon become brittle. An attempt is made, therefore, by a special process to make the canvas more impenetrable and less porous and at the same time to heighten the brilliance of the colors by means of a luminous ground. It is true that one can also work on an unprepared canvas, and for decorative purposes this is often satisfactory. For finer, permanent work, however, it is a loss of time and a waste of material. The more quickly and directly one can say in painting what one has to say, the better. Therefore the canvas must be so prepared as to permit quick and confident work.

There is an endless number of recipes for grounds, and it is sometimes amusing to read of all that is mixed together in the belief that the greater the number of ingredients the more likely is something good to result! And not only in modern recipes is this the case. Even the oldest Byzantine and many later recipes

hold to this belief. Most present-day painters pay entirely too little attention to the importance of grounds; it is quite immaterial to them what they paint on, and not a few work over already painted surfaces in preference to new ground. The ground, however, has an extraordinary influence on the durability of the picture and the action of the colors, as well as on the later preservation and luminosity of the painting. Most painters believe that with oil colors anything is permitted, that one can go on indefinitely covering up one coat of paint with another, and that therefore the ground is very unimportant. But even with the thickest oil colors the ground strikes through, giving either luminosity and clarity, as a clean white ground will, or a dirty, greasy color effect which, upon drying, becomes still more displeasing, and in the course of years allows the underlying coats of paint to strike through. Most assuredly it is not unimportant on what one paints.

MATERIAL FOR GROUNDS. Adhesive and filling materials are used, such as glue [for sizing] and chalk and covering pigments [for priming].

A ground which is prepared by the artist himself is especially advantageous, not merely because of economy but because such individually prepared grounds permit of much more charming effects than are usually possible with purchased, factory-made material with its frequently uninteresting uniform texture.

Adhesive substances. Animal glues, made from skins, bones, and cartilage boiled down and freed from fat, are albuminous substances. They can be soaked in cold, but are soluble only in warm, water. Glues should not taste sour or salty when moistened. As a result of their process of manufacture they frequently contain free acids or alkalis which may injure pigments and also attract moisture. The presence of an acid may be determined by dipping a piece of blue litmus paper into the glue solution. If acid is present, the paper will turn red. By adding drop by drop a solution of soda, one can neutralize the acid. Inversely, red litmus will be turned to blue by alkaline action, and diluted acids added drop by drop will in turn neutralize this alkaline condition.[2]

[2] An exactly neutral solution has no effect upon litmus. It will not turn red litmus blue nor blue litmus red. [Translator's note.]

Cologne glue, and all other glues made from leather waste, are the best for sizing. This kind is obtainable in the trade in small sheets of different sizes. The characteristics of a good grade of this type of glue are clearness, absence of air bubbles, sharply distinct lattice-like reticulations, sharp margins, and a conchoidal, not an even, fracture. Such glue should never have a muddy or burnt appearance, and should not break easily. A deciding factor for its good quality is its power to absorb a great deal of water. A good sheet of glue should not go to pieces in cold water, should not discolor it, and should double in weight. Moreover, it should greatly increase in volume. After the glue has been soaked in cold water, it is heated slightly until completely dissolved. To boil glue is unnecessary; boiling, in fact, destroys its adhesive qualities. After cooling, glue congeals; when warmed slightly it will again become liquid. Glue can be made permanently liquid by adding strong acids which are hygroscopic and injurious to pigments, especially to ultramarine blue and Cremnitz white. Prolonged cooking also liquefies glue, but reduces its adhesive power. A good grade of Cologne glue, because of its density, is not hygroscopic, but often slightly alkaline.

Glue made from clippings of white sheepskin and kid leather, and also from parchment waste, was frequently used for sizing by the old masters, who carefully prepared their own glues. Of these, parchment glue is the better.

All glue solutions putrefy after some time and lose their adhesive power. Putrefied glue is mentioned in old recipes where little adhesive power was required. Additions of carbolic acid as a disinfectant are not advisable; it is better and simpler to pour the rest of the chalk-ground material, zinc white and gypsum or chalk, into the glue solution. It will then keep for weeks. After some time glue loses its adhesive power, air bubbles form in it, and the lower layers become sponge-like. Therefore a glue solution should not be used longer than about two weeks, even though it may not have putrefied. Cooking salt destroys the adhesive power of glue, and wooden boards which have been exposed to salt water are difficult to size.

Cold liquid glues are casein or vegetable glues. Their apparent

advantage in not gelatinizing is often dearly paid for, because this quality is the result of strong lyes used in their manufacture. These glues are used only in the trades.

Bone glues made from sinew and cartilage contain much acid and, as compared with Cologne glue, are very inferior. They are often sold in granular form instead of sheets.

Russian glue, a white glue, is often bone glue or, worse, a dark, burnt Cologne glue, its deficiency hidden by the addition of white clay, the quality of which is no less uncertain.

Rabbit glue [made from clippings of rabbit skins] can be used in place of Cologne glue. It possesses very great adhesive strength. That bearing the French trade-mark is the best.

Gelatine (transparent) is a very fine and expensive glue, which has, however, no advantages over Cologne glue for ground purposes. It cracks easily when many coats are applied, and is most suitable for fine fabrics or as a last coat, also especially for half-chalk ground.

Fish glues are best avoided in grounds.

Artificial glues are not to be recommended. They are mostly starches converted by the use of alkalis.

FILLING MATERIALS are added to the adhesives in order to fill the pores of the support and render it more solid.

Chalk (marble white, Paris white, whiting) is calcium carbonate. It dissolves with effervescence when heated in dilute hydrochloric acid. Chalk has but very poor covering power. The whiter it is, the better. The best kind, French (Champagne) chalk, is very smooth and gives firmness to the ground. Precipitated chalk is more suitable than ground chalk, which often absorbs water badly and must therefore be thoroughly softened. Rügen chalk [from the Island of Rügen in the Baltic] is a coarse material, crumbly, and not so white as French chalk. In addition to these there are many other varieties. Neuburg [a town on the Danube] chalk is really not a chalk but an infusorial earth. Gray chalk is not suitable; it develops ugly spots when penetrated by oil. Through the addition of small amounts of coloring matter to white chalk any desired color can easily be obtained.

Gypsum is sulphate of lime (hydrated calcium sulphate). It dissolves without effervescence in a hot dilute solution of hydro-

chloric acid. We are concerned here only with the natural hydrated ground gypsum (light spar), and not with the slightly burnt sculptor's gypsum (plaster of Paris), which, when mixed with water, quickly solidifies into a hard mass. Alabaster is a granular, natural gypsum. Bologna chalk is (according to Keim) a very light and airy, repeatedly precipitated gypsum, corresponding approximately to the recipe of Cennini. It is very porous and therefore not suited to the preparation of grounds. Bologna chalk is used by gilders as a ground on wood. Gypsum, to be sure, is denser than chalk, but has poor covering power. Gypsum grounds are especially satisfactory for use on wood panels, but may also be used on canvas. They possess extraordinary luminosity and have the advantage that they can be surfaced with a putty knife.

Kaolin (China clay) and white bole are decomposed feldspar; pipe clay, which is somewhat fatter, also belongs to this classification. All the clays retain moisture for a long time, and for this reason they seem less suitable for grounds than gypsum or chalk. They also peel off more easily than the latter, and have no greater covering power than chalk. Clay sticks to the tongue and has a very peculiar odor.

Heavy spar, baryta white, a natural mining product, is a very heavy mineral. It is less clean and has less covering power than artificial barite, known as *blanc fixe*, permanent white (barium sulphate). Both substances, the artificial as well as the natural product, are practically resistant to acids and lyes, but of poor covering power. They are used as extenders in the manufacture of sketching colors, but rarely in grounds.

Marble dust was used in old Italian grounds. It is related to chalk, but is more crystalline. Wehlte [3] recommends marble dust and marble grit in casein grounds to achieve a fresco-like effect. Marble dust was used in Pompeii as an extender in colors.

Pumice-stone powder and *soapstone, talc* (magnesium silicate), are seldom used. Sifted ashes (cernada), mentioned in old Spanish recipes, make a ground brittle.

[3] A former student of Doerner's. [Translator's note.]

Body colors. All the materials so far listed have no covering power; they lose their own color when they come in contact with oils and varnishes. Body colors are therefore added to the grounding preparation, and in this way the luminosity and permanency of a painting are increased.

Zinc white (zinc oxide) is the best covering pigment for grounds. It is a loose powder, and a little of it goes a long way. Used alone, however, as a ground material, it is dangerous because of its brittleness. Not many fabrics would hold more than one coat of it.

Titanium white, a new pigment, appears to be quite satisfactory in water-color techniques. Its covering power is good, and it is not poisonous; but it has not yet been sufficiently tested.

Lithopone is useful in the new and better varieties, but its resistance to light is as yet uncertain. Inferior grades must be avoided because of their tendency to turn dark.

Cremnitz white, white lead. Although the white pigment with the greatest covering power, it is not recommended for chalk grounds because it is extremely poisonous. There is always danger that it may be carried into the air in the form of dust. Zinc white in a ground goes much farther. The Flemish painters added one-third white lead to their gypsum grounds to increase their luminosity. They could not very well use zinc white, because in their day it was unknown.

Grounds made without the addition of body colors obviously not only change considerably when they come in contact with oil, but they also continue to darken afterwards. Where parts of a ground in a painting remain uncovered, to contribute to the artistic effect of the picture, as, for instance, in the sketches of Rubens, some body color in the ground is an absolute requirement.

THE CHALK GROUND for textile fabrics is made according to the following recipe:

1. *Size: 70 parts (70 gm.) glue to 1,000 parts (1 liter) of water.*
After the size has dried, the priming is applied with a brush,
as follows:

2. *An equal measure of chalk, gypsum,[4] or pipe clay,*
 etc.
 An equal measure of zinc white } mixed.
 An equal measure of glue solution 70:1,000

3. *After this has dried, possibly still another coat the same as 2.*
One liter of glue size will cover about eight square meters.

The mixture must be thin enough to be easily worked with the brush. If such is not the case (because the absorbent power of different ground material varies), a little more glue solution may be added. (Note to 1: The glue is heated in the liter of water in which it was soaked, but only enough to dissolve it.) Boiling reduces its adhesive strength. It must also be pointed out that the strength of present-day glues varies considerably. The proportion of 70 gm. glue to 1 liter of water can therefore be only approximate, and may possibly be either too small or too large. The glue size must not be so applied that the canvas becomes soaked through, in which case the latter only becomes brittle and bumpy. Using the tip of the brush, one should go over the canvas without much pressure, with the brush only half full of the size. The glue size, like all the following ground coats, must not be dried in the sun or near a radiator, because, while the ground under these conditions dries very quickly, it is apt to chip easily. Extreme cold causes quick shrinking of the glue and subsequent cracks in the ground. The glue sizing must be completely dry before any further coats of priming are applied. In summer it takes half a day and in winter perhaps a full day for the sizing to dry. When the size is applied to the canvas, the latter shrinks and becomes tighter. Upon drying, many fabrics become slack and must again be stretched. This is preferable to a sharp tightening of the wedges. Therefore it is important to remember to drive in the canvas tacks provisionally only and not too tightly. To tighten the wedges a little after priming while the ground is still wet is of advantage. If there are creases in the canvas where it was folded which do not disappear when it is sized, they must be

[4] The gesso ground of Cennino Cennini was made with gypsum. Examination of old panels has shown that whiting was also used in "gesso" grounds. [Translator's note.]

pressed out while the size is wet with the handle of the spatula or some other suitable instrument.

First but very little glue solution is added to the chalk and zinc white, and these are mixed well with a brush, much as one mixes flour and milk for a cake batter. Then the rest of the glue size is added, and, should the mass be lumpy, as may be the case if the gypsum or chalk was poorly ground, the whole mixture is put through a wire sieve. The brush is then pressed out on the edge of the spatula, and a little of the ground is taken up and applied thinly without pressure to the sized canvas, which, of course, must be dry. When the canvas is very large, one may use a large brush such as is used in the trade for calcimining. One need not wait for a thorough drying of the first coat, but after a superficial drying of perhaps a half to a full hour a second coat may follow. If a smooth ground is desired, all superfluous ground is removed by means of the spatula edge held obliquely, much as one scrapes an excess of butter off a slice of bread. In this way only the pores of the canvas are filled. This process has always proved very advantageous, because grounds made in this way provide a pleasant surface to work on and set off the colors well. The simplest method is quickly to cover a part of the canvas, say, a square meter, with a full brush and at once, before the ground begins to "pull," remove all excess ground with the spatula, as described above. A ground may also be applied entirely with the spatula and then scraped. One must merely be sure that, particularly in the case of light fabrics, every successive ground coat is scraped. In this way the ground remains elastic. If the first ground coat is applied with a brush and only the following coats are scraped, cracks may develop, particularly if the grounding material contained much water. Grounds applied with the brush are rough to the degree in which they contained water; they also show more of the texture of the canvas. Very coarsely textured fabrics are not advisable, particularly in small-sized pictures. They make work difficult, swallow up much material, and the parts painted opaquely easily lose their texture. [Hans von] Marées once said that he preferred to determine for himself which parts of his picture should show texture. There is no sense in putting a smooth ground on a coarsely textured canvas. A ground should

only fill the pores and should not lie on the canvas like a sheet. Otherwise it cannot follow the movements of the canvas and is likely to come off. One must also guard against using too much pressure while putting a ground on a canvas. Should the inner edge of the stretcher press through while the ground is being applied, the wedges must at once be tightened. If the grounding material is forced through to the reverse side, very disturbing un-even areas appear in the canvas. Very heavily applied ground is also apt to be uneven. In this event every bit of ground must be sandpapered down to the deepest brush marks, and what was thought to be a saving of time proves to be the contrary.

Without any preliminary sizing all grounds are very absorbent. When only chalk and gypsum have been used in the ground, it will darken when painted on; and, as a further consequence, the whole picture later will do the same.

The left-over portion of the chalk ground may be set aside for later use. Its diminished water content (especially where steam heat is used) must, however, be replaced, otherwise the top layers of the ground will be tighter than the lower and will tear them off. If the solution is not workable with a brush, a little glue solu-tion is added (70 parts to 1,000). Small remnants may be put back into the glue size to prevent it from spoiling; this is better than adding harmful carbolic acid or other disinfecting agents.

Giving a ground a smooth surface. Primings may be surfaced when either wet or dry. Those which are surfaced when wet are smoother. On a dry ground, besides sandpaper, ossa sepiae [cut-tlefish bone] or pumice stone may be used. In this process it is necessary to slide a piece of cardboard between the back of the canvas and the stretcher so that the edges of the stretcher will not press through. One then goes over the ground with a light pres-sure and a circular motion. If a wet ground is to be surfaced, a sponge is moistened with water, wrung out well, and then passed very lightly over the well-dried priming. If inadvertently one has wet the priming too much, one must wait until the moisture has been absorbed, otherwise the priming will come off. Thickly ap-plied primings, especially when they have been prepared with too much water, are liable to come off when surfaced. For wet sur-facing artificial pumice stone is best used, which is obtainable in

different degrees of hardness. Natural pumice stone often contains hard particles which may cut the ground. Knots in the canvas are removed, wherever possible, by being cut off; otherwise they may be rubbed down, after having been moistened, while at the same time a slight pressure is applied with the tip of a finger from the back of the canvas. In this way one can best determine when the knot has been removed. Dry-surfaced grounds are usually rougher, wet-surfaced smoother. Strong surfacing, particularly wet, is dangerous, as it frequently causes cracks. Also on very smooth grounds even alla prima painting may tear. Therefore it is better to scrape off the ground than to surface it by other means. For very fine work one may use ossa sepiae or horse tail.

Tempering the ground. Through the addition of a good quality of alum, $\frac{1}{10}$ the weight of the glue, the latter loses its absorbent powers. The priming becomes insoluble in water, which is very important if one wishes to work over it with a watery medium (tempera). Otherwise the chalk ground will dissolve. However, the ground does not become impervious to water.

If *chrome alum* is used to harden a ground, the glue will turn yellow and become brittle. Tannic acid will give it a reddish color. Both agents are therefore useless. The insolubility in water of tempering agents is not absolute, but sufficient for our purpose. A 4% formalin solution may be applied with a fixative blower, or a 4% coat applied with a brush will serve the same purpose. The formalin solution may be added to the glue solution directly before the size is put on, but not to a glue solution which is to be allowed to stand for any length of time. Alum has the peculiarity of causing the brush marks to show. Upon pictures of the Italian High Renaissance one often sees opaque brush strokes in the priming, which are probably due to the addition of alum to the size. Alum also has the disadvantage that it discolors ultramarine blue. Therefore spraying with formalin is to be preferred.

Loosely woven fabrics, which would allow the usual ground material to fall through, must first be sized with a glue solution to which powdered alum has been added in an amount equal to $\frac{1}{10}$ the weight of the glue. Alum similarly is added to the prim-

ing, and this is best applied when cold and in a congealed state. When it cannot be easily applied, let it be stirred up well with a brush or a spatula. The sketching canvases of the trade are such wide-meshed fabrics, and naturally also of such inferior material that they should be used only in an emergency. The cold priming is applied with the brush and smoothed at once with the spatula. Congealed grounds are especially suited to being applied with the spatula. If one wishes the brush marks to be invisible, and this is often desired by the trade, let the first priming coat be slightly dampened or the second coat put over the first while still damp.

Additions to the chalk ground. For the purpose of increasing the elasticity of the ground additional substances are added, such as soap, soft soap, honey, syrup, glycerin, and the like. These substances have the great disadvantage of adding considerably to the hygroscopic properties of the canvas, and by continually absorbing and giving off water they increase the movement of the canvas and render it slack. This was already ascertained about honey by Van Dyck (according to De Mayerne). Honey, he said, blooms like saltpeter. Lyes and acids have a hygroscopic effect and only deceive one into thinking that they increase the elasticity of glue. Glycerin decomposes completely in the course of time and is then, as such, no longer present; but its decomposition takes place only after a considerable length of time, and in the meantime it may do much damage. Soft soap, a by-product of the chemical industry, tends in addition to darken the colors considerably by reason of the caustic lyes which it contains. All of these additions are also unnecessary, because the chalk ground is smooth enough in itself. Skim milk in small quantities is an invaluable addition to glue in preventing brittleness.

The excellence of a chalk ground is best tested by pressing on it from the tube a small quantity of Cremnitz white. If the chalk ground is of a satisfactory quality, there will be no oil stain around the white. A too absorbent ground can be improved by a coating of egg emulsion, with the possible addition of a little white. Moisture and varnish should not change the brightness of a good chalk ground, nor should a spot of oil on it change it; and, if held against the light, the ground should appear uniformly thick.

Faulty grounds. Grounds applied too thickly may come off, as has been reported of the gypsum grounds of Veronese. The chalk ground should not rub off when dry. If it does come off, it is a sign that not enough glue was added. Grounds containing too much glue develop cracks, the so-called "glueworms." The ground should not crackle if the canvas is held to the ear and pressed with the finger on the reverse side (a sign of too much glue). One can often eliminate the "glueworms" by applying a thick coat of half-chalk ground to the reverse side of the canvas. It is best, however, to wash off such imperfect grounds with hot water and then apply, not a chalk, but a half-chalk ground, because experience has taught that chalk grounds do not hold well to such glued-over canvases. Cracks in the glue which have been painted over frequently cause deep furrows on the back of the canvas. Usually these cracks in the glue go no farther, but are rather "beauty-blemishes," at least with otherwise carefully prepared grounds, particularly if glue has been used in moderation. Excessive use of glue becomes apparent only after a ground has thoroughly dried. A ground, when held against the light, should not show gaps or crevices, but present a perfectly even appearance. Correctly prepared chalk grounds, upon being moistened with water, should lose but little of their essential whiteness. Canvas which becomes very dark when moistened, as do many shoddy linens which have been greased with fish oil, will cause the picture to turn dark even if painted alla prima. Primings which have been put on very wet crack easily upon drying, owing to excessive evaporation. Canvases which shrink greatly when sized are likely to warp the stretcher, particularly if this is made of unseasoned wood. In that case the stretcher is laid flat on the floor and the corners are weighted down until the canvas has dried.

The greatest possible permanency of the whiteness and brightness of the chalk ground, even when wet, is essential for the continued preservation of the luminosity of a picture. In this lies the value and importance of adding zinc white. On other grounds, prepared without body color, and especially with insufficient glue, oil color is "drowned." Every increase in the brightness of the ground is of lasting benefit to the picture. A good cohesion

of the ground is also an important requirement. Hodler,[5] as I was told, at one time, just before starting work, applied with a spatula to the bleached canvas a coat of zinc white mixed with water and a thin glue solution, and then painted into this half-wet ground. He probably obtained in this manner, at the cost of the permanency of the painting, a fresco-like, robust effect as compared with the often unpleasant and smeary smoothness of oil colors. Zinc white by itself is brittle, this brittleness increasing when it is used in water without a binding medium, and colors applied to it do not hold well.

Creases and bumps in the ground are removed by moistening the reverse side a little and then lightly driving in the wedges of the stretcher.

The qualities of the chalk ground are brightness and luminosity, leading to a thin, vaporous, and mat character of the paint which approaches the effect of fresco painting. Chalk ground is being used again today to an increased degree because of its pleasing optical properties. The beautiful mat effect, which is obtained through the absorption of the oil by the chalk ground, is desired by many painters, and it has led to the practice recently adopted and commonly employed of using thinning media, such as oil of turpentine, benzene, decaline, and the like, often with a small addition of wax, which permits oil color to be used semi-opaque on fine canvas almost like water color.

One may also, however, paint very opaquely upon absorbent chalk grounds. If the ground is very absorbent, it is hard to complete a piece of work at one sitting, and in repeated overpainting with thick oil colors one is really working on an oil ground. The charming mat color effect is then lost. Quick work and not too frequent overpainting heightens the effect of the ground, which is therefore especially adapted for sketching purposes, for decorative work, and above all for tempera painting. Today a heavy alla prima technique is often used on chalk ground, the color being promptly "lifted" with xylene and blotting paper. Into the remaining color surface, which has a broad, simple effect, are then put color accents in a loose, water-color-like technique.

[5] Ferdinand Hodler, the Swiss painter. [Translator's note.]

It is a mistake to believe that one can work indiscriminately with oil colors upon a chalk ground, using a great deal of oil as a medium, since the ground will absorb the oil anyway, or that later, simply through the use of resin ethereal varnish, one can make up for the lack of a binding medium, as W. Ostwald recommends. The colors would become greasy, and would turn yellow and darken, even if put on by the alla prima method. Chalk ground can, if necessary, be used immediately upon drying (during summer even on the day it is applied), but it will be better and harder after several days of drying. For all kinds of primings the following is a good rule: grounds will be so much the better and more solid, and the colors stand up so much the better, the longer the former are allowed to dry.

The isolation of the chalk ground is intended to minimize the absorbent nature of the priming and permit of a prolonged working period looking toward immediate completion. The isolated chalk ground has the great advantage of being free from oil, thus enabling the oil colors which stand best on a meager ground to show to best advantage. One can, on properly isolated grounds, paint wet in wet successively for several days. It should, however, at once be remarked here that it is absolutely essential that the ground be somewhat absorbent, in order that the paint may adhere. One should not apply an isolating medium in such quantities that it has a shining, glassy effect. Upon completely unabsorbent ground the paint loses much of its adhesive power. Isolating media are of different characters. By using them to excess one may cause cracks in the ground just as if too much glue had been used. Rather a little less than too much is a good rule here, but every painter must determine the right proportion for his own use.

Resin ethereal varnishes. Mastic and dammar diluted with oil of turpentine give good service as isolating media. The longer they dry, the better they are. They should not make a ground shine. Totally unsuitable would be coatings of fatty oils, linseed oil, poppy oil, or nut oil. The lean character of the ground would be lost, adhesion would be poor, and the colors would turn yellow.

Very useful are spirit varnishes because of their rapid drying, for example, white, bleached shellac dissolved in alcohol, such as

is used as a fixative for drawings, only much thicker, somewhat like honey, about one part to two parts alcohol. Similarly a mastic spirit varnish may be used. But with these spirit varnishes it is absolutely essential to add a little castor oil to remove their brittleness. One should not, however, add more than 5%, otherwise the isolating medium, which normally dries at once and can be painted on in a few minutes, dries poorly and remains smeary for some time. It is best measured by placing a measuring stick alongside the bottle of dissolved shellac and adding ½₀ part of castor oil. In place of the white shellac one may also use the unbleached leaf shellac, only it gives the ground a yellow-brown tone. If zinc white is present in the ground, a light reddish color quickly develops, probably a chemical reaction (see under shellac), but it is otherwise not harmful.

Sandarac spirit varnish cannot be used. Oil does not stick to it, nor to colophony spirit varnish, for many colors, such as white lead, coagulate on colophony, and in addition colophony splinters.

Collodion, 2% or 4%, would be an excellent isolating medium, but it dries so unusually fast that it is hard to use with the brush. With an addition of 5% castor oil it becomes more manageable (*collodium elasticum*). On downy fabrics the collodion dries at once on the tips of the fluff, does not adhere to the ground, and sloughs off when gone over with a brush. Collodion is highly inflammable.

Acetone varnish, celluloid varnish, are solutions of colorless scraps of celluloid in acetone or other media, as, for example, in 75 parts alcohol and 25 parts ether with from 2% to 5% castor oil. These varnishes are very smooth, but it is not recommended that they be prepared by the layman. Still unexplained is the behavior of these isolating media with respect to the oil paint laid over them. Many seem to repulse oil. Others are sensitive to moisture. I once made the mistake of painting over such an isolating material. The picture had been blocked in when all of a sudden, with each brush stroke, the isolating skin came off in rolls resembling a strip of film. Besides, these varnishes turn yellow. Such varnishes are offered by the trade as "oilless grounds," and one is advised to put a half-chalk ground over them. One has really no right to speak here of *oilless grounds*. The durability of such

grounds over a long period of time has not yet been tested. The priming must be completely dry, otherwise this isolating medium will not adhere. Any recommendation of celluloid varnish or similar products as isolating media over old coats of oil color or even as an intermediate varnish in oil pictures should be wholly discredited. Tests have shown that coats of celluloid varnish immediately lose their molecular coherence, which would destroy an oil picture.

Zapon varnish (a trade name) is too thin for use as an isolating medium, but would otherwise be suitable, especially with an addition of 5% castor oil. Zapon varnish turns yellow.

Upon properly isolated grounds colors undergo but little change and retain their full luminous strength, without the need of a varnish.

Shellac isolating media used on chalk grounds have been proved by test to lessen the movement of the canvas caused by hygroscopic action. No contraction developed in the canvas when hot water was poured over it; even after the canvas had lain in water for 24 hours, the color and ground had not become detached from the canvas.

THE HALF-CHALK or TEMPERA GROUND (HALF-OIL GROUND) is prepared in the following manner:

1. *A coat of size with glue-water 70:1,000, as for the chalk ground.*
After the drying of the glue size, the following:
2. *An equal measure of chalk or gypsum, etc., an equal measure of zinc white, and an equal measure of glue-water 70:1,000, well mixed together, with then an optional amount, ⅓ or ½ or ⅔ of a measure, of boiled linseed oil mixed in* (see page 105).
3. *After this has dried, further coats (as under 2).*

Very important is the order in which the materials are mixed. If one should add boiled linseed oil before the glue was added, the zinc white would form an insoluble mass with the linseed oil.

In the half-chalk ground watery constituents (glue-water solution) are combined with oily, fatty ones (boiled linseed oil). In this lies the nature of tempera (q.v.).

The ground material must be of a heavy, flowing consistency in order to take the oil, which is stirred in, drop by drop, with a

brush. Cold, congealed chalk-ground material is very well suited to the preparation of half-chalk grounds. Ground preparations which are very warm and therefore thinner take oil poorly, and it may quickly separate.

Half-chalk grounds are best put on with a brush, all the surplus being scraped off with the edge of the spatula and then smoothed, so that the coating is very thin. After the surface has dried superficially (about ½ to 1 hour), a second coat, which should be just as thin, may follow. It is advisable to put on the coats alternately with brush and spatula at right angles to each other, in order to fill all the pores. Coatings brushed on or laid on with a spatula may alternate. One may also, without having first applied a glue size, paint one or more coats of the half-chalk ground directly upon the canvas and smooth them with the spatula. Of course such grounds are much more absorbent. One may put on from two to four such coats. The half-chalk ground dries rapidly and may be used on the next day, but it will be better and harder the longer it is allowed to dry.

Grounds applied with a brush show the grain of the canvas and are rougher; laid on with a spatula, on the other hand, they are smooth, take the color well, and are very pleasant to paint on.

Boiled linseed oil (q.v.) dries rapidly, in from 12 to 24 hours. By itself it is not suitable for use as a ground, for it would make the canvas greasy and shiny and therefore be difficult to paint over. In place of boiled linseed oil one may, in case of need, use raw linseed oil with or without an addition of 1% siccative. Such a ground must be given at least ten days to dry.

Coach varnish and thickened linseed oil, also stand oil, are usable, like boiled linseed oil, but never poppy oil or boiled poppy oil or nut oil, which are most unsuitable for grounds because of their poor drying properties and the danger of causing cracks in the oil paint put over them. Carefully made preliminary sketchings with colors thinned with oil of turpentine crack badly here because they soften the poppy-oil ground. Grounds containing poppy oil in combination with zinc white or lithopone dry through (according to Dr. Eibner) in the course of a year. But we must nevertheless absolutely reject such grounds, for experience does not guarantee that they will dry through, and even if

they did, there would always be the danger of their softening again.

If one wishes to limit still further the absorbent nature of the half-chalk ground, it can be isolated or covered with a mixture of cold, congealed glue size and boiled linseed oil, with perhaps also the addition of a thin priming coat. But the ground must then be given a few days to dry. Half-chalk grounds of the trade often contain non-drying oils, such as olive oil or rapeseed oil, in order to keep the ground elastic. Such additions cause the colors later to turn dark and become sticky. Their effects are especially bad when there is also glycerin and soap in the ground. Such grounds should be rubbed off with alcohol before being used, particularly when they feel greasy. All sorts of ground materials are offered by the trade either in powder or paste form, such as glue solutions containing much glycerin, casein powder with lyes, celluloid varnishes with fillers, etc. The composition of all these materials is uncertain, as is also their durability.

Utensils and brushes must be cleaned at once with soap after working with grounds containing oil. Left-over ground containing oil must not be added to glue size. It can be used only over a short period of time.

Half-chalk ground material is best used immediately upon being prepared; it is difficult to preserve. This can be accomplished for a short time by covering with damp cloths or by carefully pouring on water which must not be allowed to mix with the ground.

Grounds containing oil yellow somewhat, but that is an artistic advantage. In the light this yellowing quickly disappears.

OTHER TEMPERA GROUNDS. Tempera emulsions (q.v.) can be used with chalk and zinc white or white lead, etc., as grounds, but they absorb much moisture. They are very suitable as additions to the half-chalk ground (about ¼ part), but best of all as thin coats over the ground when mixed with zinc white or white lead, and possibly with an addition of oil or resin.

The casein ground. (For the preparation of casein, see page 218.) Technically pure casein is insoluble in water and well adapted for use in grounds. Casein is used in the same manner as glue. Casein grounds become exceptionally hard; they are there-

fore best used on strong, tight materials such as wood or paste-board, and only on very strong canvas. Oil grounds or half-chalk grounds of the trade also may be covered on the back with casein and then painted on. Owing to its strong adhesiveness casein must be thinned when used as a ground (1 part casein solution to about 4 parts water). The casein solution can be used by itself, as glue with the chalk ground, or as casein emulsions.

Casein grounds must be put on very thinly, because casein forms a skin on the surface. The underlayers then dry poorly, and tear and crumble upon being surfaced with sandpaper. Casein grounds containing oil turn yellow and are therefore usually colored in order to conceal this, but are otherwise practical.

The egg ground. Egg yolk is added to grounds in order to increase their suppleness, and many recipes cannot say too much for its use. Only a very small quantity must be added, however, else the ground becomes smeary because of the non-drying egg oil and presents a very poor painting surface. It then turns quite dark, and all the colors are apt to scale off. The addition of egg should always be made after putting on the glue size, otherwise the egg may cause the glue solution to rot. Such egg grounds (egg emulsions) give best results when, in addition to the chalk or half-chalk ground, they are applied as a finishing coat. (See also egg tempera.)

White-of-egg ground (albumin ground). Its preparation is set forth under "Tempera." It can be mixed with water as an addition to chalk or half-chalk grounds, but is best as an emulsion and when used as a thin coating with zinc white and chalk and scraped smooth with the spatula. Egg white is very brittle and comes off easily if too much is used, or if it is used by itself as a ground.

Rye paste can be used like glue in chalk ground, stirred up in hot water in the proportion of 1:15. The rye flour should be mixed with some cold water. This ground can also be made into a half-chalk ground through the addition of boiled linseed oil. Paste grounds, however, are brittle; Volpato already (in 1588) warned against this. These grounds also must be applied very thinly. On a solid basis like wood they have proved very satisfactory.

In Spanish recipes (Pacheco, 1649) rye paste mixed with olive oil and honey is mentioned. On top of this two oil coats were applied. No wonder such grounds would not last! Paste, linseed oil, and chalk constitute a recipe of the Piloty period (1850-1886) used in the commercial manufacture of grounds.

Starch paste, potato or rice starch stirred in the proportion of 1:15 in boiling water, may serve in place of glue. The cohesion of oil on such grounds is questionable. Peeling has been observed. For tempera such a ground would be better.

THE OIL GROUND is prepared according to the following recipe:

1. *Glue size with glue-water 70:1,000*
2. *Glue, chalk, zinc white or white lead, each in equal parts.*
3. *In addition, up to two parts of boiled linseed oil.*

The recipe is the same as for the half-chalk ground, only the amount of oily constituents is increased. Immediately after grounds of this type are applied, they must be scraped smooth with a spatula so that each coat is very thin. The fatter and richer the ground is in oil, the thinner must be the coats, so that they will dry well.

In place of boiled linseed oil one may here also employ coach varnish, stand oil, sun-thickened oil, or linseed oil with or without 1% siccative. In general one must be sparing in the addition of oil. The more is added, the less satisfactory the ground becomes to paint on, and the longer it takes to dry (at least eight days).

Poppy oil is entirely unsuitable, and nut oil less satisfactory than linseed oil. Poppy-oil grounds take a whole year to dry and cannot even then be used without danger. Grounds which have turned out too oily may be sprinkled with powdered chalk or clay and then dusted off by knocking the frame on the floor. It would be very harmful to saturate the canvas with oil, as is often recommended. Such canvases are very bad to paint on, and not only will the painting turn yellow to a very marked degree, but the canvas itself will soon go to pieces like tinder. The oil content of a ground is governed by the requirement that the superimposed painting must be still richer in oil than the ground.

For every type of painting, either in the trade or in the arts, the time-old rule holds: *fat over lean*.

Over a glue size one may also apply coats of oil colors. Cremnitz white is rubbed into a somewhat thicker paste than tube colors. Since Cremnitz white is very poisonous, one must guard against breathing in the dust while mixing the paste. The first coat of ground may be put on with the brush, and for this purpose let a little oil of turpentine be added as a thinner. After a thorough drying (4 to 6 days) one can use either the spatula or brush for putting on the second coat, but without oil of turpentine. Cremnitz white as a tube oil color is usually too rich in oil and too fluid for ground purposes. By means of the spatula it is mixed with fillers, such as chalk or gypsum, into a very opaque paste, which can be used over sized canvases or over chalk or half-chalk grounds, or also, in an emergency, over an unsized canvas.

Chalk, clay, or gypsum, etc., may also be mixed with oil and used as priming material, particularly when a very inexpensive ground is required. Such grounds, however, turn yellow and have little luminosity.

Since very oily grounds easily turn yellow, some color, bone black and umber, etc., is frequently added to the last priming coat to produce a silvery gray tone. Coats of oil paint must dry a long time, for good results fourteen days—the longer the better.

If, because of its oiliness, the ground takes colors poorly, it may be rubbed off with a slice of onion or potato, or, better still, with dilute ammonia, also with alcohol.

Oil grounds of the trade. The manufacturer is naturally interested in keeping his product saleable as long as possible. Since a roll of canvas is often kept a long time and is continually being rolled up and unrolled, it must be as supple as possible. Considerable additions of non-drying oils, of soap, glycerin, and similar substances, serve this purpose, but such grounds offer great dangers to a painting. Even crude lanoline is recommended in one recipe. Because of these undesirable additions a thorough drying of the superimposed coats of paint is prevented; the results are darkening, stickiness of the paint, and, later on, cracks. On highly surfaced oil grounds in particular the color does not ad-

here well. In addition, such canvases, which often resemble a wax cloth more than an artist's canvas, are difficult to paint upon in successive layers. One must, before using, rub off such canvases as feel oily with ammonia or alcohol in order to improve the adhesion. Rubbing with a potato or onion only prevents the trickling of the colors and does not improve the adhesion. On such over-oily grounds oil color does not hold well. I learned of a case where the picture of a well-known artist permitted of its being pulled completely off the ground, like a skin. I have in my possession samples of trade grounds which were applied to the canvas in the year 1892 and which today are still sticky through and through and have become an ugly brown. But there are also available today in the trade unobjectionable canvases for oil painting, prepared as half-chalk or oil grounds.

According to a recipe by Blockx,[6] canvas with an oil ground is manufactured by painting a thickly mixed coat of white-lead oil color over a moistened canvas. Undoubtedly material is saved in this way, but the adhesion suffers. Despite the great dangers of the oil grounds sold by the trade, they are today by far the most widely used, and painters thus deprive themselves of the most beautiful qualities of colors in their pictures, for it is only on a meager ground that oil colors reveal their full beauty.

TONED GROUNDS. One can, if desired, tone a completed chalk, half-chalk, or oil ground by means of thinly applied, transparent color tones, and in this way obtain a glazed ground. For this purpose resin-oil colors or oil tempera may be used; on a solid basis also glue size. The addition of a little dry pigment to the shellac isolating medium will also produce a glazed effect. The Gothic masters and those of the early Renaissance toned their white gypsum grounds with thin reddish or yellowish, also greenish coats of earth colors (so-called imprimatura), which reduced the absorbent quality of the ground. They were also used as middle tones in the picture.

The bole grounds of later days were toned with brown or red earth colors, such as Armenian bole, burnt sienna. burnt light ocher, and caput mortuum.

[6] A Belgian color manufacturer. [Translator's note.]

Gouache grounds, opaque color grounds, are best made by the addition of a little pigment to the last priming coat. Such grounds are more atmospheric in effect than glazed grounds, and they are particularly pleasing when kept very light. They seem to meet the requirements of oil painting. The use of tempera mixed with white or very lean oil paint as a final coat will give a good toned ground.

Rubens went over his dazzling white gypsum grounds, laid on wood, with a mixture of ground hard charcoal, some white color, and some binding medium (probably glue). This coat was applied quickly with a sponge and had a striped silvery gray tone which gave to the subsequent thin coats of color an unusually loose, pleasing, and live appearance. If a sponge or brush is passed back and forth over such a coat, the latter quickly dissolves, and the tone becomes uniformly gray and like an ordinary coat of paint. On the other hand, there are to be found solidly painted coats of gray ground on canvases by Rubens, Van Dyck, and many other masters.

Interesting and of very pleasing optical effect is a ground which may be mentioned along with the bole ground, and which was used by painters of the late baroque period, or perhaps even earlier. I have found it on the pictures of Januarius Zick and Rachel Ruysch. The ground was painted with dark caput mortuum, and over that was laid a further coat of dark ocher and chalk. By coating over the ground with a resin medium a very useful warm color was developed, which did not appear burnt, as might a coat of burnt sienna, and which through its usefulness as a middle tone permitted extremely fast work.

This much may be said in a general way concerning the effect of colored grounds upon a painting: white grounds permit the greatest degree of colorfulness—all colors look well on white. On the other hand, the proper relating of colors on white grounds is more difficult; the picture may easily become too cold and flat. The well-trained painter knows how to combat the danger of too high coloring through the proper and free use of cold, warm, and contrasting color tones. It is possible to work both in glazes and opaquely on a white ground. On a toned ground only an opaque technique is possible, that is to say, the

darker the ground the more opaque should be the technique. Through a semi-opaque technique which allows the ground to be active result the "optical grays" which were used by the old masters Rembrandt, Van Dyck, and many others. These grays have a more charming quality than painted grays.

On light gray grounds, as on gray underpainting, the color becomes duller and more earthy. This is desired by many painters and has a good effect in the painting of flesh, especially when the ground is used to help the effect. Gray-green tones of Veronese green earth are effective for flesh tones, as well as for the all-pervading tone of the picture. On colored grounds such as light ocher, or, for example, on red, the color range of the picture is reduced, for the contrasting tones of blue or green are weakened or even broken; but the harmony of the picture as a whole is heightened. Here very fine effects may be obtained, especially when one paints with cold or warm colors in contrast with the ground. On very strongly colored and dark grounds it is best to seek brightness above everything, and consider that contrasting colors cancel each other and may give the picture a dark effect, especially if used as glazes. Umber grounds are not to be recommended; on umber all light colors change and become dark. De Mayerne already made this observation in relation to oil grounds.

It is certain that all sorts of fine effects as yet unexploited may be achieved on colored grounds.

HOW TO TREAT THE BACKS OF CANVASES. All fabrics are hygroscopic and hence, if hanging on damp walls, may suffer damage. Attempts are made in many different ways to prevent this. The obvious preventive would seem to be a coat of ground material on the back of the canvas. It has been shown, however, that many canvases treated in this way become brittle and tear easily. This is also true of canvases manufactured for the trade. This is, however, a variable condition, and canvases of varied makes behave differently in this respect. They should be tested before using. A coat of glue applied to the back, or one of shellac or resin, increases the danger of brittleness. Coating with wax is just as little to be advised, as is also a mounting of tin foil or a coat of oil. The best method of preserving a canvas, as is agreed

by many men of practical experience, is to leave it alone. But it is recommended that a preventive agent be provided against immediate hygroscopic action of the canvas. It is quite sufficient to fasten a strong piece of paper by means of thumbtacks over the stretcher. This has the additional advantage of preventing a person who may be carrying a picture from getting his fingers between the canvas and the stretcher and thus causing bumps and cracks. Good veneered wood is also useful here. It can easily be fastened to the picture frame with wing screws.

PAINTING OVER OLD STUDIES. One frequently hears of painters who prefer to paint over old studies; and here the meaning of "old" is quite relative, for often the studies painted over are scarcely dry.

Poorly dried poppy-oil colors, when used as a basis, may very easily cause cracking. An opaque coat of paint poor in binding medium is better to paint over than are glazed surfaces or colors very rich in oil. Old, well-dried canvases offer usable bases for sketches in an emergency if they are painted opaquely and not too thinly, and if pains are taken beforehand to remove all rough spots with a spatula or sandpaper. It must always be borne in mind that the under color invariably works through thin coats of superimposed paint, and that pure white must not be glazed over, but covered with opaque paint, since superimposed glazes easily tear, especially those of madder lake, umber, etc. Experiments have shown that, as compared with paint put on over clean chalk or half-chalk grounds, painting on old studies has, without exception, a greasy, muddy appearance, which increases with time. In times of economic stress, however, one is forced to make the most of one's material and use the reverse sides of old studies. Canvas which has been painted on is hard to re-stretch; besides, one is forced to use many of the old tack-holes. I have found it useful to apply to the back of old canvases two coats of half-chalk ground and pull them off with the spatula. Such a ground feels somewhat like a wood panel, and the color stands well on it.

REMOVING OLD COATS OF OIL PAINT. One may free a canvas of its coat of oil colors or of the ground by cooking it, or by means of a caustic medium, such as soft soap mixed with

slaked lime, which should be allowed to stand on the surface. The paint removers which are offered for sale by paint shops may also be employed. One must be sure, however, to wash off this caustic material cleanly with hot water, and then preferably to apply a half-chalk or oil ground to the cleaned surface. Certain grounds of the trade which contain much glycerin and soap may be pulled off the canvas like a skin, after immersion in hot water. To insure a prolonged action of highly volatile solvents I add wax dissolved in oil of turpentine. Panzol (a trade name) is made in this way. Trichloroethylene is a very effective paint remover (caution, dangerous fumes).

II. WOOD PANELS, PAPER, PASTEBOARD, METAL, ETC., AND THEIR PREPARATION FOR PAINTING

WOOD PANELS as supports for painting have been used from the earliest beginnings of painting, and because of their density and firmness have special advantages. In different countries different kinds of native woods were used; for example, in South Germany pine, fir, and larch, linden, beech, or ash, while in North Germany or Holland oak was used almost exclusively. Very seldom were elm and alder used. In Italy the Italian poplar and wood of the cypress were employed. Vasari writes that when the Venetians needed a wood panel, they chose fir from the Adige. Imported woods are often used today, such as mahogany and the American cottonwood. Well-dried, seasoned wood must be used which has been exposed to the air for one or more years, because new, green wood contains too much water and shrinks and warps upon drying. The tree should not be cut when the sap is rising. For evergreen woods one should allow 20 months, for oak three years, or as long as it takes to dry properly. (The water content of air-dried wood is, on the average, 29% in the case of evergreen woods and, in the case of deciduous woods, about 36%.) Kiln-dried woods check easily. There are processes in use today by which new, green lumber is dried in three days by treating it with live steam. The albuminous bodies in woods are supposed to be fixed in this way. But for our purposes such methods are hardly practicable. The wood of young trees is

less valuable than that of older ones. With respect to the lasting qualities and permanence of our native German woods, the oak comes first, followed by the elm, larch, pine, ash, beech, willow, alder, and poplar in descending order. There is great difference in woods of the same kind, depending on the locality.

The hardest are ebony and the imported hardwoods, then maple and hornbeam (a variety of beech), ash, plane-tree, elm, locust, beech, oak, walnut, pear, and edible chestnut. Soft woods are fir, Scotch pine, larch, alder, birch, horse chestnut, and sallow. Very soft are linden, poplar, and willow. While maple wood is very firm, it warps easily. The wood of linden, maple, alder, and birch is of the same consistency throughout; in the case of fir, pine, and beech the heart or inner portion is denser; in the case of oak, ash, Scotch pine, and larch the heart is colored darker by resin or gummy substances. Larch seems to be least affected by borers.[7] Wood cut in autumn is denser than wood cut in spring. While evergreen woods show narrow, on the other hand, deciduous woods show broad, annual growth rings. Green-blue or brown streaks are found in wood which, owing to lack of air, was not properly seasoned.

The old masters exercised great care in the choice of their wood panels and in their protection against the effects of moisture. Old German panels had frequently a thickness of only 2 to 3 cm. for those of the larger size; in the case of Italian pictures one often comes across panels up to 10 cm. in thickness, and only roughly surfaced with an adz. This is the case also with Böcklin's "Vinum Bonum" in the Schack Gallery at Munich.

Wood expands in dampness, and in warmth will shrink very considerably through loss of moisture. Even very old seasoned wood is still subject to these conditions. The dried paint on a wood panel cannot follow the movement of the wood and may easily chip off. To prevent the warping of wood panels, reënforcement strips are dovetailed into the back, as in the case of drawing boards. The expansion and contraction of wood is prin-

[7] The California redwood (*Sequoia sempervirens*), however, has a still better reputation in this respect. [Translator's note.]

cipally in opposition to the grain. The dovetailed reënforcement strips, the so-called cradle, which cross the grain, must therefore not be glued in, but must be free to move in their grooves; otherwise the wood panel may crack. If one is lucky enough to obtain wood panels from old chests or drawing boards, these make excellent supports. But even the best-seasoned and oldest woods will be affected by moisture or abnormally dry air. Larger panels glued together from several pieces must be so selected that the grain of the cut edge is perpendicular to the surface. Only glue which is not soluble in water, preferably casein, should be used.

Priming on the two sides, as was the custom on altarpieces of the Gothic period, has proved very effective. On top of that a good coat of paint on the back will be useful, as is recommended in old Italian recipes. Cooking the boards in oil in order to prevent warping, aside from the bother it causes, serves no good purpose, because then only an oil ground can be put on over them, and the leanness of the ground is destroyed. Moreover, when a wood panel is soaked in oil, blisters may develop under the influence of heat.

In order to check the movement of wood, it has been tried by means of steam to break down the albuminous bodies which it contains. Composition board is made from wood tissue broken up by steam under high pressure. The pulp is then pressed into boards, Zapon varnish being used to increase the cohesion. Another process uses finely distributed metallic particles, which are pressed into the wood. Opinions as to the lasting quality of these products are as yet impossible, even though the problem may appear theoretically to be solved. In the building trades there are now available composition boards made with cohesive substances which may prove very useful to the artist.

In the case of coniferous woods resin which exudes must be removed, either by painting with acetone and afterwards shellacking, or by chiseling it out and gluing other pieces of wood into the panel, as one often sees done on old German pictures. Wood is preferably chosen which is free from knots. Knots must likewise be chiseled out. Wood panels should not be planed too smoothly, because the ground should be able to get a good grip

on them. Holes and crevices can be filled in with glue and sawdust, or with gypsum and glue, or with casein.

Veneered boards are much used today by artists. But here it should be said at once: plywood is largely a matter of confidence. Along with many satisfactory experiences there are recorded as many disappointments. There is no veneered board made expressly for artists. Artists often for economical reasons buy the cheapest stuff, intended for packing cases.

The center of ply boards is made of a thicker piece of soft wood to which have been glued on both sides thinner sheets of harder wood, the so-called veneer. There is a five-ply board used for doors and furniture which is highly regarded. The veneer must be glued on in opposition to the grain of the center wood. The center wood or "core" should be made from thoroughly seasoned or kiln-dried wood. Unfortunately no one can absolutely guarantee that either three- or five-ply boards will not warp.

A greater thickness of the core as compared with the veneer is essential. Wood from the middle of a tree is excellent for cores. Such wood shows a vertical grain at the edges. To prevent the warping of veneered wood, some manufacturers use as a core many small pieces of wood in place of a single piece. The spaces between the pieces are intended to leave room for the expansion of the wood. One should use only sawed and not peeled veneers, which always curl up in trying to return to their original spiral position in relation to the core of the tree. Cores made from evergreen trees are said to hold glue better than those from deciduous woods.

The sizing and priming of veneered wood requires great caution. It should be done thinly and in a stippling manner, and with a fairly dry brush holding little material. An excess of moisture will loosen the veneer. One should prime equally on both sides, and it is advisable to close the edges with shellac or varnish against moisture. Veneered boards should never hang flat against a wall, but should tilt forward at the top so that the air may circulate behind. For sketching purposes it is sufficient to coat veneered woods all over with mastic or dammar varnish.

GROUNDS. On wood panels the only grounds which are serviceable are chalk or gypsum [gesso] grounds, especially half-chalk grounds, while an oil ground would be senseless, because one would deprive oneself needlessly of the much-cherished meager character of the basic material.

THE GYPSUM [GESSO] GROUND is prepared as follows:

1. *Size, glue-water 70 gm. to 1 l. of water; but here the glue solution can be made even stronger, for example, 100 gm. to 1 l. This first coat of glue must be allowed to dry well before further coats are applied.*

2. *A measure of glue-water, an equal measure of zinc white, and an equal measure of gypsum.*

This first glue-gypsum-zinc white ground must be exceptionally thin, not wet, and must not be put on with a full brush, but stippled in such a way that it lies over the ground like a veil. This is absolutely essential, so that later grounds may obtain a good grip. In about half an hour, after the first coat has dried on the surface, a second thin layer may be put on at right angles to the first, and so on perhaps five or six times or more until the ground, even in a wet state, is smooth and bright and white and nowhere allows the veins in the wood to show through. In order to save time or work, thinner grounds of only one or two coats may be applied, but not when the greatest degree of luminosity is desired.

After one coat has been put on with a brush, the following coat is applied and smoothed down with a spatula, and other later coats are put on in the same manner. In this way a very smooth ground is obtained. It would be a mistake to believe that one can save work by simply putting on one or two thick coats. Such grounds must be surfaced down to the deepest brush marks until the ground becomes uniformly smooth, when it is likely to peel off or crack upon drying. The consequent tiresome patching is considerably more work than the putting on of many light, thin coats. One can in the course of a morning conveniently prepare in this manner, one after another, a whole row of boards, since it is not necessary to wait for the complete drying of a single coat. One should under no circumstances attempt to dry

the grounds quickly in the sun or near a stove. An instructive experimental specimen in my collection clearly shows the consequences. A board, after having been given a coat of glue size, was cut in half. To one half the gypsum ground was applied in many thin layers to both sides, in the course of a morning. The other half, upon being prepared on both sides in the same way, was dried alternately on either side by placing it near a stove. That evening the grounds on both halves were apparently equally satisfactory; on the next morning, however, the artificially dried ground was standing up in large curls, and had in part fallen off. The other ground is today, after twenty years, still without blemish. Both panels were treated on both sides in exactly the same manner. In order to make the gypsum ground less absorbent, one may put over it a light coat of glue or make use of an isolating medium (see page 21).

The advantage of the gypsum ground over the chalk ground is that it can be scraped smooth with the edge of a spatula, which is an easy matter, while the chalk ground must be surfaced with sandpaper and other similar materials. The old masters used to dust powdered charcoal from a bag over the ground; in this way they were able to detect the areas not scraped, because the charcoal would remain in them.

In surfacing care must be taken to see that the ground is thoroughly dry and that it is dampened only a little, otherwise it will come off. If it has been moistened too much, it is best to wait a minute until the ground has absorbed the excess moisture, otherwise there will be cracks, especially if the ground is very smooth. The spatula must always be used following the grain of the wood, else the board will be made uneven by a troublesome cropping out of the grain. If a very smooth surface is desired, one must use horse tail or ossa sepiae. Ordinarily artificial pumice stone is used. Very smooth grounds may be obtained by a light burnishing with a very slightly dampened linen rag, or by rubbing with the ball of the hand. When surfacing casein or casein-emulsion grounds care must be taken to see that the ground is entirely dry, for these grounds tear and crumble when surfaced wet. For this reason casein grounds must be put on very thinly, since they harden quickly on the upper surface and remain wet

for a long time underneath. If the ground has been put on in this way, it takes only a few minutes and the process is completed.

Soft woods, such as pine, fir, linden, and larch, must be well primed, otherwise in the course of time the grain will become disturbingly prominent. Another danger is their discoloration upon contact with the air. Thin linden boards (1 to 2 cm.) are excellent material.

One should never attempt to straighten out warped boards by force. It is best to dampen them a little on the back, lay them on a level floor, and put weights on them, increasing the weight gradually; in difficult cases a cabinet-maker should be consulted.

If China clay is used in place of gypsum, the ground will be glossy when surfaced with a spatula, and the gloss can be increased still more by a light rubbing with the ball of the hand. A coat of water applied with a brush will render it dull again. For work demanding a careful, thorough, and fine use of material, a board properly primed with gypsum is an excellent ground. For opaque painting fewer priming coats are necessary.

The old masters frequently glued strips of canvas over the joints of the panels, and it was often the custom to glue a thin piece of linen canvas over the entire board to prevent its cracking. For this purpose a thin fabric, cotton or fine linen, is dipped into a glue solution, and the board also covered thinly with glue-water. The fabric is then laid on it and smoothed down from the middle toward the corners, so that no blisters or folds remain. Such glued-on canvases can, after drying, be prepared in the same way with a gypsum ground. Among others, Böcklin and Marées made use of such grounds. Wood panels with such fabric coverings are the basis for valuable works. Even oakum or tow threads were used by the Cologne school with old gypsum grounds to prevent cracking.

Pictures by Brouwer and related masters may give the impression that the wood panel has not been primed, but that is deceptive. The ground has merely become transparent through the saponification of white lead, otherwise the veinings of the board would also show through in a disturbing manner.

GILDING. In compliance with many requests, I will describe the preparation of a ground for gilding. The gilding process itself

I cannot here go into at further length. The panel is given a coat of thin hot glue; after drying it should have a silk-like gloss. Over this a chalk ground is applied. Gray chalk is soaked in water to a thick consistency and, after the addition of a strong glue, is put through a wire sieve.

This first ground is stippled on very meagerly. Fissures, cracks, and small openings are filled with congealed ground by means of a spatula. The chalk ground is put on twice. It should congeal well after it cools.

Next comes a ground made with Bologna chalk and less than 2 mm. thick, which is put on in five or six very thin coatings. The first coat of this ground should be as thin "as a breath."

For this ground a strong, lukewarm glue solution is prepared, one pound of glue to a liter of water. Bologna chalk is next added until it is hard to stir, and this is then put through a sieve. For parts which are to be covered with incised ornamental decorations six coats are essential. The last coats should be more liquid and less strong in glue.

The well-dried ground is surfaced with horse tail, pumice stone, or sandpaper. If the gold is to be burnished, the ground must be evenly surfaced and free from grease. Yellow bole well ground in very weak and hot glue-water is now applied. Over this the yellow "poliment," also very thin, is put on lukewarm; and over this again red "poliment," made of beaten white of egg finely mixed with red bole and thinned with water, is applied twice cold. When this carefully made ground is thoroughly dry, it is covered with a solution of 10 parts water and 1 part alcohol. Only a small area is covered at a time and the gold leaf at once laid on, which may be burnished within two or three hours with an agate or boar's tooth. On very old pictures may be seen green as well as yellow egg "poliment." All gilding must be done before one starts to paint. Ordinarily the Gothic masters gilded only the parts which were not to be covered over with paint, but pictures are occasionally to be found where the entire ground has been gilded.

Highly burnished gilding can be employed on chalk and gypsum grounds only indoors. In the open only oil gilding will last. Minium or chrome yellow is ground in thick boiled oil

and applied twice. It must be surfaced after each coating. On this thoroughly dried ground gold size is applied evenly and meagerly. In an excess of ground the gold will drown. Gold size is a very thick oil varnish, which may be thinned with oil of turpentine. It must be allowed to dry until it feels slightly "tacky." Then the gold is laid on, and at once pressed on evenly with a soft, clean brush. It is best to allow the margins of the gold leaf to overlap to be sure of covering every part of the ground. To test the genuineness of gold leaf, it is laid on a sheet of glass and covered in spots with a dilute solution of nitric acid. If held against the light, these areas should not show as spots.

PAPER. The best is heavy white paper, sold in rolls, which has been given a coat of glue or casein solution. This can in an emergency be used for sketching in oil. There are in existence today works of Holbein the Younger in oil colors on paper which have kept perfectly; it is true that the papers of that time were good rag papers and not, like those of today, mostly wood-pulp papers. There are also oil paintings on paper by Rembrandt, Delacroix, Hans Thoma, E. von Gebhardt, and many other painters. But they were usually glued to wood or canvas to give them greater permanence.

Paper, particularly paper covered with a coat of glue, permits of exceptionally quick work because of its smooth surface, especially when a fixed drawing serves as a basis. For the better preservation of such paintings it is best to glue them to a wood panel or canvas.

Papers of the trade designed for oil painting are usually covered with a very oily priming, and hence are apt to tear easily or turn brown. In moisture and warmth paper expands considerably, and shrinks greatly upon again becoming dry. This fact is taken into account when mounting paper on a frame. Good strong water-color papers mounted on veneered boards with glue or rye paste provide serviceable supports. The paper must be well moistened beforehand.

PASTEBOARD must be good rag pasteboard which has been well pressed and glued. Wood and straw pasteboards are inferior. As in the case of wood panels, pasteboard must be sized and primed on both sides and laid aside to dry. Here a strong glue

solution is used, at least 100 gm. glue to a liter of water, and this ground is applied in the same way as with boards. Primings with water glass are not serviceable, but casein will do very well. Heavy pasteboard would be excellent material, because it is not subject to damage by worms, but it has the disadvantage that in thick sheets it warps easily. Pasteboard especially for painters' purposes is offered by the trade, with a surface resembling that of canvas (Lenbach board). Since the color tones of the pasteboard are almost never lightproof, it is better to prime the board and then tint it as desired. A coat of glue alone does not protect the colors against the influence of the ground. Pasteboard may contain sulphuric acid. Rubbing oil over it to serve as a neutralizing medium is not at all advisable; a good priming coat should be put on as with wood panels. Work on pasteboard which has been covered only with glue size often turns very dark later on. Oil grounds are here just as useless as in the case of wood.

Recently pasteboards with white half-chalk and oil grounds have again been introduced, on which in a few months even alla prima paintings have cracked badly in all directions. It is apparent that the manufacturer, in order to offer a long-lasting, permanently white, and saleable material, used white lead, zinc white, or lithopone ground in poppy oil. An exact description of such grounds must in the future be demanded of manufacturers. Such grounds must, according to scientific principles, be allowed to dry for a year before being painted on. In the trade this is practically impossible. The painter who buys such materials is the one who suffers. Heavy white gypsum grounds are excellent for pasteboard. I saw at the studio of a colleague pasteboard which had been fastened to a stretcher, and which thus offered an excellent support for painting. He had used well-pressed, glue-sized pasteboard which had first been given a coat of boiled oil and oil paint on the back. On the front, after this coat had dried, he brushed a thin coat of chalk ground over a glue coat, and then nailed the still damp, but not wet, pasteboard to a stretcher. After it had dried, he applied still other coats. Naturally such supports are excellent. Also good are the well-pressed English sketch boards which are painted gray on the reverse side.

LINOLEUM as a support for painting is of very questionable value. There can be no talk of its ever taking the place of canvas. Large pieces are too heavy; they warp and are easily broken. Linoleum which consists of cork waste and very fat, thickened oils is not suited to lend colors a beautiful meager character, and will tolerate only oily colors.

METALS AND THEIR GROUNDS. For metals oilier, but not liquid, primings are used. All sheet metals expand with heat and contract with cold. Electrolysis very probably plays a considerable rôle in metal supports.

Copper was much used by the "little masters" of Holland. A copper plate must be sandpapered or otherwise roughened in order to rid it of the colored iridescent oxide. White lead ground to as thick a consistency as possible in boiled linseed oil is then put on with an old brush in a stippling manner, very thinly, like a veil, but several times, over the metal. Care must be taken to see that each coat is dry before putting on the next. The first coat must be the thinnest and leanest. An artist is reported to have once covered certain copper plates with a liquid ground of poppy-oil zinc white and painted over this with a tube oil color containing copaiva. His work was artistically a great success—but after a year the pictures were returned, very badly cracked and fissured. I have seen pictures, painted on copper from which the film of oxidation had not been removed before painting, which had turned completely green.

Aluminum must likewise be rubbed off and sandpapered, and the ground prepared in the same way. Its value as a background is open to question. It is impossible to remove the coat of aluminum oxide by any of the ordinary means; it promptly forms again. If one should succeed, an increased electrolytic action would take place. Aluminum is very susceptible to lyes and, as a trade product, varies considerably in quality.

Sheet iron must, before the ground is put on, be sandpapered or rubbed with petroleum in order to remove every trace of rust. So-called "charcoal iron" and not "coke iron" is best used, because the latter rusts easily. Then the surface must be thinly coated with boiled linseed oil, and this burned in through the application of heat. Over this a thin layer of white oil color is

stippled, the same as with copper. Chromium steel is rustproof. On nickel oil color holds less well than on iron.

Sheeted zinc is declared (by Täuber) to keep the colors wet unusually long; it is claimed by others, however, that only zinc colors are suitable for priming coats, and that zinc-plate, because of its tendency to expand with warmth, offers a very poor support for painting. It is soluble in acids and very sensitive to lyes, as well as affected by electrolysis. All grounds used in connection with metals should be made only with boiled or raw linseed oil and white lead, and never with poppy or nut oil, zinc white, lithopone, or titanium white.

OTHER SUPPORTS. Slate, marble, and other minerals or glass are rarely used as a basis for painting. But there are ancient wax paintings, such as the "Muse of Cortona," which are painted on slate, and also pictures by Titian, such as his "Ecce Homo" at Madrid, and works by Lenbach, Böcklin, and others.

One can paint on such bases without applying a ground, or one can give them a coat of oil color, the same as with metals.

Xylolith, magnesia cement mixed with sawdust, a building material, is subject to "blooming." The same may be said of artificial stone slabs. Eternit, asbestos slate, has proved satisfactory where pictures had to be set into a wall (in casein painting). Eternit is sensitive to injury, and easel pictures painted on it, when framed, are best protected on the back with veneered wood. Slate plates must be carefully handled. Before being used they should be tested for efflorescence by being moistened. If efflorescence appears before drying, the slate is rubbed off with ammonium carbonate.

Note: It is very important that all supports for painting, especially wood panels, have free play in the rabbets of the frame; otherwise the panels may crack and break open the miters.

CHAPTER II

PIGMENTS

ARTISTS' COLORS (pigments) have body in contradistinction to purely visual colors. Organic colors of plant or animal origin are to be distinguished from inorganic, mineral pigments. Pigments are here divided, for the sake of simplicity, into white, yellow, red, etc.

As opposed to the earth colors which are found in nature there are a great many new, artificial colors produced by chemical processes, to which belong some of our best colors, such as viridian, cobalt blue, etc. The objection of many painters to the use of any chemically manufactured pigments, which arises from the belief that all unpleasant changes in pictures are to be ascribed to them, is unwarranted. On the contrary, these pigments can always be reproduced to possess the same quality and purity, whereas the much-praised earth colors, such as ocher, are often impure and varying in their composition, as are incidentally all natural products. It is often heard said among artists that the old masters had no "chemical" pigments, and for that reason their pictures are so well preserved. This, however, is a misconception, for the old masters had white lead, Naples yellow, vermilion, copper and sulphur colors, etc. The reason for the greater permanency of many of the old pictures lies in the fact that they were built up in a correct, craftsmanlike manner.

That the pigments of the trade often leave much to be desired in the way of purity and genuineness is certain; as a matter of fact, however, the pigments designed for use as artists' colors give far less cause for complaint through their possible injury to a picture than the binding media. I am gratified to be able to state with certainty that the larger paint manufacturers are constantly striving of their own accord to furnish only the best materials for the purposes of art. A new difficulty arises from the fact that in recent times the methods of manufacturing certain pigments have changed and multiplied. Waste products of

45

other industries serve more and more as basic materials. The final product looks the same as always, even more beautiful, but, when used in painting, gives rise to new and very undesirable results.

Since the introduction of coal-tar dyes, the number of pigments has multiplied to a bewildering extent.

Confusion increases through the unreliability of the nomenclature. In a collection solely of artists' color catalogues I found listed over 900 different names of colors, with every sort of fantastic designation and duplication. Thus under the same name may be found the unobjectionable oxide of chromium green as well as the exceptionally poisonous and treacherous emerald green. For one and the same pigment I found a long list of arbitrarily chosen names, which gave no hint as to the pigment's nature or method of manufacture.

Many decidedly impermanent colors are to be found in artists' color catalogues. Intelligent dealers are themselves opposed to offering these colors for sale, but they say that painters demand them, and if they did not supply them, they would lose their trade. The great majority of these listed colors are not only worthless, but even injurious. Every sensible painter will choose the fewest possible colors for his palette, for only a very few are qualified to meet his requirements. From ten to fifteen unobjectionable colors are quite sufficient for all purposes. But however limited may be the number of colors chosen, only very few will be found which are absolutely reliable and unchanging in their effects, for every color shows in some respect a different reaction from any other. The difficulty is vastly increased when the binding medium is taken into consideration. The unequal requirement of oil when pigments are ground, and the varying length of time required for drying, particularly in the case of metallic colors, present in themselves great difficulties to the manufacturer.

The pigments of the trade are never "chemically pure," that is to say, absolutely free from foreign elements, but only "technically pure," coming from the factory with a certain admixture of impurities, which, however, must not exceed a certain fraction of a per cent. In the case of dry pigments, those used for

trade and industrial purposes must be distinguished from those used in fine artists' colors.

By the "improvement" of a color is understood an inadmissible manipulation whereby a poor-looking color is given a more attractive appearance at the expense of its quality, for example, when chrome yellow is added to gold ocher in order to enhance its brilliance.

"Cutting" means the addition to a pigment of cheap filling materials such as barite, chalk, or clay. A close examination with the microscope has revealed the fact that already ancient and Renaissance pigments were sometimes adulterated with powdered marble. For many purposes inexpensive colors are needed, and there should be no objection to colors which have been "cut" provided they have been marked as such and priced accordingly. When an artist, however, buys pigments in powder form, for fresco, let us say, he must be particularly on his guard against this, because the cheaper colors used in the trade are often "improved" or "cut," and therefore not suited to his purpose. Colors for sketching purposes are "cut," usually with barite. In the case of high-priced artists' colors "cutting" constitutes fraud.

A color which is to be used for artists' purposes must have body, so that it can be put on easily with a brush, as, for example, white lead. Not all colors have body of themselves. Many, such as coal-tar colors, for example, are originally ink-like solutions; and such colors require a white filling material, a substratum, which will take up the coloring matter so as to form an insoluble compound which can be mixed with oil and put on with a brush. Many pigments, such as ultramarine, cobalt, cadmium yellow lemon, and others, are treated in this way. With these the addition is usually clay, which in this case is not a "cut" or adulterant, but a necessary element in their manufacture. The earth colors, such as ocher, naturally contain such a substratum. Here clay is the body and iron oxide the coloring principle.

Lake colors are made from the ink-like solutions of organic dyes by precipitating the coloring matter on hydrated clay or tannin, with which they combine into an insoluble pigment. The old masters used alum solutions and chalk for the same purpose and in this way prepared pigments from the extracts of berries

and plants. The court painter J. von Stieler had a recipe for madder lake which called for a precipitation of alum solution with an addition of potash solution. The precipitate is hydrated clay, a white powder, which is colored by the madder red.

Pigments are carried by the trade in broken pieces, small cone-shaped blocks, or in powdered form, which last is the most suitable for our purposes.

Methods of testing pigments. In the reaction of different pigments to acids or lyes lies the possibility of their chemical analysis. Since the methods employed by manufacturers do not always coincide with those described in textbooks, and since every factory besides has its own secret processes of improved and cheaper manufacture, it is clear that analysis is difficult for the chemist, and for the artist almost impossible. As far as possible, individual colors are adequately described. The heating test because of its simplicity is perhaps more practically useful than scientifically dependable. If, for example, some white lead is taken up on a spatula and gently heated over an alcohol flame, it should turn permanently yellow. Similarly zinc white turns temporarily yellow, ocher red, and green earth a yellowish brown; vermilion disappears completely; coal-tar and other organic pigments leave a colorless residue, and so on.

Pigments must be compatible with one another. The artist must therefore choose his palette carefully, and if he intends to work with vermilion or cadmium or ultramarine blue, he must avoid emerald green, since the former will become black if mixed with the latter. Fortunately most pigments are more compatible with one another than those mentioned above. The permanence of certain colors varies with the use of different media. Red lead keeps its color well in oil, but darkens when in the form of powder.

A pigment is tested for fineness of grain by rubbing a sample between the thumbnails. If a sample is shaken in water, a sediment should not form too quickly, and the water should not remain cloudy for long. The finest particles remain suspended the longest, while the coarse particles sink quickly to the bottom. Pigments, chalk, etc., are "washed" in this way. Pigments should show an even grain. The covering power of a color is increased

if it is finely ground. There are, however, limits to this. Many manufacturers carry to extremes the grinding of their pigments, with the result that an otherwise durable material incurs the danger of cracking. This is especially true of Cremnitz white, which is so important in painting. Coarse-grained color is less liable to crack, which is the reason why the custom of the old masters of grinding their colors by hand was so excellent. As a result of the fact that colors are intermixed (particularly in mixtures with covering colors like Cremnitz white), non-granular colors such as madder lake gain in strength. Researches in this connection made by Dr. Eibner now give scientific support to my old contention that all colors, especially if used as glazes, should have at least a little white mixed with them.

Raehlmann also showed through microscopic examination that many of the old pigments were more granular than those of the present day, and sees therein the cause of the better preservation of old paintings.

In order to determine whether or not a pigment is lightproof, it is mixed with gum-water and a very thin layer put on white paper which will not turn yellow; half of the paper is then covered up, perhaps by being placed in a book. After the sun has shone on the exposed half for some time, this should show no change. Most organic colors are not lightproof; many bleach in a few hours, others turn brown. Vermilion, when exposed to light, develops black spots, madder lake fades, and so on.

A pigment is oilproof if, when mixed with oil, it does not dissolve or change its hue. Pigments which are not oilproof "strike through," they "bleed," that is to say, they penetrate through superimposed coats and come to the surface, like the so-called indelible pencil, the coloring agent of which is a coal-tar product. In an analogous way one speaks of waterproof and alcohol-proof colors. Colors intended for fresco painting must be lime-proof. Prussian blue is not lime-proof; it disappears in lime in a few hours.

Newly developed pigments should be received with caution, no matter how tempting their color appears. Often enough defects become apparent which were not at first in evidence, such as sensitiveness to light or lack of stability in oil or lime.

The reaction of pigments to binding media. A pigment should not dissolve in the binding medium nor be affected by it. Many colors, such as white lead and umber, accelerate the drying of the oil; others, such as the lakes and vermilion, retard this process. In general the dense, heavy pigments dry well and quickly, since they require little oil. An exception to this is vermilion.

Painters of today know but little of the exhausting struggles which had to take place in order to insure some safeguards in the field of artists' materials. These struggles began in Munich, where A. W. Keim and the *Deutsche Gesellschaft zur Förderung rationeller Malverfahren* [1] were the untiring pioneers. Here and there today attempts are being made to break down these protective guarantees, which unfortunately are not founded on permanent contracts. Colors "after Ostwald" appeared, which were made for the most part of coal-tar dyes, were not lightproof, and were not labeled according to the contents of the tubes but given an arbitrary number of the Ostwald color chart. Thus, instead of cadmium lemon the designation was oo, instead of madder lake, let us say 25, and so on. It is clear that with practices such as these the doors would be opened wide to fraud, and in a short time the materials of the artist would be hopelessly spoiled.

It would be to the manufacturer's as well as the artist's advantage if they would both reduce their color requirements to the fewest possible unobjectionable colors, which should be accompanied by an accurate statement of their composition. The artists' economic societies in Germany have taken up this question of materials with the *Deutsche Gesellschaft zur Förderung rationeller Malverfahren*, and it is to be hoped that within a reasonable time agreements may be reached which will put an end to the present uncertainty.

The often discussed, but not yet realized, control of artists' pigments by some neutral official commission is more needed today than ever before.

[1] German Society for the Promotion of Rational Methods in Painting.

I. WHITE PIGMENTS

WHITE LEAD, CREMNITZ WHITE, flake white, *Kremser-weiss, blanc d'argent*, is basic lead carbonate. The best grade of white lead is called Cremnitz white.[2]

In the Dutch and old German process (which furnished the so-called slate white) strips of lead rolled into spirals are placed in closed earthenware jars containing acetic acid, and the pots are then buried under tanner's bark or dung; the heat evolved by the fermentation aids in the formation of white lead through an increase in the amount of carbonic acid. A test experiment can easily be performed on a small scale by pouring a little vinegar into a bowl and fastening a lead plate over the top in such a way as not to touch the vinegar. Very soon a thin white coating is formed on the lead—white lead. If the vinegar comes into direct contact with the lead, colorless crystals are formed—lead acetate (sugar of lead), which is often present as an undesirable addition to white lead, but in small quantities is not harmful. If present in larger quantities, it turns brown and effloresces. It can be eliminated by washing.

Whatever its method of manufacture, the purity of white lead depends on the purity of the lead. Purifying processes greatly increase the cost of the product.

In the German chamber process, an improvement over the Dutch process, the lead is likewise exposed to the fumes of acetic acid; but this process is carried on commercially today on a much larger scale. Strips of lead a meter long and about 12 cm. wide are mounted on racks in an enclosed space and exposed to the vapors of acetic acid, carbonic acid, and steam. After about six weeks the lead has oxidized. The white lead is then washed off and cleaned.

According to the English and French methods, white lead is obtained by the wet precipitation process through the action of lye upon a solution of lead acetate and an admixture of carbonic acid. This white, lead carbonate, is possibly whiter than

[2] Originally made at Kremnitz in Czecho-Slovakia. [Translator's note.]

the German white lead, but lacks its covering power because more crystalline.

De Mayerne reports the care that Rubens and Van Dyck exercised to obtain the best white possible. It was carefully washed and freed from remnants of acid and sugar of lead. According to the painter Ludwig, the Venetians left the white lead exposed to the air in sacks for at least a year before using.

White lead is sold by the trade in the form of a powder, in small cylindrical cones, and in broken pieces. The first is the best type, and not the second, as many painters believe (it contains much sugar of lead). The last is usually very hard and difficult to grind. White lead as offered by the trade is often "cut." Venetian white contains 50% barite, Hamburg white 65%, Dutch white 80%. A considerable quantity of barite can be added to white lead without causing an immediately noticeable change in its quality or covering power. Later on is another story. White lead for sketching colors commonly contains one-third barite, and often even more, but the best grade of artist's white lead should not have been "cut."

A warm, dilute solution of nitric or acetic acid, if sprayed on white lead, will dissolve it (the carbonic acid escapes). Barite does not dissolve. Chalk dissolves with effervescence; it alone is used for the "cutting" of commercial white lead. White lead dissolves in hot lyes. Hydrogen sulphide turns white lead black; when exposed to fresh air, the blackness eventually disappears. Resin ethereal varnishes, such as mastic and dammar, constitute the best protection against hydrogen sulphide. If white lead used in water color or tempera should turn black, its whiteness can be restored through the application of blotting paper moistened with hydrogen peroxide. Sulphate of lead is formed, which is a stable white compound.

When heated, white lead turns yellow and remains so permanently (the old painter's color massicot, king's yellow, lead oxide, which today is rightly excluded from the palette). Barite, clay, and chalk remain white. If white lead turns gray when heated, it contains much sugar of lead. White lead which has the odor of vinegar must be washed.

There are many kinds of white lead which have a tendency to

turn yellow. The white lead of commerce is only technically, and not chemically, pure. It often contains traces of iron, silver, or other metals. White lead which shows a yellow tinge is often doctored with ultramarine. For artists' purposes it can then no longer be used, because it changes its color when ground in oil.

White lead, according to some opinions, is not compatible with ultramarine and vermilion; this, however, is contradicted by other scientific authorities. As a matter of fact, mixtures of white lead and vermilion turn black today, which formerly was not the case. I have never observed any bad effect of white lead on ultramarine.

White lead is very poisonous; even the inhaling of dust containing it has serious consequences. When grinding white lead with a medium, the greatest caution is advisable, and the hands should be very carefully washed afterwards. This danger should not be underestimated.

White lead has extraordinary covering power, which is what makes it so desirable to the painter. That it is a good dryer is of no less importance. It is therefore entirely senseless to add siccatives to white lead, which only cause it to turn yellow.

In modern artists' colors white lead is often ground in poppy oil in order to retard its drying. Even partly drying oils are added. Vasari and others recommended grinding white lead in nut oil, which yellows but little and dries more slowly than linseed oil. In the process of manufacturing white-lead color, it is first given a batter-like consistency by mixing it with water; later the oil is added, which forces the water out. In this way the color becomes "short."

White lead ground in linseed oil dries through better and more quickly than white lead mixed with poppy oil, but the former is more apt to turn yellow and is not so "buttery" in character as the latter. It also has a piercing odor which is unpleasant to some people. A small addition of wax gives to white-lead paint an opaque quality and also minimizes the danger of yellowing. White lead has the advantage that it requires very little oil, about 15%. But there are new varieties of white lead, such as Klagenfurt white, which have greater volume and are not so heavy as the older types, and which require considerably more oil, up to

25% or more. Cremnitz white a few decades ago, I am thinking of the 90's, was much denser and heavier, and at the same time not so finely ground. It covered in a different way from the white of today, and was less slimy in character. A Munich color manufacturer recently prepared, according to a recipe of mine, such a thick, dense white, which had all the advantages of the older type. Decidedly to the advantage of the manufacturer are the newer, looser sorts of Cremnitz white. When one considers, however, what an important rôle Cremnitz white plays in modern pictures—and this is no exaggeration, for it usually constitutes three-fourths of the body of a picture—it becomes clear that, owing to the large amount of oil which this modern loose white requires, the whole character of the picture and its preservation are bound to be unfavorably affected. Competition among manufacturers is the reason for the extraordinarily fine grinding of white lead in oil. Formerly Cremnitz white, because of its great drying power and its moderate requirement of oil, acted to a certain extent as a regulator when combined with colors which dry poorly and which are richer in oil. A change in this relation is bound to cause damage.

It is a good practice to add to all colors, especially glazes, at least a little white; the picture then acquires more unity in its structure, tensions are equalized, and drying also becomes more uniform. Among some artists the old notion persists that if Cremnitz white were ten times as expensive as it is, pictures would be so much the better off. The exact opposite is the truth. White lead of all colors is least likely to crack when it is not mixed with a superfluity of medium which works against its natural character. In pictures of the late baroque period it may frequently be observed that those parts covered with dark glazes have cracked badly and become unrecognizable, whereas the parts painted with white show few cracks and stand out from their murky surroundings.

White lead is compatible with all needed colors. As a metal pigment, it forms a sort of soapy compound with oil, whereby it loses in covering power but gains in durability. One may sometimes observe on old paintings places where old parts of the picture have apparently "grown through" superimposed coats

of paint. This is not a case of "striking through"; it is simply that the last layer of paint has lost its covering power through the saponification of white lead. Even in modern works which have been often painted over may be seen such patches. Acid resin varnish or a siccative which contains colophony may congeal white lead.

White lead may be used in oil painting, where, as has been said, it is the principal color, and also in tempera painting, where it lasts best when varnished. It is better not to use it in connection with water colors, pastel, or gouache; in fresco it cannot be employed, for it quickly turns to brown lead and remains so permanently. In oil grounds white lead is used to advantage.

Substitutes for white lead are not worth considering, despite certain shortcomings of the latter, especially its poisonous nature. Mühlhauser white, Pattinson's or Freeman's white, are perhaps less poisonous than white lead (but not non-poisonous!); they have, however, considerably less covering power. Many substitutes are offered by the trade for industrial purposes.

For commercial purposes, especially house painting, basic sulphate of lead, which is poisonous but dries and covers well, is today used. For artistic purposes it has not as yet been tested. It is made by roasting a natural lead glance and is a less pure white than white lead.

ZINC WHITE, Chinese white, snow white, Zinkweiss, blanc de zinc, when of excellent quality, is nearly chemically pure zinc oxide. "White seal" is very good, but of less covering power; "green seal" is the best covering type. "Red seal" is preferable for grounds. When buying it as a powder, one should always demand "pure" zinc white.

Zinc white was first introduced as an artist's color in 1840. As compared with Cremnitz white, it is a much looser, bulkier powder. It is colder in appearance and covers less well. Zinc white is very economical to use and is practically non-poisonous. For this reason it is preferred to white lead in grounds and in water-color technique. It is permanent in light, does not yellow, and as a basic mineral color has perhaps less than white lead a solidifying effect upon fatty oils. Hydrogen sulphide also acts upon zinc white; the result is the equally white zinc sulphide.

When exposed to the air, zinc white becomes gritty; through the absorption of carbonic acid it turns into basic zinc carbonate. It should therefore be kept in tightly closed glass jars. When heated, it will again turn to powder.

If zinc white is heated, it turns lemon yellow; in cooling it changes back to white. It differs in this respect from white lead, barite, etc. Pure zinc white dissolves in alkaline solutions, ammonia, and acids, in the latter without effervescence. Effervescence indicates chalk; an odor of hydrogen sulphide, lithopone; a residue, clay or blanc fixe. Acetic acid attacks zinc white; it must therefore be avoided in tempera emulsions. Lyes will also attack zinc white. Zinc white disintegrates quickly out of doors; it increases in volume and causes cracks. Ground in oil, zinc white dries slowly, especially so if ground in poppy oil. This retarded drying is welcomed by many painters, but the color never dries so solidly as white lead. It also has a tendency to crack. Zinc white is not suited to underpainting in oil; cracking will inevitably follow, because it does not dry solidly. For alla prima painting, on the other hand, it is unobjectionable, even for work spread over several days, and especially if the artist prepares his own zinc white. As it is a very fine, loose powder, it is quite sufficient to mix it with the oil by means of a spatula, using as much pigment as possible. Such freshly prepared color is excellent; it covers well and is inexpensive. Tube color rarely has the same covering power. A small addition of dammar or mastic varnish will cause it to dry faster and more solidly. Color prepared by the artist will not need this addition.

Zinc white requires about 30% oil. It is well to add 2% wax to prevent its hardening in the tube. If zinc white is ground in oil to be put up in tubes, it is advisable to let it stand, covered, for about 12 hours. It is then possible to add an amount of pigment equal to that used in the beginning. This, incidentally, is true of all loose pigments. If this is not done, on the next day the color will flow out of the tube.

Formerly zinc white possessed more glazing quality; today it is used by many artists for opaque painting because it does not turn yellow in oil, as does white lead. But it is harder and colder, and has a somewhat slimy effect. It is more susceptible to change

and disintegration than white lead. It has caused spontaneous combustion when in contact with cotton waste and other loose materials.[3] Combined with ground preparations made with acid rosins, such as colophony, in inferior boiled linseed oil, it forms an unworkable mass when the ground is put on. It is more likely than white lead to peel off when a canvas is rolled.

Zinc white is useful in all techniques but fresco, where its place is taken by lime, which here furnishes the best white. It is excellent in tempera and in all water-color techniques, as also in grounds, but never when ground in poppy oil. It is compatible with all other pigments, even with copper. In time it loses its covering power somewhat, owing to saponification, exactly as does white lead. Light yellow shellac used as an isolating medium over zinc white turns a reddish color, but this is in no sense a dangerous symptom.

Dr. Eibner found that zinc white in water color had a destructive influence on the permanency of coal-tar pigments when the glass in the picture frame came too close to the picture. Prussian blue is partially deprived of its color by zinc white, but in darkness the color will return. Cadmium yellow, vermilion, and cobalt yellow may be affected similarly to the coal-tar pigments. Zinc white here acts as an agent in accelerating the process of fading.

Zinc white in oil, to the best of my knowledge, will not behave in this way.

MIXED WHITE, made from Cremnitz white and zinc white and sold as an oil color in tubes, is said to possess all the good and none of the bad qualities of both components. It naturally dries more slowly than white lead.

TITANIUM WHITE, titanium dioxide, a newly introduced pigment of great covering power, has the advantage of not being poisonous. In water color and tempera, as also in fresco secco, it seems to be very useful, although a definite opinion is not yet possible. Changes in the process of manufacture may cause quite unexpected changes in the practical use of this pigment, as the turning gray of a titanium poster color suggests. The cause was of a photochemical nature. As an oil color, titanium white is still very much in dispute. True, it has good covering power, but it

[3] Probably caused by the oil it contained. [Translator's note.]

dries poorly by itself as well as when mixed with other colors, even with white lead. A pure titanium white in oil turned very yellow within two weeks. The new sorts are not behaving in this way. They are "cut" with sometimes considerable quantities of zinc white to increase their drying power and cohesion with oil. It is not unlikely that titanium white will become a valuable addition to our palette. It is said to have, as a water color, a fading effect on coal-tar pigments, as had zinc white. Incidentally, this has also been reported of white lead. As an article of commerce, titanium white is of very uneven quality.

LITHOPONE is zinc sulphide and artificially precipitated barite, which here is not a "filler" but an agent in its manufacture. This pigment is not poisonous, and is resistant to weak lyes and acids. It must not be mixed with colors containing copper, like emerald green. The very best sorts have about the covering power of zinc white. It is used for grounds and in water-color technique. As an oil color it cannot be considered, because in that vehicle its drying power is very limited. The oil requirement of lithopone is the same as for zinc white.

Earlier experiments in using the best quality of lithopone in grounds in place of zinc white resulted in the ground becoming black while still wet. When the ground dried, the blackness partially disappeared. A coat of lithopone mixed with linseed oil turned brown as compared with one made of zinc white; it lost besides in body. Lithopone ground in poppy oil has been used commercially for the priming of canvases. Even when covered with alla prima painting, cracks developed.

It should be stated, however, that the newer lithopones behave very differently, particularly in regard to turning black when exposed to light. But since scientific authorities are still disputing the behavior under light of even the very best quality, we are compelled to wait for more satisfactory developments.

Inferior grades of lithopone still turn black even today, particularly if used as white in water color. In this technique and as a poster color lithopone is much used. The term "opaque white" is not a fixed one; all sorts of pigments travel under this designation, and many are not to be trusted. Lithopone is easily recognized: if hydrochloric acid is added, it will smell like

hydrogen sulphide. If boiled in a test tube, it should not leave a gray line. Theoretically it should be useful in fresco, but there is no reason for using it.

The following white pigments all have but very poor or no covering power in oil. They are principally used as fillers in *grounds*, where they have been described more adequately. They are also used as "extenders" in pigments or as a base in their precipitation. In unvarnished tempera, in gouache, and in fresco secco, also in pastel and in glue colors, they are all useful. When varnished they practically cease to be white.

CLAY, China clay, kaolin, pipe clay, white bole, is hydrated aluminum silicate. The different sorts vary in color and purity. Kaolin is the whitest and purest product.

Clay is decomposed feldspar. When pure, it is very resistant to acids and alkalis, and it remains white when heated. Clay is used for grounds, for pastel, and as an addition to colors ground in oil with the idea of making them "short." Ultramarine colors, ocher, umber, and green earths naturally contain a certain amount of clay. The ochers are clay colored red by iron, as are also the burnt ochers and red bole and sanguine red chalk. Clay holds water for a long time, and many sorts seem to tend toward further decomposition, which may possibly explain the action of some of these pigments in fresco, but also in oil pictures —the decomposition of varnishes over ultramarine blue and umber. Therefore I do not advise its use for ground purposes. When used in the preparation of grounds it often tends to flake off. Clay has but little covering power. It might be used in unvarnished paintings, as in gouache. It is excellent in glue.

Loams and marls are impure clays. The latter are very bad in fresco mortar because they decay and do not set well.

TRANSPARENT WHITE, aluminum hydroxide, if ground in oil, is a glazing white without covering power. It is formed as a precipitate by shaking together aqueous solutions of alum and potash. Aluminum hydroxide is employed as an addition to tube oil colors to prevent separation. Beeswax, however, is to be preferred for this purpose. It is also used in colorless putties by mixing it when still wet with oil or resin varnishes. As a white

in water color it is not recommended because of its poor covering power.

CHALK, calcium carbonate, dissolves in acids with effervescence (the carbonic acid escapes). Chalk is unaffected by alkalis. When heated it remains white. Impure sorts discolor; for example, when they contain iron, they turn red. When strongly heated, chalk is converted into quicklime. Oil colors which contain chalk "set" quickly in the tubes. Chalk is not poisonous and has little covering power. The whiter it is, the greater its value; therefore French chalk is the best. Precipitated chalk is a very fine material. Gray chalks are not useful in grounds; they develop ugly dark spots when touched by oil.

Very finely powdered chalk must be thoroughly soaked in water, because sometimes it takes water poorly and then causes very fine air bubbles in a ground. In unvarnished tempera chalk may be used as an addition to white. It is also used in the manufacture of pastels and in putty for restoration purposes.

MARBLE DUST, marble meal, marble grit, were already employed in Pompeii as cutting material in or additions to colors, and likewise in paintings of the Renaissance. They are used today in ground preparations and in fresco plaster.

GYPSUM is hydrated calcium sulphate. We are here concerned with the finely ground natural gypsum (light spar), and not with the slightly burnt sculptor's gypsum (plaster of Paris). Light spar is a natural hydrated mineral which is won in the Harz mountains from the transparent selenite; it occurs also in many other places. Natural gypsum dissolves without effervescence in a dilute solution of warm hydrochloric acid (chalk dissolves in cold hydrochloric acid). It is only partially soluble in lyes, in water only in the proportion of 1:400; still it offers great dangers in fresco through this slight solubility, as also through its tendency to effloresce. When strongly heated gypsum remains white, if pure. Gypsum is not poisonous, and, while it has no covering power in oil, it is useful in water-color techniques, pastel, and especially in grounds.

BARITE, heavy spar (mineral white, barium sulphate), is a non-poisonous mineral obtained from mines. It is without covering power and reacts but slightly to lyes and acids. It is as heavy

as white lead, and serves as an extender in sketching colors. The artificially precipitated barite, baryta white, barium sulphate, permanent white, *blanc fixe*, is purer and has a finer grain than the natural barite, but otherwise possesses all its properties. It is used as a base in the manufacture of various pigments, such as lithopone, and as an extender, but rarely in grounds.

Talc is hydrated magnesium silicate; it is insensitive to either lyes or acids. It is a soft, soapy white powder, and is used in the making of pastels.

II. YELLOW PIGMENTS

NAPLES YELLOW, *Neapelgelb, jaune de Naples*, essentially lead antimoniate, one of the colors already known to the old masters, is said to have been found on the tiles of Babylon. It is very heavy and dense and therefore of exceptional covering power; moreover, as a lead color it is a good dryer, but poisonous, as are all lead colors. The trade distinguishes between light Naples yellow and dark Naples yellow; both are very permanent. The reddish Naples yellow, on the other hand, is an impermanent mixture recolored with coal-tar dyes, chrome red, minium, or similar pigments, which is quite superfluous, but for some incomprehensible reason a great favorite with artists. In oil, tempera, and even fresco excellent use can be made of Naples yellow, and it is compatible with all other colors. It is also indifferent to alkalis and insoluble in acids; heat does not change it, but it is attacked by sulphuric acid, which, however, as in the case of Cremnitz white, is for practical purposes of no significance to the artist. Naples yellow is a much more compact compound of lead than is white lead. When pure, it requires very little oil, about 15%. It is totally unaffected by light, very seldom cracks, and in varnished tempera painting is an invaluable color because of its great covering power. It is often claimed that Naples yellow should never be allowed to come into contact with a steel spatula, else it will turn a grayish green. Despite many experiments I have made, I have never been able to effect such a discoloration in Naples yellow, although I have allowed the color to remain for a month on a steel spatula. I suspect that

too much is made of this point, and that this alleged discoloration may be ascribed to an optical illusion by which a thin layer of bright yellow lying over the dark background of the steel comes to appear greenish. This conjecture has been proved by facts. The spatula used must first be clean and polished like a table knife, not gray-black, and must be made of steel, not soft iron. The belief that Naples yellow must not be mixed with iron colors, such as ocher, is entirely erroneous. We might well be happy if we had nothing but colors of the quality of pure Naples yellow! On the other hand, I have found exceptional discoloration of Naples yellow in tempera colors put up in tubes, caused probably by the metal of the tube which was attacked by disinfectants contained in the tempera medium. I have seen Naples yellow in oil tempera and water color which had turned a dirty gray in tubes.

It is a mistake to believe that Naples yellow may not be mixed with white lead, as is often stated in books and credited by many painters. Both colors are lead colors and therefore closely related. The lights in the paintings of Rubens are the best proof of the permanence of this mixture, and especially of the permanence of the genuine Naples yellow.

Naples yellow as a pigment needs but very little grinding with the medium; a brief working of the powder with a spatula is sufficient. If it is too finely ground, it becomes heavier and more earthy in texture, and for this reason the tube colors which are prepared in a factory are not to be compared in beauty to the colors which are prepared by hand with a spatula. Although Naples yellow is an absolutely permanent color and, because of its covering power, so advantageous to painters, there are manufactured substitute color mixtures, for example, ocher or, in the case of some English colors, cadmium, with white lead, which naturally cannot be compared to genuine Naples yellow in beauty or quality.

URANIUM YELLOW, uranium oxide, light and dark, is regarded as a fast color in mineral painting [stereochromy], but is otherwise used only for china painting.

CHROME YELLOW (*Chromgelb, jaune de chrome*).—Neutral lead chromate is poisonous, and occurs in the trade, according

to its method of manufacture, in all the different nuances from the lightest lemon yellow through light, medium, and dark to orange. The colors are brilliant and relatively inexpensive. Chrome yellow covers and dries well, and it goes a long way. It is therefore often cut. The lighter tones, unfortunately, do not stand up well under light; even as a powder they turn a dirty leather color, and in oil a dirty greenish brown. The darker shades of chrome yellow are, according to their degree of darkness, considerably more permanent. Chrome yellow must be given an addition of wax (2%), otherwise it is apt to harden in the tube. The color is mixed with about 25% poppy oil. When heated, chrome yellow becomes a reddish brown; when cold again, a dirty yellow. Cold hydrochloric acid dissolves chrome yellow into a yellow fluid. The darker shades can be used both in oil and tempera. In contact with wet lime all tones turn quickly to orange. Böcklin used chrome yellow extensively, in fact he was a champion of this color, as was also L. Ludwig, who, however, kept his pictures in portfolios, so that naturally the chrome yellows remained permanent. I know of one case where the change in chrome yellow became an artistic advantage, and this was in the sunflower paintings of van Gogh. His yellows were originally much harder and lighter and not so mysterious as they are today. With chrome yellow and Prussian blue are prepared mixed colors, the so-called chrome greens (more correctly chrome yellow-greens), which are relatively more permanent than chrome yellow, as likewise are "green cinnabar" and silk green; these somewhat heavy colors, however, are far surpassed in beauty by colors made of cadmium and oxide of chromium green (viridian) (see under green).

Cassel yellow, mineral yellow, Turner's yellow, jaune minérale, patent yellow, is an impermanent lead yellow not compatible with other pigments.

ZINC YELLOW (*Zinkgelb, jaune de zinc*).—Zinc chromate is a slightly poisonous, light lemon-colored pigment, which is obtainable only in this one color expression and no other, although richer types could be produced without difficulty. But cadmiums are here to be preferred. Zinc yellow requires about 40% oil, dries well, but has the fatal quality of turning green,

especially when used pure as an oil color. Zinc yellow is not absolutely waterproof; the powder dissolves in part when shaken with water. Zinc yellow may effloresce if moisture condenses on the surface of the picture, when a kind of yellow sheen will spread over the affected parts. Once, when I was painting a fresco, it happened that this color disappeared completely from the spot to which it was applied and wandered off to an area in the plaster 30 cm. away which had longest remained wet. Zinc yellow, because of its tendency to turn green, should not be used in such sensitive parts of a picture as atmospheric tones. When mixed with chrome oxide, permanent green, as a half tone, it is, on the other hand, very useful (see under green). It is readily and completely soluble in dilute hydrochloric acid, when it becomes a reddish yellow (chrome yellow remains yellow), and, when heated, turns a dirty brown. This dirty discoloration differentiates it from both of the following colors.

BARIUM YELLOW, permanent yellow (*Barytgelb, jaune d'outremer*), yellow ultramarine, is barium chromate. In appearance it is very little different from zinc yellow, only somewhat brighter; under artificial light it is luminously bright, almost white. It is likewise readily soluble in dilute hydrochloric acid, and at the same time turns a reddish yellow. When heated, it becomes reddish, and, when cold again, pure yellow (a distinction from zinc yellow). Barium yellow is also slightly poisonous. With respect to permanence, barium chromate is undoubtedly superior to zinc yellow. Used as an oil color, it requires less oil than does zinc yellow, about 30%; it is fairly permanent in tempera, water color, and pastel, but somewhat doubtful in fresco, though even here it has a better reputation than zinc yellow.

STRONTIAN YELLOW, strontium chromate, is somewhat richer in color than barium yellow. Otherwise it has the same properties, but is reputed to be more reliable than zinc yellow. It is also partially soluble in water. When heated, it turns first a yellow ocher color, and, upon cooling, a pure yellow again (a difference from zinc yellow). Zinc yellow, yellow ultramarine, and strontian yellow, which greatly resemble one another, are frequently not very sharply differentiated in the trade. It may be for this reason that the same green discoloration has been ob-

served in all of them when ground in oil. They are used, therefore, for tones where this effect is not harmful, as, for example, in mixtures with green and with darker tones. Mixtures with white of these three colors are fairly durable. The covering power of all these tones. and likewise their chromatic strength, is poor.

CADMIUM YELLOW (*Kadmiumgelb, jaune de cadmium*) is cadmium sulphide; it is permanent and non-poisonous. It dissolves in concentrated, hot hydrochloric acid, giving off hydrogen sulphide. A yellow solution would indicate the presence of chrome yellow, and a reddish of zinc yellow. In lyes it is permanent. When heated on the spatula, it turns red; upon cooling, it returns to yellow. Heated cadmium lemon turned orange within a year.

Cadmium lemon is a substratum color precipitated upon a white filler. Some commercial samples turned green under light, like zinc yellow; others stood up well. The darker types of cadmium, light, medium, dark, and orange, have more covering power and are permanent. A certain cadmium lemon advertised as 100% pure cadmium sulphide upon analysis showed titanium white as a base.

Today there are many different methods of manufacture, and the quality and price of the products vary accordingly. Cadmium yellow requires about 40% oil and a small addition of varnish to act as a slow dryer, also 2% wax to prevent it from drying up prematurely in the tube.

Cadmium is not compatible with copper colors such as emerald green; in mixtures with these it turns permanently black. Many cadmiums in powder form show streaks under light; the cause of this change is the presence of cadmium salts other than sulphide.

Cadmium is very useful in all techniques; only in fresco is it doubtful. I have found it permanent indoors. It should first be tested for its behavior with lime. In the open it turns brown when mixed with lime.

BRILLIANT YELLOW (*Brillantgelb, jaune brillant*) is a very light mixture of cadmium yellow and either Cremnitz or zinc white; it is durable, but wholly superfluous.

The old masters had only the very poisonous orpiment, yellow sulphide of arsenic, and realgar, arsenic orange (arsenic disul-

phide), to work with. It was very coarsely ground and applied with tempera. In oil painting it was used pure without admixtures between layers of varnish. In Pompeii it has frequently been discovered in ochers, but it has also been traced in present-day cadmiums.

HANSA YELLOW 10 G. and 5 G., a new coal-tar pigment, is said to surpass cadmium lemon in permanence. It is reliable in both lime and oil.

INDIAN YELLOW (*Indischgelb, jaune indien*), magnesium euxanthate, is a natural organic lake. It is made from the urine of cows which have been fed on mango leaves. The raw product, Monghyr [a city in Bengal] purree, in the form of yellowish brown lumps, betrays its origin by its odor. When cleaned and powdered, it is a beautiful golden yellow glazing color, which is quite permanent and can be used in all techniques other than fresco. Indian yellow is slightly soluble in water, as is evidenced by the way it penetrates the paper in water color and the difficulty with which it is washed out. If a small piece of Indian yellow is boiled in water and hydrochloric acid then added, the yellow color, if the sample was genuine Indian yellow, will immediately disappear. The many substitutes for Indian yellow remain yellow in the solution. Like many organic substances, it should leave an ash when burned. But it should leave only a white ash, which must be completely soluble in hydrochloric acid; otherwise it is evident that the product has been adulterated. The cleaner and more golden yellow it is, the greater its value. The brownish varieties are less valuable. The color requires very much oil, up to 100%, and, because it is a poor dryer, an addition of varnish. There is no substitute pigment for this peculiar color. Indian yellow is very expensive and therefore very often adulterated, a fact which has had a bad effect upon its reputation. Pure Indian yellow is an absolutely unobjectionable color. Today coal-tar pigments such as naphthol yellow are called Indian yellow by the trade.

SUBSTITUTES FOR INDIAN YELLOW. Plant lakes, lake pigments, derived from yellow berries, quercitron, etc., under the name of yellow lake, brown pink, Italian pink, stil de grain brun, laque de gaude, are unfortunately still very much used. Taken as

a whole, they fade quickly in the light or turn brown in oil. The peculiar blue-green effect of the foliage in Dutch pictures must be attributed to the fading of the coats of yellow plant lakes originally put over them. Yellow, as well as brown and green, plant lakes were often used by the old masters as glazes over lighter underpainting of heavier body. These glazes were mixed with resin varnish or used directly as a color varnish. Many have held up surprisingly well, probably as a result of their being isolated between two layers of varnish. Made with fatty oils, they turn very brown. One can easily recognize the yellow lakes by boiling them in water with an addition of hydrochloric acid. The solution remains yellow in contradistinction to Indian yellow. When retouching pictures which are being restored, these impermanent colors are also often used to imitate the gold tone of old pictures.

Coal-tar dyes often pass under the name of Indian yellow, which is obviously a misrepresentation. The impermanent azo yellow, as well as the naphthol yellow lake, turns brown in a few days when exposed to the light. In dilute hydrochloric acid naphthol yellow lake remains yellow, azo yellow turns brown.

Continued attempts are being made to produce, from the many coal-tar dyes, a reliable substitute for Indian yellow. In indanthrene yellow the *I. G. Farbenindustrie* claims to have produced such a color. The color tone of the genuine Indian yellow is best obtained by adding cadmium yellow to indanthrene yellow.

COBALT YELLOW, aureolin (*Kobaltgelb, jaune de cobalt*), is a mineral color. It has covering power, which Indian yellow has not, which serves as a means of distinguishing them. In the trade this color is very uncertain. It is, moreover, very expensive, and is superfluous. Cobalt yellow often appears in the trade under the name of Indian yellow.

GAMBOGE, *Gummigutt, gomme-gutte*, is a gum resin much used in water color, but it is not lightproof, nor are the mixtures made with it, such as Hooker's green, etc. In thick layers it shows a gloss because of its resin content. As an oil color it strikes through, and so is absolutely unusable. It burns with an odor of resin, is poisonous, is not attacked by acids, and turns red if alkalis.

THE YELLOW AND BROWN OCHERS, *gelber Ocker,
ocre jaune*. The ochers are earth colors, which owe their hues to
the iron hydroxide which they contain. Many painters are firmly
convinced that there is nothing better than earth or natural col-
ors, and the mere fact that a color is an earth color is proof suf-
ficient to them of its quality and permanency. But this most as-
suredly is not the case. All the natural ochers are more or less
impure, with admixtures of humus, or bituminous organic matter,
or clay, etc. Often the beauty and brilliance of the ochers are
due to such impurities. If these are washed away, the ochers not
infrequently lose their fire. But the washing is necessary to free
the ochers from harmful iron sulphate compounds. Ocher colors
are found nearly everywhere in nature. Their purity determines
their use as artists' colors. The purest ochers come from France,
but the Harz mountains, the upper Palatinate, and many other
regions furnish beautiful ochers. One of these, "Amberg yellow,"
a bright ocher color, was formerly especially treasured for fresco
painting, but today is no longer available.

Ochers are ground and washed. The old masters worked hard
in preparing their ochers, because they had to wash and grind
them themselves. Böcklin often looked for his ochers in the
Roman Campagna, where they were washed up on the banks
of the streams, and the various tones were to be found in different
layers, according to their weight. Ochers may be cleaned in small
quantities by putting some of the powdered color into a preserve
jar, pouring water over it, and then stirring it thoroughly. The
heavier, coarser color particles sink quickly to the bottom, and
the finer particles, which remain suspended, are quickly poured
out into another glass and allowed to settle. This can be repeated
until the required degree of fineness is attained.

It is very easy to test the genuineness of yellow ochers. When
heated, they turn red. If they become black or charred, it is evi-
dence of an admixture of some organic matter, either humus or
a coal-tar color designed to improve their appearance. This can
also be ascertained by the alcohol test. Ochers should not discolor
alcohol. In alkalis ochers are insoluble, but partially soluble in
acids; they remain yellow and yield a large residuum—clay. They
should not effervesce in acids (lime content). Ochers are offered by

the trade in many different tones and hues. According to their degree of brightness, there are distinguished light ocher, medium ocher, gold ocher (a fiery, half-glazing variety), dark ocher (a dull, very useful tone), Italian earth, Roman ocher, brown ocher, etc. Gray varieties, such as stone ocher, and especially greenish ocher, are best avoided. The ochers have medium covering power, require about 60% oil (they vary much in this respect!), are very permanent when free from impurities, dry fairly well, and can be used in all techniques. They belong to some of the most frequently used and inexpensive artists' colors. Ochers in powder form must for our purposes be pure and not "cut," as is house paint; otherwise, if used in fresco, ocher will effloresce. As a result of their clay content, the ochers, though not so frequently as ultramarine, are apt to decompose, and therefore they would have a bad effect on superimposed coats of varnish. On old, badly preserved oil pictures the ocher can often be wiped off like dust. If bituminous organic substances are present, they render the ocher impure, which turns brown and later dark, because these impurities are soluble in oil.

The artificially manufactured ochers have the advantage of always being reliable in color and purity, which is not the case with the natural product. They bear the name of

MARS YELLOW, *Mars orange*, etc., are more transparent than the natural ochers, because they contain less clay, and are disproportionately expensive. They must be well washed. When heated, they turn red. Yellow iron oxides are very strong and permanent artificial ochers.

RAW SIENNA is an ocher containing silicic acid. It is found in Tuscany, the Harz mountains, and other localities. The color by itself is beautiful and luminous, but it should not be used as an oil color because of the enormous amount of oil it requires (up to 200% and over). This leads to rapid darkening, especially in the underpainting. In oil-free techniques, such as tempera or fresco, the color is unobjectionable.

III. RED PIGMENTS

THE BURNT RED OCHERS AND THE RED EARTH COLORS. If yellow ochers are heated, they turn red; they lose

their chemically bound water content and thus become thicker and denser. Under moderate heat yellowish-red warm colors are produced, while under stronger heat rich saturated colors result, which, if mixed with white, yield colder tones. The coloring agent is iron oxide. This offers the painter an opportunity to prepare for his special purposes, in the manner of the old masters, very useful light yellow-reds which are not sold as tube colors. But the ochers must be pure and free from adulterants, such as chalk, because this, when heated, would turn to quicklime. Gypsum likewise should not be present, certainly not in fresco color, where it would lead to efflorescence. They should not effervesce in hydrochloric acid (chalk!). None of these colors is poisonous.

Natural burnt ochers, red earths, frequently occur in volcanic regions as a decomposition product, often also as a natural product finely washed on the banks of rivers. One may distinguish warm colors, such as burnt light ocher, burnt gold ocher, and flesh ocher, and cooler tones, such as terra rosa, terra di Treviso, and an especially strong, beautiful color, Naples red, etc.

TERRA DI POZZUOLI [*pozzuolana*] occupies an exceptional position. It is a natural cement already known to the ancients, rich in silicic acid. It was used with lime in Pompeii. Dr. Eibner has pointed out that in fresco it prevents superimposed layers of color from setting, while, itself, it sets quickly and solidly. Other volcanic earths act in the same way, such as Santorin [4] earth from Greece.

The burnt ochers and red earths are reliable in all techniques. They are resistant to acids and lyes, and require about 40% oil. For artistic purposes only unadulterated and "unimproved" colors should be used. If slightly heated, the color should not suffer; if coal-tar colors are present, they burn. It has been variously reported about these otherwise absolutely reliable colors that they bleed if ground too finely. Like asphaltum, they will then penetrate into superimposed layers of oil colors. This was not the case when colors were ground by hand. It is a great mistake to grind colors so finely and in this way completely destroy their body.

[4] An island in the Aegean Sea. [Translator's note.]

SINOPE was a very light red ocher from Asia Minor which was used from ancient times to the Middle Ages, but today its source of supply is no longer known.

Red iron oxides, oxide reds, are artificial pigments made from iron ore or waste material of chemical industries. They are very closely related to the red earths and have the same properties. They are known under many names, such as English, Indian, Pompeian, Persian, and Venetian red. Intensive heat produces the dark colors with a violet nuance, such as caput mortuum, light and dark, and colcothar. With these colors, if ground too finely in oil, "bleeding" has also been observed. English red, light red, in powder form is often cut with gypsum, and is consequently dangerous to use in fresco. All these pigments require from 40% to 60% oil. They possess good covering power and dry fairly well. Mixed with white, they yield cool tones, and they may be used for all purposes and in all techniques. The Mars reds, burnt Mars yellows, also belong here. The newer red iron oxides made by the *I. G. Farbenindustrie* (Ürdingen) are especially beautiful in color.

BURNT SIENNA, a fiery glazing color, requires much oil, about 180%, and as an oil color is apt to jelly. This may be remedied by washing, but the sienna then frequently loses much of its fire. This color, like all other red and brown earths, can be used in all techniques. It was often used by the Venetians with iron oxide for flesh tones, whose warmth and fire it increased. Unless used with discretion, however, its effect is unpleasantly hot. Ludwig maintains that the luminous red in the flesh tones and reflections of Rubens is not vermilion, but an especially well-burnt (calcined) sienna. This is not impossible, and would be worth a chemical analysis. Martin Knoller in his manuscript (1768) states that very strong heat will produce a sienna resembling vermilion which may be used in fresco out of doors. It is to be hoped that the color industry will restore this color to us for fresco.

VERMILION, cinnabar (*Zinnober, vermillion*), is a chemical compound of mercury and sulphur. It is slightly poisonous. The natural product, found chiefly in Almadén and Idria, has been eliminated for practical purposes. The properties of the natural

and the artificially prepared product are practically the same.

Vermilion is manufactured either by a wet or a dry process. By the wet process the yellowish, so-called light German vermilion is produced; the dry method produces darker, cooler tones. In the preparation of vermilion a black mass is first formed, the "ethiops." When it is heated to a high temperature, the darker tones are produced, at lower temperatures the lighter tones, and with still greater heat the very dark nuances.

Vermilion turns black when exposed to sunlight. This was already known by the ancients. Therefore the vermilion wall panels in Pompeii were covered with wax. The madder lake glazes which the old masters put over vermilion served the same purpose, in addition to enhancing the color. The blackening does not appear on the whole surface, but only in spots.

The vermilion reverts to its original black state, the "ethiops," and remains black. There is no known method by which, when changed by a physical process, it can be restored to its original red color in the picture. The cause of this darkening, which cannot be attributed to the action of the light alone, has not as yet been definitely determined. Of two vermilions prepared in the same way and with the same precautions, one will turn very black and the other darken only imperceptibly. The farther light can penetrate into the binding medium, the more quickly will the vermilion darken (according to Dr. Eibner). If this is true, varnish would be less protection in this case than would a less transparent medium, such as a tempera emulsion.

Vermilion is very heavy; it requires only about 20% oil, covers well, but dries poorly despite the small amount of oil it requires as a medium. It needs an addition of 2% wax to keep it from hardening in the tubes and to hold the oil in solution. It is insoluble in weak acids and alkalis and burns with a blue flame, leaving almost no ash. The sulphur burns, and the mercury vaporizes. It was formerly thought that the darker sorts, such as the Chinese letter vermilion, were the more permanent, and that the lighter German vermilion turned dark much more quickly in the light. But lately there seems to have been a change in this respect, and many lighter German varieties of vermilion (according to Dr. Eibner) far exceed the stability of even Chinese vermilion. How-

ever, these lightproof vermilions, manufactured after Dr. Eibner's recipe, do not seem to have appeared as yet in the trade. Pure vermilion and white lead should be compatible. I have in my possession the results of an experiment performed by A. W. Keim in 1886. A piece of glass was covered with two sorts of vermilion, each used pure in one instance, and in the other mixed with white lead. The two pure vermilions have blackened considerably, but those mixed with white lead could still be called red. In this case the white lead seems to have protected the vermilion. Dr. Eibner also insists that vermilion is compatible with lead colors. This apparently is no longer the case today, perhaps because of changed methods of manufacture, for my own experiments with German and Chinese vermilions mixed with white lead (or zinc white) in various tones approximating flesh color show quite different results. Vermilion without white lasted, while the same vermilion with white became blackish under ordinary daylight. All these mixtures turned gray and gray-black, so that in some of them no trace of red is longer recognizable; and such discoloration in the flesh tones would have ruined the whole picture. The cause of this change is not yet definitely known. Free sulphur—which one could imagine was the cause of the formation of lead sulphate—at ordinary temperatures does not change white lead. Church-Ostwald, however, insists that the contrary is the case. In contrast with the black spots which vermilion develops when exposed to the light, the discoloration here covers the whole surface. Experiments made by others with vermilion mixed with white lead are said, on the other hand, to have held up quite well. It is not advisable to use it with copper colors, such as emerald green. The mixture turns black. On old pictures vermilion has lasted very well. Raehlmann found, through microscopic examination, that the crystalline form of the old native cinnabar was different from the present-day powder of the modern artificial vermilion, and this no doubt is the reason for the better preservation of the old pigments. He found Cremnitz white with vermilion very well preserved on Venetian pictures. The old vermilion is said to have been only coarsely ground. It is a question, however, to what extent the vermilion-like tones in old pictures really are vermilion, and not, for example, red lead or burnt ocher

and iron oxide which have been strengthened with vermilion. Through contrast with other colors, many a weaker color may acquire the effect of vermilion.

Carmine vermilion contains English red. Patent vermilion is a dark vermilion made by the wet process. Chinese letter vermilion (it is put up in envelopes) is cool, dark, and especially beautiful. Antimony vermilion is poisonous and impermanent, as is also scarlet vermilion (mercuric iodide). Eosine vermilion is colored with the fugitive coal-tar dye eosine.

In any case, vermilion can be said to be only conditionally permanent, and if considered in individual cases. With these reservations it can be used in oil, tempera, or water color. When used in fresco, it must in every case be tested for stability in lime, as well as for its action under light. But this whole subject is so lacking in clarity that one is compelled to look round for substitutes.

MINIUM, red lead (*Bleimennige, saturnine, mine rouge;* not to be confused with the house painter's color, iron oxide), is red oxide of lead. The artist's color is called Saturn red. Red lead is produced by heating white lead in the presence of air. The color is very poisonous, sensitive to hydrogen sulphide, attacked by hydrochloric acid, but indifferent to alkalis. Red lead should not discolor alcohol. If it does, it has been adulterated with coal-tar dye. Dilute nitric acid turns red lead into brown lead peroxide = brown lead, the last stage to which white lead may be oxidized. Under great heat red lead becomes a light violet, and, when cooled again, a yellowish red. Like white lead, this color requires very little oil, about 15%. As a pigment in powder form, it quickly turns dark in the light, but, when ground in oil, is, on the contrary, fairly permanent (according to Dr. Eibner). When mixed in oil with white lead, it has a tendency to fade rather than turn dark. But this may be different with pigments of different manufacture. In any case, a mixture of red lead and white lead, when exposed to the light for the same length of time as a coat prepared from vermilion and white lead, stood up relatively better. Red lead can be used only as an oil color; as a powder and in fresco it eventually turns black. Freshly ground red lead is the best. When red lead is produced under insufficient heat, red-yellow oxide forms, which is not sufficiently permanent. This can be eliminated by

washing with sugar-water. When it is ground in oil, a little wax should be added to guard against its hardening too quickly. Red lead ground in oil dries the most quickly of all pigments. I have observed the bleeding of a certain brand of red lead when painted over with white lead. Obviously it was doctored with coal-tar colors. Coal-tar colors are frequently precipitated upon red lead, and give brilliant tones whose permanence must in each case be tested.

CHROME RED (*Chromrot, rouge de chrome*), which is similar to chrome yellow and also dries quickly, is basic lead chromate. It is poisonous, and, when heated, turns a reddish brown. Acetic acid changes it to yellow (vermilion is unaffected). Chrome red is a good example for showing the effect of the size of the grain on the character of the color. With little grinding, the color becomes considerably lighter and more of a yellowish red. It should be worked only with the spatula and just before being used. Chrome red is not to be compared with vermilion for brilliancy, and, when mixed with white lead, it gives cold, dull tones. It can be used in fresco, but it does not show up well.

HELIO FAST RED R.B.L., No. 9 of the "universal colors" of the *I. G. Farbenindustrie*, also lithol fast scarlet R.N., No. 8, are coal-tar lakes which may serve as substitutes for vermilion. Helio fast red is a brilliant color, which has proved itself permanent in water color, tempera, and in indoor fresco. Also in outdoor fresco favorable results have been reported. However, as long as the question of the usefulness of coal-tar colors is scientifically still subject to dissenting opinions, we must continue to use caution. I have personally made satisfactory experiments with helio fast red, but others say that it turns brown in oil. There are today many vermilion-like coal-tar colors for artists' use whose permanency under light and in lime will have to be tested in every single case. Helio fast red is said to attack the metals of tubes. These will therefore have to be covered inside with a protective lacquer.

INDANTHRENE BRILLIANT PINK R., Nos. 13 and 14 of the German "universal colors," is a color expression between vermilion and light madder lake. The latter has an admixture of ultramarine blue to give it a cooler quality. These colors are useful in all techniques, including indoor fresco.

When heated, all coal-tar pigments, because they consist of organic bodies, turn black. The base and filler material remain white.

CADMIUM RED is very properly regarded as the best substitute for vermilion, especially those varieties more recently developed, the very brilliant yellow-red types. Cadmium red is cadmium selenide and cadmium sulphide, a substratum color. As an oil color it needs a little wax and about 40% oil. In tempera the color easily solidifies in the tube; it is therefore better for the painter to prepare the color himself immediately before use. Cadmium red is reported to turn brown in out-of-door fresco. With copper colors such as emerald green it turns black, as do all cadmiums.

MADDER LAKE (*Krapplack, laque de garance*), natural root madder lake, an extract made by boiling from the root of the madder plant and precipitated on a clay base, is a beautiful, transparent red, but unfortunately impermanent. In the trade the color is obtainable in many shades: rose, light, medium to dark, and violet. Rose madder bleaches out in a few months; the darker sorts are relatively permanent. Burnt and violet madder lakes are no more permanent and are, furthermore, unnecessary colors. Rubens' madder, Rembrandt madder, and Van Dyck red are unnecessary and doubtful color mixtures of fantastic nature. In fresco lime destroys madder completely.

Alizarin madder lake, artificial madder lake, is a coal-tar color, and in permanence exceeds the natural product, even if not absolutely permanent. The permanence of alizarin madder has been fixed as a standard for other coal-tar colors. In the madder root there are two coloring agents, the permanent alizarin and the quickly fading purpurin. From the alizarin madder lake the purpurin is removed, from which results its superior permanence. All red pure alizarin madder lakes, rose, light to dark, and violet, are very serviceable and sufficiently lightproof. Other shades, the so-called yellow, brown, blue, etc., alizarin madder lakes, cannot be used.

The pigment comes in the trade in small pieces, which contain starch to insure their solidity. They are easily broken up into powder. Crystallized madder lakes cannot be used; they are very diffi-

cult to grind. Madder lake burns, leaving a small amount of gray ash; it is not poisonous, should not discolor alcohol, and is completely soluble in ammonia. If hydrochloric acid is added, the alizarin must be precipitated; if the solution remains red, it indicates the addition of coal-tar dyes or carmine. Madder lake requires about 70% oil, dries poorly, and should therefore be first mixed with linseed oil and ground with an addition of varnish. Pure madder lake is characterized by a tendency to crack, especially on white grounds, but this may be corrected by a small addition of Cremnitz white or a mixture with other colors. Alizarin madder lake can be used with oil, tempera, or water colors, but not with wet lime; it is, however, quite reliable on a dry plaster in the interior of a building. Here and there it has been observed that madder lake bleeds, which is an indication that it has not been used properly (used too thickly in underpainting), or that it has been mixed with impermanent coal-tar dyes.

CARMINE (*Karmin*, crimson lake, purple lake, *laque cramoisie*) has its origin in the cochineal insect. The finest quality, known as nacarat carmine, is a non-poisonous, very beautiful color, even surpassing madder lake. But it is a very impermanent pigment, with the peculiarity of being apparently more permanent in transmitted light, as a transparent color, than when under direct light.

Carmine lake does not essentially behave better, nor do mineral lake, purple lake, Vienna lake, and Florentine lake. Carmine lake is soluble in ammonia and turns it purple. It is insoluble in water. It burns completely, leaving a white ash, and smells in the process like burnt horn (a difference from madder lake). Despite their rapid fading, these colors continue to be used a great deal in water-color and oil techniques. Just as impermanent are red lakes, geranium lake, and laque Robert, which color ammonia violet.

Ultramarine red, *violet* (see under ultramarine blue).

Helio fast pink R.L. is a new coal-tar pigment resembling rose madder. It is useful in indoor fresco, and more permanent than alizarin lake.

IV. BLUE PIGMENTS

ULTRAMARINE BLUE (*Ultramarinblau, outremer*). Natural ultramarine is made from lapis lazuli, a semi-precious stone. Since the stone is very hard, it is difficult to separate the blue pigment from the other constituents, and old books on painting have much to say concerning the troublesome process of levigating and washing. The color is very expensive and was therefore used only as a thin glaze over a light base; and artists had to exercise the greatest possible care to prevent the color from being spoiled by the yellowing of the oil. Therefore Van Dyck (according to De Mayerne) used ultramarine in tempera on his oil pictures. On Dutch pictures of the 17th century I found ultramarine (natural) used over a white ground as a local color for air and draperies; doubtless this was done in tempera. A difference in color tone and value was achieved by glazing with other colors, such as ocher and white, particularly in skies, over the ultramarine. This was made necessary by the great cost of the pigment, which would be largely lost in mixtures. The gradations were easily achieved, as I had the opportunity of observing in small sections of paintings which had become worn. The color tone is very beautiful, but today this pigment has disappeared from use because of its cost and because a much cheaper substitute is available:

Artificial ultramarine. This is a pigment prepared by heating china clay with sulphur, soda, carbon, and Glauber's salt. One differentiates "reddish" and "greenish" ultramarine. In the trade ultramarine is often adulterated. Cobalt substitute is a bright greenish ultramarine, strongly adulterated. Ultramarine is non-poisonous. Unfortunately this beautiful and valuable color becomes quickly discolored by the action of weak acids, which attack it, forming hydrogen sulphide. Vinegar, which is often used with tempera, and also carbolic acid used as a disinfectant, can by their continued action, even in very small quantities, completely ruin this beautiful blue color in a picture. Alum will likewise discolor ultramarine. Free acids in the very fat oils may

do the same. The "acid-proof" ultramarines of the trade are often very questionable.

Ultramarine, which is otherwise dependable in all techniques, must not be used in outdoor fresco, especially in industrial centers, because the sulphuric acid contained in smoke condenses on the walls, attacks the sinter skin [calcium carbonate], and destroys the color. Recently it has been maintained that this danger is greatly exaggerated, but there is no doubt that damage of this sort has occurred. The cause, however, is not yet explained. Gypsum may cause efflorescence; therefore the artist should use in fresco only the best artist's pigment and never an inferior pigment sold usually in powder form. It is not sufficient to ask for ultramarine blue suitable for fresco; the artist in the future will have to insist upon known and tried varieties. Ultramarine blue J.C. 832 of the *Vereinigte Ultramarinwerke*, formerly at Leverkusen, has proved itself durable in fresco.

Ultramarine blue is ordinarily not sensitive to lyes and is therefore, with the restrictions indicated above, dependable in lime. Ultramarine blue should not change when heated; if such a change occurs, it is not suitable for artistic purposes. Additions of glycerin to simulate a deeper tone are occasionally found in trade products. Ultramarine should be free from Glauber's salt (sodium sulphate), because this may cause efflorescence. Ultramarine should not discolor water, alcohol, or ammonia. The color is absolutely lightproof and can be used with all except copper colors (like emerald green). It requires about 40% oil and dries slowly. About 2% wax is added to the color to make it "short" and also to prevent its hardening too quickly in the tube. One should allow the ground color to stand a day before putting it into the tube; the color then becomes thin again and is able to absorb more of the powder pigment. Ultramarine may form hydrogen sulphide, for example, in egg tempera, especially in tube colors. Ultramarine is therefore mixed with gum emulsion for use in tempera. As the result of hygroscopic action ultramarine may form a whitish coat on the surface of the picture, the so-called "ultramarine disease," the result of decomposition of the varnish, which, however, is easily removed by means of alcohol vapors. It may also be destroyed by free acids or oil acids present in the

painting. Under artificial light ultramarine mixtures look blackish.

When ultramarine is manufactured, first white and then green tones are produced. Ultramarine green is permanent, but low in coloring power. It is used by house painters. The action of hydrochloric acid gas on the blue ultramarine produces the violet and red ultramarines.

RED AND VIOLET ULTRAMARINES are always strongly tinged with blue. Both tones can be used in fresco and are invaluable in this technique because of the limited scale of available colors. In other techniques they are superfluous because weak in coloring power.

KING'S BLUE, light and dark, is a useful mixture of ultramarine and Cremnitz white, especially for atmospheric tones. It is also made from cobalt blue and Cremnitz white, but in this case the yellowing of the oil has a worse effect on its appearance than on the ultramarine mixture.

COBALT BLUE (*Kobaltblau, bleu de Thénard*), cobalt oxide and aluminum oxide, a non-poisonous metal color, is equally unaffected by acids, alkalis, and heat, and therefore useful in all techniques, and very lightproof. To be sure, the color requires very much oil, up to 100%, but in spite of this dries very quickly (the metal cobalt has the same drying power as the metal lead). Because of this drying power cobalt often causes cracks in the picture when put on over coats of paint which are not yet sufficiently dry. In the picture cobalt blue suffers, as do all cool tones, through the yellowing of the oil. This color gives clear tones, whereas ultramarine in thick layers, or if not mixed with sufficient white, may give a black effect. One differentiates the reddish and greenish cobalt blues.

SMALT (*Zaffer, bleu de smalte*), a potash glass containing cobalt, may be found now and then in old pictures. Today it has been replaced entirely by cobalt blue. It is a sandy powder of poor covering and tinting power, and, although it is not attacked by acids and alkalis, it tends to decompose rapidly. It then loses its bright blue color and becomes a whitish gray. Since many sorts contain arsenic, one should be careful when using it. When strongly heated, it fuses (melts). It is not suitable for use in oil.

CERULEAN BLUE, coeruleum (*Coelinblau, bleu céleste*), is a greenish, light, very pure and dense compound of cobaltous and tin oxides which, as a color, is very valuable to the landscape artist, for example, in atmospheric tones. This color is absolutely durable. As a tube color in oil it needs an addition of wax. A cerulean blue ground only in poppy oil became solid in a few weeks. The cause may have been gypsum.

COBALT VIOLET, light, of French manufacture, is cobaltous oxide arsenate, hence very poisonous, and is subject to darkening in oil.

The dark cobalt violet, cobaltous phosphate, a German product, is, on the contrary, very permanent. Cobalt violet is very expensive and scarcely necessary. In tempera it is not a good tube color because it hardens too easily.

MANGANESE VIOLET, mineral violet, Nuremberg violet, is a permanent, heat-proof, non-poisonous color, which, however, as a trade product is not a beautiful tone and so can be dispensed with. It finds use here and there in fresco and mineral painting. The new manganese violet of the *I. G. Farbenindustrie* is a very powerful, fast color furnished in several different tones. It covers and dries well in oil and tempera, and is useful in tempera, pastel, and water color, but not in fresco. When heated, it fuses into a hard white substance.

PARIS BLUE, BERLIN BLUE, PRUSSIAN BLUE (*Pariser-, Berliner-, Preussischblau, bleu de Paris*). The pure pigment is called Paris blue, has a coppery, reddish sheen, and is a compound of iron and cyanogen. Antwerp blue and Milori blue are adulterated products which, because of their intense chromatic power, are often met with. Paris blue is non-poisonous, uncommonly strong in coloring power, and very permanent in all techniques with the exception of fresco, where it soon loses its intense color and leaves rust-colored spots. According to Täuber, in very light mixtures it bleaches out. Paris blue is almost instantaneously discolored by potassium hydroxide, in fact is very sensitive to all alkalis. For this reason it does not hold up in fresco. Indanthrene blue G. G. S. L. is said to be a good substitute in indoor fresco. Paris blue dries well, although it takes up much oil,

about 80%. In linseed oil it tends to become granular and should therefore be mixed with poppy or nut oil. In the picture Paris blue produces splendid effects, especially with oxide of chromium brilliant, or in shadows when mixed with madder lake; but one must be sparing in its use, because, as an oil color, it tends to give the picture a darker, heavier character than cobalt blue or ultramarine. It can be used in tempera, also in water colors. There, when mixed with zinc white, it has the peculiar characteristic of fading when exposed to light, but of completely regaining its chromatic strength in the dark.

A thin mixture of Paris blue with vermilion may separate, probably because of the difference in weight of these two pigments; but a mixture of these two colors is hardly ever attempted. If mixed with Cremnitz white, the separation will not take place. The frequently made assertion that it eventually turns green in oil can probably be traced to the yellowing of the oil.

When Prussian blue is heated, one gets Prussian brown, a permanent color, which, however, must first be washed and dried again.

INDIGO, natural indigo, a plant pigment, is a heavy and impermanent color and entirely superfluous; so also is thioindigo, a red-violet coal-tar pigment, which is fairly permanent in water color, but wholly unnecessary. It does not hold up as an oil color.

BLUE COPPER PIGMENTS, such as mountain blue, Bremen blue (blue verditer, *cendres bleues*), are all impermanent in oil, very poisonous, and incompatible with many other colors, such as white lead and vermilion. Combined with sulphur colors such as cadmium, all copper colors turn black. In old paintings copper colors were used by necessity, but they were isolated by layers of varnish and applied pure with egg tempera, as Raehlmann's examinations with the microscope show. Mountain blue, blue basic carbonate of copper, azurite, was frequently confused with ultramarine (lapis lazuli). Good grades may be used in fresco, but only by themselves, never in mixtures. These colors turn green in oil. Egyptian blue also belongs here, a color used by the ancients. It is a glass frit containing copper.

V. GREEN PIGMENTS

EMERALD GREEN, Schweinfurt green (*Deckgrün, vert Paul Véronèse*), is basic copper arsenate, the most poisonous and dangerous of all pigments. In order to conceal the fact that one is dealing with this highly poisonous stuff, it appears under all sorts of fantastic names. The color is luminous by itself, bluish or yellowish green, and would be a very useful color, which is also permanent in oil; but, since it is incompatible with sulphur colors, such as cadmium yellow, vermilion, and ultramafine, its use should be avoided. It is also doubtful with white lead. On mural paintings of the Romanesque period light copper greens have been analyzed which had stood up very well. This was probably here a natural mineral green, because emerald green was not known in those days. Malachite green, ground malachite, was formerly used as a durable tempera color. It is basic copper carbonate. As an oil color, emerald green requires but little oil, about 30%, and dries well. Emerald green becomes a deep black when used with sulphur colors. Many years ago, when a beginner, I painted a very green and very bright spring landscape which turned absolutely black, not merely blackish. Neither I nor any of my friends whom I asked at the time could offer an explanation. It was not until much later that I discovered that cadmium and emerald green were the cause of the disaster. Since then I have seen many pictures which have turned black in this way. Verdigris and other blue and green copper colors, such as mountain blue and mountain green, had to be used by the old masters because of a lack of other pigments. They were well aware of the dangerous nature and incompatibility of these pigments and took the precaution of placing them between coats of varnish. Verdigris was the cause of the blackening of the shadows in the canvases of later masters, such as Ribera, who used it in oil instead of tempera and without protective varnishes. All copper colors are easily recognizable because they give to ammonia a deep blue color. Emerald green turns black when heated and smells of garlic (arsenic). Potassium hydroxide slowly discolors emerald green to an ocher color; in weak sulphuric acid it dis-

solves, turning the solution blue. The copper colors of the old masters look under the microscope like coarse glass splinters as compared with modern colors, which have a mud-like character.

OXIDE OF CHROMIUM brilliant (transparent), viridian, *vert émeraude*, hydrous green chromic oxide, is one of our best colors and renders all the copper greens unnecessary. The color is transparent, is not affected by alkalis or acids, and is non-poisonous. It dries well. It should not lose any of its color in alcohol, water, or ammonia. If it does, it shows adulteration with coal-tar dye. The color requires much oil, about 100%, and must be allowed to stand for a few hours after grinding, when it will again absorb almost as much pigment as before. 2% wax is added. Contrary to Professor Hauser's assertion, it is very permanent in all techniques. It easily acquires a gelatinous character, especially in tempera. In the trade product, when mixed with much fatty oil, I observed after a few days the separation of a soot-like substance which floated on top of the oil. When the color dries on the palette in thick layers in either oil or tempera, it looks quite black. The color justly finds many uses, and with Prussian blue or madder lake and cadmium forms especially valuable mixtures. If strongly heated, the pigment loses its water content and gradually turns into

OXIDE OF CHROMIUM mat (opaque), chrome green, *vert de chrome*, anhydrous green chromic oxide, a dense, covering color tone of high tinting strength. This pigment, one of our best, is absolutely permanent in all techniques and requires very little oil, about 30%. Despite its small oil content, this color dries no faster than oxide of chromium brilliant. It is not used so much as it deserves to be. Because of their ability to withstand the action of acids and alkalis, the oxide of chromium greens can be distinguished from substitutes.

PERMANENT GREEN, dark, is a minor sort of oxide of chromium brilliant which has been strongly adulterated with barite and in mixtures is naturally less high in coloring strength than the latter.

BLUE-GREEN OXIDE AND GREEN-BLUE OXIDE are somewhat heavy, unnecessary, and expensive colors (cobalt tin

colors) which resemble cobalt green. They are permanent and non-poisonous.

GREEN COLOR MIXTURES.—*Green lake*, Hooker's green, leaf green, sap green, are impermanent pigments composed of Prussian blue and yellow lakes. Today we also have green coal-tar colors which are no better.

Permanent green, light, yellowish or bluish, is a much-used mixture of oxide of chromium brilliant with cadmium, lemon or light, and in this case absolutely reliable. But here, as with all mixtures, the composition often differs, and the resulting color is uncertain; for instance, oxide of chromium brilliant is frequently mixed with zinc yellow.

Victoria green is a very bright color tone, usually made from light permanent green and zinc yellow, but also often from cheap, much-adulterated pigments, for example, Paris blue and zinc yellow. There exists a great deal of confusion about this color, and also about

Chrome green. Under this name is sold the valuable oxide of chromium green as well as much less valuable mixtures of Paris blue and chrome yellow, which give heavy, earthy tones and should more properly be called chrome yellow-green.

Silk green is yellowish chrome yellow-green.

Green cinnabar is a senseless but commonly adopted name for various green mixtures, among them chrome yellow-green, also mixtures of Paris blue and chrome yellow.

Zinc yellow-green (zinc green) is composed of Paris blue and zinc yellow or of a mixture of oxide of chromium green and zinc yellow. The name zinc green is often used incorrectly for cobalt green.

Thus the confusion and arbitrariness of the nomenclature make it difficult for the artist to obtain reliable material unless he wishes to forgo the use of all color mixtures. It is absolutely necessary to insist that a statement of the composition of the contents appear on the tube, etc., for example, cadmium green for mixtures of cadmium and oxide of chromium green. Then every painter could be sure of having before him an unobjectionable and valuable product.

COBALT GREEN, Rinmann's green, also falsely called zinc green, *Kobaltgrün, vert de cobalt*, is a compound of cobaltous oxide and zinc oxide. It is attacked by hot acids and alkalis, and becomes reddish in hot acids, but does not change when heated by itself. The color appears in the trade in yellowish and bluish tones, is very permanent in all techniques, but has not much coloring strength, is somewhat gritty, and does not adhere well. It requires but little oil, about 30%; and 2% wax should be added to keep the color from hardening in the tube. It dries quickly, as do all cobalt colors. Despite its poor coloring strength, because of its fine, cool tones it is much used for flesh tints.

ULTRAMARINE GREEN (see ultramarine blue).

GREEN EARTH, *grüne Erde, terre verte*, is similar in nature to ocher and contains silicic acid (ferrous hydroxide and silicic acid). The Bohemian and Tirolean green earth, a warm glazing tone, is distinguished from the colder Veronese green earth (not to be confused with vert Paul Véronèse, emerald green). The green earths require much oil, up to 100%, but dry normally. They are not poisonous, dissolve partially with a yellowish-green color in hydrochloric acid, but not in alkalis, and should not discolor water, alcohol, or ammonia. When heated, green earths turn brown. The green earths can be used in all techniques. They are among the oldest known colors, especially the cool tones, resembling the color of unripe apples, and played an important rôle in the Middle Ages and in early Italian painting as middle and shadow tones in flesh, thus forming the dominant color of the picture. Böcklin and Marées used it in the same way. The most beautiful Veronese earth came from Monte Baldo on Lake Garda. Today the color is chiefly a durable mixture of oxide of chromium green, black, white, and ocher, since the natural product is scarcely any more obtainable, though at present it is said to be again on the market. The natural color has a gelatinous character in oil and tempera. This color is excellent in fresco, but turns considerably lighter when drying. In Pompeii it was used a great deal. The glazing Bohemian green earths were often used as undertones by the older Munich school as a frottie into which to paint wet in wet, which may be clearly seen in the earlier pictures of Trübner. The color is excellently suited to this technique and

gives to other colors painted over it a somewhat subdued tone. The green earths darken later because of their large oil content, but this makes little difference in a picture planned in a brown key. The cheaper sorts designed for commercial purposes may show rusty discolorations when used in fresco. Green earth is frequently used today as a substratum on which to precipitate coal-tar colors which are used extensively in calcimining under the name of lime blue and lime green. For artistic purposes these are not sufficiently permanent.

VI. BROWN PIGMENTS

BURNT GREEN EARTH is denser than green earth because it loses its water content when burned. It is a semi-glazing color and is permanent in all techniques.

BURNT SIENNA has been described under burnt red ochers.

BROWN OXIDE OF IRON is a permanent pigment resembling burnt sienna, but without its strength.

PRUSSIAN BROWN is prepared by heating Prussian blue. The color, when well washed and dried, is permanent.

RAW UMBER, *Umbra, terre d'ombre*, is an ocher containing manganese oxide and iron hydroxide. The color, because of its manganese content, is an excellent dryer. It can be employed in all techniques, requires much oil, about 80%, and, when used in tubes, must be given a 2% addition of wax so that it will not readily solidify. The best variety goes under the name of Cyprus umber, but comes chiefly from the Harz mountains. Many umbers have a greenish tinge, which is especially valued. In acids it dissolves in part, yielding a yellow solution; hydrochloric acid gives it an odor of chlorine. In alkalis it discolors a little (Cassel brown a great deal) and, when heated, becomes a reddish brown.

BURNT UMBER has the same properties as natural umber. In oil both tend to turn dark later on, especially if the underlayers were not thoroughly dry; but this darkening may also occur in alla prima painting, as an experimental study proved which I once made with and without umber. The study in umber had in the course of a few years turned as dark as an old master. Burnt um-

ber turns especially dark, most surprisingly because the burnt tones are ordinarily the more reliable in this respect. Here again the tendency to darken is increased by the modern practice of grinding the tube colors too finely. This often makes a color "bleed," and it strikes through like asphaltum. It is best not to use the color in fresco. In the open it tends to decompose and then produces a burnt, heavy tone.

CASSEL BROWN, Cologne earth, Vandyke brown, is brown coal. This color is partially soluble in oil and has a slight tendency to turn gray. It burns, leaving but little ash, and turns ammonia brown (a difference from umber). When used with resin ethereal varnish, it is more permanent than when used in oil. Its use in painting, however, is in no way necessary. It requires about 70% oil. This color is found on the pictures of the old masters, among them Rubens, who used it mixed with gold ocher as a warm, transparent brown which held up well, particularly in resin varnish. For restoring purposes it is useful when mixed with varnish. Cassel brown is sensitive to lyes and becomes a cold gray in fresco. Therefore it cannot be used on the wall.

FLORENTINE BROWN, Roman brown, Hatchett's brown, a copper color related to Paris blue, is impermanent and should be avoided. It is to be found in reddish-brown madder lake, such as Van Dyck red, and is poisonous.

BISTRE, brown lake, is an impermanent soot brown, but despite this defect is used as a water color.

SEPIA, a pigment from the ink bag of the cuttlefish, is not entirely but still reasonably lightproof, and is soluble in ammonia. Sepia is very good as a water color, but not in other techniques. Colored sepia "beautified" with madder lake, sienna, etc., is permanent.

ASPHALTUM, bitumen. The color is soluble in oil, for in its preparation the pulverized asphalt is heated in hot oil. It dries poorly, hence a good drying medium, such as boiled linseed oil, is often added. When used for purposes to which it is not suited, such as in the underpainting of a picture, where its use is very tempting because it permits of a sketchy and free technique, it has caused a great deal of damage because its poor drying power and its tendency to soften in higher temperatures, for ex-

ample, when the picture hangs over a stove, have caused deep cracks in the top layers of paint, and the asphaltum has pressed through.[5] The old masters, Rembrandt for one, used it as a glaze, and as such it did no damage. Asphaltum is lightproof, unaffected by acids, and requires much oil, about 150%. Its use is advised against in every technique, including fresco.

MUMMY does not behave much better than asphaltum. Mummy brown is burnt green earth.

VII. BLACK PIGMENTS

IVORY BLACK, *Elfenbeinschwarz, noir d'ivoire*, is prepared by charring bones, horns, etc., in the absence of air. It is the purest and deepest black and also relatively the best dryer. Ivory black is partially soluble in acids. When heated, it burns, leaving much ash. It can be used in all techniques. When used by itself over a smooth white ground, for example, a coat of Cremnitz white, it cracks, but not when slightly mixed with other colors.

VINE BLACK, *Frankfurter Schwarz, noir de vigne*, is plant charcoal with a slightly brownish tinge, and is a useful color.

BONE BLACK and bone brown are prepared from bones which have not been entirely charred, and are treasured by many painters because of their warm tones, but they are the least permanent of the black colors.

LAMPBLACK, soot freed from oil, is usually used for drawing purposes and is permanent.

IRON OXIDE BLACK, type N. extra 201 of the *I. G. Farbenindustrie* (Ürdingen) has proved itself a dependable black in fresco. When strongly heated, it turns a very dark red-brown.

MANGANESE BLACK is strongly heated manganese brown. It has a good reputation in lime.

PEACH BLACK is a permanent black.

The blacker and the less tinged with brown a black pigment is,

[5] Under high summer temperatures in museums without thermostatic control whole areas of the picture surface have moved and become permanently dislocated. Thus in several warm climatic belts of America it has caused the destruction of many paintings of the Munich school, which at one time was passionately fond of asphaltum as a frottie. [Translator's note.]

the more permanent it is. All the popular nuances of bone brown and bone black, etc., in a short time become heavy and turn a dirty gray. Therefore it is better to mix such tones from ivory black and umber. All black pigments require much oil, about 100%; for the most part they cover well, but dry poorly and therefore receive an addition of varnish. Since as a powder they are very light, they often absorb oil poorly, which makes their preparation as an oil color difficult. Especially is this true of soot black. Hence a thick paste is first made by adding alcohol, the alcohol is allowed to evaporate somewhat, and the oil is then added. A black pigment should not discolor water, alcohol, or ammonia. None of these colors is poisonous. The old masters frequently added a little verdigris to the black, making the color drier and better in tone. It lost its sootiness. An addition of viridian brings out the same tone effect.

GRAPHITE, black lead, a form of crystalline carbon, is but seldom used, chiefly in mural painting. It is permanent, but of little use. It has a tendency to strike through. Böcklin used it in the frescoes at Basel.

VIII. COAL-TAR COLORS

Coal-tar colors are distillation products of coal tar and are composed chiefly of carbon, hydrogen, and nitrogen, also often of sulphur, as in the case of thioindigo. Aniline colors were discovered by Sir William Henry Perkin (1838-1907) of England in 1856. At the outset they were very changeable in light and were not alcohol- or waterproof. Their precipitous and ill-advised introduction into painting was the cause of a great deal of damage. The aniline colors are only a small group of the enormous number of coal-tar colors, which, because they have no body, must be made into a lake or body color by precipitation on clay, tannin, mineral colors, etc. The manufacturers of coal-tar colors have given them designations including a name, letters, and numbers more carefully to differentiate them, for example, hansa yellow G.R., 3 R. Coal-tar colors are very powerful. The original color requires additions of fillers in very considerable amounts, for instance, 15 parts of color to 200 parts of filler. Only in this

way can they be made practically useful. Such colors therefore might be very inexpensive. Coal-tar colors in general are not poisonous (still doctors have claimed that the dust from alizarin indelible pencils has been the cause of blindness). The coal-tar lakes are essentially more lightproof than the coal-tar pigments. When precipitated upon a mineral color such as minium, green earth, etc., the coal-tar lakes may be made more permanent and of heavier body. Coal-tar colors as lake colors require a fair amount of oil. They char when heated, as do all organic pigments, and leave the substratum as ash. There is a confusingly great number of coal-tar colors, many thousands of them, which are manufactured for various purposes, but chiefly for the dyeing and printing trades, and they exhibit as a consequence various characteristics. In accordance with a proposal by Professor Marr [6] at a meeting at Hanover in September, 1907, an agreement was reached between the manufacturers and the artists whereby the latter were to accept coal-tar colors only after they had been given a prolonged test over several years by both parties. A very excellent coal-tar lake, alizarin madder lake, was chosen as the norm to which other newly introduced coal-tar lakes should conform in respect to stability in light. Alizarin madder is not unconditionally, but only relatively, lightproof. Unfortunately this agreement was broken by one manufacturer, and the others soon followed to meet competition. Enthusiastic claims and extravagant advertising ensued, to be followed by a return to a more sober consideration of the facts.

Many colors did not prove to be oilproof, and it was shown that especially the lemon-yellow colors, which were supposed to be a much-needed lightproof substitute for the changeable light chrome yellows, as well as for cadmium lemon, zinc yellow, etc., were in no way better than these; on the contrary, they turned even greener! I placed on a board samples of these much-praised coal-tar colors, and alongside of them such of our older colors as cadmium yellow, lemon to orange, barium yellow, gold ocher, and various greens and blues, and showed them to my

[6] Karl Ritter von Marr, one-time president of the Royal Bavarian Academy, was born in Milwaukee in 1858. [Translator's note.]

class. Not once were the coal-tar colors designated as stronger or more beautiful.

But today there are fast light-yellow coal-tar colors, such as hansa yellow 10 G. and 5 G., which surpass alizarin madder in permanency. The problem is to select the right colors from the enormous number of those available. For fashionable colors and poster painting absolute permanency is not required. But an artist cannot be satisfied with this. A choice of the right pigments is made difficult by the fact that the manufacturers of artists' colors rarely use the same designation as the producer of the pigment. Often the most arbitrary, fantastic names and mixtures are invented, which are impossible to check and therefore are better avoided. Special color lists for oil, tempera, water color, and fresco should be established, because the behavior of pigments varies with different vehicles. I have listed the really useful colors as far as possible with the different techniques. But caution is still in order as long as the opinions of fresco technicians are so much at variance that Dr. Eibner recommends more than 30 coal-tar colors for outdoor fresco while Dr. H. Wagner of Stuttgart insists that there is not a single one which is trustworthy. If this is so, then I think we had better practice "hands off." For indoor fresco we have at least today helio fast pink R.L. as a lime-proof rose madder substitute, indanthrene blue G.G.S.L. for Prussian blue, and helio fast red for vermilion. Without doubt we shall receive still more valuable additions to our palette. Indanthrene yellow with an addition of cadmium is at present the best substitute for Indian yellow.

Helio fast red R.L., permanent red R., and lithol fast scarlet G. are, according to Dr. Wagner, sufficiently lightproof for artists' colors.

Aside from the uncertainty of their reaction in light, oil, water, and with lime, one very weighty factor must not be overlooked, namely, that these colors as lake colors and glaze colors have as little body as madder lake, which puts limitations on their use in pictures. In addition the fact must be taken into consideration that the coal-tar colors have not so far been thoroughly tested to determine all their characteristics beyond a doubt. There are lightproof colors among them which stand up well by themselves

but, when mixed with other colors, go to pieces in a short time. Some hold up well as water colors, like thioindigo, an artificial indigo, but last only a few hours in oil. The methods for testing coal-tar colors offer to the layman almost insurmountable difficulties. In the past, when there were only aniline colors, one could ascertain if the pigment was aniline by placing a sample with alcohol on a piece of blotting paper; if the color struck through, it was aniline. Many coal-tar colors are today recognizable in this way. There are, however, a great number of alcohol-proof coal-tar colors which must be tested in an analogous manner with respect to water, oil, or lime. Along with this, the same colors must still be tested for proof against light. This is best done by exposing very thin coats of water color to sunlight.

It is advisable to cover metal tubes on the inside with a protective lacquer if they are to be filled with coal-tar colors. Furthermore, we should demand that only unobjectionable and thoroughly tested coal-tar pigments be sold as artists' material, and, what is more, under their correct names. Moreover, they should all be marked with the letter C[7] (coal tar). Recent attempts to give to coal-tar colors the names of some of our best and most reliable older pigments, such as oxide of chromium, cobalt blue, and cadmium, are, to say the least, inadmissible. One really cannot protest against this too strongly, because it would lead straight to chaos. The word "substitute" is a good word, and it cannot be mistaken.

IX. LIST OF COLORS

To Adolf Wilhelm Keim and the *Deutsche Gesellschaft zur Förderung rationeller Malverfahren* founded by him at Munich we are indebted for our basic ideas in the field of color. A normal color list was already set up in 1886, and a very necessary control of trade materials effected; unfortunately, however, this was later abandoned.

It was discovered, when this list of normal colors was made, that there really are no colors which are completely alike in their characteristics. For instance, certain disadvantages in white lead

[7] "T" in the German text (= *Teerfarbstoffe*). [Translator's note.]

must be taken into the bargain because we cannot get along without this color.

All colors should be pure and free from adulterations, and their names should not be used for other pigments and their substitutes.

The original list comprised the following colors:

1. Cremnitz white.
2. Zinc white.
3. Cadmium, light, dark, orange.
4. Indian yellow.
5. Naples yellow, light, dark.
6. Yellow and brown, natural and burnt ochers, sienna.
7. Red ocher.
8. Iron oxide colors.
9. Graphite.
10. Madder lake.
11. Vermilion.
12. Umber.
13. Cobalt blue.
14. Ultramarine blue.
15. Paris blue.
16. Oxide of chromium, opaque and transparent.
17. Green earth.
18. Ivory black.
19. Vine black.

Today we should add to this list cadmium red, and perhaps also lithopone, titanium white, and manganese violet.

The pigment problem is today much more difficult than in the days of Keim. Increased and changed methods of production and different basic materials constantly effect in accepted pigments unexpected and new symptoms. It would be desirable, in order to meet the requirements of each color, to examine scientifically their methods of production and to list them accordingly. This would be the first step in anticipation of a legal control of the color problem.

The economic unions of German artists have for many years taken an active interest in artists' materials, and their activities

have resulted in advantages to all artists, even to those who are not members. It has been insisted that manufacturers honestly state the contents of tubes, omit arbitrary color designations, and furnish an exact statement of the percentage of "cutting" materials in sketching colors.

CHAPTER III

BINDING MEDIA OF OIL PAINTING

The binding media of oil painting are fluid substances, which in time solidify and thus serve to bind the pigments permanently to the ground. They should dry into a transparent film and not lose in the process much of their volume or change greatly in color, and should remain elastic. Unfortunately all our painting media fulfill these requirements only in part.

We are here concerned with fatty and essential oils, the latter as diluents or solvents, and with resins, balsams, and wax, which are all used in oil and also in tempera painting.

I. THE FATTY OILS

The fatty oils used in painting are of vegetable origin. Such an oil, however transparent, is not the homogeneous substance it appears to be to the layman, but is a mixture of liquid and solid, drying and non-drying constituents. A difference in fluidity marks the only dividing line between the oils and the fats, such as coconut butter and the like. These different components are present in varying amounts in different oils. According to its content of drying or non-drying ingredients and various fatty acids, an oil drys quickly, slowly, or not at all.

With the non-drying and partially drying oils the painter is concerned only in their undesirable aspect as "cutting material" in the drying oils. Non-drying oils are peanut oil and olive oil; semi-drying oils are soy-bean oil, rape-seed oil, cottonseed oil, and sesame oil. Closely related are the fish oils and animal fats.

The demand of artists for oil colors which will remain wet a long time for the purposes of alla prima painting has led to many attempts at mixing a certain percentage of non-drying or slow-drying oils with fast-drying oils; but the results have been merely prolonged stickiness and eventual darkening. Perhaps some day science will find a way. For, as a matter of fact, our reliable

painting oils are naturally also mixtures of drying and non-drying constituents.

Linseed oil, poppy oil, and walnut oil are the best of the drying oils. Upon the fact that some fatty oils have drying properties rests the possibility of oil painting. On paper the fatty oils leave a lasting grease stain.

The drying of fatty oils is the result of absorption of oxygen from the air.[1] For this reason the house painter opens the windows, in order that the air may operate on the paint. In this process all oils, especially linseed oil, greatly increase in weight, up to 15%. At first the absorption of oxygen is small, and the oil is easily worked. Then the oil thickens, and the color becomes "tacky." Since the drying proceeds from the outside, the top layers of oil, which naturally come first into contact with the oxygen in the air, form a skin which slows down the drying of the underlayers. The surface skin becomes uneven, probably owing to the increase in volume of the oil; in fact, it forms wrinkles, in some cases more, in others less. The forming of wrinkles in coats of oil paint is essentially the result of too much oil, especially linseed oil, for the amount of pigment. It creates unpleasant effects, but is otherwise not dangerous. Many transparent oil colors of the trade wrinkle on the palette into nothing but a skin owing to an excess of oil and lack of pigment. The oil finally dries into a transparent and, because of its content of non-drying constituents, at first very elastic skin, the "linoxyn" skin, which is proof against outside influences. Air in motion, warmth, and light hasten the drying; quiet air, coolness, and darkness retard it. It is a fact known to every practicing artist that pigments can variously influence the time required for oil to dry. Umber, for example, greatly accelerates it, vermilion retards it. After a complete and thorough drying of the oil no further reactions can be detected for a time, and then there takes place a gradual loss of oxygen, hydrogen, etc., which causes a decrease in the volume of the oil. In the open and under unfavorable conditions the oil coat may go to pieces owing to the effects of the temperature. The "linoxyn" skin which was so elastic in the beginning becomes brittle

[1] Dr. Eibner has recently demonstrated that water also, obviously in the smallest amounts, is a necessary factor in the drying of fatty oils.

and full of cracks, and can be rubbed off like a powder resembling flour. Indoors this same process takes place, but of course very much more slowly.

A result of age upon oil paintings is that they turn brown—develop the so-called "gallery tone," which cannot be prevented. The picture is slowly obscured by the progressive oxidation of the oils, which may lead to a further decomposition of the layers of paint. In protected rooms and with expert care this deterioration can be delayed for a long time, and, by suitable methods, it can even be prevented. The excessive addition of siccatives to oil will have the opposite effect.

The yellowing of the fatty oils. The fatty oils turn yellow, more or less, and may have a very unfavorable effect on the appearance of a picture, especially one painted in cool tones. If a small amount of oil comes to the surface, the yellowing is considerably increased. This is most noticeable in paint areas put on with a palette knife, which are therefore very smooth, and is most annoying after the impasto reaches a certain heaviness. I own a mountain landscape on which snow patches, according to their lightness, were painted in thicker or thinner color (alla prima). The more thinly painted remained white, but those painted in a heavy impasto, because of an excess of oil, became, on the contrary, very yellow.

Darkness and dampness increase this yellowing. The placing of the picture in the light is a preventive which has been recommended for hundreds of years. The yellowing, however, begins the moment the oil starts to dry on the surface. In contrast with the later darkening after drying, it does not take place throughout the whole body of the paint but only on the surface. Many colors, such as white lead and titanium white, accelerate the yellowing. The cause of the yellowing is not yet certain. It is believed today, after many unsuccessful attempts have been made to remedy the yellowing of the oils, that the substance which causes the yellowing keeps forming anew in the oil.

The bad effect of the yellowing on the cool color tones, especially blue, was well known to the old masters. De Mayerne mentions the fact that Van Dyck in his oil paintings used a tempera blue for the draperies, etc., in order to avoid yellowing. Hydro-

gen peroxide applied with white blotting paper over yellowed spots tends to have a temporary neutralizing effect, especially at warmer temperatures.

The oils, like all natural products, are very uneven in their composition. Thus linseed oil and linseed oil, unfortunately, are not always the same thing. Every color manufacturer can sing a song about this. One oil can take up more, another less, pigment. Color, fluidity, and drying power vary. Impurities caused by seeds of weeds, insufficient care in pressing, storing in barrels in which non-drying oils were previously kept, and, not least of all, adulterants, are all harmful to the quality of oil. Already in the 13th century Theophilus Presbyter, the monk of Paderborn, complained that his linseed oil would not dry. No wonder, since he had used a press previously used to make olive oil!

The fluidity of the oil varies with the temperature. With warmth the oil, and with it the color, becomes more fluid; with cold it becomes viscid, and the color can no longer be worked. The painter not infrequently blames his materials if, when used under different temperatures, they behave differently. The attempts made with different media to equalize the conditions caused by differences in temperature have not as yet met with general success. Often the painter of winter scenes uses oil of turpentine instead of fatty oils, which, as media, quickly solidify when exposed to cold.

Oil is not so impermeable to water as many believe. Tests have shown that water will filter through a fresh coat of oil color. The fatty organic oils may become saponified; as fatty acids, they combine with lyes to form soap.

The oils are subject to many adulterations. For the painter it is unfortunate that these adulterations are often hard to detect. Even an expert has difficulties here, and it is impossible to eliminate them. The odor and appearance of the oil and a test of its drying power are the factors which help the artist to make a choice. Fish oil and non-drying animal fats may be detected by their odor. The presence of resinous oils gives the oil a violet cast. Mineral oils and resin oils appear a deep blue if laid over a black ground.

The fatty oils serve as a vehicle in the preparation of colors.

Old oils are thready and viscous, as is often noticeable in old tube colors. This fault is only temporarily remedied by the addition of oil of turpentine, because this evaporates quickly, and the color then becomes increasingly sticky. For grinding colors one should use only fresh oil which flows freely. The fatty oils also serve as painting media, in the preparation of tempera emulsions, and as an addition to the priming coats. Oils must be used sparingly in the picture, never in overabundance, since they are, as a matter of fact, a necessary evil. De Mayerne writes, "It is the oil that kills the colors."

LINSEED OIL is obtained from the seeds of the flax plant, the same plant which furnishes us with the fiber for making our linen canvases. The ripeness and purity of the seeds are the factors which determine the quality of the product. One may have either good flax fiber, which must not be fully ripe, or ripe seeds, but not both together. The oil varies according to the type of soil on which the plant is grown and the fertilizer used. Some years have produced better oil than others.

Baltic linseed from the Baltic Sea provinces ranks as the best; next, and of nearly the same quality, come the Dutch and the South American La Plata seed. The Indian Bombay seed is considered of poor quality. Until a few decades ago there could be found all over Germany oil mills which produced a good, cheap linseed oil. In the meantime, however, linseed oil had become a trade product of the entire world, and, for artistic purposes, the oils became of poorer quality, since the trade gave no heed to the needs of the artist because of his minor requirements. For these reasons a few of the color manufacturers decided to manufacture their own oils, even though this involved considerable expense. It is to be hoped that this practice will be continued, for it offers the painter the assurance that he may obtain absolutely unobjectionable materials.

Cold-pressed linseed oil is the best for artists' purposes. This oil is the result of the first pressing only. It is golden yellow and clear, contains the least solid matter, and does not become viscid so quickly when subjected to cold. Unripe seeds yield an oil containing milky and watery substances—an emulsion which is unsuitable for artists' purposes. Linseed oil for grinding pigments is

best kept in a full bottle in a dark room. Fresh-pressed linseed oil is odorless and very fluid. It is not until later that the oil develops its characteristic, but not unpleasant, linseed-oil odor. Linseed oil is rarely cold-pressed, because this method yields the smallest quantity of oil. I once received a sample of cold-pressed oil which had been pressed by an artist friend, and which showed how much superior such material can be to the trade product in respect to fluidity, brightness, and purity.

Hot-pressed linseed oil yields a greater quantity, but the oil is darker and contains more solid substances, such as mucilage, etc. It is cloudier than cold-pressed oil, quickly becomes thick when cold, has a pungent odor, does not dry through so well, and has not the thin fluidity of the cold-pressed oils.

Extracted oils are drawn from the seeds by various solvents, such as carbon bisulphide, etc. They are likewise dark-colored, less fluid, and contain much solid matter. This method gives the greatest yield, but is unsuitable for artistic purposes, since the extracting agent can never be removed entirely from the oil and has a bad effect on the colors and binding medium. There are "extracted" linseed oils which are chemically pure, but, as they will not dry, they are worthless for our purposes. I received samples of guaranteed "cold-pressed linseed oil" which, when used with white lead(!), would not dry even after months. According to Dr. Eibner, the abnormal action of the oil was attributed, in a similar case, to moldy seeds.

Bleaching the oil. In order to remove their yellow color, the painting oils are often bleached. For this purpose colorless, well-covered flasks are filled with the oils and set in the sun. In a few weeks the oils become bright and clear. If the containers are only half filled, the action takes place more quickly, but the oil becomes thicker because of the absorption of oxygen. Some oils remain dark under this treatment. The March sun seems to have the strongest bleaching power.[2] Oil in partly-filled or open flasks thickens because of absorption of oxygen from the air. Unfortunately, bleaching the oil is of little value to the artist, in fact it has more disadvantages than advantages. The oils appear beau-

[2] There are during March probably more sunny days in Munich. [Translator's note.]

tiful only in the flasks and deceive the buyer, for, as we know from experience derived from many experiments, the bleached oil, often as clear as water—which must naturally appear highly desirable if the oil is to be used for grinding colors—returns in a very short time to its former yellow condition. If unbleached oil is used, the inevitable yellow tone is taken into account from the outset. The changes in a picture are then naturally much less than when bleached oil is used. Pictures will sometimes even turn lighter when unbleached oil has been used.

Heating the oil at a certain temperature until it looks white, cooking it with fuller's earth, or heating it over bone charcoal containing no fat will also effect a whitening of yellow oil. The product appears to be as clear as crystal, but it changes back to its former yellow condition. Even zinc-white linseed oil became unusually yellow, although the oil was purified with fuller's earth and was crystal clear in color.

Today there are chemical bleaching processes which yield products unsuitable for artists' purposes because the drying power of the oil has been considerably weakened.

Purification. Of more value to the painter than bleaching is the purification of the oil. Mucilages and other watery and solid constituents are often contained in the oils which have a weakening effect on drying power and probably tend to encourage yellowing, especially in the case of hot-pressed oils. They also make the oil sticky. By simply being allowed to stand for a long time in well-covered flasks, the oil will to some extent purify itself. The impurities settle to the bottom. A more thorough and quicker purification, however, can be effected by mechanical means. The addition of a piece of quicklime, which is very hygroscopic, will serve to remove the water from the oil.

The best purification is accomplished with barite. Artificial barite (baryta white) is warmed somewhat to free it from water, and the powder is then mixed with the oil. After repeated shakings the impurities and solid elements in the oil will settle on the bottom of the container. The clear oil above may then be poured off. Barite has absolutely no chemical effect on the oil; it is an almost entirely inactive substance. Freshly prepared barite is the best. Often an emulsion is formed (indicated by cloudiness), or

a lack of fluidity of the oil holds particles of barite in suspension; they are, however, harmless. An addition of benzine, or of oil of turpentine, causes the barite to settle. Slight heating may likewise cause the suspended particles of barite to settle to the bottom, because the oil becomes more fluid. Clean, dry sand, powdered glass, chalk, and similar substances may be used in the same way. Dürer filtered oil through pulverized wood charcoal into a cup of linden wood.

Well known, also, is the old method recommended by Professor Hauser of purifying oil with snow. A vessel is filled with fresh, dry, powdery snow; the oil is poured in, and the two thoroughly mixed. This is allowed to freeze for perhaps eight days and then slowly to thaw by bringing it indoors into an unheated room. One will be astonished at the amount of dirty yellow silt and solid particles which have been separated from the oil by freezing—also from the snow of the city, if this was not perfectly clean. This method has the disadvantage that it cannot be performed at any time, that some of the water may remain in the oil, and that the oil may be contaminated by acids contained in impure city snow.

It is always a good practice to allow purified oil to stand for some time. Linseed oil stored for one or two years is considered the best. Shaking with water naturally has the same disadvantage as purification by means of snow, namely, that water will remain in the oil. Young oils in particular take up in this way much water that is not easily eliminated and that forms an emulsion with the oil. Purification of oil with alcohol, etc., is not recommended, since it also produces an emulsion. The same may be said of an addition of salt. No foreign substance should remain behind in the oil. Chemically purified oils cannot be used for the same reasons. Oils become more fluid when purified and will, when used for grinding, take up more pigment.

The keeping of oil. Linseed oil, like all painting oils, must be stored in tightly closed flasks, which should be filled as full as possible. The old masters had the excellent idea of dropping glass balls into the flasks to take the place of the oil used. If the flasks are allowed to stand open, or if much air stands over the oil in the flasks, the oil becomes thick and dries more quickly. Such

oil is not suitable for grinding colors, because it cannot take up so much pigment as thin oil and becomes viscid. The oil must be stored in a cool place.

Freeing oils from acids. Free fatty acids may form in the oil—the oil may become rancid. This happens with poorly drying oils, especially when they have been exposed to the air for a considerable time. Powdered, slightly warmed bicarbonate of soda free from water, about 5% of the weight of the oil, will free the rancid oil from acid. Rancid oils may cause the colors to harden quickly in the tubes. Chalk as a purifier, likewise powdered quicklime, or letting the oil stand over white lead, with which it has been shaken in flasks, will also sweeten the oil. Fresh oils often will form emulsions, as the deacidifying agents combine to form a milky fluid with the oil. Especially does fresh nut oil act in this fashion.

The emulsion cannot always be broken up by the addition of benzine. For this reason the sweetening medium must be as free from water as possible. For tempera purposes cloudy oil may always be used, but for grinding oil colors only when it is sufficiently thin, which is seldom the case.

Properties and use of linseed oil. Linseed oil is used chiefly for grinding oil colors and, further, as a painting medium and in tempera emulsions. It normally dries thoroughly in from three to four days in a thin layer. But that is for us, as with all painting media, merely of theoretical value. The ground and the pigment influence the drying of the oil—they either hasten or retard it. In a thick coat it forms a skin. Pure linseed-oil colors should therefore be put on only in thin layers, and new coats should not be applied until the preceding ones have thoroughly dried.

Linseed oil, in accordance with its nature, gives to the painted surface an even, smooth character. Also in opaque painting a smoother effect is obtained on the whole with linseed oil than with, perhaps, poppy oil. An addition of about 2% wax gives to colors an opaque quality; a larger percentage, however, only makes the color smeary. For the smooth manner of painting of the old masters, which, because of the way their pictures were built in layers, depended on the thorough drying of the under-

layers, linseed oil was the best material; and for this reason we often find it mentioned as the best of all the oils.

In order to make oil thick and varnish-like for certain purposes, it is treated in special ways.

Sun-thickened oil. The oil is poured into a flat container, for example, a plate, in a thin layer, perhaps ½ cm. deep, and exposed to the sun. It may be covered with a piece of glass supported by small corks, so that the air will have access to it, but as much dust as possible be kept out. The oil thickens quickly in a few days, depending on the heat of the sun and the access of the air. The oil must be stirred occasionally, in order to keep it from forming a skin. When the oil has acquired the consistency of honey, it is put into flasks. This thickened oil dries with a certain gloss, is varnish-like, and has been used for centuries as an excellent painting medium as such or as an addition to painting media, by Rubens among others. It gives the colors an enamel-like character and permits, despite its viscidity, a great amount of technical freedom. Since it has already absorbed oxygen, it dries more quickly than ordinary linseed oil. The old masters still further accelerated the drying by setting the oil out in the sun in leaden vessels.

According to my experience, sun-thickened oil is to be preferred to boiled oils, as also to the resin-oil varnishes, such as copal, amber, and mastic dissolved in hot oil. When used as small additions to painting media, it has a good drying effect, like siccative. It does not crack and is very elastic. The old masters knew well the great advantages of this oil, especially that it had lost all objectionable qualities before being introduced into the picture. Cennini calls it the best of all oils. "I could not give you anything better," he says.

Boiled oils. As a result of its thorough drying, linseed oil is the best of all the oils for the production of boiled oils and oil varnishes.

Linseed-oil varnish is boiled linseed oil that has been heated for several hours at about 200° C., with the addition of a drying medium, such as lead or manganese. The long heating makes the oil thicker and dryer. Linseed-oil varnish must dry, without being sticky, in from 6 to 24 hours. The dried coat must not splinter

when scratched with a knife, but form shavings. (Adulteration with colophony is not uncommon; such varnish is splintery, as is likewise overheated varnish.) Linseed-oil varnish better withstands atmospheric conditions than the raw oil, but for artistic purposes it is of little use, since it dries with a sleek, greasy sheen and easily forms a skin. This applies especially to the trade product. Homemade, carefully boiled varnishes are brighter and better adapted to painting techniques, but the boiling of the oil, owing to the danger of fire and the sharp acrolein vapors, is not recommended to the inexperienced. It would be very desirable if some manufacturer of artists' colors would take an interest in the preparation of good linseed-oil varnish and stand oils.

Linseed-oil varnish is an excellent material for the preparation of grounds, but it is absolutely unsuitable for the varnishing of a picture. In a short time it becomes cloudy and yellow and can be removed from the picture only at the risk of damage. Here and there it serves well for grinding poorly drying colors, such as the lakes. Sun-thickened oil is to be preferred. Old linseed-oil varnish loses its quality. "Double varnish" is repeatedly boiled linseed-oil varnish.

Young oils are unsuitable for the preparation of varnish. When boiled, they form white patches of mucilage and albumin, which lessen the transparency of the oils.

Boiled oils, with and without a drying medium, for a time played an important part in the technique of the old masters, much more so than they do today. They were not always carefully and adequately prepared, as is evidenced particularly by the Byzantine recipes. Sulphate of zinc, litharge, red lead, verdigris, and other materials were used by the old masters in the preparation of drying oils.

There are offered today linseed-oil varnishes made by the "cold" process, the so-called linoleate varnishes, which are heated for a short time to 100° C. with lead or manganese. They may be used in place of the linseed-oil varnishes, not, however, the resinate varnishes, which are compounds of colophony which often coagulate the lead colors, and also zinc white in grounds, if they are not sufficiently neutralized. Linseed-oil varnishes are often adulterated with these. If mineral oils are added to linseed oil

varnish, oil particles will rub off, although the painted surface apparently has dried.

Stand oil is oil boiled with carbonic acid without the addition of a drying medium. As a result of this special process, these oils dry more slowly than raw linseed oil, because they have absorbed no oxygen. Stand oil is highly weather-resistant, and therefore is used by the trade for weatherproof painting. According to the degree of boiling, these stand oils are more or less fluid, brighter or darker. Stand oil of the trade has a greenish, iridescent (fluorescent) appearance, probably brought about by the action of decomposition products when the oil is being boiled. Stand oils dry with a high gloss; they give to colors a high luster and permit of soft, fluid handling. Resin ethereal varnishes, and especially Venice turpentine, increase the enamel-like effect of these oils. Stand oils are also known in the trade as English oil varnishes. For artists' purposes stand oil can be used only as an addition to media or when very much thinned, because otherwise it would be too fat. Half-oil is half stand oil and half oil of turpentine. Poppy oil and nut oil can be treated the same as stand oil; they are then very similar to boiled linseed oil.

Ozonized oils are oils prepared by boiling and without a drying medium which have been made rapid-drying by the blowing of oxygen through them. They are very viscous, and are in the last stages of thickening and drying. They are preferred as painting media for enamel-like effects (thinned with oil of turpentine) which are intended to dry quickly and firmly. But such oils have as yet scarcely appeared in the trade; they are manufactured for the preparation of linoleum. Oils which have been thickened in the sun can be used in their place and are more reliable for artistic purposes.

Siccatives, drying oils, are salts soluble in oil made from manganese, cobalt, and metal oxides. They are diluted for use with oil of turpentine. The absorption of oxygen by the fatty oils is accelerated by these oxides. They can dry the oils in a few hours, but they are dangerous to the permanency of the picture unless used very sparingly. Too much siccative causes deep, wide cracks, discolored spots, and cloudiness of the color. Only a few drops, about 2% of the painting medium, are sufficient to effect

the drying; more is an evil and causes the colors to jelly. The result of too much siccative is always a disagreeable sticky effect, and the surface turns brown, like leather. Siccative should preferably be used only for underpainting. When used in top layers which have not dried thoroughly, it is dangerous and causes cracks. No siccative should be used with colors which dry well by themselves, such as white lead, Naples yellow, etc. Light, cool tones, such as blue, for example, suffer especially from the effects of siccative.

Lead siccatives are supposed to be more injurious than manganese siccatives, of which the newer sorts prepared from manganese resinate are said to be better than the old manganese siccatives which were made of limonite (brown clay iron ore). In actual practice they are all equally dangerous.

Siccatif de Courtrai is a siccative oversaturated with lead and manganese, which has already ruined many pictures. Similar to it and no less dangerous is Japan gold size.

Siccatif de Haarlem, consisting of thickened oil and dammar varnish, is, on the contrary, when pure, unharmful. Dr. Fiedler's cobalt siccative has proved satisfactory, the basic drying agent of which is the oxide of the metal cobalt. It is very light, but must also be used sparingly.

In place of siccatives it is much more practical to use mastic or dammar varnish. In blocking in a portrait an addition of powdered white lead to the tube colors will cause the underpainting to dry well and quickly. This is incomparably preferable to a paint skin saturated with painting medium.

Lead acetate in linseed oil was recommended as a drying medium by Professor Hauser. It is, however, not without objections, although the danger from the sugar of lead has been greatly exaggerated. It clouds the colors and leads to rapid decomposition because of its solubility in water.

Malbutter,[3] *medium*, *megilp*, and the like are salve-like mixtures of drying oils, wax, etc., and often contain sugar of lead. They are said to give the colors a buttery character, but must be used just as sparingly as the siccatives.

[3] A German trade name meaning literally "paint butter." [Translator's note.]

NUT OIL is pressed from the seeds of ripe walnuts. One speaks here, as in the case of linseed oil, of the first press and later presses. If the nuts are pressed too soon before Christmas, an emulsion results which is not useful to an artist. Leonardo recommended boiling the nut kernels, after they had been soaked and cleaned, until the oil separated. Nut oil is lighter in color than linseed oil; it is greenish at first, but later turns yellowish. Fresh nut oil kept in a bottle is very thin and well adapted for taking up a great deal of pigment. Because of its fluidity it permits of a very free technique. Moreover, it does not turn so yellow as linseed oil. It ranks between it and poppy oil in respect to technical advantages. It dries much more thoroughly than poppy oil, and should be used only in painting which is not too opaque. For grounds raw and boiled linseed oil are decidedly preferable, although nut oil for grounds is already mentioned by Vasari. In the treatises on painting by Leonardo, Vasari, Borghini,[4] Lomazzo,[4] Armenini,[4] Bisagno,[4] Volpato, etc., as late as De Mayerne and even later, nut oil is highly recommended for all light pigments. Armenini recommends it for all colors, and he will have linseed oil only when he cannot have nut oil. Doubtless the use of nut oil was far more widespread among the old masters than we have any idea of today.

The reason why today it has fallen into disuse is that it easily becomes rancid, and that manufactured tube colors ground in it are difficult to keep in storage for any length of time. For private use it should still be very useful. Heraclius and Theophilus already mentioned it, and Dürer was fond of using it. Van Eyck also knew it. Van Dyck, because of its liquid nature, employed it for grinding white. Leonardo recommended nut oil thickened by exposure to the sun. Nut oil prepared like stand oil would be a useful addition to painting media, particularly where an enamel-like effect is desired.

(*Hazelnut oil* is a non-drying oil.)

POPPY OIL is pressed from the seeds of the white poppy. The ripeness and purity of the seeds are here also the deciding factors for the quality of the oil. Cold-pressed poppy oil is almost

[4] Italian artists more noted as theorists than as painters. [Translator's note.]

colorless, hot-pressed (second pressing) is reddish in color. By bleaching one obtains a nearly water-clear poppy oil. The bleaching, however, as in the case of linseed oil, does not last. One should therefore use natural poppy oil. The trade product is often adulterated with non-drying oils and then remains sticky. Poppy oil has been known for a long time, but it was not until the 17th century that it came, in Holland, into general use for painting.

In present-day painting and the manufacture of tube colors it is practically indispensable. To be sure, Professor Eibner would have it barred from artistic painting because of its numerous disadvantages, and above all because of the poor drying qualities of poppy-oil color as compared with linseed-oil color. But all this depends on the way it is used. In practice artists have known for a long time how to make use of the undeniably great advantages of this oil and how at the same time to avoid or minimize its disadvantages. Poppy oil seldom yellows as much as linseed oil and is in itself much lighter in color. But to say that it never yellows would be incorrect. I possess samples of originally almost colorless poppy oil which turned just as yellow as any linseed oil. As with linseed oil, this varies with different sorts. Poppy oil forms a skin, but much less so than linseed oil. This and the advantage of the "buttery" application which poppy-oil colors permit make these the ideal colors for the alla prima painter. Opaque or semi-transparent painting, or a scumbling technique, may be practiced without danger when using poppy-oil colors; in fact, one may paint wet in wet 6 and 8 days at a stretch if one works without a painting medium or uses it very sparingly. Everything depends on having the proper proportions of pigment (which is always of prime importance in a color) and binding medium. I have painted pictures in this way in ten, even twenty, layers, but wet in wet, when perhaps they were beginning to get tacky but never when dry, and they have stood up perfectly. In the same way one may paint a picture piecemeal, completing a part of it at a time. When painting in layers, under- and overpainting in accordance with the technique used by the old masters, after the single coats have dried, linseed-oil color is much more reliable than poppy-oil color. If not thor-

oughly dried and too quickly painted over, poppy-oil color may crack; and, as a matter of fact, many recently painted pictures have suffered damages by such improper use of poppy oil. Poppy oil would take much too long to become firm enough to permit of a durable overpainting; it is also subject to the danger of softening when the top layers contain essential oils. It has also been observed that poppy-oil color which had already become dry turned soft again in the dark and remained sticky. The reason for this is probably some adulteration with non-drying oils or too much oil for the amount of pigment. I would recommend pure poppy-oil color only for alla prima painting.

Glazing and underpainting involving the use of much poppy oil and little pigment will inevitably bring disaster.

Light colors, particularly Cremnitz white, are today for the most part ground in poppy oil, because this oil is lighter than linseed oil, permits, furthermore, of a buttery manner of painting, and dries more slowly than linseed oil. This "buttery" painting permits of the fullest development of the charm of opaque painting, particularly in more recent pictures, as against the comparative smoothness of linseed oil. Poppy-oil zinc white is a very slow-drying white and therefore much desired, but, if not used alla prima, possesses all the dangers of poppy oil to an increased degree. Dark colors are often ground in a varying mixture of linseed and poppy oils in order to correct the difference in the drying periods of different pigments. For grinding pigments poppy oil should be very liquid. It should have been kept in a full bottle. Old oil jellies in the tubes. 2% clean white beeswax, dissolved in the proportion of 1:3 in oil of turpentine, is added, because some pigments, especially when old oil is used, harden too quickly. If the artist is able to grind his own color, so much the better. It should be made compulsory to indicate on tube colors, but particularly in the case of whites, whether they contain linseed or poppy oil, so that the painter may use them accordingly.

Poppy oil wrinkles less than linseed oil, but more frequently turns rancid. 5% pulverized, water-free bicarbonate of soda eliminates this disadvantage, sweetens the oil, and renders it again usable. Old poppy oil, particularly in open flasks or flasks not

properly closed, becomes sticky and draws threads during the grinding. Poppy-oil varnish boiled, poppy oil with the addition of a dryer, and sun-thickened poppy oil are stickier and not so good as linseed-oil preparations. Poppy oil is likewise recommended for tempera painting.

I know of undoubtedly old poppy-oil pictures which, without yellowing or cracking, have remained perfectly preserved. This is also the case with the portraits in the "Gallery of Beauties" by the court painter Stieler in the New Pinakothek at Munich, which are painted with poppy oil and which have held up surprisingly well. It all depends on its being properly used.

A further objection from scientific quarters against the use of poppy oil has to do with the alleged difficulties, in fact, the impossibility, of restoring such pictures. We cannot be expected to be much concerned about this. We must do what artistic necessity demands, and we certainly cannot be expected to paint pictures in order to furnish material for the picture restorer of the future. Aside from this, there really are no pictures which are easier to regenerate than poppy-oil pictures, and still easier are poppy-oil resin-varnish pictures (see page 134). The regeneration of pictures has been particularly developed in order to eliminate as far as possible the services of the restorer. The best protection for pictures is a more widely spread understanding among restorers of the materials of the painter.

According to Dr. Eibner, poppy oil evaporates considerably when placed in the sun. Pictures painted with poppy oil could in this event develop cracks.

Poppy oil should absolutely never be used for grounds. The slow drying of the oil, especially with zinc white or lithopone, causes cracks in painting when still wet. One could perhaps—theoretically—paint over such grounds after a year, but how could one be sure that the grounds in the trade were that old? And then there still remains the danger of softening, owing to the presence of essential oils in the colors. Unfortunately these grounds are still to be found in the trade, because the manufacturer wishes to take advantage of the slight amount of yellowing of poppy oil.

The following oils are seldom used in painting:

Hemp oil, the first pressing of which is colorless and later pressings greenish. It dries more slowly than poppy oil (in about 8 days), but unfortunately wrinkles most of all the fatty oils and is, because of its greasy nature and its gloss, least useful for purposes of modern painting. Coats with Cremnitz white lasted very well, without yellowing. Hemp oil is used as additions to other oils, since it has some good qualities.

Sunflower oil, pressed from the seeds of the sunflower, is a slow-drying oil, light yellow in color, very fluid, and used in the preparation of oil varnish. In Russia it is said to be used for grinding colors.

Soy-bean oil is a very fluid, semi-drying oil, and is also used for the preparation of varnish. It is lately used in tube colors to meet the demands of the painter for more slowly drying colors. As a result of its use, the colors later become dark and sticky.

Cottonseed oil is a semi-drying oil, possessing similar properties to soy-bean oil, and, when used as an addition to linseed oil, makes the latter sticky and causes it to congeal more quickly when cold.

Chinese wood oil cannot be employed despite various favorable qualities, because it forms an untransparent film when it dries, and may also cause skin diseases. Furthermore, it yellows badly.

Spruce-, fir-, and pine-seed oils. Various tests have given such variable results that it is impossible to say whether these oils should be introduced. According to scientific authorities, these oils should neither wrinkle nor turn yellow; and, above all, they are said to have all the advantages and none of the disadvantages of linseed and poppy oil. In practice this has turned out quite otherwise. Many oils yellowed considerably in only 14 days, wrinkled, and separated from the colors. Some dried normally in a few days, others were still wet and could be wiped off after many months. It may well be for this reason that pine-seed oil is classed as non-drying in trade circles.

Candlenut oil is as heartily recommended by a few as it is condemned by others. When cold-pressed, it dries quickly and is viscous and light. Hot-pressed oil is brown.

Lallemantia oil from the Caucasus is used for making commercial oil varnish and yellows markedly.

Castor oil is the heaviest of all the fatty oils, almost colorless and very viscous. In very thin layers it dries in about 40 days; in thick layers it never dries. When genuine, it does not turn yellow, and it would be an excellent painting oil, but unfortunately it is too fat and viscous. Many attempts have been made to introduce castor oil into painting, especially in tempera emulsions. With such slow-drying oils one can naturally prepare emulsions which remain wet for a long time; but the watery parts of the emulsion evaporate quickly, and there remains a sort of oil color with all the drawbacks of its type and difficult to handle.

Its property of mixing in any proportion with alcohol makes it a valuable constituent of isolating media, especially spirit varnishes, the brittleness of which it removes. More than 5% should not be added, otherwise the coat is difficult to paint over and becomes smeary. In similar proportions it is used as an addition to mastic and dammar turpentine varnishes to prevent the very annoying "blue" appearance of these when used on old pictures and over dark areas. It should not be used in petroleum varnishes.

Non-drying oils, like almond and olive oil, peanut oil, palm oil, and the lards (non-drying oils of animal origin), concern us only as objectionable adulterations of oils used in painting. They may be the cause of injuries to the picture, and of later darkening, stickiness, and the accumulation of dust on the surface.

Among the non-drying oils belong the fish oils, which, in spite of everything that is being done to prevent it, occur here and there in artists' colors.

II. THE VOLATILE ESSENTIAL OILS

In contrast with the fatty oils, the essential oils leave no permanent grease stain on paper, but evaporate almost entirely. They are componds of hydrocarbons, alcohol, ester, etc., which have a sharp odor and volatilize under steam. They are soluble in fatty oils for the most part, but also in alcohol and ether. Essential oils of organic origin, such as oil of turpentine, absorb oxygen when evaporating, but the mineral oils, such as petroleum,

do not. The essential oils play an important rôle in painting as diluents for colors and as painting media, and, in addition, as solvents for balsams and resins. All essential oils should be kept in a dark and cool place in well-closed flasks, which should be as full as possible.

1. Volatile Plant Oils

OIL OF TURPENTINE (spirits of turpentine) is for the painter the most important and by far the best of all the essential oils. It is prepared from the balsam (pitch) of various pine trees through distillation by means of steam without pressure. The residuum is Burgundy pitch, and further fused colophony. Oil of turpentine was already known to the ancients. The trade distinguishes different varieties:

French oil of turpentine, from the maritime pine, is today the best for artistic purposes. When twice rectified, that is to say, vaporized and condensed in an enclosed cool glass container and completely freed from resin, it is the best for varnishes and media.

American oil of turpentine formerly dominated the market. Today its importance has declined, and as a trade product it is often cut with petroleum distillate. This may be easily detected by the odor. The pure product would be very useful.

Good oil of turpentine should make a rapidly evaporating spot on paper and should leave no residuum behind. When shaken in a bottle, the air bubbles which form should disappear quickly without iridescence. The odor of good oil of turpentine is pleasantly aromatic, not penetrating or like benzene,[5] as is the case when adulterated. Oil of turpentine must be kept in a cool place in tightly covered bottles; otherwise it will evaporate and

[5] Benzene, a colorless, liquid hydrocarbon corresponding to the formula C_6H_6, is obtained from coal tar. In the German literature this compound is called *Benzol*. Benzine, a colorless liquid obtained from petroleum, is a mixture of several hydrocarbons. It is often called petroleum ether. In the German literature this mixture is called *Benzin* or *Petroläther*. Benzene and benzine are both common solvents for fats, oils, and resins. Following the nomenclature adopted by the American Chemical Society, the names benzene and benzine are used throughout this book for these two solvents. [Translator's note.]

also becomes resinous, in which process the poorer sorts turn very brown. Resinous old turpentine has a drying effect like siccative, and frequently causes color to remain sticky for a long time. It is a poor solvent for resin and has a tendency to turn dark. Doubly rectified oil of turpentine also thickens in the open or in bottles not completely full, and becomes sticky and dries poorly. It can then no longer be used for varnishes, since these remain sticky for a long time and may later become soft again. To free it from water and acids, a small piece of quicklime is put into the flask. Oil of turpentine containing water can be the cause of the vexatious "bluing" of varnish. It is tested for water content by shaking one part with three parts of benzine. If water is present, the mixture will become cloudy and discolored. In 95% pure alcohol oil of turpentine should dissolve in the proportion of 1:3. When linseed oil, white lead, and oil of turpentine are mixed together as liquids, the oil of turpentine should completely separate within half an hour, otherwise it has been adulterated. Adulterations and cuts with petroleum or coal-tar products reveal their presence by the odor.

Turpentine substitutes. There are in the trade many substitutes for oil of turpentine, the so-called German, Russian, Swedish, Belgian, and Polish turpentines. These are prepared by dry distillation at higher temperatures from the pitch of pine tree roots. They have an unpleasant, piercing odor and are poor dryers. Attempts are often made to improve them by rectifying, but without lasting results. These inferior products turn brown-red in concentrated hydrochloric acid. Good oil of turpentine should at the most only turn yellow.

Rosin spirit, rosin essence, *Pinolen,* prepared from the less valuable sorts of resin and questionable resinous oils, do not dry hard but remain sticky, and are used frequently as cuts for oil of turpentine.

Patent turpentines are petroleum products intended for the trade and not for artistic purposes.

Other turpentine substitutes, *cleaning oils,* are petroleum or coal-tar products which have little value as painting media, but can be used for cleaning purposes.

Oil of turpentine finds employment in painting as a diluent for

colors and painting media, and also as a solvent for resins. It is not a binding agent, for it has no binding power and does not cause colors to adhere to a ground. If thinned too much with it, much of the binding medium of the colors will be absorbed by porous grounds. I have seen pictures painted with oil of turpentine from which the pigment had fallen off in small sheets as soon as the painting had dried. It gives to colors a thin, dull character, a quality which today is much sought after, but only too frequently attained at the expense of the later preservation of the picture. It also increases the annoying tendency of the colors to sink in. When used in considerable quantities, it dissolves the colors to such an extent that they lose their body. The cause of this, as in the case of ox gall in water colors, is its low surface tension, whereby a drop of it tends to spread out and disappear. When used in considerable quantities, the rapid evaporation of oil of turpentine may be the cause of cracks on non-porous grounds, especially when the painter allows the picture to dry in the sun. On poppy-oil grounds painting with oil of turpentine is especially dangerous because it softens the ground. Especially where a glazing underpainting is employed may such evils appear, which the artist is frequently at a loss to explain because he believes that he has proceeded in a very rational manner. If oil colors have turned viscous in the tube, an addition of oil of turpentine will not render them workable. It evaporates too quickly, and the colors become still more viscous. Oil of turpentine evaporates quickly and by the absorption of oxygen accelerates the drying effect of the oils. This property of oil of turpentine is too little taken into account by painters, who add it to painting media which are intended to dry slowly and thereby partly abrogate the intended effect. The solvent effect of oil of turpentine is known to every painter. He cleans his palettes with it and employs it as a spot remover. And yet he is not greatly concerned about its solvent properties in the picture! Over dry, or more frequently over slightly dry, coats, when used in considerable amounts as additions to the painting medium, especially when overpainting many times, it results in a dissolving of the lower layers and a coalescence which inevitably results in intense later darkening. The excessive use of the essen-

tial oils is with present-day methods of painting a tremendous danger, and the blackening of many modern as compared with the golden tones of older pictures is really due to the irrational and exaggerated use of essential oils and their solvent powers. Here also must be mentioned the "biting" of dried color coats with oil of turpentine, whereby they are dissolved on the surface and then harmonized. This no doubt gives the picture a momentary charm, but only at the cost of its later preservation. In the house painter's trade oil of turpentine is used as an addition to the priming coats, which should be allowed to dry well, while the top coats are prepared with pure oil colors according to the correctly used old painters' rule: fat over lean. One should proceed similarly in the arts. This is accomplished by allowing the underpainting made with oil of turpentine to dry well and then painting over it with a little oil, or resin varnish and oil; also in pure alla prima painting, when one should paint thinly or in a half-covering manner during the first day or so. Very valuable, on the other hand, is the solvent power of oil of turpentine in the preparation of resin varnishes (mastic, dammar).

Oil of turpentine remains fluid at low temperatures, at which the fatty oils would become thick, and is therefore useful to outdoor painters of winter subjects. It has a bleaching effect, which, however, is of little consequence in the picture. Along with its use in oil painting it is also used as a thinner in oil tempera. Also in fresco it can, in certain cases, be used (q.v.)

Well-rectified oil of turpentine will always remain the most valuable diluting agent, since it evaporates normally, quickly, and without leaving a residuum, and dries faster than the fatty oils, which is not the case with oil of cloves, copaiva balsam oil, lavender oil, etc. It does not affect the fatty oils in their natural drying process.

Terpineol (hydrate of turpentine) is prepared by various methods from oil of turpentine, and is known in both solid and liquid form. The trade product is a mixture of liquid and solid constituents, having for the most part a high boiling point, 216-218° C. Because of its lilac odor it is used chiefly as a perfume, but has recently been used by some painters in place of oil of turpentine because it remains wet longer. It has so far proved

satisfactory, but observations based upon longer experience are not yet available. The trade product is a colorless, heavy liquid, like fatty oil. It gives to color a meager and mat quality, like oil of turpentine, but, like the latter, has no binding power whatever.

2. *Volatile Mineral Oils*

Mineral oils, as contrasted with the essential oils of plant origin, absorb no oxygen. They evaporate, leaving a greater or less residuum according to their purity. They are made in part from crude oil (naphtha) and in part from coal-tar oil, and are used as thinners and solvents. From the crude oil, a brown, viscous mass, a great number of valuable substances are obtained by fractional distillation, various substances being liberated at different temperatures, such as, among others, benzine, heavy benzine, and cleaning fluids (turpentine substitutes), which, taken collectively, are colorless, easily inflammable liquids. They boil off between 60-160° C. They evaporate rapidly and leave no lasting grease stain. Between 180-270° C. the kerosene or petroleum of the trade is produced, and at still higher temperatures, 270-400° C., are produced the lubricating oils. What remains in the stills is a residuum of buttery character, petrolatum, from which later are prepared liquid petrolatum, heavy petrolatum, paraffin, and ozocerite (ceresin). All these substances, when pure, are quite unchangeable, since they absorb no oxygen and so cannot become oxidized. They also do not become rancid.

ILLUMINATING PETROLEUM, kerosene (coal oil), contains, according to its variety, various amounts of sticky residuum, often over 10%. Petroleum was already used in the early days of Italian painting under the name of olio di sasso, olio di petra (rock oil). The painter Ludwig in Rome sought, on the basis of Leonardo's writings, to reintroduce petroleum painting. His color was a resin-oil color with a 10% addition of petroleum. Since all naphtha products thin the colors to an unusual extent, much more so than oil of turpentine, the color was suitable only for a thin, glazing technique. But since the various sorts of petroleum, according to their origin, and especially the trade products, act very differently and contain considerable quantities

of non-drying constituents (lubricating oils), which come to the surface, many difficulties arose. The colors often rapidly darkened until they were almost black and remained greasy and sticky, and also frequently became sticky again after they had started to dry and caused resin to separate. In other instances paintings remained perfectly preserved where the raw material used was unobjectionable. Ludwig's own style of painting was limited to a luminous, thin technique over careful drawings on a white ground, where there was naturally little danger.

By repeatedly treating petroleum with sulphuric acid and sodium hydroxide and shaking it with water a product is formed which serves as an unobjectionable painting medium for certain purposes and also as a cleaner for pictures. It evaporates, leaving no residuum, has relatively little solvent power, and is unapt to change. In Vibert's varnish, a French retouching varnish, such petroleum is used.

Under the name of Sangajol petroleum products of Borneo naphtha are offered by the trade. Those which have approximately the same boiling point as oil of turpentine and therefore evaporate slowly have proved to be useful diluents for oil colors and good solvents for resin.

The more volatile are naphtha products, the greater their solvent strength. Benzine is used occasionally as a diluent. It is such a powerful diluent, however, evaporates so quickly, and is, moreover, such a fire hazard (it explodes at 50-70° C.), that its use as a painting medium seems unwarranted. It is used in pastel fixative (thin 2% solutions of dammar in benzine).

LIQUID PETROLATUM is a non-drying oil. It is the chief constituent of Dr. Büttner's "Phoebus," a much-advertised regenerating medium for oil painting. It is, to be sure, a chemically inactive substance, but as a non-drying oil is a great danger in pictures, from which it cannot be removed. It cannot loosen the "linoxyn" skin of old oil paints, and therefore is of no use (see under regeneration).

CERESIN and PARAFFIN, see page 142.

From coal-tar oil are prepared:

BENZENE, which, when pure, is a powerful solvent for colors. It has been used recently as a painting medium by many painters

when striving to obtain a mat effect with very thin colors, also with an addition of beeswax. The permanence depends on the purity of the product. Pure benzene is colorless, has a strong odor, and is highly inflammable. It dissolves most artificial resins and can be mixed with alcohol. Impure benzene turns brown and causes colors to darken. Benzene vapors are injurious. It freezes at about 5° C.

TOLUENE likewise can be used only when well purified. It dries more slowly than benzene.

XYLENE is a well-known brush cleaner and is also used as a paint remover. As a trade product it is less pure than benzene and toluene, and therefore not to be recommended as a painting medium.

TETRALINE evaporates more slowly than oil of turpentine and is said, apart from its sharp odor, to cause the reddening of white coats of paint. It is likewise poisonous and a powerful solvent.

DECALINE, a more refined product, is as clear as water and less poisonous than tetraline. It evaporates faster than oil of turpentine and, as one of its substitutes, is called hydroterpene. It has less solvent action on paint than has tetraline; it may therefore perhaps be used as a cleaning medium for old pictures in place of the dangerous method of washing with water.

3. The Semi-volatile Oils

The semi-volatile oils are essential oils which dry leaving more or less of a resinous residuum. Since they dry more slowly than oil of turpentine, attempts have been made to introduce them into modern painting. They would be suited, however, only to pure alla prima painting without further overpainting; but even here they have no special advantage. Their great solvent action on the lower layers of paint is harmful to the overpainting of the picture and causes considerable later darkening and blackening. Since these oils, in contrast with oil of turpentine, will not have evaporated when the fatty oils have dried, they may cause cracks if repeatedly painted over, and especially when a glazing under-

painting has been used. These oils are entirely unsuited to the preparation of tube colors.

ROSEMARY OIL somewhat resembles oil of turpentine, but evaporates more slowly. The best sorts come from France and Dalmatia. It is slightly greenish, if not colorless, intensely odorous, and of high solvent power. It is suitable only for alla prima painting. When used in painting over dry coats of paint it quickly dissolves them and is the cause also of strong later darkening. Brush strokes are diffused by it. It should, when necessary, be used only in very small amounts. Two parts of rosemary oil should dissolve completely in one part of 90% alcohol. It thickens and becomes resinous in air and makes the colors sticky.

LAVENDER OIL, as well as the cheaper oil of spike, is more resinous than oil of turpentine, evaporates still more slowly than rosemary oil, is of a yellowish to greenish color, and has a strong odor. Lavender oil is prepared from the blossoms, oil of spike from the whole lavender plant. Both are powerful solvents for resin and have a solvent effect on the lower layers. Brush strokes are easily diffused by them, and they allow the colors to run and make them sticky.

Retouchings with all these essential oils quickly turn dark later, especially in the case of repeated overpainting. Oil of spike and lavender oil can, in contrast with the other essential oils, be made into soap by the action of lyes and find use in tempera (oil-of-spike casein tempera, q.v.). De Mayerne testified to the occasional use of oil of spike by Rubens, but with the qualifying remark that Rubens had declared oil of turpentine to be the better of the two. Lavender oil is soluble in the proportion of 1:3 in alcohol. It must be kept in tightly closed flasks, otherwise it becomes resinous.

OIL OF CLOVES. The best sort is taken from the blossoms of the clove tree and is light in color; the less valuable comes from the branches and is darker. Oil of cloves has a penetrating odor; it evaporates and dries very slowly. Through its use pictures can be kept wet longer than by any other known means, and today it is much used as a painting medium. With zinc white it remains wet up to 40 days on non-porous grounds. Since oil of cloves has a very solvent effect upon the underlayers, one

must be very sparing in its use, otherwise a darkening of the picture will be brought about by the coalescence of the upper and lower layers. The frequent practice of spraying pictures with oil of cloves, particularly in portrait painting, also leads to the same results. Oil of cloves turns very brown in bottles when exposed to light, but this, peculiarly enough, is but slightly noticeable in the picture. Oil of cloves should dissolve completely in ether or alcohol.

Eugenol (eugenic acid) is artificial oil of cloves and is said to be identical in its effects.

COPAIVA BALSAM OIL, COPAIVA ETHER, is distilled from copaiva balsam. It is of almost transparent color and has a fruity odor. According to Bornemann, the evaporating power in 100 hours of the above-listed oils is as follows:

Rectified oil of turpentine	95%
Rosemary oil	24%
Lavender oil	10%
Oil of cloves	2%
Copaiva balsam oil	0%

The painter might thus be led to the conclusion that copaiva balsam oil, as a result of its small evaporation, would surpass oil of cloves as a slow-drying painting medium and therefore be the best medium for keeping pictures wet. But this is absolutely not the case! While it is true that copaiva balsam oil evaporates but very little, yet it dries, and dries, indeed, as fast as linseed oil and much faster than rosemary oil or oil of cloves. When copaiva balsam oil was recently introduced into painting, it was promptly regarded as a nostrum, particularly because it was highly recommended by scientific authorities. It was supposed to prevent the wrinkling of oil colors, which only occurs when there is a preponderance of fatty oils over the pigment and can easily be avoided. The resin of copaiva balsam oil is of poor quality, is splintery, and later becomes sticky. Copaiva balsam oil tends to prevent the thorough drying of the oils. It is a powerful solvent and is well adapted for restoration purposes, as are all the essential oils, but not for painting purposes. All that copaiva balsam oil is supposed to be able to do may be found

in an article by the color manufacturer B. contributed to a Munich publication on art technique in December, 1915. There copaiva balsam oil is recommended as a reliable and excellent drying medium far surpassing all other drying media. A few pages farther on in the same article we read: "With the help of copaiva balsam oil a slow-drying medium can be prepared." What more can one expect at one time! In the same article copaiva balsam oil is recommended for the softening of under-painting in order to permit of painting wet in wet, which is practically identical with the old practice of "biting." Copaiva oil will soften in the sun. It is superfluous and at the same time very expensive, and its use is fraught with danger. Dammar or mastic varnish is cheaper and better.

ELEMI OIL, distilled from elemi balsam, is an almost water-clear, slightly yellowish oil with a strong odor of fennel, and is also a powerful solvent. It is therefore suitable for restoration purposes. It becomes resinous and partially evaporates. In thin layers it dries in from two to three days. It is very expensive, but useless and dangerous in artists' colors because of its strong solvent powers.

OIL OF CAJUPUT resembles oil of spike in its properties and volatilizes fairly well.

COPAL OIL, distilled from copal resin, cannot be used and has an unpleasant odor.

OIL OF AMBER, distilled from amber, leaves much residuum, dries poorly, and is just as useless.

WAX OIL has the same properties as amber oil.

LIGHT AND HEAVY CAMPHOR OIL remain sticky, have a strong odor, and are used sometimes inadmissably in combination with petroleum products for "cutting" colors and painting media.

CAMPHOR likewise belongs here. It is a solid, viscous, crystalline substance of strong odor and taste, which easily volatilizes at the usual temperatures. It can be used as a preservative in tempera emulsions and the like. On the other hand, its use in resin varnish (see under mastic) is harmful. Synthetic camphor behaves in the same way. De Mayerne mentions camphor as an addition to varnish. Synthetic camphor possesses similar qualities.

III. BALSAMS

Balsams are liquid exudations of various plants and, in contrast with the gums, are insoluble in water. When exposed to the air they lose their essential oils by evaporation and quickly become hard and resinous (the pitch of the pine tree, for example, is such a balsam). The resin is splintery and decomposes readily.

Oleo-resins [6]

They are soluble in oil of turpentine, spirits of wine, ether, benzine, and petroleum, and, when dissolved in fatty oils, easily separate when cold. They contain 20-30% essential oil.

VENICE TURPENTINE is exuded pitch of the larch, has a pleasant, aromatic odor, and is light in color, with a slightly whitish, cloudy appearance. Venice turpentine comes from the region of Trent. As an article of commerce it often has a brownish color caused by impurities, such as particles of bark, which get into it while the balsam is being extracted. By making incisions in the bark the turpentine is caused to flow out. Even from the very resinous larch cones turpentine is won in springtime by boiling. The brown product of the trade is not dependable; it may turn still browner. The best sorts formerly came from the Trentino and Styria. This source has of late become exhausted, and domestic products are unfortunately no longer obtainable. According to its content of essential oil (oil of turpentine), the Venice turpentine is more or less viscous. It is free from crystals of abietic acid, which strongly discolor the common turpentines. It is naturally soluble in oil of turpentine, especially when slightly warm, and in the proportion of 1:1 in a water bath; likewise in fatty oils. Venice turpentine, like all the oleo-resins, completely dissolves in 80% alcohol or in spirits of ammonia, and in the proportion of 5:1 in oil of turpentine. Common turpentines, like pine or fir turpentine (galipot), which may be distinguished by their unpleasant,

[6] *Edelterpentine* in the German text, for which I have been unable to find an exact equivalent in English. [Translator's note.]

sharp odor and their cloudy yellow color, would become cloudy and milky. Venice turpentine can, if first thinned with oil of turpentine, be filtered through layers of gauze. This is best done in the sun, because it then becomes very fluid. Unfortunately, the brown color of impure sorts cannot be entirely eliminated.

Pure Venice turpentine is an excellent, non-yellowing painting medium where an enamel-like effect of the colors is desired, especially in connection with sun-thickened oil, for which it was often used by the old masters, Rubens among them (about one-third thickened oil). Venice turpentine permits of an easy, flowing stroke and a fusing of the intermediate tones which gives to painting a great deal of charm. It must be used sparingly, especially with dark, slow-drying colors (tube colors in particular), or an unpleasant gloss, poor drying, and a tendency to turn blue may result. It must not be used as a finishing varnish, because it quickly succumbs to atmospheric influences, and the remaining resin soon becomes splintery and brittle. For this purpose it must be mixed with mastic or dammar, but there is no advantage in this as against the use of pure mastic or dammar. In painting media it is advantageous to mix it with resin ethereal varnish or fatty oils. In old Italian recipes it is mentioned as a varnish. It may be that under the climatic conditions of Italy it is better suited to this purpose than in the north, Van Dyck used it as an intermediate varnish in portraits dissolved in the proportion of 1:1 in oil of turpentine in a water bath. He painted into the very thin film of Venice turpentine, because through its enamel-like flowing the hard edges caused by retouching and overpainting could be avoided, and the work acquired the desired soft, blended effect (oil of turpentine is added until the desired degree of fluidity is obtained). Exact information cannot be given because turpentine varies a great deal both in fluid and solid form. According to the viscidity of the turpentine the amount of oil of turpentine to be added must be increased until the solution can be easily handled. For tempera emulsion it may likewise be used, but here it has the unpleasant tendency to cause the hairs of the

brush to stick together. To avoid this, it is well to use a glaze of Venice turpentine with thickened linseed oil and paint into this with opaque tempera in mixed technique.

STRASBOURG TURPENTINE comes from the white fir, is very clear, has little tendency to turn yellow, and has the properties of Venice turpentine, producing a fluid, enamel-like coat, which gives to the work a wonderfully mellow effect, such as can be found on the pictures of the old German and Flemish masters. Grünewald's Isenheim altar may have been painted with this medium. In Italy the turpentine from the white firs of the southern slopes of the Alps was likewise very often used. It is preferred by many to Venice turpentine. Unfortunately all these excellent painting media are obtainable in the trade only with great difficulty and then seldom in a pure state. The same may be said of Chian turpentine.

Canada balsam,[7] recommended by Gussow, has not been generally adopted in painting, but may be used as a substitute for other oleo-resins. It is light yellow and of great clarity.

COMMON TURPENTINES. The common pine or fir turpentine, pine or fir pitch—galipot—has a strong, unpleasant odor and, in contrast with the oleo-resins, a dirty yellowish or blackish color. From it is prepared oil of turpentine, leaving a splintery, brownish resin, colophony (violin rosin). The common turpentines become cloudy and milky in 80% alcohol or ammonia, as was mentioned above. They are substances of inferior value.

So-called *artificial turpentines* are useless substitutes distilled from inferior resins.

COPAIVA BALSAM. Various sorts are differentiated, which, however, are not always recognized by the trade. To the practitioner the fluidity, that is to say, the content of essential oils, is the determining factor. Para, the most fluid variety, contains 90% oil; Maracaibo and angostura balsams are thicker and contain perhaps 40% oil. The several sorts are of very different value.

[7] It is not improbable that species of fir and similar trees indigenous to the United States may yield balsams comparable to Venice turpentine, Strasbourg turpentine, and Canada balsam. [Translator's note.]

Gurjun balsam frequently goes under the name of copaiva balsam, but it should not be used; it turns brown and dark (according to Dr. Eibner), as does also Segura balsam. Copaiva balsams have a peculiar fruity odor and are soluble in fatty and essential oils, as well as in alcohol. What has been said about copaiva oil, distilled from copaiva balsam, applies also to its balsam. Copaiva balsam may be used for pure alla prima painting at one sitting, but not for overpainting, and never in tube colors. Its general introduction into tube colors, as well as the extensive use of copaiva balsams and oils in general, is difficult to understand unless one attributes it to the mistaken idea that this material, so invaluable for restoration purposes, must also be equally serviceable for painting purposes. Once, about the year 1900, at the studio of a friend, I had the opportunity of studying the ravaging effects of copaiva balsam in a picture. The material has a certain enamel-like effect and permits of pleasing, soft strokes, but it later darkens to an unusual extent because of the prolonged action of its solvent properties. The pictures of my friend became very dark in a few weeks, although they were painted with very sound workmanship. They were painted with a color which an artist at that time had introduced to the profession. My friend's fondness for copaiva seemed to know no bounds, and every few days he produced a new color which contained still more of this balsam. The results of this mistaken enthusiasm became rapidly evident, a perfect demonstration of rapid darkening due to the sinking in and intermingling of the various coats of paint by which the lower layers were repeatedly being dissolved. In the end the effect resembled palette scrapings. All colors had drowned in this mess, even the purest and most luminous, aside from becoming smeary. There are still, regrettably enough, resin-oil colors which call for the use of copaiva balsam, and also in technical works copaiva balsam is continually being recommended as the perfect medium. E. Berger thus writes, in the 8th [German] edition of the "Bouvier," 1910, page 95: "The use of copaiva balsam for oil painting is quite harmless, and of all thinners it is the best and most to be recommended. It does not cause colors either to darken later or to crack." Farther on he recommends copaiva wax mixtures, which are just as dangerous.

It would be very harmful to use such a balsam thickly in many layers over half-dried grounds, for it dries on the surface and then becomes resinous. Deep, furrowed cracks are the result. Copaiva balsam can therefore be considered only for pure alla prima painting which is finished at one sitting, and for best results on white grounds, but never for painting that is done in successive layers. Franz von Stuck, as he himself told me, employed it in that way over tempera. Its easy solubility in alcohol constitutes a great danger to pictures painted with it whenever they are cleaned. The resin of copaiva balsam is splintery and brittle. Copaiva balsam is unsuitable for tempera emulsions; the balsam makes the brush sticky, and its tendency toward later darkening is also here in evidence.

But copaiva balsam cannot be praised too highly as a material in restoration technique. As Pettenkofer has demonstrated, copaiva balsam, that is to say, its essential oil, has the property of being able to dissolve the brittle, dried-out "linoxyn" skin of old oil paint. One application of copaiva balsam is often sufficient, in very many cases, to make an obscure picture gradually clear again by its effect upon resin varnishes which have lost their molecular cohesion, and also upon resin-oil colors. This balsam performs a valuable service in Pettenkofer's regeneration process (q.v.). The several sorts of copaiva balsam vary in the degree of their fluidity. They must be suitably thinned with oil of turpentine. For restoring purposes the thinnest varieties are the best.

ELEMI BALSAM, a soft, whitish to yellowish, milky, turbid balsam of very varying value and fennel-like odor, can be used for restoration purposes because of its solvent properties, but is very uncertain as a painting medium. I have many times observed a crystalline exudation of elemi balsam from recently ground colors which caused these to look as if covered with frost. The same may be said of elemi resin.

IV. RESINS

Resins, like balsams, in contrast with gums, do not dissolve in water, but only in fatty and essential oils and partially in alcohol.

Like the fatty oils, they are mixtures of different substances in varying amounts. A balsam whose essential oil has evaporated becomes a resin.

1. Soft Resins

Soft resins, mastic and dammar, give invaluable service as varnishes, as painting media, and as additions to oil colors. They tend to prevent the oils from wrinkling and forming a skin, and also act as a preventive against their later shrinking and decay, since they dry from the bottom up and through all the layers of paint simultaneously as their solvent evaporates. They are not so subject to oxidation as fatty oils, and they provide an excellent protection against atmospheric gases and dampness. If they are attacked by moisture, they can easily be regenerated. They give to colors great depth and clarity, but, used as heavy glazes, produce a polished effect like window glass. They dissolve in essential and in hot fatty oils.

MASTIC RESIN. The best varieties are derived from the pistachio tree (*Pistacia Lentiscus*) on the island of Chios and hence go under the names of Chian or Levantine mastic. Inferior sorts are East African and East Indian Bombay mastic. The Levantine mastic is a bright yellow. It is obtained by making incisions in the bark of the tree. Great care is taken in extracting it, so that the resin is very pure. Because of its drop-like form it has been called tear mastic (*mastix in lacrimis*). The drops are white on the outside and, when broken, clear and transparently yellow. Because there is so much inferior mastic in the trade, one should use only material of good quality and even appearance. There are also imitations which are successfully made to resemble mastic by the tedious process of dropping inferior liquid resin into water. Chian mastic is soluble in alcohol, in part also in acetone. Mastic becomes soft at 90° C., and melts between 105° and 120° C. Mastic is quite soluble in oil of turpentine, also in hot fatty oils and in hot alcohol. It is the most widely used picture varnish.

The preparation of a resin ethereal varnish is very simple. The resin is first pulverized and then slightly warmed in order to free it from any adhering moisture. It is then put into a

gauze or tulle bag and hung in a wide-necked glass, partly filled with rectified oil of turpentine—a preserve jar will serve the purpose—so that the resin hangs to about the depth of an inch in the turpentine. The resin dissolves in the turpentine, and insoluble particles and impurities which frequently adhere to the trade product remain in the gauze bag. The jar must be kept tightly covered, so that as little as possible of the turpentine can evaporate. The dissolved varnish is very light, almost colorless, with a slightly yellowish cast. For a picture varnish and painting medium mastic is dissolved in the proportion of 1:3 in rectified or doubly rectified oil of turpentine, in the proportion of 1:2 for tempera emulsion. It is much less satisfactory when the resin is simply poured into the turpentine. It may then easily form lumps and sink to the bottom, and even the expedient of putting pieces of glass into the turpentine to prevent the resin from forming lumps does not greatly help matters. Moreover, all the impurities remain in the varnish. In order to dissolve the sediment, one must turn the well-corked flask upside down and allow it to remain standing in this position. The turpentine vapor then gradually dissolves the lumps of resin. The attempt to purify such varnishes by filtration is a tedious, roundabout method which seldom gives results. One may also try to filter impure varnish through cotton which has been placed over a funnel. It would be better to add barite to the varnish and warm it slightly to make it more fluid; still such varnish will remain slightly turbid. It is not advisable to dissolve the resin in hot oil of turpentine. Hot-dissolved varnishes are sticky and very yellow. Tiny particles of bark contained in the raw resin are turned brown and discolor the varnish, which, in addition, also later turns yellow. The mastic varnishes of the trade are often prepared by this hot method, and also not infrequently given strong doses of fatty oils, such as linseed oil. It is no wonder that such varnishes often become yellow and sticky and turn soft. Mastic is often condemned because it has turned yellow, but the reason is probably faulty hot preparation and inferior raw material. Such varnishes have a deep yellow color, whereas cold-prepared varnishes are almost colorless and remain so. I have samples of such cold-prepared varnishes which

have remained water-clear for thirty years. An addition of camphor, which is recommended in many recipes to increase the solubility of the resin, serves only to impair unnecessarily the quality of the varnish, which, as soon as it has dried, becomes porous, weakly adhesive, and of a dirty milky color, owing to the disappearance of the camphor, which is replaced by air. An addition of alcohol is just as unnecessary. Alcohol has a great affinity for water, and such varnishes are very apt to turn "blue." Aside from all this, such varnishes dissolve patches of color which have not become thoroughly dry (resin-oil varnish, page 134).

Mastic is also soluble in alcohol. But alcohol or spirit varnishes should not be used in oil painting. A spirit varnish is made in the same way as an oil of turpentine varnish. 2% castor oil is added. Some artists use spirit varnishes over tempera on solid grounds.

It is not advisable to add Venice turpentine to a final varnish, because the varnish would then lose its resistance to atmospheric influences.

On the other hand, a small amount may be added when grinding resin-oil colors or when using mastic varnish as a painting medium when one wishes to produce elasticity and an enamel-like effect.

DAMMAR RESIN is derived from the dammar fir. Here also there are various sorts of resin of diverse value. Sumatra or Batavia dammar is the best. Dammar resin is soluble in oil of turpentine and benzene and partially in alcohol, ether, and benzine. Only Batavia dammar dissolves completely in oil of turpentine, other sorts only partially. It becomes soft at 65° C. and fluid between 100 and 150° C. Dammar is a completely neutral resin which, as in the case of the somewhat harder mastic, is often used—and justly—as a picture varnish. Dammar resin occurs in the trade in lumps about the size of walnuts, which appear dusty on the outside but are as clear as water within. Pulverized sorts nearly always contain many impurities. The more colorless the resin, the better it is. Very yellow sorts are inferior (see also page 138: dammar copal). Such poor, often opaquely yellow sorts lead to rapid decomposition of the varnish and are of little value. The more colorless, the better they are. Hygroscopic sub-

stances in the ground or in the layers of paint, such as glycerin, soap, or sugar, hasten the destruction of the varnish, as is likewise the case with damp and new walls.

Dammar ethereal varnish properly prepared by the cold method, as was described under mastic, has a slightly whitish sheen, is almost colorless, and yellows but imperceptibly, in any case the least of all the resins. Therefore it was formerly used for enamels and for varnishing white furniture. Dammar varnish is often accused of turning "blue." This is wholly a matter of the quality of the dammar. According to my experience, this happens just as frequently with mastic, Venice turpentine, copaiva balsam, etc. (see under varnishes for oil pictures).

Dammar is desirable in tempera emulsions, for which purpose it is dissolved in oil of turpentine in the proportion of 1:2, whereas the ratio in picture varnish is 1:3. 2% dammar in benzine serves as a pastel fixative. Mastic and dammar varnish added to tube colors in the amount of not more than 10% enable these resin-oil colors to meet the modern requirement of putting on coats in rapid succession. They are not advisable with pure oil colors. The resin varnishes made of mastic and dammar are for this reason very advantageous in modern pictures, because the majority of tube colors contain poppy oil and not infrequently slow-drying essential oils, hence are composed very differently from, and do not dry on the whole so fast as, the colors of the old masters, which were prepared with the idea in mind of rapid and hard drying. If, as is often recommended, hard resins are used, such as amber or copal, for varnishing modern pictures, they will, aside from the excessive yellowing and browning of these varnishes, cause cracks by rapidly hardening over the soft layers of color underneath. In order to make the resin varnishes more elastic, one can, where it seems necessary, for example, on old, brittle pictures, add 5 to 10% castor oil. Resin varnishes such as mastic and dammar have the great advantage that, when they become blurred by the action of dampness, they may be restored by alcohol vapors (see under regeneration). Castor oil does not prevent this.

An objection is often made in scientific quarters against the use of resin varnishes as painting media with oil colors to the

effect that such colors must eventually suffer injuries when regenerated. The painter cannot on this account ignore the valuable properties of such a varnish painting medium, and, on the other hand, such colors do not require regeneration, but coats of copaiva balsam are sufficient to restore their full clarity and transparency.

Resin-oil varnishes are made by dissolving mastic and dammar in hot fatty oils such as linseed, poppy, or nut oil. These fatty resin-oil varnishes are of darker color and naturally subject to greater yellowing than the oil of turpentine varnishes. They are, in keeping with their nature, very fat, and give to pictures the smooth, shining surface which was formerly so much admired. They should be used only as additions to painting media, never as a final varnish. It is advisable to mix the oil and varnish cold, whereby one obtains a very serviceable painting medium. Fatty varnishes were formerly very much in use as final varnishes for oil pictures and caused plenty of damage through their tendency to turn yellow and the difficulty of removing them.

Dammar as a pastel varnish, see page 252. 2% dissolved in benzine is very useful.

COLOPHONY, VIOLIN ROSIN, is the solid residuum which remains after the distilling of turpentine. It is an inferior, very acid and splintery resin, of a light yellow to dark brown color. It is soluble in oil of turpentine, alcohol, benzine, and acetone, and in lyes such as soda solution. Resin varnishes adulterated with colophony crack easily, remain sticky, and can be rubbed off in small splinters. Shellac often is adulterated with colophony. Colophony dissolves completely in benzine, in shellac only slightly. If oil varnishes are adulterated with colophony, they cause white lead and zinc white to congeal. Colophony is often used for the purpose of mounting an old canvas on a new one. Many varieties today, however, have very poor adhesive power. If cooked with soda, colophony yields a "resin soap" insoluble in water.

SANDARAC, a coniferous resin from Morocco, is not identical with the sandarac of old painters' treatises. In ancient times the name sandarac was given to orpiment and massicot sandarac. Sandarac crumbles when chewed (a distinction from mastic).

It comes in the trade in longish, yellowish- to brownish-red pieces shaped like icicles. It is often adulterated with colophony and is, like the latter, very acid and therefore easily capable of being saponified by lyes. It serves for making spirit varnishes since it is completely soluble in alcohol, ether, and acetone; in benzine it is only one-third, and in turpentine only slightly, soluble. On the other hand, it dissolves completely in oil of spike. Sandarac dissolved in ether 1:2, with the addition of one-quarter the total amount of benzene, yields a dull varnish, but not for oil painting! Sandarac is often used as an intermediate or final varnish over tempera paintings. If such a picture is re-touched or painted over with oil colors, damage soon results. Oil, for which it has very little affinity, does not cling to sandarac. Sandarac varnishes have a displeasing gloss, and should be excluded altogether because absolutely unnecessary. Sandarac oil-of-spike varnish should also perhaps not be used with oil colors; the resin separates when oil of turpentine is added.

SHELLAC. To the soft resins belongs also shellac, which comes from East India. It is a colored resin. The red dye stuff is removed by boiling in water. This produces the blond shellac or, as it is called because of its form, leaf shellac, which, for want of bleached or white shellacs, may find use as an isolating medium. White shellac is produced by treatment with carbonate of potash. It comes in the trade in the form of shiny, twisted, cylindrical pieces. Shellac is readily soluble in alcohol. If it forms a sediment, the flasks should be turned upside down; the alcohol vapor will then dissolve the lumps. Often it is necessary to turn the flasks about repeatedly. A 2% solution serves as a fixative for drawings; a thicker solution, 1:2 in alcohol, as an isolating me-dium for grounds, for which purpose 5% at the most of castor oil is added to make it smooth and supple. The blond shellac is dis-colored to a somewhat reddish hue when put over zinc-white grounds, presumably as the result of a chemical reaction; but this causes no further damage. A great disadvantage is the fact that shellac loses its solubility in alcohol when exposed to light and air. It must therefore be preserved under water and in dark-ness. Such an insoluble shellac can be made to dissolve again if melted under water or if, a few hours before being dissolved in

alcohol, it is dampened thoroughly with ether. The shellac must be well pulverized for this purpose, and the evaporation of the ether prevented by keeping the flasks tightly closed. Shellac dissolves in a watery borax solution, in ammonia and alkalis, and also in ether. The borax solution, 50 parts of borax to 150 of shellac in one liter of water, is also called "water-varnish." Shellac substitutes are inferior, for example, colophony in alcohol, which is often used for adulterating shellac and produces a splintery resin. Shellac is almost totally insoluble in benzine (only 6%). Much solubility points to adulteration with colophony. When dissolved in alcohol (denatured alcohol will do), there often remains a dirty residuum, animal wax, which, however, is not harmful. By adding benzene, shaking, and then drawing off the benzene which does not mix with the shellac, these harmless impurities may be removed. Solutions of shellac must be kept only in glass and never in metallic containers, because the resin acid will attack the metal and discolor the solution. It is unfortunately necessary to remark that solutions of shellac in alcohol are under no circumstances to be used as picture varnish, because they crack badly.

2. *Hard Resins*

Hard resins are plant products, some fossilized, others derived from trees living today.

COPALS. Copal is a collective name for resins of widely differing characteristics. Many copals are harder than rock salt, others are softer than dammar. The fossil copals, such as Zanzibar copal, also called goose-flesh copal because of its texture, and also Mozambique, Sierra Leone, and red Angola copal, are all insoluble in alcohol. They will also not dissolve in fatty oils without special treatment. For this purpose the copal must first be pulverized and roasted. Copal colophony is then formed, a dark, brittle mass, which is melted in hot oils. The result is a very dark resin varnish, which becomes uncommonly hard and at the same time forms a very glossy skin. Like all resin-oil varnishes, such varnishes are unpleasantly fluid and have a displeasing gloss. They can therefore be used only in very small amounts as addi-

tions to painting media. It is better to avoid them entirely in artistic painting, for which sun-thickened linseed oil with mastic or dammar varnish and Venice turpentine is better in every way. With many copals there is the danger of cracking. Dissolved in oil of turpentine, copal colophony quickly becomes splintery. Copal varnishes are absolutely unsuitable as final picture varnishes, for they turn very yellow owing to their content of boiled fatty oils, become turbid and brown with time, and can be removed only by powerful solvents at the great risk of injury to the picture. When applied directly over opaque and not thoroughly dried coats of modern oil colors, their hardness may cause deep cracks. Copal varnishes are also prepared from pulverized copals which are melted in Venice turpentine, oil of turpentine being later added; they are then mixed with boiled linseed oil.

Coach varnish should, when genuine, be a fatty 30% copal varnish of highest quality, but what one customarily gets under the name is frequently nothing more than a linseed-oil varnish. The English coach varnishes are especially valued because they are light in color and carefully prepared from the best raw materials under prolonged heating at very definite, exactly maintained temperatures.

Coach varnish gives to colors a certain enamel-like quality and smoothness. Depending upon its quality, it is more or less inclined to yellow. As a picture varnish, particularly by the old masters, it has often been used because of its golden tone, but, like all oil varnishes, it is not well adapted for a final varnish. Outdoor varnishes used in the trade are fat copal varnishes.

Many attempts have been made to dissolve copals without the use of fatty oils, or without employing the roundabout method of roasting, which so strongly darkens the varnish. The pulverized copal was exposed to the air for a long time, then soaked in balsams and treated with various solvents. Oil of cajuput is said to dissolve most of the copals; Zanzibar copal dissolves in part in rosemary oil. Epichlorhydrin and many other solvents were used. But these experiments were successful only on a small scale and then only in part. Hard resins no longer play the rôle in present-day painting which they did in the period when artists

loved to give their pictures an exaggeratedly smooth and glossy surface.

Soft copals, in contradistinction to the hard copals, are soluble in alcohol. Such soft copals are Brazilian, kauri, Manila, and Borneo copals. White Angola or ball copal is so soft that it rubs off on wool. It makes a sticky varnish. Many soft copals swell in oil of turpentine; they also swell in other essential oils, and afterwards dissolve in hot fatty oils. Soft copals are not infrequently confused with dammar and go under the misleading name of dammar copal. Soft copal solutions remain clear when shaken with ether, while dammar becomes milky.

Copal varnishes are prepared from soft copals. Copal "en pâte" is copal in oil with an addition of wax.

AMBER is a fossil resin derived from various pines, and is to be found in the blue amber clays on the coast of the Baltic Sea and in several other places. It is light yellow to dark brown in color, transparent or cloudy like milk. One sort, succinite, represents the hardest known resin.

These substances since very early days have enticed painters into making varnishes, and many an artist was convinced that amber varnish was the acme of all varnishes. Amber, however, like the hard copals, is difficult to dissolve. By roasting it is changed into amber colophony, which is dark and splintery, and this is dissolved in hot fatty oils. Such varnishes and painting media are very hard, but also very dark. If used over soft coats of paint, their hardness may cause cracks. They dry into an oily smoothness, forming a skin, and have a high gloss. The trade varieties contain for the most part very little amber. The name as such has become a trade-mark and means only a hard-drying varnish.

Attempts have often been made to dissolve amber directly in order to obtain light-colored varnishes. These attempts have succeeded only in part and on a small scale. Rectified oil of turpentine dissolves up to 10% of amber. Rosemary oil and oil of spike increase its solubility, but, like all balsams and semi-volatile oils, make for stickiness of the varnish. With the present-day methods of grinding colors, especially poppy-oil colors, there is no need for a hard oil varnish. The resin ethereal varnishes,

mastic and dammar and sun-thickened linseed oil, serve this purpose much better.

Amber varnishes, like all resin-oil varnishes, are unsuitable for varnishing pictures, since they turn yellow and brown, in time become cloudy, and can be removed only by the strongest solvents at the risk of great damage to the picture.

Synthetic resins, synthetic resin varnishes, and lacquers. In the house painter's and decorator's trade synthetic resins have been used for some time as substitutes for copal and amber varnishes and shellac. Attempts have been made to introduce their use to the artistic profession, but without definite results. The qualities of these constantly increasing novelties are as yet too little tested.

The best known among them are nitrocellulose lacquers,[8] which have been known in Europe for forty years under the trade name of Zapon varnish.[9] They are useful for isolating purposes, as a water-color varnish. They are colorless, soluble in acetone, and turn yellow. Additions of 5% castor oil increase their elasticity.

Collodion, a solution of gun cotton in alcohol and ether, acetyl cellulose, yields colorless solutions in alcohol or acetone. It yellows but little and is not so inflammable as the nitrocellulose lacquers.

Phenol resins, formaldehyde resins, are used as "dip" lacquers, substitutes for shellac, also for copal and amber. They surpass these in hardness and are soluble in linseed oil. There are already available today very clear, bright tones. Their extreme hardness makes them undesirable in connection with poppy-oil colors. Perhaps some day they will become useful for outdoor purposes in oil painting.

Kumarun resins are coal-tar products which turn a deep yellow; they are inferior to phenol resins. The newer sorts, dis-

[8] The word "lacquer" as distinguished from "varnish" is now generally used for varnishes which have no oil base. [Translator's note.]

[9] In America there are as many different designations as there are manufacturers. Duco is the best known among them. These lacquers are much improved and practically more useful than the earlier European types. [Translator's note.]

solved in benzene, are said to furnish useful spirit varnishes. They are very powerful solvents and of little value.

Polyvinyl resins furnish in part water-clear varnishes; like the styrol resins, they are mostly soluble in toluene. Experiments have shown that they do not combine with the fatty oils or with oil of turpentine, and that they are extraordinarily powerful solvents.

The need for synthetic resin varnishes for artists and restorers is not a pressing one. It would be more to the point if artists and restorers would agree to discontinue using varnishes made of copal and amber, because they turn dark and also because they are so hard to remove. Synthetic varnishes possess a delusive charm, and everything that has been written about these so-called "ideal varnishes" sounds very attractive. But they all require careful testing if far-reaching damage is not to result.

Several synthetic resin varnishes sold to me originally as "absolutely colorless" after a few years have turned a dark brown. Tests covering many years are necessary.

Several very clear varnishes of this type, especially vinyl and styrol solutions, showed such extraordinary solvent power that colors several centuries old gave off pigment in a few moments. Pictures less old, let us say a few decades, under similar conditions were dissolved down to the ground. In addition these varnishes are not compatible with organic oils, oil of turpentine, or linseed or poppy oil. When added to oil colors they at once become "thready" and impossible to work.

It must be clear, therefore, that one cannot use such material without danger of grave injury to pictures. It is not improbable that before very long a useful varnish of this type may be perfected, that is to say, a varnish which is not a solvent and which does not turn yellow. In the meantime, caution!

V. WAXES AND TALLOWS

Waxes and tallows are animal and plant products similar to the fats.

BEESWAX is by far the most important and most useful of these substances. When carefully prepared and melted from year-

old honeycombs which have not been used for breeding the wax is a bright yellow (virgin wax) and for painting purposes requires no bleaching. Older wax is a dark yellow and must be repeatedly melted in water, then cooled in alum water. The wax must be melted in well-galvanized or enameled vessels. It becomes a dirty brown in iron vessels. It appears in the trade chiefly in the form of flat disks. The trade product, however, is often adulterated with mineral wax, especially with paraffin, alleged to give the wax greater hardness. If a sample is chewed, such adulterations betray themselves by the taste. Wax melts at about 65° C. When merely warm it becomes soft and kneadable; when cold it solidifies. When warm (in a water bath), it dissolves easily in oil of turpentine, benzine, and fatty oils; dissolved directly over the fire, it turns brown, like butter.

Wax is very resistant to acids. With lyes it forms an emulsion. It does not oxidize, as do the fatty oils, and it does not turn yellow and lose in body. It has been found absolutely unchanged in very ancient remnants of painting. It was employed by the Egyptians, the Greeks, and the Romans. As a surface it forms a better protection than the oils against moisture from without. Moisture from within from a damp wall no painting medium can withstand.

The extraordinarily charming optical effect of wax when used for mat effects with oil and tempera, as well as the half-mat effects produced by rubbing it with a cloth or the ball of the hand, not to forget the high gloss possible by encaustic treatment, all account for its many-sided usefulness from ancient to modern times.

As a constituent in grounds wax can be used only if one intends to continue with wax colors. It is used as an addition to tube colors to prevent sudden hardening. Wax gives to colors a mat and substantial appearance. Wax made into an emulsion by means of carbonic-acid ammonia makes an excellent tempera, which may be variously modified by additions of solutions of glue, casein, cherry gum, egg yolk, etc. Under the name of "cera colla" it was used in this way with glue in early Byzantine and early Italian painting.

Encaustic wax colors were much used in ancient times.

Wax pastes, pigments mixed with wax, sometimes with additions of mastic to make them pliable, were already used in very ancient times. These colored pastes were kneaded with the fingers or spatula into strongly outlined designs and thus gave fine decorative effects.

It is not impossible that the late Greek mummy portraits from the Fayûm were made in that way.

The Punic or eleodoric wax of Pliny was a wax three times melted and remelted, tempered in salt water and soda. It then could no longer form an emulsion. This tempered Punic wax might be very useful for indoor purposes where ordinary wax would be in danger of being destroyed by soot and dust, and perhaps also for outdoor work, because it adheres better than ordinary wax. Many combinations of the technique here briefly outlined have been experimented with by different painters who are fascinated by the great beauty of wax colors.

It is questionable whether wax is well adapted to cold climates, because in cold weather it becomes brittle and develops fissures. It also absorbs water, though perhaps only in very small quantities.

Plant wax and tallows, such as Japan wax (melting point 45° C.), are sticky even in ordinary temperatures and soluble in oil of turpentine and benzine. Chinese tallow behaves similarly. Neither can replace beeswax in the picture. Carnauba wax, which comes from a palm, is used to harden beeswax. It is gritty and gray-yellow in color, and of no use to artists. Animal oil, sperm oil, a secretion from the head of whales, has been used now and then in place of beeswax in oil colors. Mutton tallow and beef tallow at one time were very undesirable additions to tube oil colors.

Mineral waxes, ceresin, paraffin, all melting at from 50-80° C., soluble in benzene and petrolatum, are not suited to take the place of beeswax, since they are not so pliant or optically agreeable.

Beeswax, when melted together with paraffin, separates from it on cooling.

CHAPTER IV

PAINTING IN OILS

I. THE MATERIAL

1. *The Grinding of the Color*

It is recommended that the painter grind his own colors, not merely for the sake of economy but also because in this way he becomes better acquainted with his material, and, furthermore, because color ground by hand possesses a charm which the factory-made product frequently lacks. For grinding a color one needs a grinding slab, a medium-sized runner or muller, and a clean horn or steel spatula, the latter of which should be cleaned often with sandpaper. Slightly roughened glass plates are preferable, likewise roughened glass runners. A layer of felt or several layers of newspaper should be placed under the slab so that it will not slide or be broken by the pressure of the runner.

There are numerous tables listing the quantitative requirements of pigments in relation to binding media. These are cited in many books on the technique of painting, as, for example, the Wurm-Pettenkofer table. It must be borne in mind, however, that such tables are more or less arbitrary or applicable only to a single case, because it is impossible to set up tables which are exact and always dependable. A Cremnitz white which is very heavy will require only from 10 to 15 parts of oil, while another of looser consistency will require 25 parts or even more; and with other, particularly dark, colors the percentage is still more variable. It is also of importance whether the pigment be damp or dry. Pigments containing clay, such as ocher, ultramarine, and green earth, are benefited by being warmed slightly before grinding, because clay retains water to a considerable degree. The dry, slightly warmed pigment will take up more oil and produce a more fluid color than a damp one. The oils also vary considerably in their ability to take up pigment.

143

The relative requirement of oil in the manufacture of colors varies to a marked degree, according to information obtained from the manufacturers themselves, as is indicated by the following:

Cremnitz white	from	7 –	28%
Zinc white	from	14 –	40%
Light ocher	from	33 –	75%
Raw sienna	from	100 –	241%
Vermilion	from	7 –	25%
Prussian blue	from	72 –	106%
Cobalt blue	from	50 –	140%
Ivory black	from	80 –	112%

The average oil requirement of the following is:

Chrome yellow	about	25%
Cadmium yellow	about	40%
Zinc yellow	about	40%
Strontian yellow	about	30%
Naples yellow	about	15%
Indian yellow	about	100%
Burnt ocher	about	40%
Iron oxides	about	40%
Minium	about	15%
Cobalt violet	about	40%
Green earths	about	80%
Oxide of chromium transparent	about	100%
Oxide of chromium mat	about	30%
Umber	about	80%
Burnt green earth	about	50%

In general, dense, heavy colors, such as white lead, minium, and Naples yellow, require little oil, while light, loose pigments require a great deal.

The size of the grain is the determining factor, the hand-ground colors of the old masters having had a coarser grain than the factory product of today, which goes through the rollers much too often and gradually loses all body. Bleeding and cracking of formerly unobjectionable colors result.

At the beginning of the grinding but very little oil is added to the pigment powder, and these are first mixed together with the spatula or a broad palette knife. The color thus made into a paste is deposited in an upper corner of the slab. A little of it at a time, as much as the size of a walnut, is then ground with a circular motion, under slight pressure, and spread gradually over the whole surface of the slab. After this the color is heaped up, the runner is scraped off, and the grinding is repeated, if necessary. The color, which may have seemed a little dry at the start, will now flow more easily. One should guard against "pouring" oil on dry pigments. If the color is too thin, more dry pigment is added. Artists' colors should be ground to the consistency of paste, so that they "stand up" and do not run like house painters' paint. The finished color is deposited in another corner of the slab. The color, while being ground, should not make a crunching sound under the runner. Finally the whole batch is briefly given a last grinding. It is practical to grind first the light colors, beginning with white. Extreme caution is advised here, as with all poisonous lead colors; by tying a damp cloth over the nose and mouth one can avoid breathing in the white pigment dust.

It is profitable to have a special slab for white, because this color is the most sensitive. Zinc white has such a fine grain that working it with the spatula is quite enough. Prolonged grinding would be only harmful. Some colors, such as the coal-tar colors, Indian yellow, and Prussian blue, penetrate into the surface of the slab and are then hard to remove.

Chrome red changes its hue if ground too long; it becomes more yellow as a result of the change in the size of the grain. Naples yellow is at its best when ground only for a short time. Asphaltum must be mixed with hot oil; it is in itself only a colored oil, and it strikes through as a consequence. Crystallized madder lakes are tedious to grind; madder lake in lumps is preferable.

The pigment in every case is of chief importance, the oil being merely a "necessary evil."

Cold-pressed oil is the best for grinding. Linseed oil gives to colors a workable consistency. A 2% addition of wax gives them a butter-like character. Poppy oil has this quality in itself. The

oil used for grinding colors must be fairly liquid and clean, but it should not be bleached. Only when oils are liquid do they take up much pigment, and that is very important. Old, viscous oil makes a poor, sticky color; such oils take up but very little pigment, and the resulting color is thready.

It is quite impossible to improve old, viscous oils with oil of turpentine, because this evaporates during the process of painting, and the color remains viscous. Mixtures of linseed oil and poppy oil are used extensively in the manufacture of colors. Poppy oil by itself is especially used for white because linseed oil frequently yellows.

After the color has been ground, it should be "short," that is to say, it should stand up when deposited on the slab with either brush or spatula and not run or seek the level of the slab. On the other hand, it should allow of a free brush stroke and in no way be difficult to handle.

A color can be made "short" only by the economical use of oil. Poppy oil is here better than linseed oil, which requires an addition of wax or hydrate of alumina. Oil should not be too young or too old; the best oil of the trade is from ½-2 years old. Homemade oil, however, even when very fresh, has proved well adapted for the grinding of colors. The color manufacturers make colors "short" by mixing the pigments first into a paste with the addition of water and later on adding the oil. Small remaining remnants of water make the color short. A larger amount of water is objectionable. Often a certain opaque quality of the color is simulated in this way, but more pigment and less water would be better for our purposes. I once discovered a whole tablespoonful of water in a tube of color which had frozen. Such color, if used, loses in body and cracks.

Frequently small amounts of casein or egg tempera, even kaolin, are added to make colors "short," chiefly, however, wax, which, if dissolved in oil of turpentine, is used as a 2% addition to tube colors because it will not increase the volume of fatty oils.

The consistency of the color improves with the addition of wax, which, furthermore, reduces the yellowing of the oils. The annoying separation of the oil in tubes containing colors of great weight is also prevented by wax. Color mixed with wax has an

appearance of greater body, and the wax gives it richness and at the same time permits of a free technique. Hydrate of alumina in place of wax is often added by manufacturers to tube colors. It does not, however, prevent yellowing and otherwise behaves very indifferently. It is said to have the advantage of not being sensitive to differences in temperature. There is no danger of color becoming muddy through a small addition of wax. True, too much wax is of no advantage. Formerly, in the 90's, as much as 30% wax dissolved in fatty oils was added to colors, and in that way, of course, they were spoiled. The oil content was enormously increased, and the color became sticky and dark and, moreover, cracked. All sorts of other additions, such as mutton tallow, suet, sperm oil, lard, etc., were used to make color "buttery," but they merely served to make it smeary and to prevent it from drying.

I have observed within a few days after grinding a very puzzling congealment of colors ground in pure oil, especially in the case of white lead, minium, cadmium yellow, vermilion, and cerulean blue. In one case old, viscous oil was the cause. White-lead powder ground to the consistency of dust often became affected in this way when ground in oil. It should, after being ground, stand covered for about eight days and then be given a further grinding before being put into tubes. Gypsum may also cause colors to congeal.

Some colors must stand for a day after first being ground, then more pigment must be added and the grinding repeated. This applies to zinc white, umber, cobalt green, oxide of chromium brilliant, and ultramarine. The two latter have a tendency to run and need a 2% addition of wax. Colors which take oil badly must be started with alcohol; ammonia is also serviceable. Such colors as the lakes, which have no body, often receive additions of heavy, thick oils.

Sketching colors are made by the addition of extenders such as barite. This every artist can do for himself. White lead will take a good third or more of barite, which is very cheap, without being deprived momentarily of its covering power; later on, however, such white becomes transparent and turns very yellow.

The color, after being ground to the desired consistency, is

carefully put into tubes by means of a horn spatula. These must not be capped at first, and they should first be rinsed out with oil of turpentine. For tempera and water colors tubes may be coated on the inside with a protective lacquer. The color is settled compactly in the tubes by tapping these lightly on the table. When the tube is filled, the end is turned over several times by means of a spatula. Tube metal may be attacked by oil acids, and a gray deposit may form at the opening. Coating with a protective lacquer, as recommended in the case of tempera colors, is advisable also with coal-tar colors. Ground colors may also be kept in wide-necked bottles covered with a little water. Some colors, however, do not tolerate water, especially the earth colors, Indian yellow, and zinc yellow. Petroleum on top of the colors is less advisable, because it is apt to mix with them.

The slab on which the color has been ground is cleaned with oil of turpentine, benzene, or xylene. Sawdust, bread crumbs, or chalk in conjunction with soft soap may also be used.

The opening of tubes and bottles may be facilitated by warming them at the neck. For the purpose of grinding larger quantities of paint handmills are practical, but they must be kept very clean.

2. Types of Oil Color

The modern tube colors offered by the trade are, from the standpoint of a rational technique, trade secrets, their method of manufacture being revealed by a few factories in its larger aspect, but not in the quantitative relationship of one constituent to another. The painter can, therefore, estimate only very unsatisfactorily the effects of these materials in the picture. The enormous contrasts in the time required for drying of individual colors is very annoying. A distinction is drawn between so-called fine artists' oil colors and study or sketching colors, which latter, however, should be equally as lightproof as the former. Sketching colors are to be distinguished only by their coarser texture and by the addition of so-called extenders, such as barite. Their lesser value should be reflected in their price.

The best qualities of factory-made artists' oil colors often suffer because they are too finely ground, as a result of which some

unobjectionable colors, such as caput mortuum, umber, etc., develop the tendency to "strike through," which is found otherwise only in colors soluble in oil, such as asphaltum (bitumen). In addition, as the result of the prolonged running of the colors through the metal rollers, overheating and subsequent partial conversion of the oil into soap is likely to occur, whereby the color becomes tough and has less body than the hand-ground product. This becomes particularly evident when the colors are used thinly. It must be admitted, however, that the artists' color factories have been practically forced into this method of manufacture because the artist, in his ignorance of the resultant bad qualities, has kept on demanding more and more finely ground colors. When in older treatises on painting, as in Cennini's, one reads that the color cannot be ground too finely, one must remember that the painters of those days had to extract some colors, for example, ocher, with great difficulty from the raw ore, and that the only known method was grinding by hand. Under these circumstances troublesome aftereffects were not likely to occur.

The color of the ancients was more granular and had more body than ours of today. Anyone who has ever painted with hand-ground colors will recognize the difference.

The manufacturer has a natural interest in keeping his colors in a saleable condition for as long a period as possible. Hence he adds slow-drying oils or other substances to the colors, which can be only detrimental to the preservation of the picture.

Experiments are under way to mix non-drying with drying oils. They should not lead, however, to an immediate adoption of these materials without an absolutely reliable examination. Otherwise the profession may pay too heavy a price.

Cremnitz white ground by mechanical means is frequently first made into a paste by adding water, and the oil is added only after several grindings, whereupon most, but not all, of the water separates. Because of the retention of some of the water the color acquires an opaque character and for a time has great covering power; the possible consequences, however, of this practice have been described in the previous chapter. Very young oils, when combined with water (to free them from sugar of lead) while

being made into a paste, easily form an emulsion, from which it is no longer possible to separate the water.

When one observes on old palettes the remnants of color which have been drying there for years, one is astonished to see how much volume such pigments have lost. The colors have acquired the appearance of dried pears or mushrooms, especially the lake colors, and yet on the inside they are still moist.

The ease with which oil colors can be handled and their tractability vary with the temperature. The same colors which in the coolness of the morning were difficult to work with may slide off the palette at midday. Out of doors wax increases these extremes.

Very annoying are the differences in time which pigments require to dry. While Cremnitz white, Saturn red, umber, and cobalt blue dry fast, other pigments dry more slowly, especially madder and vermilion. This can be equalized while painting through the use of painting media.

Pure oil color offers a good material to work with. However, a pure linseed-oil color has the disadvantage of yellowing and also of a certain gloss. It also has the further drawback that overpainting is possible only over a well-dried color, and this must not be done too opaquely. Except for these disadvantages, pure oil color is well adapted for alla prima painting and for monochrome painting. A linseed-oil color dries the most thoroughly and also the hardest; it is also less inclined to crack.

Pure poppy-oil color gives a buttery effect and dries more slowly.

Poppy-oil color is the material prescribed for the present-day painter. It seems to meet his requirements the best. The oil colors of today contain chiefly a mixture of linseed and poppy oil. White today is nearly always ground in poppy oil because this is less likely to turn yellow. The darker, more slowly drying colors contain more linseed oil. Tube oil colors also frequently contain additions of non-drying or slow-drying oils in order to keep the colors wet longer, which is fatal to the preservation of the picture.

Many manufacturers of "pure oil color" play up the fact that their color is free from wax or similar additions. They claim for

it more body and more transparency in the depths. But certain colors require additions in order to prevent oil separation and hardening in the tubes. Alumina preparations, oil varnishes, thickened oils, and similar additions may also be contained in these colors. Moreover, a small addition of wax, as has been repeatedly remarked, is not objectionable.

Tube oil colors formerly often contained considerable amounts of wax, from 15-20%, dissolved in fatty oils. It is clear that such colors absorbed a large amount of oil and must have caused all kinds of damage. Additions of tallow were likewise employed. Since it never dries, it is absolutely inadmissible in colors.

Resin-oil colors with balsams and essential oils. The disadvantage of pure oil color, that it can be used only alla prima, as poppy-oil color, or put on, as linseed-oil color, only over well-dried underpainting, can be equalized through the use of resin-oil color. Resins dry thoroughly and throughout the whole mass by reason of the evaporation of the solvent medium—oil of turpentine. The substance of the resin remains and counteracts the loss of body in the color caused by the shrinkage of the fatty oils, especially poppy oil. The oil of turpentine has evaporated before the oils begin to dry. With resin-oil color one can still paint on only half-dried, "tacky" layers without the dangers one would encounter if one used pure oil color. Resins were already used by the older schools in oil colors, for example, by the Van Eycks for glazes, by the Venetian school, and by Rubens, as well as by Rembrandt, Velasquez, etc., who all took advantage of the opportunity for rapid work offered by this medium. The oil content was lessened, the transparency and depth of the glazes increased, and, if the resin-varnish or balsam content was not too high, opaque painting was not impossible. Venice turpentine, or mastic and dammar in oil of turpentine, here find use. Such color has enough protection in itself not to require any final varnish for a long time.

Resin-oil colors put up in tubes become hard faster than pure oil colors. Hence one seldom adds more than 10% of the binding medium when adding resin varnish. In the painting medium the percentage of resin varnish may be higher.

Pettenkofer's work on oil color and the conservation of oil

paintings provided the incentive for the adding of balsams and resins, especially copaiva balsam, to the colors in order to increase their permanence, limit yellowing and wrinkling, and facilitate handling as far as possible, since, when using resin-oil colors, it was not absolutely necessary to wait for the complete drying of the underlayers. The majority of the color factories formerly used copaiva balsam and copaiva balsam oil in considerable amounts in their colors, which was intended especially to do away with wrinkling and shrinking. They could not go far enough in the way of such additions and believed that they had found the ultimate solution of the artist's color problem. Even today one finds expressed in textbooks, such as Berger-Bouvier's and Jännicke's, the mistaken opinion that copaiva balsam can be unhesitatingly added to the colors in any amount one pleases, that it neither yellows nor cracks nor later turns dark. Copaiva balsam and its oil are, however, dangerous if contained in tube colors.

The apothecary Lucanus, who in 1834 championed the use of copaiva balsam in painting, was himself well aware of the dangers involved. He therefore covered every coat of paint with isinglass and shellac in order to protect it from any solvent action. But it is self-evident that such protective measures cannot be taken by the painter, aside from the fact that they will inevitably cause cracks.

An oil resin color with a hard resin base, such as amber or copal, *dissolved in oil*, is also dangerous because of its tendency to turn yellow and form a skin, the smooth, greasy effect of which is increased in proportion to the amount of these additions. These oil varnishes practically make an airy, mat, and opaque color effect impossible. Such products have appeared many times as "colors of the old masters." Essential oils such as oil of spike increase the tendency of the color to run together and fuse unpleasantly. In any case it would be wise to use these media very sparingly if one would avoid the danger of the painting's becoming "saucelike."

A third type of *resin-oil color* is produced by the *addition of resin-oil varnishes*, such as mastic or dammar in oil of turpentine, *to the oil color as a painting medium*, but not as an addition to

tube colors. This was the resin-oil color of Rubens, the color be-
ing used with sun-thickened linseed oil, Venice turpentine, and
also with mastic varnish and oil of turpentine. It possessed a gloss
without having to be varnished, and proved by its wonderful
preservation the correctness of its technical principle. Good oil of
turpentine evaporates quickly and completely before the drying
of the fatty oils begins, and hence does not interfere with the
drying process.

Oil of spike and other essential oils dry much more slowly;
they disturb the drying process of the fatty oils, have a solvent
action like that of copaiva balsam, and unfortunately tend toward
later darkening. Ethereal varnishes serve in a much less objection-
able way to decrease the oil content of colors than the hard resins,
amber and copal, which introduce into the color much boiled and
lardy oil. They also tend to prevent the skin formation of the
fatty oils, since they dry by evaporation throughout the whole
mass, and not from above, as do the fatty oils.

Modern tube colors are for the most part poppy-oil colors or
mixtures of linseed and poppy oil, resins, and balsams, which
never become very hard. The softer resins, mastic and dammar,
are here more adequate than copal, which becomes very hard.
They present no obstacle in case later regeneration becomes neces-
sary, as some scientists have feared; on the contrary, a simple coat
of copaiva balsam is sufficient to restore their lost transparency to
pictures painted with soft resins. The deciding factor in favor of
their use is their pleasing optical effect. They give clearness and
transparency to colors, their meager character is preferable to the
greasy oil varnishes, in general they permit of a more pleasing
technique, and, finally, they reduce "yellowing" to a minimum.
With them it is unnecessary to wait for a complete drying of the
underlayers, as in the case of pure oil colors, and a charming
rich and solid effect is thus achieved. They dry well and quickly
without forming a skin, and in my opinion they constitute the
best material available in the field of oil colors.

Resin wax colors one may also prepare oneself for immediate
use. A resin varnish is mixed with wax dissolved in oil of turpen-
tine, and with this the oil color is mixed with a spatula or simply
used with this as a medium. Better still, dammar ethereal varnish

may be added to the wax while painting. These colors have a misty, pleasingly dull and mat appearance, and great brightness and clarity. For decorative purposes, such as wall painting, this material is very well adapted, much more so than the often-used wax color in fatty oils, which is lardy, turns yellow, and dries poorly, whereas wax resin varnish is an excellent and very permanent mixture.

Ludwig's petroleum color was at one time much talked about, and it was believed once more, as so often happens, that the secret of the old masters had been discovered. Anyone who has followed the trend of painting technique through the decades knows how quickly such enthusiastic acclaim is followed by disillusionment.

Aluminum soap was used as a binding medium for his color by *Gussow*. Boiling solutions of a pure soap and alum were poured together, and, after various processes and mixing with oil of turpentine, an enamel-like substance was produced, which was mixed with resins and fatty oils. Coats with white were faultless, but had an unusually pronounced gloss. The color could not introduce itself permanently, because one had only a very short time, not more than an hour, to work with it, when it became tough to such a degree that it could no longer be brushed on.

Colors made from glass frit were supposed to equalize the drying periods of different paints. They were, however, without body and dried just as unequally as other oil colors.

The Raffaelli crayons were oil colors in the form of pastel sticks which contained cocoa butter, tallow, Japan wax, and nondrying oils and remained permanently effaceable, besides darkening considerably.

All too frequently such new introductions are the hobbyhorses of their discoverers, who do not stop to think that a material which is intended for general use must be proportionately adaptable. Some capable painter will paint a picture with a certain type of color, and, lo, he succeeds! But he would have been just as successful with any other material. In the case of others the results are disappointing, and discoverer and practitioner are afterwards both alike disillusioned.

The more adaptable a color is to various needs. the better it is.

and just that much wider will be the circle of those who are able to achieve something with it. The color with which anyone can create a work of art without ability does not exist. This much-sought-after wonder medium will, in my opinion, never be found.

Mat colors and mat effects in pictures are today enjoying a great vogue. By adding a considerable amount of essential oils and reducing proportionately the amount of fatty media such effects are obtained on strongly absorbent chalk or gypsum grounds. But an exaggerated mat effect obtained by the use of essential oils is attended by bad effects on the permanence of the picture. The color becomes brittle and is likely to fall off because of deficient adhesion. A color should, if possible, retain its binding medium; it should lose only a small quantity through absorption or evaporation. Those colors which contain sufficient binding medium and hold up well on the ground, since they do not require a supplement of varnish for years, are without question the most beautiful and permanent. Mat color giving good results may be prepared as an opaque color for decorative purposes by mixing some Bologna chalk, hydrate of alumina, as a powder or rubbed in oil of turpentine, with the oil color on the palette. It is best to mix each color with the spatula. Bologna chalk may also be added only to the painting medium (wax-resin varnish or pure mastic varnish).

Beeswax in oil of turpentine also makes color mat. Oil color with oil of turpentine used on absorbent ground gives to oil color a very beautiful mat quality. Also petroleum and other volatile mineral oils are used for mat effects with oil colors.

Mixed colors. Many painters today prepare their own oil colors with an admixture of tempera emulsion in order to give the oil color a "short," lean, mat, and even-drying quality. It is forty years since such combinations were last made, but today they are being revived. In those earlier days many pictures were blackened and ruined by the use of soft soap.

Tube color is not always suited to these additions. Egg, casein, and animal glues are used today, and also saponified resins.

It is better to make an oil color leaner by an admixture of tempera emulsion than to make a tempera too fat by adding oil.

There are undoubtedly many possibilities, but only the experienced technician will succeed.

A mixed white made with half egg- or casein-tempera Cremnitz white and half oil Cremnitz white becomes very hard, dries very fast, and has much body.

I have variously examined *colors made from synthetic resins*. The colors are, indeed, very clear, but permit only of a very limited water-color-like, or perhaps tempera-like, technique. They adhere poorly on grounds containing oil, and they separate whenever they come in contact with fatty oil or oil of turpentine.

3. Painting Media

Painting media are used for thinning oil colors during the process of painting. It should be emphasized at the start that they should be used as sparingly as possible, because the tube colors of today already suffer from an overabundance of binding media.

It should further be borne in mind that painting media should be simple in their composition. The more substances are introduced into a picture, the greater the danger that they will react unfavorably on one another.

The painting media used in one and the same picture should preferably be the same in all its layers.

Quick-drying painting media, if they are to be used at all, belong only in the underlayers. Slow-drying painting media require non-absorbent grounds and the avoidance of oil of turpentine, because this accelerates the drying. The worst that was ever offered to the profession in the way of a slow-drying painting medium was probably Büttner's "recipe": it recommended painting on absorbent grounds with vaseline oil, soaking the ground, so to speak, with this substance. One could paint thus wet in wet as long as desired. If one wished the picture to dry, one simply made a paste of China clay and water and smeared this in a thick layer on the back of the canvas. When drying, all of the vaseline oil was absorbed into the clay, which was then simply knocked off. No language is strong enough to characterize such pseudo-scientific advice. The best are normal-drying painting

media which do not conflict with the nature of the oils used or forcibly increase or retard their normal drying periods.

There is a limit to the adhesion possible between pigment and binding medium. The pigment must always be regarded as chief in importance, and not the binding medium. Very strongly thinned color is often dangerous. In order to prepare for himself a useful painting medium, the painter must clearly keep in mind the effect of the binding medium in the picture.

Essential oils, such as oil of turpentine and petroleum distillates, etc., are diluents without binding strength of their own. They thin the colors to an unusual degree and therefore tend to destroy their "body." If used to excess, they may also cause cracks through their rapid evaporation. In top layers of a picture they work injury because of their solvent character. They are suited to pure alla prima painting done at one sitting or perhaps in 1 or 2 days, and to underpainting. Oil of turpentine accelerates the drying of the fatty oils.

The semi-volatile essential oils, such as rosemary oil, oil of spike, copaiva oil, etc., are suited at best only for pure alla prima work, but not for an under- and overpainting technique. Here they cause later darkening and remain sticky for a long time.

Oil of cloves is the slowest drying of the essential oils, but must be used very sparingly. The ground naturally must be almost non-absorbent. This oil must not be thinned with oil of turpentine, otherwise it dries faster.

Balsams give a smooth, elastic effect and produce a good fusion of colors, especially Venice and Strasbourg turpentine. In combination with sun-thickened linseed oil this effect is increased. If used to excess, they make the picture sticky and unpleasantly smooth. Unless in alla prima painting, copaiva balsam had better not be used at all as a painting medium.

The fatty oils are present in the tube colors of the trade to such a large extent that they should be used sparingly as painting media. Nut oil allows of a good fluid, draughtsmanlike brush stroke. Poppy oil must be used carefully; it is very fat, but serviceable where a butter-like quality is desired. Linseed oil dries through the hardest, but it turns yellow and gives a more glossy

effect. All fatty, drying oils give the color a fine enamel-like quality, but in excess a greasy effect.

The boiled oils and *resins dissolved in hot oils,* such as copal and amber varnish, also coach varnish, give a blended, smooth effect. They are strongly resistant to atmospheric influences. If used to excess, they form a skin, become very greasy and unpleasantly shiny, and turn yellow. They dry quickly, with the exception of stand oil. Raw linseed oil thickened in the sun is better for our purposes than the boiled oils; it produces a very fine enamel-like quality when used in conjunction with resin varnish or Venice turpentine, as likewise does stand oil, which, however, remains wet longer than sun-thickened oil, but should be used only as an addition to painting media.

The hardness of *copal and amber varnish* causes cracks when these are applied over soft coats of paint. All these varnishes turn very yellow, even brown; they must be sparingly used, if at all.

Resin ethereal varnishes, mastic and dammar dissolved in oil of turpentine, make the color transparent and luminous, but, when used in excess, glassy and viscous, because of the evaporation of the essential oils. They yellow imperceptibly or not at all, give to colors great luminosity, and, in contrast with the fatty oils, permit early painting over layers which have not thoroughly dried. They have a fast-drying effect. Used by themselves they are too brittle, hence, when used as painting media, they are given an addition of fatty oils.

Wax solutions make the color buttery (*Malbutter*), but only the mixtures with resin ethereal varnishes are to be recommended, not those with fatty oils, and these only for certain definite, usually decorative, purposes. They give an especially airy, mat effect.

Siccatives are comparable to "horse cures," which are best left alone. They may be carefully and appropriately used in very small amounts, but in larger amounts may cause the worst damage. Their drying power is such that a 2% addition to the painting medium is sufficient.

The time required for the drying of individual oils and var-

nishes used as painting media, which is naturally influenced by the ground, temperature, etc., is about as follows:

Oil of turpentine evaporates very fast.

Petroleum distillates ⎱ volatilize in a few hours.
Bitumen distillates ⎰

Tetraline and certain varieties of Sangajol evaporate more slowly than oil of turpentine, terpineol even more so.

Siccatives accelerate the drying by about 12 to 24 hours.

Boiled linseed oil dries in from 6 to 24 hours.

Amber varnish ⎫
Copal varnish ⎬ dry in from 24 to 36 hours.
Coach varnish ⎭

Mastic and dammar ethereal varnish dry in from 1 to 2 days.

Venice turpentine in very thin layers dries in from 1 to 2 days, but in thicker layers in about 14 days.

Linseed oil dries in from 3 to 4 days.

Rosemary oil and oil of spike dry in from 3 to 4 days.

Nut oil dries in from 4 to 5 days.

Poppy oil dries in from 5 to 6 days.

Stand oil dries in from 5 to 8 days.

Oil of cloves dries in about 40 days.

From this table one can decide on the composition of a painting medium for a definite purpose.

Essential oils make the color lean and very fluid; boiled oils or oil varnishes make it very fat; Venice turpentine, thickened oil, and stand oil give the greatest richness of color and the most enamel-like effect.

Painting media must always be used sparingly, the pigment being always the chief ingredient. If this rule is not followed, all sorts of difficulties may be caused by otherwise excellent painting media, such as Venice turpentine, but also by all the others, whether it be poor drying, stickiness, later darkening, or difficulty of handling.

Painting media should not be mixed together in the palette cup, where there may be all kinds of residua, but should be prepared in a flask, so that the painting medium for the whole picture may be available in the same composition.

Painting media of the trade. With but few exceptions the painting media of the trade are of a secret nature. Their use therefore cannot be recommended to the painter, because he cannot control the consequences. It must be the mission of all artists' organizations to unite in the demand that, in the case of these products also, there must be an exact description of their content, composition, and quantitative relationship. A dammar varnish, for example, should be labeled: Dammar varnish in doubly rectified oil of turpentine 1:2 or 1:3, and not merely as "Picture varnish."

Professor Hauser's painting medium, consisting of one part rectified oil of turpentine, one part dammar varnish, and one part linseed oil, is excellent and dries normally; every painter can prepare it for himself or modify it to suit his purpose.

4. *Palette and Brush*

The brown color of the *wooden palette* is a heritage from the time of bole grounds, when it was appropriate because it was in keeping with the color tone of the canvas. If one paints on a gray or a white ground while using a brown palette, one is forced to translate the color values. The difficulty of working correctly on white grounds is due in no small measure to the opposing tone value of the brown palette, which has an influence on every tone and makes it appear quite different from what it will on a white ground. Today the logical thing is to have a palette of the same color tone as the canvas, usually silver-gray or white.

A palette must have a good balance, so that it will not tire the arm. Very practical and light is a kind of pad palette made of many white sheets of parchment paper, which is non-porous and, after the work is completed, is simply torn off. Any artist should be able to make one himself. Folding palettes are very handy for painters when in the open country. The smaller one's color scale, the better. It is customary, in setting up a palette, to start with the lighter colors in the upper left-hand corner, but this should be left to personal preference.

Porous palettes should be brushed over with linseed oil and rubbed down with a cloth. Through repeated use they will lose their porosity. The palette may be cleaned with xylene, benzene, or oil of turpentine. In order to effect a saving, one can prepare

from the lighter or darker left-over colors and from those which are still clean mixed tones which can be used to good purpose in the unimportant darker parts of the picture, especially when they are strengthened with strong colors such as madder lake and the like.

Old dried oil colors can be easily removed with the spatula by heating the palette on the underside, for example, over the top of a stove. Burning off the colors with alcohol is not so good; by this method the palette may easily be burned in spots. A thin layer of soft soap allowed to remain standing on the palette will likewise dissolve the oil layer. If a trade solvent has been used, the palette must afterwards be thoroughly washed off with water. After such a cleaning the palette must be evenly weighted down, so that it will not warp.

Brushes. For the purposes of oil painting brushes made of pigs' bristles are used, and with them hair brushes for drawing purposes. Broad-handled bristle brushes with short or long bristles are most in use, because with them the color can be applied and modeled with the flat side, while the narrow edge permits of line work. Brushes are obtainable with bristles of various length and thickness. Round brushes are very advantageous for certain purposes where the line counts, and they were the ones chiefly used by the old masters. The brush must have the natural ends of the bristles, otherwise it is not suitable for painting. The brush must be closed at the tip and not have any hairs which stand out, and it should be conical in shape rather than spread out at the end. Before purchasing one should examine the brushes to see whether the bristles are of even thickness, and whether or not the brush has been ruined in the middle by too deep a clinching of the ferrule. Lateral crimping is to be preferred. Frequently the bristles are glued. Such brushes must be moistened to make sure that the bristles do not stand apart. Brushes should not be trimmed.

Fine hair brushes, of which the red sable brushes are the best, should, when moistened, have a good sharp point. This is necessary to permit the carrying out of exact details. When washed and put away, their points must be carefully preserved. Broad hair brushes, cow-hair (so-called camel's-hair) brushes, permit of a very soft stroke and a very delicate and tonal fusion of colors.

It is not recommended that their points be preserved in non-drying oils (as in special apparatuses and in olive oil), because some of the oil is too liable to remain in the brush and make the color lastingly sticky. The brushes must be well cleaned after the work is finished. It is practical first to squeeze out bristle brushes in newspaper held between the fingers and then smooth them out on the broad side with a light pressure of the palette knife, because in this way they hold their shape well. They may be washed with warm, not hot, water and liquid soap by rubbing them in the palm of the hand. Brush-cleaning apparatuses with corrugated bottoms save much soap, because the solution of liquid soap can be used for months. But the brushes must never be allowed to remain standing in the soap solution, or they will become black and curly. Brushes which have lost their shape are given a weak application of glue to restore it. After a few days they can be softened again.

After washing out the soap the brush should be pressed out to its proper flat shape from the ferrule to the ends of the bristles, dressed up, and allowed to dry in moderate warmth in such a way that the bristles lie free. Heat softens the colophony with which the brush is set into the ferrule, which makes the brush sticky and loosens the handle. During work one can dip the brush into oil of turpentine to clean it, but should press it out well, be-cause oil of turpentine makes the color spread.

One person would rather paint entirely with absolutely new brushes, as Trübner did, while another cannot have a brush which is too worn. It is all a matter of taste. When painting one should make it a point to keep the brushes as clean as possible and use one brush for light, cool tones, another for warm tones, a third for dark tones, and so on, as Rubens did. This makes the work very much easier, for it is only with a clean brush or a brush covered with bright colors that one can bring a clear tone to a brightly colored surface. If there is a dark color in the brush, even the heaviest white color will be of no avail, and the color which is put on with it will be dirty. This is naturally not to be taken too literally.

One should take up paint only with the tip of the brush, other-wise it will soon work itself inside the ferrule and spoil the brush.

Oil-color brushes which have dried very hard can be softened by various solvents, such as xylene, amyl acetate, acetone, etc., in which they must be allowed to hang; but brushes after such treatment are seldom of much use.

Worn brushes whose bristles have become very short can be made to last a little longer if one heats the ferrule slightly over a candle flame and then pulls out the bristles a little way without changing their natural position.

II. THE TECHNIQUE

1. *Tests and Methods of Control*

For purposes of observation and testing it is a good practice to apply samples of pigments, painting media, etc., in oil, tempera, and other techniques to a canvas or painting ground and also to glass, and carefully date and label them. Later on they often give very valuable pointers.

One must guard, however, against drawing general conclusions from these experiments, because the fact that one oil color turns yellow is no reason for assuming that all similar colors will do the same; the facts are pertinent only to each single case. There is still a great deal about these matters which is hidden from us and which is yet to be cleared up. It once happened with me that a mastic picture varnish with a 5% addition of castor oil dried overnight on a glass plate, but it took over 14 days to dry on a thoroughly dried oil painting which was two years old.

One should naturally always make these tests as far as possible under the exact conditions which exist in the picture, otherwise one may easily come to false conclusions dangerous to the practice of art. It is not until one has made a number of experiments yielding similar results that one is entitled to form definite conclusions.

Technique is the way in which the painter employs his materials. This is not so unimportant as many believe, for it is a fact that one may paint a very impermanent picture with absolutely sound materials. Technique must of necessity be subjective. It is in the individual variations in the handling of the materials, in the

possibility of a thousand and one personal expressions of a subject, that the main charm and fascination of pictures are found. For it is not the obvious and commonplace, but the individual interpretation, which awakens interest. An artist when working should never be conscious of rules. While at work he must unhesitatingly follow his feelings and be moved solely by inspiration. Through habit rules must from the beginning of his career become second nature to him, so that he has them at all times under his absolute command as subconscious servants.

Technique must be born of inner necessity. When Van Gogh at one time, in order to achieve the plastic character of the roots of a tree, squeezed color directly from a tube on his picture, it seemed to him the best means of expressing what moved him at the moment in nature. That technique is the best which permits the artist to express what he has to say as directly and convincingly as possible. When used merely as external cleverness, as a kind of virtuosity without inner necessity, it arouses the opposite of interest. Since technique is such a very personal thing, it is obviously impossible to give any recipes which would be generally helpful. But there are concerning the use of materials certain large directive ideas, rules of the craft based on scientific principles derived from practical experience. These are not to be interpreted as formulas, but often a single word of advice may be helpful to the searcher and show him the right path. It is in this spirit that the ideas here presented are to be taken.

Art is not a matter of either mind alone or handicraft alone, but a union of both. There is a heavy penalty for going too far in either direction, as when Cornelius believed he had done enough in drawing the cartoons for the murals in the Glyptothek and assigned to his pupils the task of carrying them out in color, as if this were a negligible phase of the undertaking. The frequent practice of disparaging technique, particularly on the part of literary critics, is not justified. The material the artist chooses for the expression of his ideas and how he uses it is not an incidental matter. He must, indeed, consider carefully all the different media of expression and their possibilities in relation to his special problem and select the one best suited to his purpose. Only a complete knowledge of his material will increase his power of expression.

"The more means of expression one commands, the better one will succeed in the complete realization of a picture," said Hodler. The most unpretentious motive may through creative power become a masterpiece, while a great idea, if inadequately handled technically, may result in a painful and disappointing effect. Only when artistic intentions work in harmony with ability and spiritual with technical values will a work of art be possible.

The artist at the outset of his career works purely by intuition. It is only in the course of years, by incessant observation and meditation, that knowledge and the power of conscious creation develop. In this way the painter becomes the master. Then Hodler's words become true: "Above the instruments for seeing ranks the brain. It compares one harmony with another and in this way discovers the real inner relationship of things. Out of this joint activity of the mind and feeling new splendors are born."

For practical reasons discussions of color problems, contrast and such, have been introduced at this point under oil painting because it is the most widely used technique. All the different phases of the development of a picture are thus brought into proper sequence and relationship.

2. Color Phenomena and Color Effects

All colors are manifestations of light.

According to Newton's law, white is the sum of all colors, and not a unity, as Goethe believed. The white light of the sun is broken up when passing through a prism into purple, red, orange, yellow, green, blue, and violet. These colors are revealed to us most beautifully in the rainbow. Rays of light which produce different color effects have different wave lengths.

The colors of the spectrum may be reunited to produce white. It is also possible to unite two definite color beams to create white light, such as red and blue-green, yellow-green and violet, yellow and blue, orange and blue-green. Such colors are called complementary colors. A complementary color provokes in the eye the sensation of the opposite color as a contrast, as, for example, red produces a blue-green afterimage.

Just as two colors may combine to produce white light, they

may, under certain other conditions, cancel each other and disappear in darkness. If light falls upon a body, the latter will swallow up all colors but its own, which it throws back; in this way a red body will return only red. When a light beam is completely thrown back, a reflection results (in the case of a shining surface). A rough surface disperses light.

Colors, as components of white light, are of necessity less powerful than white light.

In comparison with the colors of the spectrum our pigments are impure and possess little luminosity. Hence the principles of optics are only conditionally applicable in painting. A mixture of all the colors on the palette is not white but a dirty gray (palette scrapings).

Since we cannot, with the means at our disposal, reproduce the strength of light in nature, we are forced to translate it. All the values in a picture depend on one another. If the white is made darker, all the other tones must be relatively modified.

Different media, such as air, oil, and water, change definitely the speed of light rays and split them up, whereby they also alter the color effects.

Our pigments when in powder form reflect light from their surface. Color as such appears grayer because of the particles of air contained in it. Colors ground in different binding media, such as oils or resins, show refracted light rays and inner light according to the transparency of the color. Inner light is light which has penetrated and returns again to the eye. Because of the roundabout way it takes, this light appears weaker and less bright (glazes). Opaque colors reflect the light from their surface.

A color such as red is to the artist a sum of various colors in which red predominates. When Titian spoke of 30-40 glazes, one over the other, he was concerned with the multiplicity of variations possible within one color (see under techniques of the old masters, page 345).

The painter calls all those color tones warm which approach the yellow, the fiery, and cold all those which incline to coolness and the blues. Warm tones added to warm tones are enhanced in effect and remain luminous when mixed. Warm and cool tones, when mixed, are weakened and give a dull effect. Cold tones

mixed with cold tones remain clear. The alternating of warm and
cold tones by way of contrast gives to pictures charm and life.
Too many warm tones tend to produce a hot effect, while too
many cool tones give an appearance of lifelessness. The (artisti-
cally conceived) color tone of a picture should never be purely
cold or purely warm, but always a sum total of warm and cold
tones working together. It is the problem of the painter to lay
these tones so lightly one over the other that the lower ones are
not lost and the effect remains loose. A predominance of cool
tones improves the effect of a picture.

Warm colors seem to advance, cold ones to recede. In addition
strong colors also seem to advance, likewise colors used as glazes
and very opaque color passages. A color in a picture is always de-
pendent on its surroundings. Its effect may be heightened or de-
stroyed by these surroundings. It may therefore happen that a
part of the picture which was not even touched may lose its
effect. This the beginner often fails to comprehend, but the ex-
perienced artist consciously takes advantage of this phenomenon.
The effectiveness of red in a picture may be heightened by its
surroundings, by the presence of its complementary color, as also
of a neutral tone, a colorful gray—but also of a red of reduced
or heightened intensity. It can be made to appear warmer or
colder according to the warmth or coldness of the color next to
it; a powerful red can be lowered in its color strength and vice
versa. The color of a red house by itself and in relation to its sur-
roundings may appear different under a blue sky from what it
would in gray weather.

The artist must therefore look at objects not merely by them-
selves but also in their relation to their environment. A white
chalk mark on a black surface appears very white, while on a
white surface it looks very weak or even vanishes entirely. Upon
this simple principle is based much of the behavior and effect of
colors in a picture.

Complementary colors of equal strength in juxtaposition and
covering equal areas, as, for example, a yellow alongside of an
equally strong blue, are offensive to sensitive eyes. This harsh
contrast can be ameliorated by having one color very high in
key and the other more saturated, and by making the areas very

unequal in size. Imperfectly complementary colors give a better effect in the picture, as, for example, a yellow related to gray instead of to blue. Black also has the effect of an imperfect blue, likewise in mixtures with white. Intermediate passages of white, black, gold, or gray are very helpful in correcting unpleasant color schemes. The broken, more neutral color tones, "the colorful grays," carefully differentiated into cool and warm, are especially important and useful to the painter. They usually constitute the greater part of the picture and should carry the more sparingly used primary colors. If every color were used at its maximum strength, the picture would not become strong in color as a consequence, but loud [1] and gaudy.

Complementary colors, such as green and red, cancel each other when mixed together. The non-observance of this fact by beginners very frequently results in a blackening of the picture. This all depends, of course, on the way in which the colors are employed. By loosely applying one color over another, and, above all, through additions of white, one will avoid this mistake and will insure a reduction of the intensity of the color tones without killing them. The experienced painter reduces too strong a blue by breaking its effect through the juxtaposition of a weaker blue, thus avoiding killing the color by a vigorous mixing with another color.

To build a picture entirely out of pure complementary colors was the task which the neo-impressionists set themselves. Their method of putting on the color in the form of points and dots ideally suited their purpose. But their colors were all too pretty. There was lacking the transitional colorful gray, and the effect was therefore somewhat saccharine. The mixing of the colors took place in the eye of the person observing the picture, in which yellow dots were placed next to blue ones, red next to green, violet next to yellow, and so on. Under the microscope it may be observed that a physical mixture of two pigments takes place in the same way, that, for example, in a green mixed from

[1] The very descriptive German word "*bunt*" unfortunately has no counterpart in the English language. It may perhaps be recognized, however, in the word "bunting," which has all the qualities of "buntness." [Translator's note.]

blue and yellow the minute blue and yellow color particles lie side by side on the surface of the color, but are still separated and are only in the eye optically combined to form green.

The effect of a dominant color in a picture in relation to a contrasting color is improved by connecting it with the contrasting color by many neutral intervals, as, for example, from red through gray-red, gray-yellow, gray-green, in many gradations of cold and warmth, light and dark, to the green contrasting tone. Of importance also is the position in a picture of a dominant color and its contrasting color.

Every picture should from the outset have in its color pattern a striking effect which should carry a considerable distance.

A preponderance of cool, colorful grays helps the appearance of a picture. Unpleasant contrasts can be improved by the use of intervals through the introduction of grays, of white or black, and in decorative pictures also of gold. Outlines of complementary colors frequently serve to heighten the effect of a color.

Neutral, "dead" tones were much used by the old masters, as in the "sfumato" of Leonardo, and again in the use of white laid over dark grounds by which the varying thickness of the white layer over the warm, dark undertone resulted in half-tones, the so-called optical grays. This offered a simple means of plastic modeling. From the window displays of butcher shops one may receive valuable information concerning the effect of neutralizing media if one observes the changes which the various layers of whitish or yellowish skin produce on the red basic color of the meat—effects which at the time of the red bole grounds were happily imitated in a similar technical manner.

Contrast, opposition of colors, gives life to a picture. The painter is here not concerned simply with the coarser, all too common contrasts, such as the green-red, blue-yellow, etc., of the various "color circles," but with color combinations which are his own and which have not been seen and felt by others. He can harmonize in this way seemingly impossible contrasts and, relying on his own emotions, create new color values.

These values can neither be calculated in advance nor verified like a problem at school. It seemed somewhat amusing to painters when Professor Ostwald [the chemist], in analyzing Titian, an-

nounced that the blue of a mantle was two tones too high or too deep! It was simply Titian's own blue.

Contrast alone makes the picture appear too harsh and coarsely decorative in effect. To contrast must be added harmony, the dominant tone which runs through all the others, the carrier of the mood,[2] which gives something in common to all the colors and produces a unified, quiet effect. If contrast is excitement, then harmony is repose. Each must supplement the other. In the case of old pictures the gallery tone is the basis of this harmony; in pictures of the past century it was often the "brown sauce." With colored grounds, such as the red bole grounds, gray or green grounds, etc., the ground striking through or exposed in patches created harmonious effects. In tonal painting it is the key color or a single color added to all the others, as, for instance, green earth in the case of the earlier pictures of Trübner. One may also achieve harmony by loosely rubbing a neutralizing gray or some other tone over the entire surface of a picture which is too strong in color. The tone used for this purpose should not differ too much from the local or the contrasting hues.

Leaving the white ground uncovered in water color, as well as use of the bare canvas in modern oil pictures, tends to create a harmonious relation of the color pattern, as likewise do the blue outlines of Cézanne. The barbarous method of rubbing down with bricks restored wall paintings which look too new serves fundamentally the same purpose, the creation of unity and resultant harmony.

The attempt to create harmony by means of a final glaze gives the least satisfactory results, unless one wishes to work into the glaze in a semi-covering or covering manner, using a wet-in-wet technique.

On the other hand, it is well when trying to attain color harmony to repeat the principal colors of a picture in variations in other parts of the picture, as, for instance, the colors of a landscape in the sky or the flesh tones of a portrait in the background, whereby the effect becomes united and harmonious and hardness

[2] *Stimmung* has no exact equivalent in English; "mood" comes perhaps closest to it in meaning. [Translator's note.]

is avoided. The nature of color harmony is best explained by an example from nature. In a fog even the most glaring colors become weak at a little distance and appear harmonious. They are not colors alone, but colors plus the color of fog. If in this case a color such as red should appear simply as a full red (at a distance), the effect would be unconvincing and false. It is exactly the same in the picture. All colors must to a certain degree sink into and share the dominant tone. In nature it is everywhere the same, whether in gray weather or in the golden light of evening or in the bright blue of midday. There it is merely harder for the beginner to see. Thus it also becomes clear what the painter means when he says of a color that it "falls out" of the picture. The pure, absolute red which was mentioned above in connection with the gray, misty picture fell out unless it was harmonized by the gray tone. Color harmony may also be achieved throughout all the tones of a picture if, like Marées, one puts a fundamental tone over the outline drawing of a picture. In his pictures male figures were often sketched in with burnt light ocher, the figures of women with light ocher. These two colors were used interchangeably, and the effect of the whole picture was harmonious, yet contrasting. Again it is exactly the same in nature, where each patch of the skin and hair is influenced and harmonized by the general pigmentation of the individual. Not even the smallest patch of skin of a blond person would fit on the body of a brunet type. Various gradations and repetitions of one and the same color tone throughout the whole picture, accentuated by economically used contrast, result in fine harmonies. See Rembrandt's "friendly colors," page 372.

Masses of light and shade, half tones, dark accents, reflections, and high lights are the effects of light on bodies.

In primitive painting bodies were represented as shadowless; later shadows were regarded as merely a darkening of the light, more or less as a negation of color, as we know of Dürer.

The exact study and resultant understanding of colored shadows and colored reflections, as well as of the many different values of a single color in contrast with another, the "valeurs," is one of the achievements of recent painting. The exact observation

of values which closely approach one another in brightness or in color, as, for example, a white house and a white cloud in the picture in their subtle relationship one to the other, gives to a picture an especial charm.

Reynolds insisted that the principles of harmony demanded that all shadows should be nearly alike in color. Obviously such a harmony is relatively easier to achieve than one using colorful shadows.

Today color is demanded in all parts of a picture, not merely in the light masses and half tones. The rest was formerly frequently only a brown sauce.

Color is most effective when applied flat. Much modeling weakens the effectiveness of color.

By local color we mean the particular color of one object as distinct from that of another, for example, the color of a red gown as compared with that of a green gown. In subdued light a local color is most effective. Strong light tends to destroy the local color, just as a strong color partially or totally destroys the effect of light. Strong colors confined to one object have a hard, cut-out effect, which is quite natural since a harmonious relationship with the other colors is lacking.

It should therefore be realized that strong color and light must not be restricted to one object, but must be dispersed into other areas, or, inversely, that shadow tones must be drawn into different parts of the picture. This holds particularly for portraits and studies from life.

When light flows over color, it destroys the boundaries of a body and makes the colors brighter and more vibrant. Very bright light masses appear larger than equally large masses of darkness; they radiate upon their surroundings. In order to achieve this effect in a picture, the painter introduces the light areas in soft gradations, as if surrounded by a halo. Small masses of dark in large masses of light are eaten up, eclipsed by the light. If enough attention is not paid to this, they appear hard and abrupt in the picture. Vibration is one of the peculiar properties of light; it dissolves color areas and gives them an appearance of lightness.

Shadows and light stand to each other not only in the contrast

of light and dark [chiaroscuro], but also in that of coldness and warmth. Warm shadows imply cold light, and vice versa.

Shadow and light masses also stand in a color contrast of a complementary kind, as was expressed in the green underlying shadows of the early Italian paintings in contrast with the reddish-white light masses. All colors in a picture must be subordinated to the greater unity of the light and shadow masses.

With increasing distance the local color gradually disappears and approaches the tone of the atmosphere. This is similarly the case with distances in landscapes. Let one imagine a red roof at various distances. The more atmosphere comes between it and the observer, the more the red local color vanishes, until it finally is submerged altogether.

The plastic representation of an object is a very essential factor in the expression of a pictorial idea. The appearance of textural differences (texture) is dependent on the strength of the light and loses its effect with increasing darkness. Rubens followed this rule when he painted everything in the light opaquely as solid bodies, whereas the shadows he painted with glazes. Representation of textural qualities in a picture increases the effectiveness of light against dark, as well as of the color.

The unity of the light and shadow masses also calls for a uniformity in the means of expression; if the lights, for example, are everywhere opaque, the shadows must throughout the whole picture be painted as glazes.

The painter's means differ from those of the sculptor. In the case of the former we have to do with the appearance of form in space (not with form in itself), as it is exhibited in the many changes caused by light, shadow, color, and atmosphere. Forms are through these frequently destroyed; the single object no longer has a plastic effect by itself but only as a part of the whole in the surrounding space. Every object as a color value in the picture must be fitted into its proper place.

Through the elimination of details by the light playing over them, new and larger light and shadow masses develop beyond the individual objects, so that some parts of a body are bound up with the larger light masses and other parts of the same body

with the larger shadow masses. The realization of these larger forms is the problem of artistic vision.

A command of form in terms of drawing is a necessary requirement in painting. The painter who can draw will more quickly arrive at his goal. He can devote himself more to color effectiveness and will not torment the color so much in his search after the most expressive form. For all good color is useless if the form is not also satisfactory; in fact, it may even become a disadvantage in the picture, because one may hesitate to give adequate attention to the problem of form simply from anxiety lest the color of the picture be ruined.

Color as such, however, is not of secondary but of chief importance in a picture. But all color in a picture is bound up with form as long as we are not aiming simply at a kaleidoscopic effect.

A painting is the representation in color of three-dimensional space on a flat, two-dimensional surface. The purely pictorial means of expressing space are colored surfaces and the treatment of different materials (plastic, textural characterization). Along with these, drawing in line and plastic modeling must be considered.

Colors as such give the strongest effect when flat; this effect is lessened by modeling. The separate effectiveness of individual color areas must be preserved despite all modeling. One must train oneself, said Marées, never to observe an object by itself, but always in its relationship to its surroundings, how it here sharply separates itself and there blends with them. Through an exact study of these things one will soon be able to paint plastically without being obliged to model. At the beginning of his career a painter usually determines the relationships in his picture instinctively, whether it be balance and other necessary adjustments of the different parts of the picture, or the direction of lines, or the distribution of light and dark and also color. On the basis of accumulated experience and knowledge derived therefrom he will later come to a conscious practical use of certain rules, from which he has learned how and why some things result in a good and others in a bad effect.

The laws of composition give to the painter the rules for the systematic building up of his work. If one guards against sche-

matic one-sidedness, one can find here much that is useful. There is also here a legion of rules, and it is easier to demonstrate them on a finished picture than to build a picture in accordance with them. Well known is the triangular or pyramidal form, according to which, for example, many of Raphael's Madonnas are composed, and which was frequently repeated in religious Italian pictures enriched by vertical lines. Equally well known is the old division of a picture, no longer practiced today, into three color areas used separately in the distance, the middle ground, and the foreground. Vertical and horizontal lines are necessary for a clear conception of the picture; these must be felt even if they are not actually visible in order to give the picture and the movements of the lines stability, height, and breadth. How to use them is a matter of taste. The division of areas and lines according to the law of the golden section is demonstrable almost everywhere, whether it be done consciously or simply as a matter of feeling. The intersecting of lines and areas gives an illusion of space because it makes objects appear to be in front of or behind one another. Diagonals and their parallels lead back into the picture and create space. Parallel lines strengthen movement by carrying it on and assist in producing rhythms.

Symmetry and balance produce repose, their cancellation motion. In contrast with the absolute symmetry of conventional ornament, painting has to do with the distribution of the masses of light-dark, cold-warm, etc., in order to build them into a greater unity, creating a sense of balance in unsymmetrical terms, as Goethe said. A painter "builds" a picture in the sense of an architectural structure in color planes, and he creates a sense of space on a two-dimensional surface.

The aspiring, falling, plunging quality of the diagonal and related lines, the motives for the achievement of motion, is balanced by the restfulness and height and breadth of the vertical and horizontal lines. Sometimes, as in the paintings of Jan Steen, all the principal lines of the picture run to a single point, more or less together. With every movement one must think simultaneously of the opposing movement. The "contrapposto" of the Florentines, which in the figures of Michelangelo is expressed

with clear conformity to law, was a lesson in the combining of the main motion and opposing motion within the figure.

How is effectiveness in a picture achieved? Depending on whether the object appears as light on dark or dark on light, lighter on light, etc., a coarser or finer effect will be obtained, whereby the single object, which has already been emphasized, must not be permitted to fall out of the larger mass.

Color areas and the principal colors must be well balanced in the picture, and it is important where the color is placed. The predominant color must be repeated in the form of gradations and changes in the different parts of the picture, otherwise it will have a hard effect and function as a mere spot.

One should be clear from the start as to whether one wishes to build one's picture on light or on color. Most pictures are compromises between these two ideas. Strong light prevents a strong color effect, and, conversely, strong colors destroy the effect of light in a picture. The effect of cold colors, which recede, and of warm colors, which advance, is also to be studied. Only experimentation will teach one how two color tones which are mutually antagonistic may, by increasing the size of one tone, by introducing between them neutral tones, by varying the illumination in the direction of light or shade or merely brightening or darkening them each alike, by a strong pervasion of the harmonious ground tone in the picture, by overtrumping, by neighboring stronger effects, etc., be made to get along together without one's having to abandon the main idea of the picture. One must also consider how one can play one part of a picture against another and create interest in the exchange. But always the color effect of the whole, the effectiveness of the color at first sight, must not be overlooked.

Light and shadow must not become isolated, but must be united into large areas. Isolated light gives the effect of a hard spot. It must be spread over the objects in the picture in various gradations throughout the whole of the picture into a large, restful mass. The effect of light can be heightened or weakened by the surroundings. Surrounding darkness increases the light effect, but it appears glaring if the contrast is too sharp. The intervals here are very important, and the painter must study in

nature how small dark areas occurring in a large area of light are absorbed by it, and how the edges of surrounding dark areas are diffused by light, whereby the latter is expanded and softened. The appearance of being bathed in light, of radiance, is obtained by the use of very close values in brightness and very slight differences in the color and softness of the light. One may think of white clouds on a white ground. The principal light one tries, wherever possible, to lay over large quiet areas; conspicuous objects which call for detailed attention, such as hands and the like, are best kept in half tones, because small individual lights will break up the large area of light. Or the light must be spread beyond the object so that the light masses are not limited to a single object. The linear composition of a picture and the general movement of light in it must not be identical, otherwise the effect becomes hard and inartistic, the objective meaning of the picture becoming too prominent. Whether one places masses in strong contrast against one another or allows them to flow softly together depends on the feeling of the artist. Reynolds said very correctly that a representation, to be convincing, depended largely upon maintaining the same relationship of sharpness and softness as existed in nature. To take in nature at a broad glance, and to see it in its correct relationship and proper subordination of details, must be the constant aspiration of the artist. The special character and design of a picture are of chief importance; all manner of elaboration cannot correct the mistakes in a composition.

The Dutch arranged the masses of light and shade in a picture often in the simplest fashion. Often a diagonal would divide the picture into a light and a dark half, which in addition stood in a contrast of cold and warmth. From the light side parts were then taken over into the dark mass, and vice versa. It is very instructive to examine with how little a balance may be created, how a vertical line, for example, a tree, may act as a balance to a diagonal or a mass of adjoining dark area; how a single line is effective over a long distance, and how one may lengthen it or by separation apparently shorten it. Nearest and farthest, the largest and the smallest masses, were here placed alongside of each other in the picture in order to work through contrast.

The painter must decide what is for him the important thing in a picture, the thing he wants to stress, and sacrifice everything not pertinent to this idea. Color, form, movement of light, the line, etc., may be the essential thing. What can you do with these that no one else can do? Do that! said Lenbach. The setting free of the individual in man Schuch called the task of the teacher (according to Hagemeister).

One must from the outset think of the totality; through a clear construction of light, shadow, and color masses, through a clear development of spatial elements, the great total impression will be created. The general, dominant tone of the picture must be conserved, and the original idea logically carried out. Otherwise it is best to start all over again.

At the outset all details must be kept in the background, because they are only in the way, and they should generally be used sparingly. Repose must be played against motion; there must be contrast in everything, in form, in color, in line, in shadow and light, in the representation of textures, in the flat surfaces as well as in the plastic expression of form, and in warmth and cold.

Contour gives a flat effect to a picture and also makes forms as such flatter, because a sharp outline of a form works against its plastic effect. A gradual melting of the boundaries combined with cool, soft tones without great difference in value and absence of every hardness allows forms to recede and so gives them roundness. Receding and foreshortened forms always give a more tonal and cooler effect than forms which are fully struck by light. Hardness, warmth, sharp contrasts of light and dark, and strong colors seem to advance.

Form must always be rendered in its true relationship to space. This results necessarily in a less plastic effect as compared with sculpture, which has to do with the real object, the form in itself. Overmodeling destroys the effectiveness of the picture. The sum and substance of what has been said may be stated as follows: The cause of glaring color which falls out of the picture is the lack of harmony, of relationship of tones. An interweaving and repetition of the large, all-pervading, dominant hue of the picture in every other color produces harmony, the mood, as in the fog picture mentioned above, where all the colors were

mixed with gray. Here every color would fall out which was used as a purely local color and contained nothing or too little of the fog gray. Modification of the local color through saturation with the dominant color is the means of preventing this falling out of a color. All color tones must partake of the dominant hue. Theoretically one can form a mental picture of how a color which appears strong if seen close by may gradually be destroyed by an increasing veil of fog and atmospheric vapor and by being moved farther away from the observer. The knowledge of this phenomenon often stands the painter in good stead.

When an object in a picture appears separated, this can often be overcome by not restricting the color, light, or shadow to it alone but leading it out beyond it.

A feeble, dull effect can be improved by strong, sharply placed light or shadows and a strengthening of individual colors; and heavy tones can be similarly improved. Too harsh an effect may be counteracted by transitional, intermediate tones.

In cases where a dominant color is lacking, it can be produced by a general working through of a unifying basic color.

Here Reynolds' good advice may once more be referred to, that the proper relationship of softness and sharpness of tones be maintained by the painter just as it is exhibited in nature, so that his picture will carry the conviction of reality. One should through a thorough study of nature make this rule a part of one's equipment; one will then be able to profit by it.

Spoiled or overmodeled form is best worked again into a flat and gray effect by means of vertical or horizontal hatchings which are allowed to dry, after which the desired effect is more easily obtained.

As in the case of separate parts of the picture, the picture itself as a whole is dependent for its effect on its surroundings. It can be lifted to greater significance or killed by them, as many a painter has experienced to his sorrow at an exhibition despite the favorable appearance of his pictures in the studio. Colored light leads to deception regarding color values. Thus all colors in a forest are affected by green reflections. When the picture is brought home, it frequently falls apart, because the accommodating, harmonious, supposedly painted pervading green tone is

lacking. Hence painters prefer the neutral north light in their studios. Many painters tone their gold frames so that they will be more in harmony with their pictures. One first goes over the frame with a well-pressed-out, damp sponge. Then natural gypsum or chalk is mixed with gelatine solution (5%) or egg tempera and a little vinegar, and this mixture, which can be suitably combined with tempera color, is spread thickly over the whole frame. After drying, all the parts which are to appear again as gold are rubbed off.

What has been said in this chapter is intended only as a stimulus to experimentation and research, and is not to be taken in the nature of a cooking recipe.

3. Helpful Devices in the Building Up and Control of a Picture

The old masters usually worked from a carefully prepared drawing, which made it possible for pictures to be painted directly and without changes or experimenting in a comparatively short time. There are still painters today who do not set about painting until they have prepared a carefully thought-out plan, but they have become rather scarce.

Photography may render important service to the painter, likewise projection, especially to the portrait painter. However, only a competent artist is entitled to make free use of such aids, and that solely for the purpose of reducing time-consuming prepara tions to a minimum. The old masters not infrequently made small plastic models of their figures so that they might be able more intensely to study light and shadow effects; they also employed them in particular to study the foreshortening of figures. They also manufactured small stages for this purpose, that they might be able to study the effect of light and space under different illuminations and thus have a real plastic foundation for the development of imaginary situations.

Squinting with half-shut eyes when comparing the picture and the model enables one to determine the coherence of the larger masses in light, middle tone, and shadows. The "motive-finder" shows a section of nature by itself separated from its surround·

ings, and it can be adjusted in proportion to the size of the picture.

The most useful device for checking up on a picture is a mirror, which is so placed that one can see in it both the model and the picture at the same time. In this way one can check any mistakes in the drawing or in relationships and the proportion of light and shade in the picture. The black mirror, which one can easily construct oneself by coating over the back of a piece of glass with a dark varnish color—the best is asphalt varnish— reveals faults in the tonality of the picture by steeping all the colors of nature in the harmony of the dark ground tone of the mirror. One must realize, however, while using it, that it may easily lead to a considerable holding back of color, since it does not show its finer variations; but for just this reason it shows them more clearly in their relationship of light and dark.

A reducing glass gives a more concentrated effect of a picture and consequently of its defects.

A pure blue glass, neither violet nor green, will show whether the light strength of the warmer colors, which, like cadmium, by their glowing often produce strong high lights, really is sufficient. If it is not, the color will appear burnt. This is especially noticeable in a landscape of ripe cornfields or similar effects in which bright yellow plays a rôle.

The matter is of importance because, on the one hand, a yellow or a red which is insufficiently strong in light becomes dark when reproduced, and especially because pictures in such colors appear to advantage only under very favorable illumination; in less favorable light, such as that afforded at exhibitions, they show off badly because they do not have sufficient inner light of their own.

Colored glasses were often much used by painters in order to study the model under such effects. Glasses were placed by many painters on a part of the picture whose color tone they were seeking, and this color tested on the glass. Böcklin helped himself with all sorts of devices, pieces of colored material, papers, and such. Colored celluloid and sheets of gelatine may be used in place of glass in the manner mentioned above. Likewise trans-

parent stuffs, such as gauze, stretched on a frame were used on which to draw bodies in their foreshortening.

Candlelight or other soft light, such as prevails at dawn, reveals defects in the harmony of the picture and the lack of strong light in certain parts. The picture must hold its ground here, since one will not always be able to see it only in the favorable light of the studio, so that later one may not be disappointed in one's expectations. Here the favorable effect of deliberately built up white areas becomes especially noticeable. Such pictures, like those of the old masters, may be hung anywhere; even in the darkest corners they retain their inner light.

A plummet, a pantograph for tracing, a measuring stick, and also a reticle, such as Dürer used, can be of much help to the artist. The reticle consists of a rectangular frame covered with strings running parallel with the sides and forming squares of equal size. The picture is divided into proportional squares. By holding the reticle in front of the subject to be painted, its perspective foreshortenings and the proportions of the figures can be better controlled. The value of color charts and colorimeters is limited because the color harmonies derived from them are very restricted. In the realm of color the painter should proceed in the most subjective way, entirely in accordance with his feelings; and these everyday, commonplace harmonies are after all too ordinary to be followed profitably. To measure color and build the color scheme of a picture on these measurements, as Ostwald recommends, is such a repugnant idea to an artist that it should be promptly rejected. Any standardization reducing the use of color to a formula would be the death of the art of painting. All the labor and effort of the creative process and all the aids employed must remain hidden from the spectator. The sweat of toil should not be visible in the picture. Böcklin was right when he said that a picture should have the effect of a genial improvisation.

4. Oil Technique

With oil colors the difference between wet and dry color is very slight. Hence oil color is the best material for a convincing

representation where the exact reproduction of a color tone is of importance and where the aim is to register colors in their finest gradations ("valeurs"). No other material allows of such great variety in manner of treatment as does oil color. Its apparent ease of handling, which gives quick and immediate results, the easily obtained fusion and blending of tones, and the possibility of painting over and covering any unsuccessful work, of correcting and altering wet in wet, all these are reasons why oil painting has become the most widely practiced technique.[3] Oil color is the ideal material for the pictorial expression of form. The possibility of using it opaquely, as a glaze, or semi-transparently, to bring texture and impasto into contrast with thin, transparent color in a picture, permits of a many-sidedness of execution which is unobtainable in any other technique.

The drawing must be clear and clean, so that the ground will not be spoiled by it.

Charcoal, tempera color, and India ink are excellent for this purpose; pencil, on the other hand, is unsuitable, as it shows through thin color tones. Least of all, however, indelible pencil! It works itself to the surface through the thickest coat of oil color.

One naturally has the greatest freedom in the manner in which one may begin a picture.

It is of advantage to paint from darker into lighter values, but not from very dark into light; in this way the possibility is left open of strengthening in both directions, toward the light as well as toward the dark. It is best to lay the colors on the canvas fresh, without much mixing on the palette, without "tormenting" them, and without paying much attention to details. "Tormented" color turns dark. A certain looseness of application is necessary so that, when tones are applied one over the other, the lower ones are not lost through amalgamation but contribute their share to the effect. Thus especially the strong mixing of

[3] But it would be a mistake to assume that it is immaterial what one uses as a ground for oil painting because it is covered over anyway. In time the oil color becomes more transparent through the saponification of the white lead and other metallic colors, and it not uncommonly occurs that after a short time underlying color areas cause trouble by striking through.

complementary colors, such as green and red, with one another is the cause of later darkening in the picture, which is naturally increased still more by the use of solvent painting media. Oil color reveals its greatest charm when it is applied somewhat like a paste, has a buttery character, and at the same time is put on fluidly, wet in wet. Oil of turpentine or petroleum, especially additions of essential oils, dilute the color and take from it its beautiful buttery character. It is not well to begin with very thick colors, since the picture as a consequence may become poor in tonal variations. Frequently a fresh and too heavily applied color or a particular bit of modeling may be removed with the edge of the spatula—much as one scrapes a too thickly buttered piece of bread—to make the color looser and enable one to paint freely into it again. At the same time the outlines are often made soft and elusive by use of the fingers, whereby form acquires roundness and details may again be put in sharply. Plastic qualities may be obtained in this way without modeling, while keeping the treatment flat. The lower layers in a picture should be rich in pigment and poor in binding medium, so that they will dry rapidly and well. Opaque or body colors are therefore in order in underpainting. Here also the old painting maxim holds true, that one should paint fat over lean, but not to the extreme of painting over a very thin with too heavy a color. It must always be borne in mind that too much oil and binding medium are a constant danger in the picture, and they should therefore be used sparingly. In the modern picture opaque colors play a very important part. With them one obtains charming textural effects and increased brightness and luminosity of the picture. In contrast with the older methods, visible brush strokes are popular today, in fact, they may constitute one of the principal charms of a picture. Those parts of a picture which are painted opaquely hold up better than glazes, especially those painted with Cremnitz white, as may often be observed on old paintings. Pictures finished opaquely and with much body offer a greater range of tone values, and the effect of a picture is heightened as much in this way as through the employment of strong color contrast.

Pure oil color should be applied in thin layers rich, however, in pigment, and be painted over only when thoroughly dry.

Resin-oil color can be painted over when half wet; one must then, however, be very sparing in the use of binding media and glazes. As long as binding media, of whatever sort, are used sparingly and with proper caution, oil color is a thoroughly dependable material. Danger lurks not so much in the impasto as in the "sauce."

Colors too strongly mixed with oil may develop wrinkles or form a skin; they behave like heavy grease, especially when oil varnishes are used.

Finely distributing color with a soft, dry brush called a blender results in a very disagreeable smoothness. Years ago this was practiced to such an extent that it amounted to a hobby, and it deprived all pictures of their freshness. Rembrandt practiced it in his youth and put his accents into color which he had brushed out with a badger-hair blender. Sometimes painters use their fingers for this purpose, but this is dangerous because of the possibility of lead poisoning. Formerly also pictures were often rubbed down with pumice stone, ossa sepiae, and the like, and afterwards washed off with water, as is done in lacquering. Many cracks appeared in paint surfaces which had been polished excessively in this way. Aesthetic standards of today do not require the removal of brush marks. However, scraping with the palette knife of too heavily applied areas before further overpainting is to be recommended.

Oil color is usually applied broadly and in the consistency of a thick paste with bristle brushes, but often also with hair brushes where a finer, more draughtsmanlike, exact manner of representation is the aim. Very broad effects require the use of the palette knife. The success of each technical method must determine the choice. Each method has something to recommend it. Color which proves too thick can be lifted off while still wet with white tissue paper pressed against the canvas with the palm of the hand.

Very annoying is the "sinking in" of oil colors, so that the color effect can no longer be properly gauged. The cause of this is usually the absorption of the binding medium by too meager

or too strongly absorbent a ground or by too lean layers of underpainting; but it may also be caused by the evaporation of essential oils on non-absorbent underlayers. The use of very fat colors is no protection against this; on the contrary. Many painters believe it to be an advantage when color sinks in, because they imagine that such color stands up well later. This is a mistake. Such color can change very unfavorably when varnished. One should never paint on color which has sunk in, but should always first varnish it lightly or rub over it with painting medium.

Rubens avoided painting in such a way that the color sank in. The luminous clarity of his work was proof of the excellence of his technique. He painted with resin varnish and thickened oil and with Venice turpentine, so that his colors had so much brilliance and binding medium within themselves that, like Van Eyck's pictures, they had gloss without needing to be varnished. The binding medium of the underpainting was not absorbed by the ground, nor the binding medium of the top layers by the lower ones. Painting over fat, glossy underlayers, for example, those containing a considerable amount of siccative, with thin colors containing oil of turpentine likewise leads to "sinking in."

Today, perhaps somewhat narrowly, oil color is used almost exclusively as body color. Body color is airier and looser in effect than glazed tones. Its use in the picture is very advantageous on account of the body and textural charm of the material and the fine grays which can be obtained with it. Body colors show the brush marks; they accentuate the handwriting of the painter.

It is often urged against heavy impasto that it is impermanent and quickly deteriorates. However, unless one goes to extremes, the opposite may be safely asserted. A color rich in body, not overburdened with binding medium, is decidedly permanent and allows of opaque application. This is confirmed by pictures by Rembrandt and Titian, and by the portrait of Pope Innocent X by Velasquez at Rome. Resin-oil color is best adapted for heavy impasto. The less binding medium is used with it, the better!

Half-covering and covering colors in alternation offer the greatest charm.

It is often imagined by the uninitiated that opaque painting is only a caprice on the part of the painter. They fail to understand that a certain intensity of light and body cannot be brought out with other than opaque color. The dilettante in particular all too frequently confuses painting with tinting.

Used as a glaze, oil color gives transparency and depth of light, and at the same time great clarity. Glazed tones seem to advance. It would therefore be a mistake to use such colors as glazes as are intended to recede, such as those of a sky. Glazes require lighter underlayers and, since they are themselves without body, undertones with body.

The nature and purpose of glazing must be clearly understood if it is to be used effectively. As in the process of dyeing, it presupposes a lighter undertone, which is colored by the glaze but at the same time deepened. Only a white cloth may be dyed pink or light blue, a gray one permits only of deeper tones, a light red only of dark red to brown or black, etc. According to the same principle, a white undertone can be colored by the glaze in all directions in the picture, a colored or gray undertone proportionately less so according to its degree of darkness. On a gray ground glazed color is more or less dead. Therefore the old method of heightening with white was the technique which offered the greatest possibilities for glazing. For this reason it is best to glaze progressively from light into dark in order to create in the simplest way all possible gradations of the color values. The old masters of the early Renaissance often put glazes directly over white gypsum grounds, into which they put very thin or perhaps semi-opaque lights. The nature of glazing becomes clearer if, as an experiment, ultramarine in varnish is laid very thinly over a white and then over a black ground. One color is luminous, the other dead.

Glazes are best made with resin ethereal varnish or Venice turpentine with thickened oil. Oil alone becomes greasy, oil varnish still more so. "Glazes eat light and air," is the saying, and there is much truth in it. The colors take on a glassy appearance. If one paints with covering or half-covering tones into the glaze.

one may achieve a very charming fluid manner of painting and avoid the shortcomings mentioned above. The word "glaze" suggests the "glassy" effect it may give to a picture.

Accents of light and dark must always be put into a glaze to avoid the effect of flatness, and it is always best to paint into it spontaneously and alla prima, so that it will not kill or blacken the picture. However, if it seems desirable to change the tone of a picture, either in whole or in part, this is best accomplished by means of glazes, provided these are quickly painted into while still wet.

The painfully overdone final glaze of the "sauce" pictures with its unpleasant smoothness was an abomination against which Leibl justly protested.

Glazed pictures require much light and easily lose in effect when placed where this is not available. They then appear dark in comparison with pictures painted with body color. I once saw at the studio of a very able artist an altarpiece which possessed a dazzling effect of glazed, luminous reds and other colors. But this effect was lost when the picture was installed in the church, where little light fell on it and where at the same time light from windows behind the picture struck the eye. A picture with body color would have had more surface light and would therefore have shown to better advantage. Another time a painter came to me and complained that a sketch which he had painted in the open had a very bright effect, but that the picture painted from it appeared spotty and disjointed. The cause was the same. The picture was partially retouched with glazes. These naturally were poorer in light effect (the lights suffer particularly) than the other opaquely painted and unglazed portions. His sketches were all painted spontaneously, brushed in freely with body color, and hence had a unified effect. The most dangerous practice is to glaze some light parts in a picture and not others.

But here much depends on how the thing is done and who does it. Velasquez, Rembrandt, Frans Hals, and other great masters, and whole schools, such as the Venetian school, knew well how to handle glazes.

The old masters worked over the glazes with the fingers or the ball of the hand, and also with a rag, to bring out the finest

nuances. The glaze was applied not merely once; Titian himself testifies to 30-40 glazes, through which the picture was gradually deepened by the use of intermediate modulations and became colorful and mysterious. Interesting is a recipe for glazing offered by the court painter Stieler, whose pictures in the "Gallery of Beauties," including a portrait of Goethe and others, have remained surprisingly fresh in appearance. To a quart glass of poppy oil add a half glass of very thick mastic varnish, to this a lump of white wax about the size of a hazelnut, and let dissolve in slight warmth.

One can glaze with all colors, including white. The transparency of the varnish naturally enhances considerably the effect of a glaze.

Closely related to glazing is "scumbling" with semi-liquid, half-covering tones, which gives a loose, unifying effect and, after suitably prepared underpainting, greatly expedites finishing.

It is very advantageous to mix with all glazed tones a small amount of white; this does not influence the effect adversely, and it favors the preservation of the picture and facilitates painting over. By this means the vexatious cracking of the glazed tones when painted over can also be avoided. It is scarcely to one's advantage to begin a picture with glazes; they cause later darkening through the sinking in of the top layers unless they are immediately painted into with covering and half-covering colors while still wet.

By applying a half-covering scumble over a warm, for example, a brownish, ocherish, or reddish glaze, the so-called optical grays are produced, caused by the neutralizing media. The old masters frequently used them in transitions or half tones in flesh. They give effects which cannot be achieved by direct painting; tones which have been painted directly appear heavy by contrast.

TONAL PAINTING. In tonal painting one is concerned with the gradual enhancement of the color and form out of a single dominant color tone. The general effect of the picture is first blocked in loosely and sketchily with semi-opaque tones, usually brown or green. Into these tones middle tones are set fluidly in many gradations, giving the picture charm and richness. The dominant, basic tone, however, plays through all the tones and

gives the picture harmony, the larger tone, the unity of appearance and mood which is acquired by all the tones receiving something in common through mixture with the wet ground tone, which was formerly by tradition usually brown. Color as such is first subordinated; it appears as secondary and is only gradually emphasized. At first the picture appears weak to a certain extent and too flat; boldly emphasized lights and strong deepening of the shadows decide above all the effectiveness of the picture. Richness in values gives to tonal painting a singular charm which is enhanced by the absence of coarse effects and garish colors. Leibl's pictures and the early pictures of Trübner show to what fine, discrete effects tonal painting is suited. By the use of many variations of a single color in its subtlest gradations or nuances especially beautiful effects may here be obtained. Within each area and by the simplest means, slowly and by degrees the tones are strengthened, the color increased, and a falling out of colors thus avoided. The middle tone is the carrier of the pictorial effect in tonal painting. While painting even at the start it makes it possible for the painter to work deliberately in both directions, toward both light and dark. One should never waste one's ammunition prematurely but avoid too pronounced shadows and too harsh lights; this reserve brings its own reward. After the picture has been satisfactorily developed and seems to be sufficiently rich in values, one may at any time through the use of strong lights and rich, deep shadows give the picture freshness and immediate power and effect. The sharpest lights and deepest shadows must always be put in spontaneously and at the end of the work. If they appear lacking in conviction, the picture loses its charm. Here also belongs the technique of sketching in a luminous, warm, glazing brown (sienna, umber, gold ocher, etc.) and of laying freshly and boldly into this wet color the local tones, which should likewise be as glowing and luminous as possible, not dull. Toning down with gray, which may also be mixed in advance and in a complementary tone, will neutralize the color where this appears necessary. It will be seen that often a very slight amount is sufficient to give the color the desired effect without robbing it of its inner fire. The basic rule here is to build up the picture from the most glowing colors and then

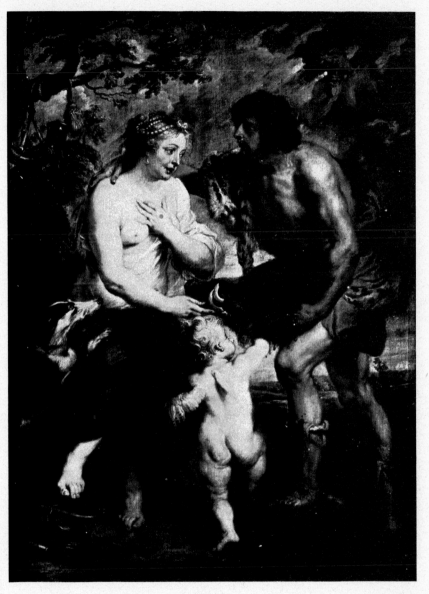

Plate 1

PETER PAULUS RUBENS: *Meleager and Atalanta*
(fragment) *Old Pinakothek, Munich*

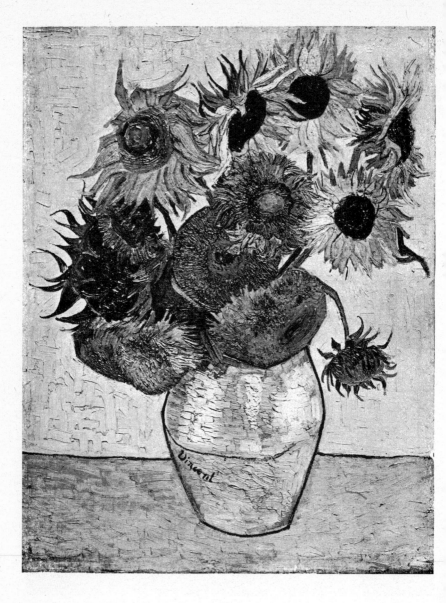

Plate 2
VINCENT VAN GOGH: *Sun Flowers*
New State Gallery, Munich

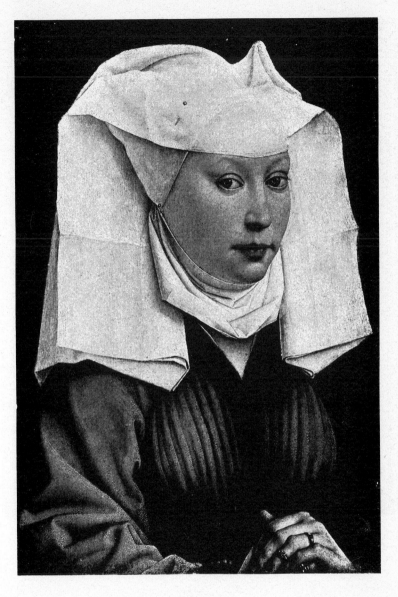

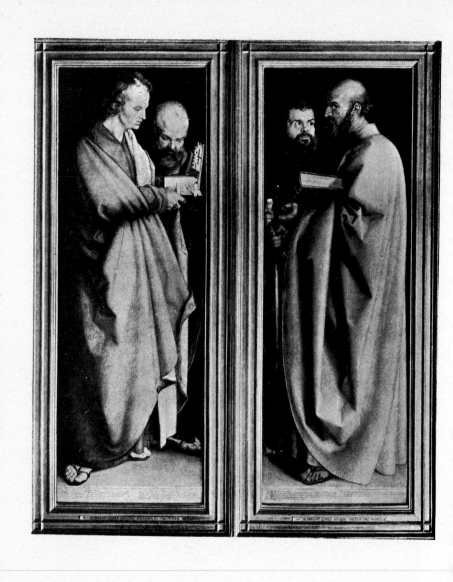

Plate 4
ALBRECHT DÜRER: *The Apostles*
Old Pinakothek, Munich

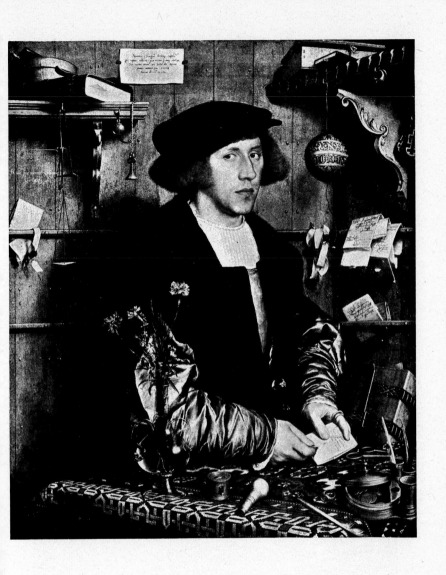

Plate 5

HANS HOLBEIN THE YOUNGER: *Merchant Gisze*

State Museum, Berlin

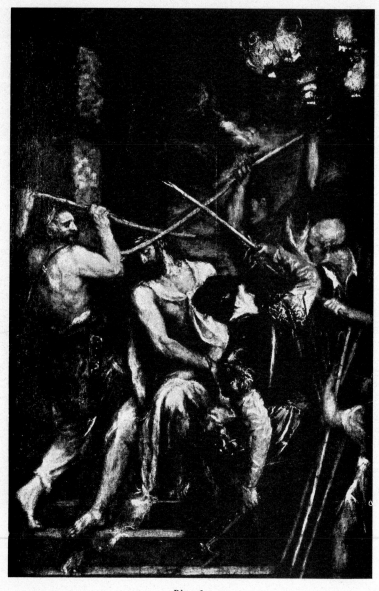

Plate 6

TITIAN (TIZIANO VECELLIO): *The Scourging of Christ*

Old Pinakothek, Munich

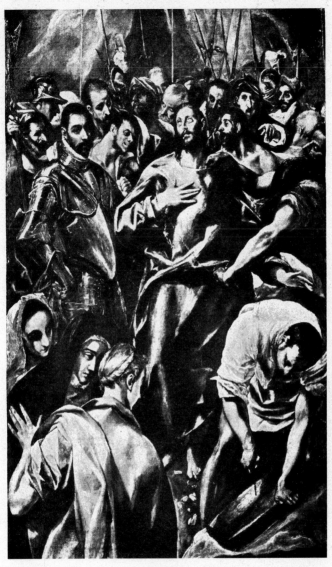

Plate 7

DOMENICO THEOTOCOPULI, called EL GRECO

The Disrobing of Christ

Old Pinakothek, Munich

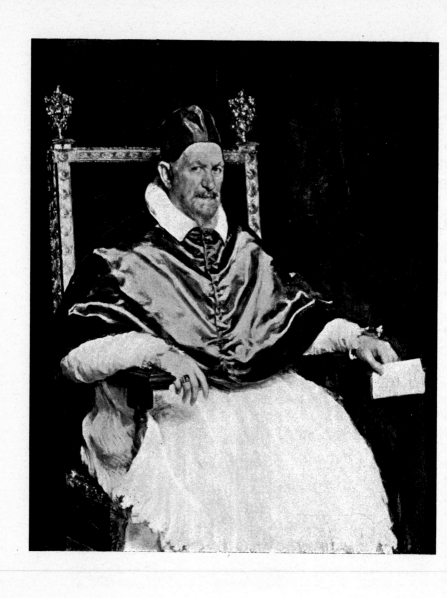

Plate 8
DIEGO RODRIGUEZ VELASQUEZ DE SILVA: *Innocent X*
Galleria Doria-Pamphili, Rome (Alinari Photograph)

tone it down to the desired effect with neutralizing, semi-opaque colors.

Inversely, one may at first hold the picture down to a gray effect and finally play into it a few stronger colors. In this manner one may preserve the harmony of the pervading gray ground tone, which should never be lost even under the strongest colors.

PAINTING IN CONTRASTING COLORS. The picture is here built up entirely out of strong color effects, the colors being used at once in their fullest strength and applied either with the brush or the palette knife, with which the color can be promptly scraped off so that only a very thin local color effect remains. The strong color tones are then modified by opposing, complementary tones or by grays. The at first too coarse colors are refined by superimposing contrasting tones (but not mixing them strongly together), and in this way harmony is achieved. To the beginner it is surprising how quickly and easily the warmest tone can be broken and rendered cool, and how the strongest color can be made to appear weak. One must start again from the beginning with strong color if the work threatens to become weak, must resolutely apply the strongest contrasts, the greatest warmth or cold, and then work them into a harmonious relationship without weakening the local color effects. Here one works toward an effect by continual comparison of the larger values. By this method of painting one can obtain extraordinary power and rapidity of execution.

While in impressionism plastic form and local color were subordinated to a momentary appearance of the totality of the subject, the painter of today creates his picture out of color contrast, starting with strong individual colors. Let us suppose that he is charmed by something in the quality of a strong blue. He seeks contrasts for it and builds his picture out of carefully gauged opposing colors. At the same time he experiments cautiously with contrasts, taking care not to jeopardize the quality of a color by altering it too much in the picture. For this purpose he places temporarily over parts of the picture pieces of colored paper or other materials in order to study the effect of a color he has in mind. Thus, without harm to the picture, he can

test the effect of a green dress in place of a red one, and so on. In this technique the "valeurs," the colorful single values, play an important rôle. The development of simple and coarse contrasts into a single great harmony, a pictorial whole, has a refining effect upon the entire painting. Color spot for color spot is carefully calculated as to its value and necessity to the whole, and the picture thus becomes unified. The finest effects are obtained through variations of contrast of a color in cold and warm, as perhaps the warmer red of the cheek in flesh against a cold, strong red of the lips.

It goes without saying that an artist sensitive to color would know how to arrange all colors so that they would blend into the dominant tone.

Today a flat, fresco-like appearance, a light and mat effect, is sought by many painters, who deliberately work in such a manner and seek a broad, flat, and tonal general effect through the avoidance of individually effective lights and shadows, etc. Light grounds, for example, chalk ground on cotton, often stained with ocher, offer the means for such treatment. The colors are laid on broadly and with little variation, and, when possible, the painting is completed, wet in wet, in one or two days.

Very liquid painting media, such as oil of turpentine with a little poppy oil, also purified petroleum, purified xylene, turpineol, Sangajol, decaline, and other essential oils, are used by painters, who thus use colors almost like water color. It is clear that in such painting one must be very sparing in the use of painting media which so strongly dilute the color. Many also employ a technique whereby they pull off with a palette knife, in fact, practically shave off, the thickly applied color in order to put into this flat color new colorful accents.

False color tones may likewise be removed by means of the palette knife, but not wiped out with oil of turpentine, because the quality of the color would thereby suffer, and cracks might also develop with thin overpainting.

Another practice has also developed of scumbling over such false color tones, after they have been scraped off with the palette knife, with tempera white used without medium. Egg-tempera or casein white are the best for this purpose. This prevents the color

put over this false tone from looking "tormented" or "drowned," with resultant loss in clarity and brightness. One can immediately continue painting on the tempera with oil, but preferably without oil of turpentine, rather with pure color. In a similar fashion Weimar "milk of figs" is also used.

Obviously no more than a general idea can be presented here, and every painter will have his own peculiar method, which will be determined by what he wishes to accomplish.

PAINTING ALLA PRIMA among the older schools was, so to speak, the crowning achievement, the ultimate in craftsmanship among artists. It was the fruit of long preparation and could be undertaken only with complete knowledge of the rules of the craft, as a brilliant summary of all the technical processes of picture building which the master might choose if he so desired.

Painting alla prima aims from the very start at the final effect of the finished picture, and attempts to arrive at that effect in the shortest and most direct way. In employing it one must therefore attend to color, drawing, and modeling at one and the same time. One of these is very likely to suffer at the expense of the others—according to one's personal capacity either the color or the form.

The importance given to the sketch is a result of the esteem in which alla prima painting is held.

Its advantage is the immediateness and freshness of presentation, to which many other things are and must be sacrificed.

A but slightly absorbent ground is a requirement for alla prima painting.

Many painters begin freely, without a preliminary drawing, and place color tone against color tone, spread out broadly one against another, in order, when a certain impression of the picture is obtained, to be able to balance the values in the whole picture against one another. In working without regard for anything but the immediate total effect, all details are sacrificed, and only when this total effect has been achieved are details added very economically. These can never improve the total impression and are never more than incidental embellishments which may be very effective in the right place, but may completely destroy the pictorial effectiveness of the picture if they swamp the larger

values. One can, when absolutely sure of oneself in an alla prima technique, sketch loosely on a good light ground and then complete the picture promptly by attention to light and dark.

A simple technique is always the best. All such tricks as scratching, scraping, wiping, lifting color off with paper, and the like are of no real advantage.

A fresh application of clear, simple, little mixed tones which are easily duplicated is essential. In the beginning the shadows can be made warmer and brighter, but the light should at first be a little colder and more subdued.

One should leave the highest lights and deepest shadows as far as possible till the end, when they should be set down with boldness and assurance. One should not play one's trumps prematurely, but should be free to work strongly in the direction of both light and dark, so that the total character of the picture is determined only at the end, and its freshness is thus preserved. A method contrary to this is that of putting in the deepest shadows as well as the highest lights at the very beginning and then adding the intermediate tones. Every painter must decide for himself how to proceed in every case.

It is wise not to put the colors on too thickly at first, but to postpone this until one is sure of one's intentions, so that at the end one may boldly emphasize those parts which are to determine the effect of the picture. Boldly placed color always has a good effect.

In alla prima painting the idea of modeling with white in the underpainting may be profitably employed, provided one does not paint with too much color at the outset. But that is always a matter for the individual to decide, who will be governed by personal preferences.

That part of a picture which is to be painted on may be rubbed over beforehand with painting medium, which, however, should be used as sparingly as possible, especially fatty oils, and all superfluous medium should be wiped off, for otherwise even alla prima painting will turn yellow. It is better, however, to set the colors flatly and disconnectedly alongside of one another, using the color just as it comes from the tube without painting medium. Our present-day tube colors are for the most part

already very rich in binding medium and have a tendency to shrink when drying.

Small pictures may under certain circumstances be completed wet in wet at one sitting. With pictures of larger size one must, in order to keep the painting wet, make use of suitable painting media, among which oil of cloves and poppy oil have come to play the most important parts, for example, two parts of poppy oil and one part oil of cloves without oil of turpentine. The spraying of the color with oil of cloves through a fixative blower as an emergency measure may be of great advantage in successive portrait sittings, but is not always without danger to the picture.

Mixed white or zinc white is best used when one has planned to paint wet in wet over a longer period.

Rapidly drying colors, such as cobalt colors, umber, Cremnitz white, and minium, must in this case be avoided.

All colors must be mixed from the start with white to give them body, and they should never be very thin in the lower layers; otherwise the top layers will sink into them, and considerable later darkening will result.

If the layer of color has become too thick, tissue paper may be taken and pressed with the palm of the hand against the paint and then pulled off and a new start made; or the superfluous color may be removed with the edge of the palette knife. Some painters work piece by piece, completing one area at a time, as Leibl did. He began without any special drawing, often with a light, sketchy underpainting, anywhere he pleased, for example, at the corner of an eye, and placed tone alongside of tone. Unsuccessful parts he scraped off with a razor. He devised all sorts of means of slowing up the drying of the oil: coolness, keeping the air away, and darkness.[4] The danger of this method of painting at the start without a design is that one is too apt to miscalculate the scale relations, particularly when one is forced to work too close to the model, a danger from which even a master like Leibl was not exempt.

Every technique which aims to realize at once the final color

[4] It was said he submerged his paintings in water, and I have heard it stated on good authority abroad that he kept a certain canvas submerged from day to day at the edge of a lake. [Translator's note.]

and form relations in their fullest development may be called alla prima painting. It may therefore also consist of painting in many layers of color one over the other, even on dried under-layers, provided the last coat covers all that preceded it.

Dangerous is the method of underpainting the shadows heavily and strongly with dark body colors like black, or giving to middle tones a similar quality, and then using color over this, particularly in the light areas. Such pictures later turn very dark despite a pure alla prima method, because the body colors sink into the wet black, which has a tendency to come to the surface.

Oil color should be applied heavily and not too thinly, for, as already stated, tube colors shrink somewhat. Today one wishes to see the handwriting of the painter, the brush strokes. The highest lights must be put in freshly and spontaneously; if they have to be changed, smeary spots result. For this reason they should be put down only once and at the very end, as also the deepest accents. To Rubens or Van Dyck the saying is ascribed: "As far as possible, always paint alla prima; there will be plenty left to be done at the end!" But in the case of the old masters one thing must not be overlooked, that under such alla prima painting there was a good, serviceable gray underpainting done by assistants.

Other painters go to work as follows: they start with a fresh alla prima painting and then scrape it off with a razor until only a very thin layer is left; this they let dry, and then repeat the process, in order to preserve the luminosity and clarity of thin color on white ground.

A striking example of this technique is Hodler's manner of painting a landscape out of doors. To begin with, he never used more than eight colors—madder lake, light ultramarine blue, oxide of chromium brilliant, cadmium lemon, light ocher, dark ocher, vermilion, and white. He began by making a drawing with the brush, the dark areas principally with blue and the light areas with madder lake; in this way he went into considerable detail. He thinned his colors with a little petroleum; then he painted very realistically and opaquely over this underpainting and promptly pulled off the color with a palette knife down to a very thin layer. In this way the color acquired a very loose character. Into this he again drew with a brush, then applied

color, and again used the palette knife. This is as far as he got at the first sitting. At the second and third sittings he merely checked his picture for mistakes and touched it but little.

Renoir (according to the painter H. Brüne) developed his pictures, which had been drawn in with pencil, out of very thin, luminous colors resembling a haze, so that he was never committed to anything definite; and it was only through many successive thin layers one over the other that the enamel-like effect of his pictures slowly developed. When painting flesh, he began with neutral grays in the main part, using but little red with them, and sought colors from the surroundings which would increase the effect of the flesh without his having to touch it. As a painting medium he used linseed oil and oil of turpentine. I cite this example here merely to illustrate how an accomplished painter understood how to adapt the technical principles of the old masters to modern aims.

A thick white gypsum ground on wood is excellently adapted for alla prima painting with resin-oil color. With this it is possible to achieve a luminosity which is otherwise foreign to oil painting.

The preliminary sketch and a light indication of form can be made in warm, thin, and very light ocher tones, in which excellent drawing can be accomplished.

Into this are set half-covering, light tones, such as white mixed with ocher, white and red, etc. These colors give a cool and fine effect in the ocher tones. The full color strength must be held back at first, and the tones of the background must not be brought too close to the flesh tones, so that they are not set off too sharply and one is left free to work without hesitation over the outlines of the forms.

All depths and sharp accents, such as the high lights and strong colors, are not added until later, when the effect of the whole has been completed. The shadows must remain thin and transparent, otherwise the luminosity is lost. By contrast the lights may be applied opaquely. The picture is built up of alternating layers of warmth and cold one over the other, which are nevertheless applied alla prima wet in wet. When the desired color strength and depth have been attained, the picture should be finished. If the work cannot be executed at one sitting, the

painting should be allowed to dry out for a few weeks if one places any value on the quality of the color.

Today it is a frequent practice, following the example of the French painters, to permit also in oil pictures the white ground to show through between the brush strokes, especially at the boundaries of the form, which tends to produce a scintillating effect and a flatter appearance similar to that produced by leaving the white ground uncovered in water color. The permanency of the white ground is naturally a preliminary condition.

But it should be emphasized that such a technique is mentioned here only as an example, and that it always comes to this, that each painter must seek his own method which will enable him most quickly to reach his particular goal.

It is a mistake to believe that alla prima painting is permanent under all conditions and not subject to later darkening and the like. Places in the picture which are put on very heavily alla prima and made especially smooth with the spatula turn extremely yellow, owing to the considerable amount of oil which comes to the surface when the color is applied in this way. There may be places in a picture which do not exceed a certain thickness, though they may be quite thick, which completely escape yellowing, while the same color in the same picture in thicker layers may change very annoyingly. Also a saturation of the canvas with painting medium because of too porous a ground, or poor grounds in general, may be the cause of considerable later darkening in pure alla prima painting. The painter should make it a rule to be sparing with every sort of painting medium.

A sketchy underpainting drawn in with the brush to facilitate putting in the color values and completing the picture is used by many painters.

This is carried out on a light ground with a lean color thinned with oil of turpentine to the consistency of water color and applied flatly, not modeled. Many use an underpainting in monochrome, for example, of green earth or brown tones, while others employ color approximating the correct local color. If one paints immediately into the underpainting in a covering fashion, the color will naturally adhere well. This is particularly true in tonal painting. If the underpainting has been allowed to dry well, and

if the ground was luminous, the best being white or a silvery gray, this will be a great aid to further work.

Such a sketchy foundation can, however, if it has not yet dried and is painted over, for example, on the next day, cause cracks in a short time, particularly if rapid-drying colors, such as cobalt, are put over it even in thin layers. Aside from this, a half-dried underpainting is also poor to paint over, because it cracks easily, especially when painting medium is used in the top layer. The painter believes that he has proceeded in a rational manner and cannot understand why his thinly painted work cracks so quickly. On thin underpainting it is best to paint promptly while wet with covering and opaque tones.

The sketchy underpainting should never be undertaken as a pure glaze, but always as half-covering with a little white, and the overpainting should follow in semi-fluid body colors without much binding medium; then all these drawbacks will be avoided.

PAINTING IN SUCCESSIVE LAYERS. *Under- and over-painting.* This old technique is based on the principle of division of labor. Whereas with alla prima painting drawing, modeling, and color must be undertaken at one and the same time, which renders more difficult a uniform completion of the various elements, by painting in successive layers the work is so divided that preliminary drawing, modeling, and also a slight addition of color are given over to the underpainting. Some painters employ an exact underpainting in all details, others block in the larger effect without regard to details.

The old masters carried out this technique logically when they put at the very beginning of the work the problems demanding expert craftsmanship, all troublesome drawing, and the main effects of modeling. Apprentices frequently carried out this preliminary work, which the master then used as a basis for an alla prima technique. In this way the freshness of alla prima painting was preserved, but one progressed farther toward completion than with the present-day type of alla prima work. With but few colors the old masters went through the whole picture, either with warm or cold tones, and laid others over them in such a way that the undertones were not lost, and the ground tone often co-operated with the shadows and intervals. From what has been said

it follows that the division into under- and overpainting is made for the purpose of painting pictures after the fashion of the old masters and is not for studies.

A properly executed underpainting should also serve to simplify and, through attention to preliminaries, relieve the overpainting, which, if possible, should be done alla prima.

An underpainting which closely corresponds to the color and light values of the projected final effect may easily lead to a painting's losing its freshness. An underpainting in contrasting colors, for example, a red with green, is of value only if one wishes to obtain dull tones, because by this method the colors are partly broken. It must be kept in mind that successive warm tones enhance each other, and that warm over cold tones weaken each other. The harmony, the large tone of the picture is without doubt easier to obtain with unified underpainting of the whole picture than with a local color or contrasting color in the under layer, which tends to make a picture fall to pieces. (See also page 30 for the effect of colored grounds.)

To complete the picture with the least effort, with few accents and a light scumbling over the tones of the underpainting, requires self-assurance and a clear determination, otherwise a tiresome patchwork will result in which all freshness is lost. Too close values over each other in the under- and overpainting may likewise become lifeless. A few simple, light tones not strongly mixed are the best. A light gray underpainting in the flesh is always profitable. If the underpainting has been overdone, if the modeling or work in general is unsatisfactory, this may be corrected with a gray, loosely applied, flat, unmodeled tone of the value of the place to be corrected. After a thorough drying this may be painted over anew.

If strong, approximately final reds or yellows in the flesh parts were used in the underpainting, they must be gone over very thinly and in a scumbling manner, otherwise the color effect will be hard and heavy. A strong color tone in the underpainting into which one must still subsequently work because one is forced to retrieve or improve the drawing loses in effect and becomes a liability, because in the pains taken to preserve it it is usually dealt with much too timidly. If one paints over it and thus says the

same thing twice, the result is no better. Hence the color should be held back as much as possible in the underpainting, and one's attention be given entirely to the perfection of the drawing and modeling.

Shadows must be kept looser and warmer, lights, on the other hand, cooler and more subdued; no harm is done if the effect is at first weak. The work as a whole should be rather flat in treatment, not strongly modeled, and should have in general a lighter effect than is planned for the final picture because of the danger of later darkening of the oil colors.

Underpainting is not intended to be overpainting, and must not anticipate this. Single high lights and strong depths, as also all details, belong to the overpainting and only interfere with it when they have been introduced prematurely.

A correct underpainting must be meager in quality. Only in this way is it possible to paint over it successfully. It must be rich in pigment and consequently in body color, and proportionately poor in binding medium, so that it will have a mat effect when dry. Glossy color is hard to paint over. The addition of oil of turpentine in small amounts to the painting medium no doubt makes the color leaner, but it also takes away its body. The underpainting must be thoroughly dry, otherwise the overpainting will suffer and the picture eventually darken. For practical reasons it is desirable that the underpainting dry rapidly. Therefore frequently siccative is added. As has often been said previously, however, only a little should be used, 2% of the painting medium. I have always found it more effective and less dangerous to mix with the tube white a quantity, about ⅛, of dry, pulverized Cremnitz white. This can easily be done on the palette with the aid of the palette knife. By this means the underpainting becomes richer in pigment, since it should be covering throughout, and more agreeable to paint over. This method is of especial advantage when doing portrait work.

The requirement that the underpainting be of a lean character is easily met by an underpainting in tempera. It allows of an easy sketching in of the drawing and a rapid blocking in of the main ideas. It also dries through rapidly and firmly and can be painted over almost immediately. The principle holds here also

that the underpainting in tempera, whose sharpness favors the requirements of good underpainting, must be kept low in color and light. Otherwise the varnished tempera color will appear to "jump out" of the picture and the oil overpainting have a dirty effect. Tempera used as underpainting for oil gives great luminosity to the colors.

Tempera, especially lean tempera, has the advantage that it quickly becomes hard and at the same time insoluble with respect to the binding and painting medium of oil colors. As a result, one can easily remove an unsuccessful overpainting without disturbing the tempera base. In pictures of the old masters one can often observe that the cool, gray tempera body, weak in color but rich in body, is still standing undisturbed, while the resin glazes and oil colors over it have vanished.

Naturally only egg or casein tempera is suitable for such underpainting, and never gum arabic distemper.

Water color as underpainting for oil can be used only in very light tones over white ground. Very light colors put down directly change but little when varnished. Deep tones strong in color fall out of the picture when the necessary varnish is applied and give a glassy effect; they are not favorable to overpainting and are not in sympathy with oil colors. Water color covered over with glue size was formerly used as underpainting for finely executed works.

The worst possible underpainting is fat oil color rich in binding medium painted on with fatty oils or resin ethereal varnish. Every color stands poorly on this "sauce," which cracks very easily and suffers from later darkening, particularly on not thoroughly dried underlayers.

The underpainting should not contain pure white spots of oil color, because experience has shown that glazes in madder and umber put over them adhere poorly.

Overpainting. Overpainting, as already stated, should be as far as possible alla prima painting. Only by this method can freshness be obtained, and, since the task of drawing and of plastic modeling with white has already been accomplished in the underpainting, one is here left free to devote oneself to the development of color effects. Especially suitable are the resin ethereal varnishes

mixed with fatty oils or Venice turpentine with thickened oil. It is of advantage to begin with a "frottie," a sort of semi-opaque glaze, and also to give each color at least a small addition of white so that it will not crack, and then complete the picture or part of the picture alla prima with vigorously applied color tones. An example of such a technique, where the opaque resin-color tones appear to be floating over the underpainting, low in color but solid in body, may be seen at its most beautiful in the portrait of Pope Innocent X by Velasquez in the Doria Gallery at Rome.

Obviously it would be very bad to construct a picture entirely of glazes, because such a picture would be lacking in all the charming qualities which color normally used possesses. Glazing should always be regarded as a means to an end and not as an end in itself.

Rubbing over the underpainting with oil and painting into this is not to be recommended. The greater transparency of resins and their leaner nature give a much better effect.

Very dangerous is the practice of dissolving the surface of the underpainting with a solvent medium, such as oil of turpentine or copaiva balsam oil, etc., and bringing it together with the paint rag or brush into a soft, blended effect, into which to paint. No wonder such pictures darken rapidly or become black, because the underlayers of the picture are also affected.

The overpainting must be applied somewhat more liquidly— at least in the first layer—than the underpainting. Fatty oils, such as poppy oil, linseed oil, or even nut oil, are used in conjunction with resin ethereal varnish. The color here must be somewhat fatter than the underpainting, according to the old rule of the craft: fat over lean.

Very heavy impasto in the underpainting should be scraped off. How far this should be carried depends on the character of the work. The scraping and scratching of paintings is practiced by many artists in order to make the color looser. Surfacing with abrasive materials, as was formerly practiced, is dangerous for the adhesion of the top layers, as is also washing off with water or even with lyes.

What has been said regarding alla prima painting holds also in general for overpainting, particularly that lights and shadows ap-

plied boldly and spontaneously at the end give the picture fresh-
ness and clarity.

The better and more definite are the preliminary drawing and
modeling, so much quicker, fresher, and more complete is the
work of overpainting. Glazes, to repeat this once more, as a
final effect spoil the picture.

It must always be borne in mind that modeling in light and
dark should at the start be attended with restraint. This may be
varied according to taste. Thus one artist may prefer to suggest
local color and heighten it with white, while another may build
his picture in light gray or sketch it in a color, for example, green
earth, etc. There are possibilities enough, if one will only remem-
ber the basic principle: underneath light and moderately devel-
oped form, on top color and strengthened modeling.

If one has gone too far with color in the overpainting, the
effect can be modified by vertical brush strokes of light gray (or
a contrasting color, such as green in flesh); overmodeling in flesh
can also be relieved through similar treatment. It is best to make
the brush strokes vertical, because in this way they give a two-
dimensional rather than a plastic effect, and also to allow the area
to dry well before further overpainting.

Intermediate varnishes serve to moisten the dried color layer of
an underpainting, in order to bring about a good fusion and co-
hesion of the colors and to permit of painting again wet in wet.
The use of fatty oils by themselves for this purpose is not to be
recommended because of their tendency to turn yellow and also
become greasy. Resin ethereal varnishes, such as mastic or dam-
mar, painted very thinly either by themselves or with additions
of fatty oils in moderation, thinned with some oil of turpentine,
are good intermediate varnishes. An intermediate varnish should
be applied exceptionally thin, all excess should be wiped off, and
its solvent action on the underlayer should be as slight as possible.
Copaiva balsam and its oil, oil of spike, etc., must therefore be
strictly avoided.

The intermediate varnish is also employed in places which have
sunk in. These must not be painted over without first having been
brought out by means of a light varnishing.

Vibert varnish, a thin, liquid solution of dammar in repeatedly

fractionated petroleum distillate, has proved good. Not to be recommended are intermediate spirit varnishes, such as the French Söhnée-frères varnish, a solution of resin in alcohol perfumed with lavender oil, or solutions of shellac with oil of spike, and the like, because, while they dry fast, they become brittle and form a heterogeneous intermediate layer between the color layers. Just as undesirable are solutions of isinglass. Van Dyck used Venice turpentine thinned in a water bath with oil of turpentine 1:2 as an intermediate varnish for portraits (according to De Mayerne). I have heard of painters of miniatures rubbing over the place to be painted with saliva, which is actually an emulsion. Formerly egg-white intermediate varnishes were used, which are absolutely to be condemned. They were applied to render the picture visible in all parts and to avoid having to varnish it too soon. The white of egg was wiped off the picture with water before applying the resin varnish. Through the action of light, however, the egg white solidifies, will no longer dissolve in water, becomes very brittle, and turns brown. Hence it creates exactly the opposite of the desired effects. The expedient of laying still another fresh egg-white varnish over the old one, by which means the old one is dissolved, and then wiping off both together, naturally only makes matters worse.

Retouching. If one wishes to make a few changes in the already dried color, for example, in the flesh, it is best to paint over a somewhat larger area up to a convenient point, so that one will not be annoyed by parts "falling out" after drying. Light areas must always be painted over entirely; in shadow areas desired changes can be effected by a few deeper accents. Portions which are to be retouched and corrected should be completely dry. They must then be rubbed over with varnish or painting medium, all surplus wiped off, and the spot underlaid, but not thickly, with slightly lighter and colder tones, over which the paint should be scumbled while still wet or, better, when dry. Otherwise such spots turn yellow and brown in a short time and "jump out" annoyingly, particularly in the light areas. Cleaning out defective passages with oil of turpentine is less advisable; they would have to be painted over thickly and only after they had dried. It is well to scrape or rub off such spots and then paint them freshly

with lean color. In recent times scumbles have been applied to wet colors with Cremnitz white in tempera to prevent sinking in. Weimar "milk of figs" is also similarly used.

THE DRYING OF OIL PAINTINGS. Light, air, and warmth accelerate the drying of oil paintings (page 97). The best a painter can do is not to interfere with the natural drying process of fatty oils. There are stories enough about pictures which were placed in the sun—and ruined. Van Eyck is said, after such a misfortune, to have looked for a new medium and thus invented oil painting. However, this is just another story. Eibner has demonstrated how the fatty oils lose their volume under direct sunlight, linseed oil 20%, poppy oil almost entirely, and that cracks are inevitable. Moreover, when a picture is exposed to the sun, the ground contracts, as do also the frame, the canvas, and the panel. Even the completely dried picture should not be put in the sun. Freezing temperatures may also cause fissures in freshly applied paint. The yellowing of the fatty oils begins the moment the top surface dries; hence the pictures must be exposed to the light until they have dried in order to prevent this as much as possible. Placing them with their faces to the wall, which is a common practice, inevitably leads to yellowing.

The drying power of the oils and of painting media is variously influenced by different pigments. Minium, umber, and oil white dry very rapidly, vermilion and madder very slowly.

The saponification of white lead by the oil takes from the body colors some of their covering power, but increases their firmness.

The oil color in the picture quickly undergoes a slight change, due partially to shrinking, saponification, and yellowing, the so-called mellowing of the picture, which increases its tonality and harmony. After a further period of time the picture begins to turn brown; it takes on the well-known gallery tone. I recall a statement of an old painter friend of mine which has today been confirmed by the recent work of the *Wissenschaftliche Versuchsanstalt*,[5] at Munich: An oil painting requires from 60 to 80 years to dry thoroughly. Ostwald made the already-mentioned proposal, in order to avoid the disadvantages due to the aging of oils,

[5] Institute for Scientific Experimentation.

of using very porous grounds which would absorb the greater part of the oil, and later supplying resin varnish in place of what was absorbed. The evils would by no means be avoided in this way; the increase in the amount of binding medium would not only harm the picture optically, but also its later preservation. The tones would lose all their airiness, and the threads of the canvas would quickly rot owing to the oxidation of the oils. A very unpleasant phenomenon in modern painting is the frequent blackening of oil paintings, which is much more harmful to the effect of the picture than is the gold tone due to yellowing. This blackening is chiefly caused by an excessive use of essential oils and balsams, such as copaiva balsam, with their solvent properties, but also by an uncraftsmanlike development of the picture, as, for example, when glazes are used to excess, or too much binding medium is used, or there is a fusing of complementary colors, which cancel each other. Also especially prone to blackening are "tormented" colors, that is to say, colors which have been manipulated to excess.

THE FINAL VARNISH. The longer the picture has to dry, the better. If pictures are varnished too soon, as long as the color layers have not yet dried and are still "active," that is to say, as long as the binding medium is still contracting, the layers of color will crack. Coats of poppy-oil color are naturally the most dangerous. The varnish must not become harder than the surface of the picture, otherwise cracks are inevitable. The picture should be so painted that it does not have to be varnished within any definite time. It should appear neither too shiny nor too mat. Pictures whose binding medium has for the most part been sucked out of the layer of color by strongly absorbent grounds necessarily lose much of their charm when varnished, and may suffer changes in color similar to those of tempera. Best suited as a final varnish for oil paintings are resin ethereal varnishes, mastic or dammar, which should be used dissolved thinly in oil of turpentine (1:3). (For the preparation, see page 130.)

The varnish should not be alien to the body of a picture. The much-praised synthetic varnishes give rise to very serious objections because they are not compatible with fatty oils and oil of turpentine. Absolutely ill-advised is the thinning of the varnish

with oil of turpentine just before it is applied, because the varnish does not always combine with it at once, and the free oil of turpentine has a solvent action on the picture. It is well to warm the varnish when the weather is cold, but one must be careful not to apply it hot, because hot oil of turpentine is a very strong solvent and disintegrates color layers which are not thoroughly dry. In no way suited to varnishing pictures are oil varnishes, such as amber varnish,[6] copal varnish, or coach varnish, which is a copal varnish, nor, as is self-evident, linseed-oil varnish, although, curiously enough, this is sometimes used. I have even found gum arabic applied over oil paintings, where it is naturally absolutely unsuitable and cracks badly. Just as unsuitable are mastic and dammar cooked in oil. The trade mastic and dammar varnishes often contain considerable amounts of fatty oils, which are here entirely out of place and inevitably bring about a yellowing of the varnish. Strong yellowing is often attributed to mastic, but it is certain that a trade product cut or mixed with oil is to blame. The fatty-oil varnishes cause much yellowing, have an unpleasant greasy shine, later become muddy, and are hard to remove from the picture. Spirit varnishes must never be used, whether mastic or shellac and sandarac or the like; they become very hard and brittle and are the frequent cause of cracks in a picture, even with an addition of castor oil.

When varnishing a picture, one should make sure that it is as thoroughly dry as possible. It must not be sticky anywhere, and the longer the varnishing can be delayed, the better. The picture should be varnished in a moderately warm room, but it should not be brought in out of the cold and varnished at once, because moisture may be condensed on it, which, if incorporated with the varnish, will cause it to turn "blue." All dust must be wiped from the picture with a dry, soft cloth—under certain conditions bread and kneaded rubber will help—and the varnish applied thinly and lightly with a broad brush from a flat dish. The varnish must go on easily and should not shine too much; if it does, it makes the picture hard to see at certain angles and takes away much of its

[6] Even though old recipes advise it. For the present-day poppy-oil color is much too soft for so hard a varnish, aside from the changes to which it is subject.

airy charm. Opaque colors suffer if varnished too much. They lose in airiness and body. A piece of cloth dipped in varnish and pressed out lightly may be used to go loosely over very heavily painted places, which will suffer no injury. The purpose of varnishes is to make the picture equally visible in all parts and to protect it from the effects of the atmosphere, harmful gases, and moisture, to which purpose the resin ethereal varnishes are much better suited than the fatty oils. The gloss of a varnish is not always desirable, but neither is it the object of varnishing.

A bad feature is the troublesome "bluing" of many varnishes, particularly over dark and glazed tones, which probably can be traced to moisture in the varnish. When varnishing a picture one should therefore avoid draughts, and one should use oil of turpentine which is as free from water as possible and warmed resin for the preparation of varnishes. Precautions against and remedies for this bluing will be found in the chapter on "Restoration." In older technical works one is advised to wash off a picture with water before varnishing, a process which recalls the technique of lacquering and which in both cases probably rested on the use of fat oil varnishes, over which it would otherwise be difficult to apply layers of color or varnish. Next to the washing off of oil pictures, the smooth surfacing of the separate layers of color was much practiced, not always to the advantage of the picture.

Today all such methods are superfluous, as much so as the formerly much-practiced pre-varnishing with egg white or egg white and sugar, which is very apt to turn brown, becomes hard under light, and by washing can be only partly or not at all removed from the picture. To the mastic or dammar ethereal varnish perhaps 2-5% of castor oil may be added to make it more supple, especially in the case of old pictures.

While drying, the varnish must be kept free from dust. Pure mastic or dammar ethereal varnish dries out in full light in from a half to a full day. Varnishes containing oil, on the other hand, often remain sticky for weeks. It is to be unqualifiedly recommended that an artist prepare his own varnishes. It is simple to do and gives the assurance that the varnish will not spoil the picture by yellowing.

Mat varnish is prepared by a very slight admixture of white purified beeswax (dissolved 1:3 in oil of turpentine) with mastic or dammar varnish. Some painters prefer to cover a regular dry picture varnish with this wax mixture, because it is easier to remove. It is applied rapidly in successive areas, and all superfluous material is wiped off with a rag. The "air gun" which is used so much in the trade has also recently been employed in the application of varnishes, particularly by restorers, who prefer an extremely thin and even coat of varnish.

CHAPTER V

TEMPERA PAINTING

The special character of tempera rests on the fact that it is an emulsion. An emulsion is a watery, turbid, milk-like mixture of oily and watery constituents.

Usually oil and water separate. There are, however, in nature a large number of emulsions, such as egg, especially the yolk, milk, and the milky juice of young sprouts of the fig tree, the dandelion, the milkweed, etc.

Artificial, such as gum, emulsions have not the good qualities of natural emulsions.

Emulsions may also be formed through the saponification of oils, resins, fats, and waxes by alkalis. Soap is such an emulsion. Natural emulsions, such as egg and casein, the curd of milk, adhere well to all painting grounds, to thin as well as fat, even in wet oil colors; artificial emulsions adhere only to grounds which are free from oil. Natural emulsions with the passing of time become insoluble in water, they "set," whereas artificial emulsions remain permanently soluble.

Tempera, despite its oil content, dries to all practical purposes, if not in reality, with the evaporation of the water. This rapid drying is very advantageous.

For the preparation of an emulsion the fatty, drying oils may be used, especially linseed oil, poppy oil, nut oil, sun-thickened oil, boiled oil, oil varnish, coach varnish, resin ethereal varnish, and also wax.

The addition of non-drying oils to an emulsion is absurd. This makes tempera "smeary." Siccatives in tempera are illogical. They serve no useful purpose and merely take away the freshness and clarity of the colors.

An excess of fatty oils causes yellowing and browning, as in the case of oil colors, and makes the tempera hard to handle. It must not be believed that, in contrast with oil colors, tempera is unchangeable under all circumstances. Tempera colors can crack,

turn yellow, or darken just as easily as oil colors in unsuitable combinations, for example, with too great a quantity of fatty oils and too little pigment.

Balsams, such as Venice turpentine, may be used for emulsions, but, if used to excess, they tend to make the brush sticky. Copaiva balsam is best not used at all.

Soap, glycerin, honey, syrup, and crystallized sugar, which are intended to improve the emulsion, are unnecessary and harmful additions. All these substances remain permanently soluble in water and prevent the "setting" of the color. When used in large amounts they injure the tempera, which under these circumstances can become as black as any bad oil color. Honey effloresces, forms granular crystals, and liquefies and exudes in dampness; syrup and crystallized sugar are no better and just as superfluous. Many tempera recipes call for extravagant amounts of glycerin. Particularly Friedlein's require incredible amounts. Glycerin has a great affinity for water, absorbing it in considerable amounts and throwing it off when drying. To be sure, very thin layers of glycerin become oxidized in time, but this is a very slow process, and before it is accomplished, enough damage will have been effected. There is no end to tempera recipes. Their number is incredibly large. Most of them are not only useless but definitely harmful. All kinds of substances are mixed together in ignorance of their behavior and effects, in the quiet hope that something useful will result.

Purified ox gall is used when an emulsion separates. We do not require it, because nothing is simpler and more reliable than the preparation of an emulsion according to our method.

Neither a mixing bowl nor half an eternity for beating is required, as in the case of mayonnaise; all one needs is a clean bottle. The best is an old varnish flask. The substances to be emulsified are shaken together well in the flask. The emulsion is formed in a few seconds, and it never fails if the rules are followed, that the substances to be emulsified be of thick consistency, such as yolk of egg, and that the admixtures, such as resins or oils, be also used thick: thus, for example, dammar varnish, which is especially good in tempera, dissolved 1:2 in oil of turpentine, or thickened oil and the like.

Emulsions can also be prepared by stirring and beating with a soft, long-haired brush or by similar mechanical means. The above method, however, is the simplest.

An emulsion should be simple in its composition—an oil, with or without a resin, but not all sorts of things mixed together.

A good emulsion, when brushed on paper, should dry without leaving a grease stain; despite its content of oil it must mix with water in all proportions and dissolve in water without forming lumps. Emulsions appear milky white because of the intimate mixture of oily and watery particles, but they dry cléar after the evaporation of the water.

Emulsions serve as grinding media for tempera colors, as well as for painting media. Colors ground in an emulsion can be painted with water or with a thin emulsion. In the trade the term "oil tempera" is used to designate a tempera made from an emulsion, because tempera colors are also made with glue.[1]

I. NATURAL EMULSIONS

EGG TEMPERA.
One measure = the content of the whole egg, an equal measure of oil, thickened oil or resin varnish, stand oil, coach varnish, etc., and up to two measures of water are put one after the other into the flask, being shaken well each time. The order of the ingredients is important, first oil, then water, otherwise the emulsion will not be a success.

Oils or thickened oils, oil varnishes or resin ethereal varnishes, can be used in any desired proportions, for example, $\frac{1}{3}$ linseed oil and $\frac{2}{3}$ dammar varnish, or $\frac{3}{4}:\frac{1}{4}$. With oils and oil varnishes the emulsion is fatter, with ethereal varnishes thinner.

If resin varnish is used alone, the tempera becomes very thin. It is then suitable for unvarnished tempera. If a strong binding medium is desired and little difference of color values after varnishing, one may add linseed oil, stand oil, thickened oil, and also, for decorative purposes, good linseed oil varnish or coach varnish.

The binding power is still further increased if, in place of

[1] Such colors are now commonly distinguished as "distemper" colors. [Translator's note.]

water, one adds a 5% gelatine or glue solution. But in this case it is recommended that the picture be tempered with a 4% formalin solution, provided it is not, or is not until later to be, varnished. By this means the glue becomes waterproof. When painting on gold ground, an alum solution (1:10 in water) is added to the emulsion in place of water. If one wishes to preserve the emulsion for a longer period, very little water is added at first, but either water or a glue solution is added immediately before use.

For practical purposes, when making a tempera emulsion, we use the whole egg, both the yolk and the white. Naturally one can also make an emulsion with the yolk alone.

Egg yolk consists of more than half water and perhaps 30% of non-drying oils, the egg oils, which keep egg tempera lastingly pliant. Vitellin, an albuminous substance present in egg white and the yolks of eggs, increases the capacity for forming an emulsion.[2] Yolk of egg will absorb an amount of oily substances equal to its own oil content.

White of egg contains considerable water, about 85%, and but very little oil, ½%, along with about 12% albumin, the specific adhesive substance of the egg white, of which the yolk contains more, about 15%. Egg white becomes hard when heated to about 70° C., but also when simply exposed to sunlight. In its hardened condition it is insoluble in water, like the glues, which are also albuminous substances; in a fresh condition it can also be made waterproof by spraying it with a 4% solution of formalin, or likewise by additions of tannin or alum. The freshness of the egg is important for the quality and permanence of the emulsion.

Artists are often disturbed by the yellow color of the yolk, especially when using it with white. But it bleaches out in a few

[2] According to Dr. Eibner, lecithin, not vitellin, is the emulsifying constituent of the egg, which, however, for our purposes is of little importance, because we cannot separate this substance from the yolks. Tests which I made with lecithin derived from soy beans did not give satisfactory results. Its emulsifying power and qualifications for painting were not equal to those of the yolks of eggs, and the substance scarcely dried—in thick layers not at all. The trade product is said to be frequently mixed with fatty oil, especially castor oil. Perhaps that is the reason for these results. In any case there is nothing more practical for the painter than the egg. It is very probable that there are still other substances along with lecithin which are effective and favorable to our purposes.

weeks and is then no longer objectionable. The egg emulsion dries, forming a very elastic skin, which becomes waterproof and unusually hard, much more resistant than oil color.

If, after drying, oil particles appear on the surface, the cause must be attributed to an adulteration of the linseed oil, etc., with resin oil or mineral oils. As a result of the nitrogen and sulphur compounds which it contains, the egg is apt to decompose—to putrefy. Pigments containing sulphur, such as cadmium, vermilion, and particularly ultramarine, when used with egg tempera in tubes, may evolve hydrogen sulphide because of the moisture present. The addition of vinegar to the emulsion to guard against spoiling is not advisable. The commercial decorative painter often adds considerable vinegar to his tempera in order to make it as liquid as water and to give it an almost corrosive adhesiveness. Tests show that even 1% of vinegar in the emulsion can, by its continued action, discolor ultramarine in the picture. Carbolic acid or phenol and other disinfectants have the same effect. Acetic acid also attacks white lead and zinc white. A drop of oil of cloves has, on the contrary, a favorable effect. I have known egg emulsions to keep for more than a year in a dammar varnish flask without any disinfectant. Alcohol, which is first thinned for the purpose and then added only in very small amounts, also tends to preserve the egg.

It is to one's advantage to have the emulsion always as fresh as possible. Emulsify only one egg at a time, enough to cover a good-sized surface. The emulsion must be kept cool and well covered. After a time an emulsion which has been prevented from spoiling by disinfectants loses its binding strength, as in the case of glue. An emulsion in the process of spoiling has poor adhesive strength.

Flasks in which an emulsion has once spoiled can no longer be used; each new emulsion will quickly spoil in them.

Anyone who believes he can make an emulsion very much smoother by adding a large number of egg yolks will be sadly disappointed. Such a tempera has a smeary quality, dries poorly, and cracks when painted over. It acts like too fat, too oily tempera, which darkens later. One can with slow-drying oils, such as castor oil, keep the tempera from drying completely for a con-

siderable time, but since with the evaporation of the water the tempera is no longer usable, one has by this method prepared only a kind of inferior oil color. For demonstration purposes I once made such an egg tempera with castor oil, which for two years remained wet enough to wipe off, but not wet enough to paint into. Work done with such tempera lacks the complete charm of tempera, its meager, airy, light character.

If allowed to stand for a long time, the oily particles separate and come to the top, just as cream does with milk. Every emulsion must therefore be shaken well each time before it is used, when it will again become a true emulsion.

Artificially dried egg yolk is not adapted for the preparation of emulsions.

The thick egg painting media of the trade, which are prepared by carefully steaming the emulsion, which is prepared without water and with the addition of preservatives, must be thinned considerably before using. In Italy it once happened that an egg emulsion which I allowed to stand in the open thickened to the consistency of a salve, which was fine to use and remained fresh a long time.

The use of egg tempera goes back to antiquity. Egg yolk was then, as in medieval recipes, for example, by Cennini, used by itself and thinned with water. It was used for panel pictures and for murals. Some old Italian recipes call for the juice of young fig sprouts, which is slightly alkaline, to be added to the egg yolk in order to make it more fluid and perhaps also to act as a preservative. See under soap tempera for "milk of figs." Armenini reports that the ancients painted on gypsum with egg. This old egg technique, which we may study on the earliest icons, became so hard that it resisted all efforts at restoration and could only forcibly be removed. Today also egg tempera, the binding power of which is increased by oily substances, is the most used tempera. Because of its adhesion to all grounds, even under certain conditions in wet oil color, it is adapted for many uses. The fact that it becomes gradually insoluble in water also renders it valuable. It permits of a smooth, soft brush stroke and possesses a very weak gloss. On "meager" grounds it attains its highest beauty.

Böcklin told me that he painted most of his pictures in the Schack Gallery [at Munich] with egg yolk and mastic varnish.

For egg tempera on walls see secco painting.

TEMPERA MADE WITH WHITE OF EGG. Egg white together with gum or hydromel was used in the early Middle Ages by illuminators of missals. Egg white is soluble in water, is brittle, and easily peels off, like glue, hence must not be used in too many layers or as a glaze in underpainting.

Egg white repeatedly taken up with a sponge and pressed out again is often used as a painting medium. Theophilus Presbyter mentions a liquid composed of egg white beaten to a froth as a medium used for grinding white paint. I myself watched Böcklin apply the blue air of the left wing picture of the "Venus Genetrix" with such an egg-white liquid. He had beaten the egg white to a froth according to the recipe of Theophilus and allowed the liquid to run off a slanting plate placed on a stove. With this he applied the blue. The color foamed when applied and appeared to be very white. When it had dried, the saturated blue color appeared. Certain small areas, however, were left uncovered. Böcklin said that he would have to paint clouds on these places, for the material permitted of no retouching. Painting with such egg white is not a true tempera but a size-color technique [distemper]. There is no emulsion, which is essential to tempera.

For white-of-egg tempera the artificially dried egg white is generally used, which comes in the trade in small transparent pieces. It is mixed 1:1 in cold water, allowed to stand for a few hours, and then filtered through a cloth. The proportions are 200-300 gm. to a liter of water. It can be made into an emulsion with fatty oils, resins, etc., in the same way as egg-yolk tempera.

As a result of its light color, it is favored as a medium for grinding white or as an addition to the grinding medium in tube colors of the trade. Albumin made from the blood of slaughtered animals is not so good, and is a dirty color.

Egg white mixed with alum gives a paint with good body and permits of an opaque brush stroke. The alum is dissolved in water 1:10, and a quarter of the solution is added to the egg white. The mixture can be emulsified with oils and resins. When alum is used, cobalt must take the place of ultramarine.

Egg white mixed with thick dammar or mastic varnish serves as a medium for oil painting which is very unusual in effect but is not easily handled.

Egg white "sets" when exposed to light, that is to say, it becomes insoluble in water, exactly as it does when warmed, especially if sprayed with a 4% solution of formalin. A small addition of egg yolk always seems to me advisable in order to make the tempera work smoothly.

CASEIN TEMPERA. Casein has been used since the earliest recorded beginnings of art. Fresh white curd, the casein of good skim milk, is a crumbly, soft substance which, if ground on a plate with the addition of about one-fifth its volume of slaked lime, becomes liquid. In that form it can easily be emulsified, like egg, and it can then be thinned with water. Casein is the strongest glue, used for centuries by joiners and cabinet makers who require a glue that will stand up out of doors.

The casein should be prepared fresh each day, which can be done in two or three minutes. The use of unslaked lime is dangerous, since particles of it may continue to "work" in the picture and eventually fall off. Casein must be diluted very strongly with about three to five parts of water or even more. It should be tested with some pigment; if it is dry the next day and the pigment does not come off, it is satisfactory. There is nothing better to paint with on a wall than casein made in this way. Lime combines with casein into weatherproof lime casein. On the wall it is best to use pure but thinned casein without the addition of oils and resins. The adhesive power of this casein is so great that, if it is applied undiluted to a wall, limewash or even thin plaster coats can be pulled off. Therefore old plaster, before being painted on, should be first tested for its firmness. Casein sets quickly and well and becomes exceedingly hard and luminous.

Casein emulsion might be used on solid supports like wood or pasteboard, but only in combination with fresco colors because of the lye in the lime. Emulsions with linseed oil turn very yellow. Resin varnishes and wax soap, also Venice turpentine, may be used with casein, but only indoors. These emulsions are coarser and turn much harder than egg tempera.

For easel paintings one had better use technically pure casein,

insoluble in water but soluble in ammonia. This casein is a coarse powder made of artificially dried and ground curd. The powder should be fresh and dry and must not smell as if putrefied, otherwise the emulsion will spoil quickly.

40 gm. casein are first mixed with very little water, then ¼ liter (250 cc.) moderately warm water is added.

In the meantime 10 gm. ammonium carbonate are dissolved in a few drops of water, and after all the lumps have been pressed out, the solution is poured into the casein. Promptly there is effervescence; the carbonic acid escapes. After a little stirring, as soon as there is no longer any foam, the casein solution is ready.

The casein solution looks turbid and white like paste. Under no circumstances must casein be allowed to boil. If the water used is very hard, a white sediment forms at the bottom, carbonate of lime, which is harmless and removable. The ammonium carbonate should be very fresh, and, if so, will show a high degree of effervescence.

Ammonia casein is easily kept undiluted in a clean, well-corked bottle. Water may be added immediately before use. The adhesive power here also is very great, although not equal to that of lime casein. It very quickly becomes insoluble in water, so that a tempering with formalin, as with albuminous bodies such as glue, is unnecessary. Out of doors formalin is said to make a paint surface very brittle.

For easel paintings it is excellent, also for use in ground preparations if sufficiently thinned. Emulsions with fatty oils turn yellow and spoil quickly. Resin varnishes, wax soap, egg, and also light stand oil, light poppy oil, and oil of spike are all used in combination with it.

Ammonia casein has the special advantage that its solvent is perfectly harmless—it can be used as baking powder—and that it evaporates completely. The same is not true of soda and borax solutions, which on the wall are inclined to produce efflorescence. The caseins sold at stores are usually prepared with a caustic solution of potash or soda. These sharp lyes remain permanently in the picture and destroy certain colors. One must therefore test all commercial caseins for lyes. They should not turn red litmus

blue, otherwise acid will have to be added drop by drop until the litmus again turns red.

Ammonia casein may also be made by pouring ammonia (i.e., a watery solution of ammonia, which is a gas) in the same proportion as above over casein and then allowing it to stand covered. The solution, however, in this case forms much more slowly and does not compare in quality with the one just described. A trade recipe also recommends mixing curd directly with ammonia; but such casein is less permanent and weaker than ammonia casein prepared as above. Copper colors would be changed to blue by ammonia.

By itself casein acts like glue. In grounds on a solid support it is practical, but on canvas only if suitably thinned. Today it is also used to make oil color short, even mat if used in larger quantities. It has even been employed as a medium with oil color, with which it combines very readily.

Casein tempera has enormous adhesive power, and many painters for this reason prefer it to egg emulsion.

Casein white is very brilliant and naturally adheres well even on fat grounds. Casein Cremnitz white mixed in equal parts with oil Cremnitz white furnishes a very quickly drying white of high covering power. Many painters use it in combination with oil colors. Casein colors in general are very hard to keep in tubes; the color soon crumbles. Additions of glycerin will prevent this, at the cost, however, of destroying the insolubility of casein in water.

Skim milk and milk thinned with water may be used as thinning media for tempera emulsions. One must guard, however, against the formation of drops on the painting surface, because they discolor, paint does not adhere well to them, and the marks left by them are very disturbing.

II. SYNTHETIC EMULSIONS

These are distinguished from natural emulsions by the fact that they do not set or harden permanently, but remain soluble in water and are not easily thinned, as are natural emulsions. They also hold poorly on fat grounds. If suddenly thinned, the syn-

thetic emulsion may disintegrate. With synthetic emulsions an intimate mixture of fatty and watery constituents does not take place as it does with naturally produced emulsions.

GUM EMULSIONS. Gum differs from the resins through its solubility in water and its insolubility in essential and fatty oils.

Gum arabic, the best varieties of which are bought in lumps and go under the name of Kordofan or Senegal gum, is pulverized and slowly stirred into boiling water. The proportions are:

> *1 measure of pulverized gum to*
> *2 measures of water.*

This heavily fluid gum solution may be emulsified with fatty oils in the same way as egg tempera; oil can be added up to double the amount of the gum solution. One must guard, however, against making the tempera too oily. The oil becomes surrounded by gum particles, and the gum tempera, after the water has evaporated, has a dry appearance. If, however, one rubs over it with the finger, one will notice that the oil particles remain effaceable for a long time. The mixture is not so intimate as in the case of egg, for gum has not the natural relationship of egg to the oils. For this reason the color trickles and causes furrows on fat grounds. Gum arabic and vegetable glues soon splinter on fat grounds. A special medium such as ox gall, or rubbing with onion, potato, or ammonia, is required to make gum tempera hold on a fat ground. But these expedients increase the adhesion only very slightly. I remember a picture of a friend of mine, done with gum tempera, which he had just finished and varnished when I arrived. He was washing his hands, and in so doing he spattered drops of water on the picture, which, as they ran down, dissolved the color and spoiled the picture. It is certain that there was much glycerin in this gum tempera. Hence it is much better always to add some egg emulsion to the gum emulsion, in fact, to all synthetic emulsions, or first to paint the painting surface with it. The addition of resin varnish to the gum emulsion is not advisable, because these do not mix any better, both substances repelling each other. The gum emulsion is the one tempera in which an addition of glycerin appears to be justified in order to eliminate the brittleness of the material (5%, at the most, may be added).

Gum emulsions are very light and give the color a somewhat pastel-like and at the same time enamel-like quality. Gum color is more brittle than egg color and is therefore more prone to crack. It easily forms a skin and then does not take the brush; old color in tubes draws threads and becomes viscous. Colors containing sulphur, such as ultramarine, cadmium, and vermilion, are ground with gum instead of egg in order to avoid the formation of hydrogen sulphide. Gum emulsions are also used today in the manufacture of water colors. A red discoloration of the gum solution when tincture of iodine is added points to dextrin.

Dextrin—starch gum—is starch roasted at 200-290° C. and treated with acids, and is of little value for emulsions. The trade product is often poisonous. An addition of water glass precipitates gum arabic from the solution, but not dextrin.

Tragacanth forms light-colored, crumpled ribbons. Yellow tragacanth is better than the white variety. Tragacanth is allowed to soak in water or in alcohol, like glue, and then more water is added. The tragacanth swells into a slimy mass, which must be pressed through a cloth. Four parts of tragacanth to 96 parts of water are sufficient. The tragacanth solution can be emulsified with fatty oils. Tragacanth painting must be applied thinly; the color behaves like glue and must not be varnished for some time. Attempts to retard the drying of tempera media by adding tragacanth have not had the hoped-for results. Tragacanth can be used as an addition to starch tempera. It is also used in the manufacture of pastel crayons.

Cherry gum—falsely called cherry resin—cerasin. Under this collective name are used the gums of the cherry, mahaleb-cherry, apricot, and plum trees, etc. Cherry gum swells only in water, like glue, and must then be pressed through a cloth, the cloth being twisted like a pouch so that the juice is pressed out. Freshly exuded cherry gum should be soluble in water without any special treatment. Cherry gum absorbs much water. About 10% of the gum is enough to form a thick solution. There always remains much undissolved gum in the cloth, which should again be soaked. With hydrochloric acid one can make the gum immediately soluble in water, but the product must then be neutralized by the addition of lye.

The gum solution can easily be emulsified with fatty oils, balsams, etc. Theophilus Presbyter, who in all probability wrote in the 12th century, recommended cherry gum as a painting medium and at the same time as an intermediate layer for oil glazes. Böcklin again took up the problem of cherry-gum technique and mixed the gum, which he set in a large flask by the window, with copaiva balsam. But his cherry gum was not uniform in consistency, because it was not pressed through a cloth but soaked. As a consequence it was partly watery and partly thickly fluid. The copaiva balsam kept coming to the surface, as was to be expected, and did not combine well in the picture. One must therefore, despite the addition of copaiva balsam, regard this technique of Böcklin's as a form of glue painting and not as a real tempera technique. Later he used a real cherry-gum emulsion, which, however, was very viscous and, because of its rich content of resin and balsam, was difficult to thin with water. Copaiva balsam made the brush sticky, and petroleum, which was also in the emulsion, is just as useless as oil of turpentine. The color naturally remained susceptible to water for a long time, even under the varnish. Thus one can see what obstacles the pioneer has to surmount.

A letter from Lenbach to Böcklin dated Jan. 14, 1867, contains a recipe for "tempera": 1 part tragacanth, 1 part isinglass [made from the air bladders of sturgeons], 1 part cherry gum, all mixed when slightly warm with a little alcohol (spirits of wine) to prevent spoiling. Such a mixture, of course, is not a tempera, because the oily constituents are lacking. The mixture, if used for painting, makes a very brittle surface and will not stand much overpainting. Böcklin's pictures showed later on that cherry gum remains soluble in water and that it disintegrates the same as out of doors.

Cherry gum gives to color great transparency and a vitreous character, which becomes especially noticeable on thick white gypsum grounds. Like glue and gum arabic, cherry gum is inclined to chip off when used by itself, especially when applied as very wet and thin glazes. A cherry-gum emulsion adheres well. As additions to egg or casein emulsion it has a very favorable effect. It approaches enamel in effect, has great brilliance, and is

at the same time very easily handled (thus, for example, egg, thickened oil, and cherry gum, also wax emulsion).

ANIMAL GLUES. *Cologne glue*. When thickly fluid, that is to say, when cold or lukewarm for best results, it can be emulsified with fatty oils, as is done when preparing half-chalk or oil grounds. Normally a glue solution is used more as an addition to other kinds of tempera, as, for example, to wax emulsion or to egg, very occasionally also to oil color to make it short. Animal glues emulsify better with oil than gums or vegetable glues. 70 grams to one liter of water are sufficient to make a thick solution.

Gelatine, an especially fine sort of glue, dissolved 6% in hot water, adheres well, gives a pastel-like effect and great brilliancy, and is good as an addition to egg and gum tempera; but it can also be emulsified by itself. All of these glues by themselves are naturally not tempera; they are made into a tempera only by being emulsified. The old masters used glue solutions very frequently. A recipe of Leonardo's for decorative painting is known where, after the canvas has been given a coat of glue size, the color, which is ground only in water, is put on the dry size. Glue underpainting, as used by the old masters as underpainting for oil pictures, seems to be very doubtful despite its general acceptance, because there is no color when varnished or gone over with oil which changes so much and loses so much of its charm as does glue color. Glue paintings, however, were frequently produced after the fashion of our gouache color. There was often not enough distinction made between the gums, glues, and resins. In order to eliminate the annoying coagulation of the glue, strong vinegar is often added, which, however, has an injurious effect on many colors (ultramarine). By continued boiling the glue likewise loses its tendency to jelly and also part of its adhesive strength. By spraying with a 4% formalin solution animal glues, but not gums, are tempered and made insoluble in water.

Parchment glue (colla di ritaglio), prepared by cooking the waste of the skins of young lambs and goats, served as a material for miniature painters.

Fish glue, prepared by boiling the air bladders of fish [sturgeons], is soaked in water and can be emulsified. But fish glue has little to recommend it. It is very hygroscopic. De Mayerne

relates unfortunate experiences which Van Dyck had with it. All glues easily chip off when applied in many layers, especially when used too thick, and still more so in glazed coats. From 2-3 layers one over the other is usually the limit possible with safety.

VEGETABLE GLUES. *Starch pastes. Rice starch* is the best, but potato starch or wheat starch can be used.

50 grams of paste are finely mixed with a little water and then slowly stirred into 350 cc. of boiling water, a little more than a quarter liter (= 250 cc.).

The solution quickly thickens into a paste and is then ready for use. The quality of the paste depends on its being well stirred until cold. Pressing the paste through a cloth is to be recommended. It can be emulsified with oils and resins.

Starch, because it is free from nitrogen and sulphur, has no effect on pigments, but it holds poorly on fat grounds and is therefore not to be recommended in connection with oil colors. It is then very apt to peel off. Starch-paste emulsion gives very bright gouache-like tones. In the trade there are many preparations, synthetic glues, vegetable glues, etc., which contain starch set free by alkalis. These substances frequently contain strong lyes which are harmful to pigments, and they must be tested to make sure that they are free from such lyes. They must not turn red litmus blue; if they do, acid must be stirred into them drop by drop until the litmus again turns red. Starches set free by alkalis become insoluble in water. Starch paste with Venice turpentine 3:1 or 4:1 forms an emulsion which is employed in the restoration of pictures when they are to be mounted on a new canvas.

Rye flour paste.
1 measure of rye flour is slowly stirred into
10-15 parts boiling water.

The flour is first mixed with a little water. The paste can be emulsified, like egg. Many tempera recipes used in commercial art are based on rye-paste emulsion, which for such purposes is combined with glue solution and boiled linseed oil. Interesting is the following trade recipe, which has been found very useful by different artists in the painting of large decorative surfaces:

125 gm. rye flour are mixed with
50 cc. warm water.
To this are added:
100 cc. cold water; after a thorough mixing of the first ingre-dients
300 cc. boiling water, then
125 cc. boiled linseed oil. Then
100 cc. cold water, and then again
125 cc. boiled linseed oil.
After this an optional thinning with water.

SOAP TEMPERA. In the painter's trade soap tempera is much used. If an emulsion is not exactly right, it is improved in the trade with soap and then promptly goes together. For artistic purposes, however, soap must not be added to emulsions, because it will make them permanently soluble in water and can always easily be rubbed off, and, furthermore, because the sharp lyes of many unneutral soaps attack colors and cause the picture to darken later. There are, however, to be found among artists a considerable number of tempera recipes which call for a good dose of soap, and at that the most dangerous kind, soft soap, which contains the strongest alkalis. Such tempera without question is very facile to paint with, and the fatal consequences do not show up until later in enormous later darkening. Venetian or Castile soap is likewise not to be advised. Beckmann's Syntonos colors contained soap, tallow, etc., and therefore later turned very dark.

It is the dream of many a painter to have a material which can be used simultaneously for oil and tempera technique, and every so often one hears of an individual who is said to possess such a "wonder medium." Nothing is really simpler than that! Every oil color, when treated with strong alkalis, such as a caustic pot-ash solution, may be mixed with water and used for painting, and similarly when treated with soaps, which contain alkalis, such as soft soap. But the result! One has in such a material neither the advantages of tempera nor those of oil, but the disadvantages of both, that is to say, the difficult handling of tempera and the strong later darkening of oil colors. Fatty oils may be saponified

by lyes, but must be neutralized (by acids), as in the previously described recipes (see starch tempera). Weimar "milk of figs" is such a saponification of resins, which is intended to make the color leaner (see soap as a medium for sizing in wall painting).

WAX EMULSION (wax soap).

25 gm. white, cleaned beeswax are melted over
¼ liter boiling water.
10 gm. ammonium carbonate are mixed in very little water and added to the wax.

At once there is strong effervescence; but the boiling temperature is maintained until effervescence ceases, and the mixture is then stirred until cold.

Täuber has pointed out that lime and magnesium salts contained in city water may prevent emulsion. Distilled water or boiled water in such cases would be advisable, or pure rain water. 5 gm. potassium carbonate or soda will also cause an emulsion, but the first recipe has the advantage that alkalis are volatile and disappear, while soda and potassium carbonate remain and are permanently hygroscopic. Potassium carbonate must be neutralized, otherwise it will effloresce even in easel paintings.

Wax emulsion is of a milky white color and lasts for years. It may be mixed with resin ethereal varnish or fatty oils (poppy oil), with balsams such as Venice turpentine, with glue-water or gelatine, and with other types of tempera, especially with casein, egg, or cherry-gum tempera. All these combinations are excellent. Under the name of "cera colla" wax emulsion was used with glue-water by the Byzantine painters into the time of Giotto. Wax emulsion mixed with two parts of glue-water made an excellent intermediate varnish for tempera in the manner of the early Italians. The glue-water must be free from acids, otherwise the wax emulsion will separate. It is advisable to be sparing in the use of fatty oils, especially linseed oil, because it causes yellowing. Reynolds praised a wax emulsion combined with Venice turpentine as the best of all painting media. Wax emulsion mixed with a thick dammar varnish serves as a very good retouching medium for indoor fresco (q.v.).

Paintings in wax emulsion possess a wonderful softness and

enamel-like quality, and on gypsum grounds and especially wood panels extraordinary brightness, which holds its own against the very whitest and brightest wall, where oil paintings would appear dark. The technical treatment is simple, and the material, because water is used as a diluent, allows of very careful and precise drawing. It is possible, if one wishes, lightly to anneal a wax emulsion painting, which results in a smoother surface very resistant to atmospheric influences. But this is by no means necessary. If one wishes a light half gloss, all that is necessary is to rub or brush the surface. The Punic wax color of Pidoll (a pupil of Marées) was a wax emulsion. Pidoll's idea that one can emulsify Punic wax is erroneous; it cannot be done.

Wax dissolved in oil of turpentine (1:3) may be emulsified with yolk of egg or casein.

III. THE GRINDING OF TEMPERA COLORS

Formerly, that is to say, centuries ago, tempera color was always prepared fresh for immediate use. Such color had body with which the unnecessarily finely ground color of today does not compare. Therefore Böcklin ground his own tempera colors just as Marées did, and many others followed their example. Raehlmann, in the course of his microscopic examination of old pictures, found that tempera colors on the whole were ground less finely than oil colors. Pigments unsuited to oil, such as orpiment, lapis lazuli, and malachite, made excellent tempera colors, and they had especially great covering power and luminosity because of their coarse grain.

Tube tempera colors often contain undesirable additions of syrup or glycerin in order to permit of a longer storage period. With colors ground for immediate use such additions are unnecessary. Nearly every artist has had in his possession tube tempera colors whose contents have hardened. Although it is possible to soften such colors to a considerable extent in hot water, they are of inferior quality and should be used promptly. Such softened color tends to crack.

The requirement of a vehicle with tempera is apparently greater than with oil, but we must remember that a large part

of it is water. Cennini advised (for the early Italian egg-yolk technique) the use of equal parts of egg yolk and pigment. According to Vercade, to whom we are indebted for the best [German] translation of Cennini's treatise on painting, this is done in the following manner. The pigment is made with water into a stiff paste and then mixed with equal parts of egg yolk. To make tempera colors for one's own use and put them up in tubes is advisable only if the color can be used within a reasonably short time. The emulsion for this purpose must contain only one part water so that it has greater binding power.

The following is a table to show the amount of tempera necessary for the grinding of different pigments. The percentage refers to the weight of the pigment used.

Cremnitz white	30%
Zinc white	50%
Naples yellow	35%
Gold ocher	80%
Cadmium yellow	80%
Vermilion	50%
English red	75%
Light ocher	90%
Burnt sienna	180%
Prussian blue	120%
Cobalt blue	200%
Oxide of chromium brilliant	220%

These percentages, however, vary according to the quality of the pigment and the character of the emulsion.

It is practical first to grind colors in water only and keep them in wide-necked bottles for later use with tempera. Such colors have the advantage of being available for many different emulsions, also for fresco. The glasses must have tight-fitting stoppers, and a little water must always stand on top of the colors. If such color should get dry, it is easy to work it with a spatula into a usable condition and mix it with emulsion.

Böcklin had a little table with a marble top on which he mixed his colors very briefly with tempera emulsion. He covered his colors with glass tumblers and laid a moist rag around the base

that the color remained in a usable state. This little table had rollers, and Böcklin used it as a movable palette.

Tube colors often show discoloration at the edge of the opening. The disinfecting material attacks metal and pigments. This can be prevented by pouring a protective lacquer through the tubes. Tempera color must be kept in a cool place so that its water content does not evaporate too quickly. Some colors easily become gritty and crumbly, such as oxide of chromium brilliant and madder lake. These pigments are best ground with egg tempera. Ultramarine containing traces of sulphur will form hydrogen sulphide, when both tubes and egg-tempera pigments are likely to be destroyed.

Zinc white is very useful in tempera, as are also the best grades of lithopone and titanium white. White lead would be still better, but, if one grinds one's own colors, there is danger of lead poisoning. Naples yellow is an excellent tempera color, also green earth and Prussian blue. The organic colors, including the coal-tar pigments, behave better in general in tempera than in oil, provided they are permanent.

IV. GROUNDS AND MATERIALS FOR TEMPERA PAINTING

The whitest, hardest, and most meager ground is the best for tempera. To be sure, one may also paint in egg tempera and casein on fat grounds, but the lean white ground gives the best results. Synthetic emulsions do not adhere well on fat grounds; they must at least be combined with egg or casein emulsion or painted wet in wet into a film of this painting medium. The white ground gives the greatest degree of brightness to all colors and permits them to show to their best advantage. A thick white gypsum ground on wood is the most desirable. Casein grounds on wood are also excellent, but also canvas supports, pasteboard, paper, and walls may serve for tempera painting. If one intends to use water with tempera, the ground must be hardened with alum or sprayed with a 4% formalin solution, otherwise the ground layer will dissolve and the canvas absorb the water. Tinted grounds are of advantage only for unvarnished tempera (on toned papers) and where white is used abundantly in the light areas.

Every tempera painter should take pains to keep the painting surface clean and neat and as white as possible, not only for varnished tempera, where every spot revenges itself, but also for unvarnished, where the cleanness of the ground is not unimportant, because spots will strike through later on. Even when wet the ground should be as white and evenly bright as possible.

White-enameled sheet-metal palettes in keeping with the painting ground and having divisions or indentations for the various colors are very practical, but a wooden palette can also be used provided it is covered with white enamel. It is not wise at the end of a working period to keep the colors of the palette under water; the colors are washed out in this way, become lighter and more sponge-like when dry, and change correspondingly more when varnished. Felt or a damp cloth placed over the colors in such a way that it does not come in direct contact with them serves to better purpose. However, it is best to take out at any one time only as much color as will be directly needed. The palette and the brushes must be well cleaned immediately after use, because the colors, especially casein colors, harden very quickly.

Bristle brushes, particularly round ones, are very well suited to tempera painting; for finer details sable brushes can be used. Water or thinned emulsion serves as a painting or thinning medium. Oil of turpentine is also often used, but this has no obvious advantages. Water is decidedly more practical, and, for the many reasons enumerated, it is best not to use so fat a tempera that it can be worked only with oil of turpentine. Oil-tempera colors of the trade contain tempera emulsions prepared with fatty oils, which may be thinned with water, but sometimes more readily with oil of turpentine.

A wrong conception of "tempera" leads to many errors.[3] The essence of tempera is the emulsion of fatty and watery constituents. The former may consist of oils or resins, which, however, in practice is of little importance, particularly since often resins dissolved in oil, such as coach varnish, are used in the manufac-

[3] The word "distemper" applies to colors ground in glue of one sort or another without the addition of oils. A real tempera is always an emulsion. [Translator's note.]

ture of tempera colors. It would be much better if a statement of the constituents of the emulsion, such as egg, casein or gum, paste, etc., were put on the tube by the manufacturer, because by this means very essential differences can be indicated to the painter which have an important bearing upon the adhesion of superimposed oil colors.

In tempera painting all the pigments employed in oil and water-color painting may be used, including the coal-tar pigments.

V. THE TEMPERA TECHNIQUE

For work which is intended to possess a certain finish an exact preliminary design is indispensable, and the ground must be kept as clean as possible. A drawing of the outlines with diluted India ink facilitates the work. One may paint on a dry ground, or the ground may be dampened with a sponge. Many painters spray the canvas from both sides with water, which runs down, carrying the binding medium with it, and as a consequence the colors lose their hold, change greatly when varnished, and crack off through loss of volume when the water evaporates. Under this treatment many binding media even spoil. A better method is to apply wet felt to the back of the canvas. Spraying with water while working must be done carefully; it loosens the colors considerably and is not especially to be recommended.

One's method of painting in tempera is naturally, as in all techniques, a highly personal matter, and, as a matter of fact, the more individual it is, the better. But there are certain rules inherent in the nature of the material the knowledge of which will not hinder the painter in his personal method of expression, but will save him much annoyance and loss of time and will eventually prove of great benefit to the permanency of his work. It is in this sense that the following discussions are to be understood, and not as schematic rules.

From the discussion of tempera emulsions it follows that there must be a great number of possibilities inherent in the use of this material, especially when it is recalled that intermixtures of these emulsions can be made in varying proportions, and that they all furnish very useful painting media. Lenbach's jocular remark here

becomes very nearly true: "One can paint with anything that will stick."

Today the use of tempera falls into three principal divisions: unvarnished, gouache-like tempera, varnished tempera, and tempera as an underpainting for oil.

UNVARNISHED TEMPERA (gouache-like tempera) is, comparatively speaking, the simplest to use. One paints with water or thinned emulsion on a dampened or dried ground. One can paint in water-color fashion or opaquely on white, tight grounds, on paper or canvas, but the best are toned grounds (toned papers), on which one can obtain charming effects with thin, half-covering tones heightened by more opaque tones. By a suitable choice of colored paper and by using the color of the ground in the pictorial effect, the work can be greatly expedited. Painting lightly wet in wet gives a better fusion of colors and permits of softer intervals. On dry painting opaque, half-dried tones may be applied to advantage without thinning. As in the case of gouache, the color tones dry out considerably lighter and reflect surface light in contrast with the inner luminosity of wet color. They produce an airy and mat gray effect. Unvarnished tempera, like all water-color techniques, surpasses oil colors in brightness; on the other hand, it is grayer in the depths and less saturated. By using an emulsion instead of water one more nearly approaches a saturated color effect. Color applied too thickly easily splits, especially if it is painted on wet, because the color loses much binding medium through its absorption into the ground and through evaporation. With practice the tones may be calculated approximately. Like water color and gouache, they possess a more fascinating quality after drying. The material has a more fortuitous charm than oil color. Unsuccessful parts may be removed with a wet sponge, while with a damp, well-pressed-out sponge a painting may be pulled together to create a simple, large effect, into which strong accents are then put. The old masters often painted on very fine fabrics, like cambric, which had no ground or just a thin coat of glue with an addition of alum. The canvas would be moistened from the back or mounted over a wet cloth. There are heads of apostles by Dürer in the Uffizi Gallery painted in this manner. It is better to use zinc

white in place of Cremnitz white in unvarnished tempera. For large decorative surfaces or inexpensive work one can with profit use as white Cremnitz or zinc white which has been extended (or cut) with barite, chalk, clay, or similar substances. These the artist may prepare himself, or simply use chalk or gypsum. The preparation used for half-chalk ground is used by many painters for cheap tempera white, and is very satisfactory. Unvarnished tempera is commonly used for decorative work, in poster painting, and also on the wall "a secco" (q.v.) For poster color, see under water-color painting.

VARNISHED TEMPERA. Difficulties are multiplied the moment a tempera painting is varnished. In the majority of cases the previously harmonious, pleasingly mat and charming color loses its airy quality; a few colors, such as ultramarine, madder lake, and viridian, appear glaring, even gaudy and hard, in comparison with other colors. A glazed, vitreous depth light takes the place of the gray surface light, and the color usually becomes spotty. Especially unpleasant is the way in which the red of the flesh stands out. Worst of all, the various color tones do not change in the same, but in varying, degrees, a few scarcely at all, others a great deal; and in the case of different colors laid one over the other it is naturally still harder to predict what will happen than in the case of layers of the same color. Most painters are influenced by oil technique and paint in tempera in the spirit of this technique, employing the same full color strength, light over dark, impasto and glazes alongside of one another, with the results already mentioned. One should not attempt to impart to a tempera painting the quality and effect of a picture painted in oils, otherwise one is merely inviting trouble. It is, moreover, a roundabout method which consumes much time.

The difficulties here then owe their origin not to the material, but to its incorrect use.

If the painter tries to correct these mistakes by using a very fat tempera, he will soon realize that the trouble is not to be overcome in this manner, but that he is only courting additional disaster in the form of later darkening and a greasy effect. Tempera is essentially a water color and must remain so if its best qualities are not to be sacrificed. After the water has evaporated,

water color becomes dry and is then no longer workable. Experiments in keeping the surface of the picture damp longer through additions of tragacanth, sugar, etc., have not had the expected results. If everyone possessed as clear a preconception of his picture as Böcklin had, who insisted that the picture must be clearly planned and visualized in advance, one could paint every part of the picture alla prima on white ground, without needing to retouch it. Impasto gives a more beautiful effect than the use of glazes, which are easily drowned by the varnish and, in the case of strong color tones, "jump out" of the picture. One should begin with very light and simple flat tones without depths and paint from light into dark, and should never underpaint with dark colors, as is done in oil painting. A requirement is a faultless, clean ground, the best being a gypsum-glue or casein ground, which, when necessary, can be isolated by means of a glue or resin solution. If the ground changes when varnished, the painting will change with it. Without a very good ground all one's efforts are in vain, because, when varnished, the color on unclean grounds becomes more transparent and spotty, even in the case of colors put on very opaquely, because every spot on the ground shows through. Strong, full color tones must be held back; the colors should remain simple, and there should be no painting of many little different color areas, which, when varnished, become merely so many spots. Large contrasts in light and shade, areas balanced against areas, are in keeping with the nature of tempera, and also, in general, a light character of the whole picture. In varnished tempera a decorative quality is an advantage; one should not strive for fine tonal differentiations, for "valeurs" and atmospheric effects, for, although they are easy to obtain in oil, they are very difficult to achieve with tempera. The material is best suited to a conventionalized style of expression. One may, as was the custom of the old masters, prepare in advance on the palette colors in three gradations, light, medium, and dark, for the rendering of an object such as a red drapery. Cennini, on the other hand, took a definite red of a mantle, let us say, and boldly at the beginning set it down in its full strength and then used it in determining the values and intensity of the other colors in the picture.

INTERMEDIATE VARNISHES. In order to be able to co-ordinate the different parts of a picture and to bring out colors which have sunk in, intermediate varnishes are used, which naturally must be kept very thin. Spirit varnishes must be excluded in this process, because they form an alien, vitreous intermediate layer, on which all further painting adheres poorly. They possess in addition a displeasing smoothness and gloss. Sandarac varnish must also be avoided, because probably in the majority of cases retouchings in oil will be used over the tempera, and this holds poorly on sandarac. The best intermediate varnish has been found to be a 5% gelatine solution in water hardened by spraying with formalin. This medium is also suitable as a preliminary varnish preceding the final varnish to minimize the changes in the tempera color caused by the latter. One must here also be very sparing with such intermediate layers, and likewise guard against soaking the picture in tempera emulsion, which is also widely practiced, because all such intermediate layers of pure binding medium without pigment make it difficult for the color layers lying over them to adhere. Mastic or dammar in oil of turpentine can be used as an intermediate varnish, as can also thin Venice turpentine 1:1 in oil of turpentine. Intermediate layers of oil are not good; through their yellowing they take away much of the charm of tempera. Nor do intermediate layers of emulsion alone produce favorable results; they tend to crack easily, unless one paints into the still wet layers with body colors. Zapon varnish is not very effective. Egg-white intermediate layers become very brittle, and turn brown. Borax shellac soap, which is prepared by soaking 50 gm. borax and 100 gm. powdered white shellac in one liter of water and afterwards heating the mixture until a solution is formed—so-called water varnish—can be used and further thinned with water (or water and alcohol). One must be sparing in the use of intermediate varnishes and not use them indiscriminately. Their danger will be appreciably minimized if one paints at once into the wet intermediate varnish. Böcklin varnished his tempera with thinned mastic at the close of his working day.

FINAL VARNISH. Varnished tempera pictures must not be placed in the sun or near a stove to dry. That is also quite un-

necessary. Coats of strong glue or gum are liable to crack; if exposed to the sun this danger is enormously increased. As final varnishes for tempera, spirit varnishes or fatty oil varnishes, like coach varnish, are not to be considered; only resin ethereal varnishes, for example, mastic or dammar dissolved in oil of turpentine, should be used. Caution is advisable in the case of many trade tempera varnishes which contain sandarac (see page 135). Very frequently one is compelled to apply a few of the high lights and the like afterwards in oil. But the character of tempera is taken away by the use of tube oil white. Cremnitz white or zinc white ground stiff in a resin ethereal varnish with the addition of a third of poppy oil to the varnish gives such color an appearance more in accord with the tempera. Mat varnish can be used in the same way as with oil color (page 210). Good results have been achieved by using wax melted in a water bath. It must be applied hot with a brush and immediately spread out with a rag. Wax gives a very lovely, half-glossy, and very durable finish. It may be thinned with oil of turpentine.

TEMPERA AS UNDERPAINTING FOR OIL.[4] Glue painting (distemper), tempera, and gray-in-gray painting—a guazzo—were employed by the old masters as preliminary exercises for oil painting, as Pacheco, the teacher of Velasquez, testifies for the Seville painter. Aspiring artists in this way learned all the advantages of these materials. Here there are the same and as many difficulties as with varnished tempera, because the painter, in ignorance of the nature of tempera, is likely to use it as he would an oil color. The tempera underpainting should not aim to realize in terms of color the effect of the finished oil painting. One should also not attempt to give at once the essential chromatic character or the full strength of color to the tempera underpainting; otherwise the colors will jump out of the picture when varnished and become glaze-like, intermediate tones will become spotty, and, in particular, the red in the flesh will be rendered disturbingly prominent, so that the painter is obliged to resort to tiresome retouching and patchwork. Thus the overpainting in oil will lose its unified, broad effect. Also very close

[4] It is self-evident that only such emulsions should be used as do not repel oil, such as egg or casein, but not gum or starch.

tone values in over- and underpainting easily become dead, while strongly dissimilar tones give a clear, rich effect. Glazes in the tempera underpainting make it difficult to paint over in oil, for oil tones laid over them appear dirty and greasy. One must renounce the use of any strong color in tempera underpainting and paint more neutrally, lightly, and opaquely with few color tones, in order not to defeat the subsequent oil painting. It is best to apply the drawing spontaneously on good, solid grounds and in the simplest manner, using neutral tones well mixed with white, for best results using the fewest possible colors modified with white or gray. Color glazes when varnished change much more than body colors like white, Naples yellow, or color tones mixed with these. Half-chalk ground material serves many painters as a cheap white for underpainting. In the flesh parts contrasting colors, for example, green, are very effective. Tempera permits of a draughtsmanlike technique, and this should be employed in the underpainting. If one wishes to model, it is best to proceed in the simplest manner with white alone or a very light, mixed tone; and it is well to indicate all deep accents very suggestively and to aim on the whole at a very light and flat appearance. This, however, by no means excludes a certain draughtsmanlike definiteness. If the advantages and disadvantages of tempera and oil painting are weighed against each other, one is bound to arrive at the following conclusions:

Tempera dries through rapidly and well. The color is lean, but permits of an opaque technique without becoming greasy or retarding the drying process. The brush stroke is sharp and draughtsmanlike; one may work with water and easily wash off with a sponge any unsuccessful parts. This is all of great value in underpainting, for here the color should be lean.

Of disadvantage in tempera are the incalculable changes when varnished of strong colors, particularly the vitreous appearance of varnished glazed tones. Furthermore, it is difficult to fuse tones; often this results in a certain hardness. Tempera is also troublesome when one is trying to maintain unity with varnished surfaces or to change their colors. These are all points which argue against the use of tempera in overpainting.

With oil color, on the other hand, it is a very simple matter

to change at will the color of any given area, and it is equally easy to obtain a fusion of tones. The chief advantage of oil colors, however, rests on the fact that, when varnished, they change scarcely at all. All these are prerequisites of a material designed for use in overpainting. On the other hand, oil color is of little value if it must often be painted over. It is very apt to become dull. Its slower drying process, its tendency to sink in and remain sticky, the tiresome waiting for it to dry, particularly in the case of opaque colors, as well as the greasy effect of opaque underpainting and its resultant disadvantages as compared with tempera in the way of permitting overpainting, all speak against the use of oil color for underpainting. From this it appears that it is advantageous to use tempera as an underpainting for oil, according to the old rule: fat over lean. The process of painting is shortened, the luminosity and beauty of the color are increased, and the picture takes on brightness and is protected to a great extent against yellowing and later darkening. Another advantage of tempera is that it does not dissolve when painted over with oil and becomes harder than oil color.

The advantages of a tempera underpainting for an oil picture is that such a sketchy, but also plastically developed with white, simple tempera underpainting which has been painted with water or very thin emulsion becomes dry in a moment and hence can easily be used for alla prima painting in oil. Oil color sits well on lean tempera, and since the tempera underpainting does not anticipate the chromatic effect of the finished picture, one can work broadly and freely with it. A tempera underpainting shortens the process of painting to a very great extent, and through its use the picture becomes more richly luminous and is protected more against later darkening than when an oil-color underpainting is used. The tempera layer quickly hardens and is pleasing and profitable to paint over in contrast with opaque oil underpainting, which neither attains the strength of light nor the leanness of color and material beauty of tempera. The chromatic character of the final picture can easily and quickly be achieved in oil over tempera by means of a shortened alla prima technique. Drawing and simple modeling in large planes can be done very quickly in tempera, and it lessens work materially.

Any unsuccessful oil-color overpainting can also easily be removed with some oil of turpentine without disturbing the lean tempera; and, inversely, the watery tempera underpainting (before the application of oil) can easily be removed at will with a sponge if it fails to satisfy. One can work very fast in this technique, particularly in portrait painting, because a solid, direct underpainting in tempera can be made very quickly, and a spontaneous overpainting in resin-oil colors can be laid over it soon after. It is not improbable that the portrait of Pope Innocent X by Velasquez in the Doria Gallery was executed in this way. The painter of today, who is usually versed only in oil technique, had better give some time to experimentation before using this technique. The old masters in this respect were in a very different position, because they learned glue painting and tempera first.

PAINTING WITH TEMPERA INTO WET RESIN-OIL COLOR (MIXED TECHNIQUE). This technique is better suited to a deliberate, stylistic type of painting than to a naturalistic type, especially to pictures carefully planned in advance. Solid supports like wood are the best for the natural emulsions, that is to say, egg and casein. They allow of being worked into with oil colors, which is not the case with gum or starch media. One succeeds best with a tempera white, which dries quickly and can be used to heighten the lights and increase plastic modeling. Over this resin-oil color is used in glazes or in a half-covering fashion. The paint in this way is not "tormented," and time is saved because the drawing has been previously fixed.

The old masters proceeded by using a colored "imprimatura," a very lean oil color or, better yet, a glazing resin-oil color mixed with ocher or green earth, which was heightened with tempera white. The imprimatura formed an evenly glazed and lean basic coat, and, when applied, all excess was wiped off with a rag. It must be uniformly dull in character, like toned paper, and not have a gloss. One can work over this with tempera white when the imprimatura is either wet or dry. The picture in the beginning was outlined on the white ground with tempera color before the toned imprimatura was applied.

Wherever there are to be shadows in the picture, the white must be used very thinly so as not to destroy the tone of the

ground. This results in the very fine optical grays which are so effective in the pictures of the old masters and which can never be obtained by direct painting.

The tempera white may be applied by means of hatching, beginning with the highest light, or one may employ scumbling, but, wherever used, it should have body and a broad, flat effect. The first layer usually sinks in a trifle, and it may be used profitably as a middle tone for the next layer. It would be a mistake to use the white merely for definitely marked light areas or for high-light accents. In the first case, the picture surface would have no unity when worked over with oil color, and, furthermore, the flat effect would be lost. The very last thing to receive attention in a picture should be the high lights and the very dark accents, and when their time comes, they should be set down very spontaneously and freshly.

If a direct gray underpainting instead of the optical grays is the aim, it is best to mix in advance two tones of gray in tempera. When the form is sufficiently developed with them, one may go over them with oil-color glazes and semi-opaque colors in the lights and shadows, if possible finishing the picture immediately by the alla prima method. Should it develop that the form is plastically unsatisfactory or the picture lacking in luminosity, one may continue to paint into the wet oil color with tempera white. Glazes should be applied quickly and with a broad brush.

The main purpose of this mixed technique is a division of labor. Without any concern about color, the forms are plastically developed in the underpainting. There is no danger of "tormenting" color, because no color is there to be tormented. Inversely, by means of flat glazes or semi-opaque resin-oil colors an effect of color is quickly achieved, because the form has already been plastically developed. If the color is not satisfactory, it may be removed carefully with a rag. The heightening with white must naturally be higher in key than the ultimate effect of the picture, because glazes darken and need a lighter base in order to be effective. If the color glazes become too "pretty," this may be remedied by a light scumble of white or of the complementary color. One may continue to alternate heightening with tempera white and oil color without interruption or wait until the last

painting is dry. The tempera should not be unnecessarily heavy, and the oil color even less so. In order to avoid hardness of appearance and lack of harmony, the heightening with tempera white should not be restricted to single parts of the picture but be carried out with an eye for the total effect.

To move from light into dark is the better method. Finally, with thinned tempera medium, even with pure water, the most minute details, such as single hairs or bits of jewelry, are set in in the manner observable on the pictures of the early German schools. For this purpose the color is made more liquid by working it with the palette knife and is laid with a fine, very long-haired sable brush into the wet oil color. Fine lines thus made are extremely sharp and definite, much more so than one could hope to produce with any oil medium. It should be unnecessary to say here that the oil color must not be too heavy and greasy. In this manner were produced with casein and egg tempera combined with resin-oil color the effects which we admire so much today in the works of the Flemish painters and also of Dürer. Pictures heightened with white everywhere, either on a white wall or in a half-dark room, are always luminous and effective, because they have inner light of their own. The modern oil picture too easily succumbs when it is not seen in a strong light.

Heightening with white is also the best possible protection against later darkening. It is by no means necessary, however, to imitate literally the old masters in their mixed technique; there are plenty of pictures of our own time which prove amply that one may create very freely and personally in this manner.

Another version of the mixed technique, which had grown out of very early practices, was that employed by the Venetian school. The drawing was made with white chalk on a dark ground. Then a mixture was made of equal parts of casein white or egg-tempera white and thickly ground oil white. With this mixed white in many subtle gradations the forms were plastically developed. Over this underpainting the picture was finished alla prima with resin-oil color. If there were parts which seemed deficient in plastic effect or insufficiently strong in light, the mixed white was used to improve this defect. The beautiful optical grays which resulted also from this technique were

loosely gone over with oil color. One may work very rapidly in this technique without waiting for the drying of the surface, because the white sets very quickly and is very soon in a condition to be worked over. This same mixed white is used in conjunction with oil colors by many contemporary painters who prefer a white which sets quickly.

Very striking decorative effects of light, such as one sees in the pictures of El Greco, are obtained in this way. This technique is suited to a great variety of methods and readily enables painters to realize their individual aims. At the same time it is simple and effective. The white hardens extraordinarily, and therefore the palette and brushes must be cleaned immediately after use. Very high lights and deep accents are left to the very last, so that the freshness and total effect are determined by them (see page 190).

The optical grays which played so important a part in the pictures of the old masters are today no longer systematically exploited despite their obvious advantages.

Egg tempera is duller and softer in effect, while casein sets hard and has a more robust quality.

Tempera colors made by the artist like oil colors facilitate enormously this mixed technique. Tube colors, because of additions, often create difficulties. Additions to tempera to make it resemble oil are less desirable than additions of egg or casein to oil color to make it more like tempera, that is to say, more meager and mat in quality.

In concluding this discussion of the mixed technique, I should like to repeat once again that it is not to be recommended for studies or sketches, but that it is of value only to those who plan to build up a picture systematically. It is, on the other hand, no sure means to success; on the contrary, it calls for strong discipline, clear thinking, and an accurate observance of the rules of craftsmanship. It will also serve present-day aims of painting, but painters individually will modify it and adapt it to their individual requirements.

CHAPTER VI

PASTEL PAINTING

Pastel color possesses only surface light, gives no glazed effect whatever, and in appearance most closely resembles the dry pigment. Here there is no "sauce," no yellowing or turning brown, and no cracking, as with oil color. On the other hand, the material has the disadvantage that it is very sensitive to mechanical injuries, for example, to shock, because the color adheres but loosely to the ground.

The manufacture of pastel crayons requires but very little binding medium, and the pigment is not saturated with it, as in other techniques; otherwise the color will not come off the crayon so easily.

All sorts of adhesives are used, for example, strained oatmeal gruel, which has very little binding strength and is therefore used for colors which would otherwise become too hard, such as madder lake, Prussian blue, and cadmium red. 3%, at the most, of glue or gelatine dissolved in water may be used; gum arabic (2%) tends to make the color brittle and produces a hard crust. This brittleness is eliminated by adding honey or crystallized sugar. Skim milk, which is a weak binding medium, is also used, especially for mixed-tone crayons and zinc white. Thin soapy water, hydromel, and thinned tempera emulsions, of which wax emulsion gives especially good results, are likewise employed; chiefly, however, gum tragacanth. 3 gm. of tragacanth are allowed to soak in 1 liter of water, and the jelly which forms is warmed until the tragacanth becomes a paste. The tragacanth may be given a preliminary soaking in alcohol.

In general the pigments used in tempera may also be used for pastel. All poisonous colors, however, must be avoided, such as Cremnitz white, Naples yellow, minium, chrome yellow, and especially emerald green, because breathing in the dust when working with pastel is dangerous and, moreover, difficult to avoid.

Clay, whiting, alabaster gypsum, and talcum powder serve as white color. Clay and gypsum must be precipitated as finely as possible and be a pure white, otherwise the mixed tones will appear dirty. Chalk is less suitable. Body colors, zinc white in particular, have the advantage that they change little when fixed. Lithopone is usable only if unchangeable in light. Titanium white, as far as we know today, is also serviceable as white body color.

Crayons prepared with gypsum or clay require a minimum amount of binding medium; the more pigment is used, the more binding medium is necessary. The insufficient covering power of these materials is the cause of marked changes in pastel when fixed. It is well, therefore, to mix pigments 1:1 or 2:1 with zinc white. The remarkably good preservation of the pastels of the rococo period is very probably due, aside from the correct construction of the picture in clear contrasts, to the use of a strong-covering body white. Pernety (1757) mentions white lead. In its place we use today zinc white.

The following pigments can be used in pastel:

Zinc white
Lithopone
Titanium white
Clay
Chalk
Gypsum
Talcum powder (soapstone)
Yellow ocher, natural sienna
Zinc yellow, yellow ultramarine
Indian yellow
Cadmium yellow
Burnt red ochers and iron oxides
Caput mortuum
Alizarin madder
Vermilion

Cadmium red
Helio fast red
Ultramarine, blue, red, violet
Cobalt blue
Paris blue
Manganese violet
Oxide of chromium, transparent and opaque
Permanent green, light and dark
Green earths
Cobalt green
Umber, raw and burnt
Burnt sienna
Burnt green earth
Cassel brown
Ivory black

Here also the palette must be limited as far as possible. Furthermore, coal-tar dyes, with the exception of alizarin madder lake

and helio fast red, must have previously been tested for stability in light. They are subject to "bleeding" when fixed.

The pigments are ground into a stiff paste with water, after which the binding medium is added. The color is then allowed to dry somewhat, or the water can be absorbed by placing the color paste on white blotting paper. When molded with the fingers, the color paste should form little balls like bread balls, and should no longer be sticky. Color from which too much water has been removed crumbles. The color paste is then rolled out, which can be done with the hands or between slightly greased glass plates, pains being taken to see that the latter are well cleaned afterwards. It is more profitable to make crayons thicker than the thin trade product, the broad surface of which can also be used. Kneading the mass when in the process of drying is not advisable, because air bubbles may easily be formed. The color paste may also be poured into slightly greased molds or pressed into forms or through a metal nozzle. It is always profitable first to make a sample crayon with but little binding medium and then dry this in the sun or in an oven, in order to be able to test the crayon quickly. The rest of the crayons should be dried in moderate, even warmth on blotting paper or newspapers.

The dried crayon must be capable of easily absorbing water. Crayons which are too hard are again ground up and washed with water, and a little skim milk is then added. De Mayerne recommends a trace of soapy water instead. Broken pieces should be ground up with some oatmeal gruel and then reshaped. Tone gradations are obtained by using white fillers. The preparation of mixed tones is very simple. The pure pigment, the full tone, is divided into two equal parts. One part remains in its full chromatic strength, while the other is mixed with a white filler; then this is divided again, and half is again mixed with white, and so on. In this way can be easily created an indefinite number of equal gradations of one color, and naturally also certain mixed tones, which are preferred for painting. Gradations of black are less important. Gray crayons are very easily made in all sorts of variations.

The pastel boxes of the trade are gotten up more with an eye for beauty of appearance than for serviceableness. They contain an unreasonable number of intermediate tones which the painter never needs, while of the valuable full strength colors, from which all the mixed tones can easily be prepared, there are far too few. The result is that the box soon develops embarrassing gaps, and half of the material is needlessly wasted.

The worst features, however, are the arbitrary and fantastic names which are given to most of the color tones and, above all, the fact that many of the colors used cannot stand up to any degree under light. Professor Schulz, who tested 64 French pastel colors from various firms, found that 30 had completely faded in a month's time. They had been prepared with fugitive coal-tar dyes.

An artist who works much with pastel would do well to prepare his own crayons. Only a few colors are necessary, and one need not be too particular about having the crayons uniformly shaped. One will be astonished to see what power and depth can be obtained with pastel colors of full chromatic strength. The earlier painters also prepared their own pastel crayons and in this way obtained the characteristic brilliancy and richness of their colors. I once had to restore a pastel portrait of Napoleon by David. It was simply impossible with the trade material to equal the depth and richness of a certain blue; it was only when I made for myself a pure Paris blue (the best sort "with the coppery sheen") that I had any success. All of the crayons available in the trade were in comparison a dirty gray-blue and too light. One would believe that one had an entirely new material with such homemade color crayons, so powerful and luminous are the tones made with them.

As *supports for pastel painting* paper, pasteboard, or canvas are used, and they must be specially prepared. A certain roughness of the support is desirable; supports which are too rough, however, act like a file, devour much color, and make work difficult and tedious. Before the work commences, this support should be mounted or fastened on a firm basis, so that it is as immovable as possible. Every movement is apt to cause some of

the particles of the powder to drop off, thus impairing the charm of the material.

The pastel ground is prepared in the following manner: The support is covered with starch paste and sprinkled with finely pulverized pumice-stone powder while still wet. By knocking a corner of the frame on the floor any surplus which does not adhere can be shaken off. The paste must be laid on very thinly and in such a manner that, when dry, it will show no brush marks, which otherwise would have a disturbing effect in the picture. One may spread the paste very evenly with the palm of the hand or a wet sponge. Such painted grounds hold the color exceptionally well and give the picture great permanence. Canvas and pasteboard can be prepared in the same way, or oil varnish can be painted thinly over the paste, and then as much pumice-stone powder sprinkled on this as will adhere to it. A lean ground, however, is unquestionably better. Either a dark gray or tinted ground, according to one's taste, is suitable. In the case of old pictures one sometimes finds roughened parchment as a support for pastel.

As far as *the technique* is concerned, one is free to handle the material to suit oneself. The color tones may be placed broadly and abruptly alongside of one another or laid one over another, for which purpose a dark ground will be very serviceable in the shadows and transition tones. The color tones may be applied and wiped off with the finger, with the brush, or with a chamois skin, and uncommonly soft, velvety tones thus obtained, which, to be sure, often display a deceptive brilliance of execution rather than excellent draughtsmanship. The tones may be easily fused with the fingers or a brush; in this way they are softened and serve as a basis for the light and dark accents, which are set in very spontaneously and freshly, thus giving to pastel its typical charming and playful character.

Large surfaces are covered with the side of the crayon, to which purpose the self-prepared handmade crayons are excellently suited. Any unsuccessful parts may be dusted off with the bellows. One must guard against polishing the ground so smoothly with hard crayons that it holds the color powder only

with difficulty and the velvety depths are thus lost. One can proceed in a drawing-like manner, setting in but few color tones in a chalk or charcoal drawing, or build up the effect in a more painter-like fashion with pronounced contrasts of strong local colors and then blend them together. Homemade pastel sticks have the greatest coloring strength. The technique should always be easy and charming and expressive of a playful mood. A pastel picture that has been fretted over, that looks "tormented," is an abomination and a complete contradiction of its essential nature.

A heavy application of color and a rough ground tend to prevent the danger of the picture's losing too much pigment if mechanically injured and so eventually appearing poor in pigmentation.

Cool and light tones give especially good effects in pastel. From them flesh tones are usually built by laying warm tones loosely over them. Alternating coolness and warmth gives much life to the effect. With warm flesh tones, such as are commonly used in oil, a "hot" appearance is too apt to develop. It is advantageous to sketch the flesh lightly with a simple, light, warm, somewhat reddish tone and then blend it together in a looser, easier fashion. Then cold, light tones, bluish or greenish, transition tones, are set in and laid very lightly over the light area, scarcely touching it. Light, cool tones give a plastic effect. The shadows are then deepened, and warm reflexes and warmer high lights put in. By a continual balancing and opposition of the warm color values of the light and the cold color values of the shadows and their complementary colors the final effect is achieved. The cold masses are played over with warm tones, and the warm masses with cold tones, until a mutual penetration has developed, which relieves the material of the quality of ordinary pastel and at the same time creates harmony. This, however, is not to be taken as a recipe, but only as a suggestion!

Pastel is excellently suited to a rapid fixation of the more evanescent color effects in nature and particularly to the development of ideal sketches. The translation into another material, such as oil, must then, to be sure, follow quite freely and not

minutely, for the simple reason that each technique has different requirements. Many painters begin with tempera or gouache and work over this with pastel, or even with the related, but harder and greasier, chalk crayons.

Too heavy tones in oil paintings are also given a looser appearance by lightly playing over them with pastel crayons. However, such a technique is quite unsound; it loses all its charm when varnished, and only dirty color remains.

One can, if desired, even use the pastel with water, after the fashion of tempera, or use it in connection with tempera. The best results, however, are obtained by using each technique by itself. The weak, insipid, and saccharine effects which one often sees in pastels do not necessarily lie in the nature of the material, which is capable of strong contrasts in light and velvety soft depths; and, in respect to strength, it is second only to oil painting.

Ostwald hoped that his "monumental" pastel would take the place of fresco, which seemed to him to be entirely out of date. The mat quality of pastel and the facility of its use would seem to be a great advantage in mural painting. The colors no doubt would hold well on the rough surface of a wall; but fixation is necessary, not to mention the fact that the "monumental pastel" must be rubbed over with paraffin, and then its greatest charm is lost—the picture under such treatment falls to pieces, so to speak, it blackens and darkens, and the troublesome and hopeless task of retouching begins. With tempera the effect would have been obtained with more certainty and speed.

Furthermore fresco has the charm of the visible brush stroke, which would be absent from a pastel fixed in this way.

The fixing of pastel has always been a very difficult problem in this otherwise very profitable technique. If fixed too carelessly or too strongly, all the charm of the color is lost, which becomes heavy, and all the technical shortcomings which were previously concealed by the airy, evanescent charm of the material, which is at once so captivating and diverting to the eye, now become doubly apparent. One reads often of pastel fixatives which, according to their discoverers, are "ideal," but which in practice soon show their defects. One must try to visualize what

happens when a pastel is fixed. In pastel fine particles of color lie irregularly and loosely one over another, and they reflect light from many different angles. The air which lies between produces the agreeable light gray tone, the surface light.

When a pastel is fixed, the color particles at once arrange themselves differently in relation to one another. They absorb the fixative until they are saturated, when they collapse, and eventually may form into a smooth surface layer similar to a coat of paint applied with a brush. At the same time they lose their optical effect, and the layer of color becomes darker and in a great measure loses its airy quality. As has already been mentioned, bodiless fillers, such as chalk, clay, and gypsum, which lose considerably in covering power when moistened, are the chief cause of the pastel's changing so much when fixed.

While moistened by the fixative, depth and glaze effects result which darken the picture, which, after it has become dry, seldom completely regains its previous charm. A very weak fixation is usually employed in this emergency; one may likewise go lightly again with crayons over the picture after it is fixed. It would be better to use only a small amount of fixative even at the risk of some of the color's coming off. The fixative must be used carefully, perhaps by first blowing it into space, and then quickly for only a second and from a sufficient distance over the picture, in order to avoid blowing off any of the color particles by the force of the spraying. The fixative causes a light binding of the top surface to take place. The spraying is then repeated a second and even a third time. If the fixative should be applied too strongly at one time, the color would "drown" in it. A good way to form a picture of what happens when a pastel is fixed too strongly is to imagine many lumps of sugar piled up irregularly which, when moistened, all collapse together into one mass. That fixative would accordingly be the best which works the most rapidly and evaporates the fastest, because it will cause the fewest changes in the position of the color particles. Solutions of resin in ether, benzine, or alcohol best fill these requirements. They also have the advantage that with their use there is no danger of the formation of blobs of liquid.

Rapidly evaporating fixatives are:

2% mastic resin dissolved in ether, perhaps thinned with alcohol;

Dammar (the whitest possible), 2% dissolved in benzine;

Venice turpentine, 2% dissolved in alcohol. Genuine Venice turpentine remains clear in alcohol.

2% white colophony dissolved in benzine, ether, or alcohol; Zapon varnish, strongly thinned with ether.

Also the ordinary commercial shellac fixative, thinned with two to three parts of wood alcohol, or a 2% solution of shellac. All these media dry rapidly through evaporation and have relatively a very limited effect. According to my experience, they are the best for a pastel, especially dammar-benzine fixative.

More slowly evaporating fixatives consist of combinations of watery and alcoholic constituents, or merely of the former. Here also belong the casein fixatives, thinned casein with an addition of alcohol, or ammonia casein, as was described under tempera, thinned with two parts water and one part alcohol, which must first be added carefully in small amounts and well shaken, since otherwise the casein will flake out of the emulsion. Similar in composition are also the Ostwald casein fixatives, in which the casein is dissolved with borax or ammonia, alcohol being added to the solution.

4% gelatine dissolved in water, to which has been added an equal amount of alcohol, forms a similar fixative, which, like casein fixative, can be hardened by spraying with a 4% formalin solution. These watery alcoholic fixing media remain wet longer than the purely alcoholic. The alcohol prevents the water from gathering into drops. Owing to the longer action of the water, the original irregular position of the color particles is changed, and they are brought more or less into an even position. The charm is lost, and the color becomes darker and heavier.

Watery fixing media are thinned casein solutions (1:5 in water) and soap solutions. Pure watery binding media remain wet for a long time and for this reason cause later darkening; even pure water does this for the reasons already mentioned. Pure watery pastel fixatives have the disadvantage of gathering into drops owing to the surface tension of the water. The basis of the

"Bössenroth fixative" is the well-known method of tempering the glue or gelatine by means of formalin. According to De Mayerne and Pernety,[1] pastels were formerly fixed by laying them face up on a very weak solution of gum arabic or fish glue. Afterwards they were allowed to dry on a glass plate.

Attempts have often been made to bring about a hardening of the color without the use of external mechanical assistance by adding hardening substances to the color crayons. The fact that egg white solidifies in light or warmth has led to much experimentation in this field; however, no practically useful results have as yet been obtained.

Palmié caused resin powder to swell up by exposing it to alcohol vapors and then used it as an addition to the color crayons. Even then a corresponding change in effect took place when fixative was applied. A good, solid ground which does not change when fixed, a white filler of good body, and a rapid-drying fixative together afford the maximum protection against changes. Even then one is still often forced to touch up some final high lights.

When framing a pastel one must see to it, despite advice to the contrary, that the picture does not touch the glass. The pastel should be sealed on the edges with absorbent blotting paper to keep out dust.

Restoration of the pastel. Dark grooves caused by drops of water on the color surface of carelessly framed pastel pictures must be carefully scraped with a penknife, so that they will take color. Such defects are then worked over lightly with the crayon and the tone built up of contrasts.

On old pastels smooth flesh parts often become spotty and the color appears rough, especially if parchment has been used as the support. If one should work into this with the crayon, the blemish would only become worse, and the old color would stand out in relief from the rest. In this case the corresponding color crayons are rubbed on rough paper, and the color is then gently lifted with the finger tips and dabbed on the picture.

[1] Pernety, A. J.: *Dictionnaire portatif de peinture, sculpture et gravure; avec un traité pratique des différentes manières à peindre.* Paris, 1757. [Translator's note.]

Pastels from which considerable color powder has fallen off can be restored somewhat to their original effect by carefully applying new color in a stippling manner. It is best to refrain from using fixative on spots which have been thus gone over. It would have incalculable consequences on the old parts of the picture as well as on the new.

CHAPTER VII

PAINTING IN WATER COLORS

Water-color painting is based on the glazing quality of colors, which in this case are applied in the very thinnest layers.

Every glaze presupposes a light ground. In pure water-color painting all the light comes from the ground, which is usually paper. Parchment, ivory, silk, and cambric, as well as chalk or gypsum grounds, are also employed.

This ground must be as white and clean as possible and at the same time unchangeable.

Papers. Handmade papers made of linen rags fulfill these requirements, but not those made of cotton or wood fiber, nor papers adulterated with these substances. Machine-made papers are inferior for use in water-color painting. Handmade papers can be recognized by their irregular edges, which are not cut. They have, moreover, definite watermarks, which become visible when held against the light and serve as proofs of genuineness. Handmade linen papers take water well, they stand rough treatment, and the color on them has a bright, fresh appearance.

Cotton papers are hard to moisten and are not suited to washes; the color on them appears heavy and dull.

Wood-pulp papers rapidly become brittle and turn very yellow.

The color looks better and also holds better on paper of a rough, grained texture, and has a much livelier and looser appearance, because the irregularities of the surface catch the light and cast shadows.

The paper must be glued throughout its entire structure. When a corner of the paper is scraped, color put on it should not run. It frequently happens today that papers are not sufficiently glued and consequently make work difficult. It is best to cover them with a very thin, approximately 3% gelatine solution and spray this with a very thin formalin solution (4%). Water-color paper must be free from alum, otherwise the color is apt to run.

On the other hand, it must not be greasy, or it will take color badly. The paper may be freed from grease by rubbing it off with thin, purified ox gall or dilute ammonia.

Water-color papers should leave only about 1 to 1⅓% ash when burned, otherwise they have been weighted with clay or other fillers.

The papers must be tested to ascertain if they are lightproof, because a change of tone, for instance, yellowing, when thin colors are applied, would naturally jeopardize the entire effect of the picture. The simplest way of making the test is to put the paper in a book, leaving one half exposed to the sun for about 14 days. In order to be suitable, there must afterwards be no difference in tone between the two halves. According to Täuber, glue containing colophony is the cause of yellowing. Animal glues do not have this objectionable feature, and recently manufacturers have taken this into consideration.

Water-color papers should not be rolled, or creases may easily develop, in which case Chinese white will not adhere, and glazed colors will appear uneven. It is therefore best to preserve the papers in portfolios.

The most reliable brands of papers are Zanders' handmade papers, the English Whatman papers, and the Italian Fabriano papers. Harding paper has a yellowish tone and is soft and velvety. It has proved very satisfactory, as have other English makes, such as the Creswick, Joynson, and also Cartridge papers. The new German product of Schöller, papers with the hammer trade-mark, likewise appear to be lightproof, and they take color well. They may be used as a good substitute for the English Whatman papers, as may also the German Zanders' papers.

Water-color paper, when held to the light, shows a watermark on the front, but may be used on either side.

Parchment is used now and then for water-color painting. Genuine parchment does not crumble when chewed. Like water-color paper, it must, when necessary, be freed from grease. Parchment paper is a very dense cotton paper which has been treated with sulphuric acid, and is naturally inferior. Egg yolk and gum arabic serve as a gilder's medium on parchment.

The paper is mounted on a drawing board by means of thumb-

tacks, or is pasted on a frame. In the latter case the paper must be moistened on the back, and the edge bent over beforehand and then covered with paste and pressed smooth. When wet the paper becomes wrinkled—it expands; but it becomes perfectly smooth again when dry. One must guard against getting any particles of paste on the back or on the painting surface.

Very practical are water-color blocks, which are available in various sizes, because they do away with the necessity for mounting the paper. There are also available frames into which the paper may be fastened without glue.

Water colors.—The grinding. Water colors must be ground with only a very small amount of binding medium and must remain readily and permanently soluble in water.

Gum arabic, dextrin, tragacanth 4%, fish glue, and other glue solutions are used, and in addition glycerin, crystallized sugar, or syrup or honey.

Gum arabic stirred 1:2 in boiling water has the disadvantage that the colors easily acquire a gloss, form a skin, or become stringy.

Admixtures of glycerin, crystallized sugar, etc., are made to increase the solubility of the color in water, and, where the color is applied so thinly, as in this technique, are not objectionable. Glycerin in the proportion of 1:15, used as a grinding medium and in very thin layers, in time decomposes and is therefore relatively harmless.

In dark water colors there is often present a not inconsiderable amount of arsenic. One must therefore be very careful not to put the brush in one's mouth, which one is apt to do in a moment of excitement or absentmindedness.

Water color is difficult to prepare, and for this reason the artist is advised not to attempt to do this himself.

Water colors must be ground exceptionally fine, otherwise they "separate" when mixed together, especially when strongly thinned. The color "disintegrates" and becomes dirty. Gum colors in particular have this undesirable tendency; they cannot stand being suddenly and strongly thinned.

The pigments must be well washed, so that they will be free from soluble salts, which cause the colors to coagulate. Purified

ox gall helps to avoid this coagulating and trickling of the colors. Ox gall tends to prevent the water from gathering into drops by reducing the surface tension, it facilitates large surface washes, and it promotes a uniform adherence of the color even on spots inclined to be greasy. It is also applied to silk both as a ground and as a painting medium.

For purposes of grinding water colors water from the tap should not be used for the reason that hard water containing lime causes a separation of the colors. Neither should rain water be used; it is often quite impure and may cause rust spots. Distilled or boiled water is unobjectionable. Pigment in powder form presents a very finely ground raw material for the preparation of water colors. Water colors are sold by the trade in small cakes, in porcelain pans, in glass jars, and in tubes.

One expects of a good water color that it be easily soluble in water without having to be worked much with the brush. Unfortunately the trade colors do not always fulfill these requirements. For instance, since tempera emulsions are also used for the preparation of water colors, a tough skin often forms with certain colors, as a result of which the color no longer possesses a uniform solubility in water. The strong gloss which develops at the same time points to the presence of a surplus of binding medium. This bad feature is evident in colors of German as well as of English manufacture.

English water colors were for decades the best material to be found on the market; in recent times, however, the German products have at least equaled the quality of the English.

Because of their momentary charming effect, impermanent colors are more frequently used in water color than in any other technique, as, for example, carmine and carmine lake, purple, scarlet, and geranium lake and pink lakes, laque Robert and madder brown, brown lakes, bister, and Vandyke brown; of yellow colors the vegetable pigments stil de grain, gamboge, Italian pink, and yellow lake; also the mixed colors sap green, moss green, green lake, and Hooker's green; and, further, Delft blue, indigo, and neutral tint.

Since the introduction of many coal-tar pigments, the number of impermanent colors has considerably increased. Helio fast

pink R.L., indanthrene blue G.G.S.L., helio fast red, lithol fast scarlet, hansa red, permanent red, and hansa yellow I.O.G., especially fast violet A.L. III, are, acording to Dr. H. Wagner, sufficiently permanent for use in water color. Coal-tar colors in general are more dependable in water techniques. Their disadvantage is that they sink into the paper. In water-color technique one should train oneself to get along with a few lightproof colors; for with the unusually thin application of the color they are more exposed to the bleaching action of the light than in any other technique. For body color painting the best white pigment is Chinese white, an especially dense zinc white. The trade product today, however, appears to be not infrequently prepared with lithopone, to which can be attributed the blackening which appears here and there on pictures and at the edge of the glasses. The new lithopones have proved useful, and so has titanium white, as far as experience goes.

Opaque white, actually white lead, is also used as a name for permanent white (artificially precipitated barite). Cremnitz white should here be excluded, although it so far surpasses all other whites in covering power, because in water-color painting, as a result of its small content of binding medium, it is too much exposed to the effects of the atmosphere and may consequently turn brown.

Of yellow colors one may use all the ochers and raw sienna, the yellow cadmiums (with the exception of cadmium lemon, which cannot be trusted), yellow ultramarine, and a very important color: Indian yellow. Of the many substitute yellow pigments, only the coal-tar dye indanthrene yellow can hold its own with Indian yellow in respect to stability in light. Naples yellow is the best covering color; as sold, however, in tubes, it is rarely clear in tone, but more often a gray-yellow.

Of red colors, burnt red ochers, the iron oxides, and caput mortuum can be used, to a lesser degree alizarin madder lake and artificial indigo (thioindigo), which is permanent only as a water color. Vermilion is questionable, even as to being lightproof; coal-tar dyes, such as helio fast red, take its place.

Blue pigments are ultramarine, cobalt, and cerulean blue, and the color which is so highly prized in water color: Prussian

blue. Prussian blue with zinc white bleaches in strong light, but regains its color again in the dark.

Green pigments are oxide of chromium, transparent and opaque, permanent green, light and dark, cobalt green, and the green earths.

Of brown pigments burnt sienna, the burnt green earths, umber, and sepia, natural or colored, are used; of black colors, ivory black. However, in water color it is best to leave out brown and black tones entirely, because their effect can be produced in a more lively way by mixed colors.

In water color much depends on the quality of the brushes used. Sable brushes are the best, and next to these camel's-hair brushes and the broad so-called wash brushes.

A water-color brush must have a good point, must not divide, and must be wedge-shaped rather than stubby. After being washed the brushes must at once be reshaped, so that the points will not suffer. The points must lie free when drying. If some of the hairs protrude, they are not cut off, but the brush is dipped in water and the hairs which stick out carefully singed off. For very fine work snipe feathers are also used.

White-lacquered tin palettes are most suitable, because they are in harmony with the white painting ground.

The technique. Preliminary drawing should be done carefully with light pressure on the pencil and with as little erasing as possible, so that the paper will not be damaged and will take the color well. The paper is dampened with a sponge, the water is allowed to soak in somewhat, so that it no longer stands on the surface, which now appears mat and no longer shiny, after which work is begun at once. Water is the exclusive painting medium. The selection of colors must be limited as far as possible; in this way the picture becomes so much the more colorful. The majority of tones can be obtained with Indian yellow, madder lake, Prussian blue, and oxide of chromium transparent; and others are seldom required for supplementation. One can start in boldly and set in the color tones broadly and in their full strength, if one is sure of one's subject, and it is best to begin with the shadows, putting in tone alongside of tone, progressing toward intervals and light. In water-color painting everything de-

pends on freshness; troubled or "tormented" color is dirty and dull in effect.

In the older manner of water-color painting one began with very thin, light, unexpressive, neutral tones, which were then gradually strengthened. By fusing the colors and permitting them to run together certain effects were obtained which are no longer in keeping with present-day requirements. Lights had to be left open, and gave the work a kind of scintillating charm, a pleasingly decorative and harmonious effect. By washing out, which is possible only on rag papers, or lifting up the wet layer of color with the brush or a chamois skin, or with the eraser or similar devices, lights may likewise be "picked" out, which, however, are softer than those left open. On too dry a surface colors take on edges, which may be deliberately used for artistic effect if they have been taken into account from the outset. This is often evident in modern decorative water-color painting.

Today water color, following the precedent of Dutch painters, is handled more freely and frequently in combination with opaque white, which is laid over a half-wet or dry surface; in this way are achieved airy, soft, or body effects. The charm of water color is based on its soft, bright, light tones. In order to make the gray-appearing shadows deeper, many painters go over these with a water-color varnish consisting of one part Zapon varnish and two parts alcohol. Also thinned shellac fixative which does not shine is used here as a varnish. This should first, however, be tested by varnishing a coating of ultramarine in order to see the effect. It is better, however, to refrain altogether from using such varnish.

Ivory finds use here and there as a basis for water color. Ivory turns yellow when stored. By treating it with hydrogen peroxide, the yellowing can be eliminated; this is done by moistening blotting paper with the peroxide and placing the ivory between two layers. Ivory is very sensitive to grease; therefore the painting surface must never be touched directly with the finger. The grease can be removed with benzine, dilute ammonia, or ox gall. The ivory is scraped smooth, rubbed down with cork and the finest pumice-stone powder and water, or with the muller, and dried under even pressure between clean pieces of blotting

paper. In tracing the drawing, tracing paper free from grease must be used on a pure white foundation. The color is applied wet in wet, but not too fluidly, so that no edges develop. Painting is from top to bottom. There are old miniatures on thin ivory on the back of which were applied intense but meager oil colors which shine through, the front showing only light glazes with here and there a few accents. In some cases silver foil was placed behind them, which gave the colors a saturated appearance and at the same time a fine gray quality.

The color effect must remain light and loose. Bleeding colors, such as coal-tar colors, for example, alizarin madder lake, and also zinc yellow and Indian yellow, must not be used, because they penetrate into the ground. A tone which has become too heavy can be made lighter by scraping or pricking it up with a needle (with the aid of a magnifying glass). It is best to begin with the simplest glazed tones. The brush must be damp, but well pressed out, not full of color. One must be very sparing with red in the flesh tones; it is best not to apply it until the end. A preliminary coat of an alum solution 1:10 mixed with a trace of glycerin greatly facilitates a free and broad technique.

Gouache color. In solidity of tones water color is far surpassed by gouache, the method of painting with body colors. For here are developed gray, airy tones of great charm, an effect similar to pastel, but obtained in a wet fashion. Body-color painting offers much greater freedom and ease of handling than does pure water color [aquarelle].

As binding media those of water color are used.

To all these colors white fillers, barite, clay, etc., have been added.

For gouache painting colored grounds, colored papers, and toned linen, etc., give better results than white grounds, which are calculated primarily for glazed effects. For best results round bristle brushes are used, and also hair brushes along with these.

One may first lay the colors on thinly, then strengthen them, and gradually paint more opaquely wet in wet, with or without the aid of the ground tone, which, when covered very thinly, gives very useful, unifying, harmonious tones.

Lights are set in opaquely and half-dried with very little bind-

ing medium; by this method is obtained a very solid effect. A unified quality of light is most characteristic of this technique.

Gouache painting can be hardened and made insoluble in water by spraying it with 4% gelatine followed by a fixing with 4% formalin.

Gouache color today has been largely replaced by the more diversified tempera. Today also so-called poster colors are much used. These are essentially glue colors containing a large amount of "fillers." The poster colors cover well and uniformly. If sprayed with a 4% formalin solution, they become insoluble in water. If gum is the medium, this is ineffective.

When *framing water colors* one must take pains to see that the water color does not touch the glass, but that there is sufficient space between. The paper must not lie upon wood, or it will develop spots. There should be a space of about a millimeter between the glass and the painting. Water colors are best preserved in portfolios. In any case they must be protected from the direct rays of the sun and from dust.

The restoring of water colors. Dusty water-color paintings should be cleaned with kneaded gum or bread crumbs. Dusting with a pure white cloth and a light rubbing with soft buckskin has been recommended to me as the best method of cleaning.

After the cleaning, faded water colors are placed for a moment flat in a very thin watery solution of borax (1 part borax to 60 parts water). Yellowing can be removed to some extent by covering with white blotting paper dampened with hydrogen peroxide. If care is taken and one does not rub, one can work without danger with the watery solution. When there are creases in a water color, it is moistened on the reverse side and afterwards placed on a dampened glass plate. In the case of tears one must back up the picture with paper and starch paste and then insert into the cracks a paste made from scraped or filed-off paper of the same kind with a little glue, and, when possible, impress on it the same grain as that of the paper. I have observed a blackening of white (probably lithopone), and in some spots total blackening, on water colors and miniatures. In this case only a careful scraping of the lights and a new application of zinc white are helpful.

CHAPTER VIII

MURAL PAINTING

In contradistinction to easel painting, painting on walls is a restricted technique which is governed not only by laws arising from its special character but also by others which are imposed by the surrounding architecture, as well as by the colors and forms of the surroundings in general, which must be reflected in the picture in both variation and contrast.

A mural must remain an essential part of the surface of the wall. It must not try to create an illusion of space; in other words, it must not have the effect of a hole in the wall. The surface of the wall must never be destroyed by the wall painting, neither must a wall painting create an illusion of space within an architectural space. Hence a wall painting does not necessarily require a background in the same sense as does an easel picture, and still less a frame. This does not apply to the ceiling pictures of the baroque period; here, on the contrary, the illusion of space was carried to extremes. Contours and juxtaposed color areas are the means of expression. Exaggerated modeling defeats the structure of the wall as such. Local color used in simple patterns or a unified ground which asserts itself everywhere in the composition intensifies the "mural" effect, as do also strong outlines.

It is possible to achieve a good pictorial effect with color areas alone, but this is more difficult than with the help of good vital contours.

The surrounding architecture requires large, simple forms and decoratively effective surfaces. The mural is especially adapted for a draughtsmanlike, simplified style, for strict conventionalization, and for a more schematic use of color.

But also very opaque painting, as in the baroque frescoes, is technically quite possible. It is certain that the fresco technique could be still considerably improved if only adequate attention were given to its problems and exact observations made of the relationship of various mortar mixtures to applications of color.

Such practically useful investigations should be extended to all monumental techniques, and, should they result in dependable discoveries, these should be made available to the profession. The possibilities of painting on concrete should also be more carefully investigated. It is largely through technical errors that fresco has unjustly acquired a bad reputation in respect to permanency. The fresco technique is much more flexible than is generally believed, and is not suited merely to historical, stylistic effects. Its possibilities have not nearly been exhausted and permit of unsuspected scope in the matter of color strength as well as in the handling of materials in the modern sense, especially also on tinted walls. The laudable attempts to introduce color into commercial life should also be a boon to mural painting. But, lacking good craftsmanship, works in fresco will soon perish, and art patrons will once again turn from wall painting. The entire artistic profession will then be made to suffer through the carelessness of single individuals.

One may paint on the wet mortar "a fresco," or on dried plaster "a secco."

To paint a mural picture on canvas and then transfer this to the wall is a less satisfactory but, to be sure, very convenient makeshift.

I. FRESCO PAINTING

Fresco painting is painting on wet lime plaster (fresco buono = true fresco). The water evaporates, and at the same time the lime absorbs carbonic acid gas from the air. On the surface of the picture is formed a glassy skin of crystalline carbonate of lime, which incorporates the colors with the ground in such a manner as to make them absolutely insoluble in water, and at the same time gives to them the fine sheen peculiar to genuine fresco painting.

In fresco lime is not merely the binding medium, but is also at the same time the only as well as the most beautiful white color. The technique demands a restriction of the number of colors used, and it offers the difficulty that the colors dry out lighter than when first applied, thus compelling the painter to have a clear conception in advance of what he wishes to accomplish.

For casual experimentation, as is practiced in oil painting, fresco is not adapted. The more certain one is of one's subject in all its details of form and color, so much the easier is one's task, and so much the fresher and more lasting will be the finished results. The method of work demands simplification and restriction to what is essential, since the artist has only a relatively short time at his disposal. More than in any other technique everything here depends on good craftsmanship. This is absolutely indispensable to the fresco painter.

For this reason the question of materials must here be thoroughly discussed, and one will soon realize how much depends on the exact observance of very simple and apparently non-essential rules of craftsmanship—so much, in fact, that the greatest work of art will soon perish if its creator was not clear in his mind regarding these rules. To the experienced fresco painter much that he finds here will appear superfluous, but it must be remembered that frequently artists find themselves confronted with the problem of a fresco without any previous technical knowledge, and then good advice is dear. Therefore special emphasis is placed upon rules which govern fresco in contrast with oil painting. The best artistic creation is lost if the ground and the color were not applied according to rule. The painter must therefore here be even better acquainted with his material than in the case of oil painting. It is not necessary for him to do all the preliminary work himself, although the example of Michelangelo may here be a great incentive, but he must know what counts, so that he can manage and supervise the execution of the work. Painting in fresco is a thrilling experience, and anyone who has tried it once will love this technique just for the difficulties which are so often exaggerated. It requires the whole man. Delacroix said that the necessity for having everything ready at once in fresco stimulates in the soul a feeling of excitement which is directly opposed to the indolence which oil painting engenders.

Many objections are raised against fresco painting. Indoors frescoes have been preserved splendidly for centuries. In the open many works have stood surprisingly well, while others, where technical errors were committed, have lasted only a very

short time. Fresco painting for this reason, and also because of the difficulties and annoyance said to be inseparable from its practice, has in some quarters acquired a bad reputation.

Frescoes should be painted in the open only at that time of the year which is free from frost, and never on the weather side of a wall, where rain and snow will strike the picture with full force. The south and west sides are therefore the least suitable because of fluctuations of temperature, direct rays of the sun, and pelting rain. A roof with a wide projection offers a certain amount of protection.

It was formerly commonly taken for granted that, as also Ostwald maintained, a fresco in a large city or industrial center would go to pieces within a short time, because the acids containing sulphur which were liberated into the air by burning coal attacked the skin of carbonate of lime. Recently it has been very seriously questioned whether this danger is as great as generally believed. Materials of the best quality together with a correct technique will go a long way toward warding off destruction.[1] Of course Ostwald was ambitious to substitute for fresco his "monumental pastel," for which he did not hesitate to claim unlimited durability. But the material effect of pastel is very different, and optically it is very inferior to fresco; furthermore, its greatest charm, its loose and airy effect, is lost through the unavoidable fixing or rubbing over with paraffin which Ostwald required. The color then becomes heavy, dull, and spotty. Many of the older great masters, as, for example, Titian and Tiepolo, undoubtedly owe their grand style, as well as their simple, monumental color effects, in no small measure to their experience with fresco.

The Materials of Fresco Painting

The lime. Natural limestone is calcium carbonate. When burned, it gives off carbonic acid gas. The burnt lime (calcium oxide, caustic lime), if combined with water, turns into slaked lime (calcium hydroxide). This is the material for fresco painting. When lime is slaked, it gives off heat. The slaked lime also

[1] California, because of its freedom from coal smoke and its mild climate, should be an ideal region for fresco paintings. [Translator's note.]

gives off water into the air, but again absorbs carbonic acid gas.

In this process a thin film of carbonate of lime forms on the surface of the plaster, in which limewater in solution, calcium hydrate, combines with the carbonic acid of the atmosphere. Indoors this process is much slower. (Neutral) calcium carbonate is no longer caustic, which is important in secco painting.

Pure limestone, when slaked, makes a very "fat" lime, which quickly turns to a soft consistency, giving off much heat in the process. Gray limestone slakes very slowly, as do gritty limestones and those containing clay. If, after slaking, there are small, solid, lumpy remnants, they must never be broken up and used. Frequently they slake later on in the picture and break out in the plaster.

The best lime is that which has been burned over wood fires, because, if coal has been used, the lime is likely to absorb sulphuric acid and partially turn to gypsum. Gypsum prevents the setting of the fresco plaster and causes efflorescence. The quality of lime is therefore determined by its gypsum content. Pure lime as limestone dissolves completely with effervescence in a dilute solution of hydrochloric acid, and carbonic acid escapes. Slaked fat lime effervesces only to the extent to which it has absorbed carbonic acid. If there are remnants which do not dissolve, a test may be made with warmed hydrochloric acid; this will dissolve gypsum, but not clay or marl. If lime taken from a pit is to be tested, the proportion is one part lime to twenty parts hydrochloric acid. Another test for gypsum is the following: If the hydrochloric acid becomes milky and shows a white precipitate, the latter is heated in a spoon until very hot and dry. Then a little water is poured into the palm of the hand and the precipitate put into it. If it turns hard quickly and feels warm at the same time, it proves the presence of very considerable amounts [more than 5%] of gypsum. In the open only lime free from gypsum should be used, and it is also advisable indoors. A 5% content of gypsum makes lime useless for fresco. Magnesia in lean lime dissolves slowly in hydrochloric acid, therefore it is best to allow a day for this. Lime containing much clay is hydraulic, like cement, and is then not useful for fresco because it sets too quickly.

The slaked lime which through the addition of water has be-

come fairly liquid is allowed to run into a pit. Impurities there settle on the bottom. This process of purification should not be shortened. According to Vitruvius, well-slaked lime [lime putty] should hang from the hoe like glue and be uniformly creamy, not lumpy.

Experienced fresco painters have always insisted that lime should ripen well in the pit; at least two years is a minimum. The older lime becomes, the more buttery it is; that is to say, it stands up in chunks. Fresco painters have told me of lime which was twenty years old and more which was marvelous to paint with, which set solidly, and which gave a fine gloss to the surface.

Sometimes fresh slaked lime is recommended. It is true that chemically it is identical with old lime, but in physical consistency there is every difference in the world, and there is always great danger of particles of lime slaking in the picture. Besides, fresh slaked lime has no body and is therefore not useful for fresco painting; it is too readily absorbed into the plaster ground.

When lime is removed from the pit, it is necessary first to remove the top layer, the crust, because this has already turned into carbonate of lime and therefore cannot be used. It is important that the lime pit have a steady supply of water and that it have good masonry walls and be protected against freezing temperatures.

It is advisable to put even the best of lime through a sieve and in this way catch all the lumps.

White lime or marble lime is the best material. Gray limes and all yellowish and reddish limes which have been discolored by iron content should not be used. Hydraulic lime of a good quality sets very well, but much too quickly, so that, if used for fresco, the colors will not hold. Partially slaked limes sold in sacks in powdered form are very dangerous, because they continue to slake in the picture and thus ruin a fresco. Carbide lime is also of no value for fresco. Old, fat lime from a pit is of a buttery consistency and is the best material.

The addition of water to lime in different proportions gives milk of lime, limewash. Limewater is formed when thinned milk of lime, after being stirred, settles to the bottom and the water above it clears. Such clear water is excellent for fresco painting.

On the surface of this water a very fine film of carbonate of lime forms identical to that which fixes the colors in the fresco. To prepare limewater hot is of no advantage, because, when it turns cold, the excess of dissolved lime separates again.

The important thing in fresco is that the lime set well with the colors, that is to say, it must not rub off and must become insoluble in water.

Thin lime paste enters into more or less solid combinations with skim milk (casein), glue, sugar, soap, fatty oils, and resin varnishes, which are all used in secco painting and in "stucco lustro" [imitation marble]. It is possible to use small quantities of casein in fresco mortar as well as in fresco painting, but this is not necessary. Additions of fibrous materials such as oakum, chopped rope, calves' hair, and straw were recommended as additions to the plaster in the Byzantine recipes (Athos book) in order to prevent cracking; but such plaster dries more slowly. All these substances before use must be soaked for a considerable time in the lime paste. Today these additions sometimes are still used when plastering vaults and ceilings.

SAND. Sand and lime are the necessary basic constituents of the mortar or plaster. The sand makes the plaster porous and thus facilitates the transformation of caustic lime into carbonate of lime. Some sands contain particles of humus and loam. Used in this form, they would be dangerous to a fresco, since these particles decompose when exposed to the air. Such sand must be washed and dried again. This process frees it from loam and humus. A practical way to test the sand for clay is to throw a handful into water; it should become cloudy only for a short time. Sand containing clay causes cracks in mortar. The sand must not be stored on open ground, or it may cause efflorescence on the surface of the fresco. Plaster containing water-soaked sand, when painted on, exudes moisture, it "weeps," and so makes it difficult for the colors to adhere. The plaster remains soft, and the single particles of sand may be easily rubbed off with the finger. If one sticks a wet trowel into buttery lime, it will come out clean. The water serves as an insulating coat. The lime in this case will not hold to the trowel anywhere. If, on the contrary, the trowel is dry, it will be covered with lime when pulled out.

This also holds true of sand, the particles of which should be as angular as possible, not round. Upon such simple rules of the craft depends the permanency of the fresco. Disregard of them has brought fresco painting at times into bad repute and for a time closed to painters a large field of activity.

Coarse, but not too coarse, sands serve best in the under coats; the finer sands are for the finishing coats. The sand should consist of particles of approximately the same size. The solidity of the plaster depends very largely upon this. Very useful are the sands of primitive rocks, such as gneiss, granite, and porphyry.

Very fine sand should be sharp, and not powdery. Sands made from solid rock have the advantage that they need not be washed, because they contain neither clay nor humus.

Sand must be free from mica. Fine river sand often contains many flakes of mica, which (according to Friedlein) decompose when exposed to the air and so may ruin a fresco. The frescoes in the New Pinakothek in Munich have suffered because this requirement was not met. Powdered limestone in place of fine sand, also marble sand, marble grit, and marble dust provide excellent materials for the top plaster coats in fresco. When they are used, however, the paintings become very light and correspondingly less rich in color, in fact often annoyingly white. Therefore, if a gray-toned plaster coat is desired, marble dust cannot be used in it. Ground pumice stone, unglazed, triturated porcelain, and a few infusorial earths are used now and then in place of sand. Cement must be absolutely excluded from the fresco ground, as must also gypsum.

The wall. A wall which is to be used for fresco painting must be dry and should be exposed to the air, that is to say, without a plaster coating, for some time. If old plaster is present, it must be completely removed, and even the mortises between the bricks must be "picked" out to the depth of half a finger (for secco overpainting a total removal of the plaster is not necessary provided it is otherwise in good condition). Before going to work, one must for at least a day, but for best results a week, repeatedly soak the wall to see whether all the stones absorb water equally well. Those which do not, which are burned dark red and which, because they are covered with a hard glaze "clinker," cannot ab-

sorb water, must be partly or totally removed. A disadvantage is the smoothness of machine-pressed bricks as compared with the old handmade type. Such bricks will have to be roughened.

The more or less even setting of the fresco depends, as a matter of fact, to a large extent on whether or not the brick wall was soaked with water to the limit of its power of absorption. On poorly wet walls or walls which are not wet at all, especially on old plaster, the mortar will remain soft and will easily come off even if it should set on the surface. The limewater will then be absorbed into the wall instead of working its way outward. The wall must give water to the plaster coat and not swallow it up, otherwise the plaster becomes spongy and does not harden through.

A fresco painter was quoted to me as having said that he had never painted more easily than when at one time he had had a wall hosed off with a high-pressure fire hose.

When a white efflorescence appears on bricks, the affected places must positively be removed, because otherwise the efflorescence will in the course of time force its way through to the color on the surface and ruin the fresco. These exudations on walls and bricks consist for the most part of calcium sulphate (gypsum), sodium sulphate (Glauber's salt), magnesium sulphate, and earthy substances. Too much emphasis cannot be placed on the necessity for removing bricks which show "bloom" before the work commences, because this bloom will jeopardize the whole fresco, and the spots thus made can seldom be removed later on. To dash a coat of cement over efflorescing bricks is a very questionable remedy; such a coat would have to stand exposed for several months and be thoroughly roughened.

In an emergency one may try to wash off the bloom by brushing with hot, thinned hydrochloric acid. The parts must then be rinsed off with a great deal of water, as long as "bloom" is in evidence, because gypsum dissolves only in 400 parts of water. I know of a case where a painter tarred the wall after this process. The tar was mixed with dry, coarse sand. Another nailed asphalted felt over "blooming" tufa. In both cases the result was satisfactory. Nevertheless, such processes are always uncertain. Glauber's salt "bloom" may develop when the stones were burned

with coals containing very much sulphur. It is eliminated in the same way as gypsum. Dousing with large quantities of water is here necessary—the best results are obtained by using a high-pressure fire hose.

Bricks, according to the temperature at which they were burned, absorb more or less water and give it out again very slowly, so that several days elapse before they have lost half of their absorbed moisture. This is a very important moment in fresco painting.

With bricks care must be taken to see that they are of as even a red color as possible, which depends on good firing and a high content of iron oxide. Dark violet bricks the color of clinkers do not absorb much water; they should therefore be removed. Very smooth bricks must be roughened.

The earlier hand-pressed bricks were rougher and more uneven, and the mortar could get a good hold on them. The present-day machine-made bricks are too smooth, and the mortar will adhere to them only if they have been roughened.

With newly erected walls one must see to it that no bricks are used which have lain directly on damp ground, since these bricks usually have absorbed considerable amounts of salts which cause them to bloom. For the same reason it is very dangerous to preserve bricks on oven clinkers or ashes. New walls must be left alone for at least a month. Outside walls must be surrounded by an air space.

When Michelangelo painted his "Last Judgment" in the Sistine Chapel, he had a special wall of selected bricks built for it in front of the real structural wall. This new wall tilted forward at the top; it had an overhang of half an ell [about ⅔ of a meter], so that dust could not settle on it and, furthermore, the fresco could be better seen. The space between the two walls provided good ventilation. On the advice of Sebastian del Piombo, a mortar coat mixed with resin which was to be burnt in and painted with oil was first put on, but Michelangelo had it knocked off and painted his fresco on lime-mortar ground.

Ceiling frescoes must be provided with ventilation, so that moisture will not condense on them.

The "good" side of the wall, the side on which the stones lie

in smooth regularity, is the side adapted for fresco work, and it is an advantage when wide mortises are to be found between the bricks.

On a permanently wet wall caused by a constant supply of moisture coming from the earth neither plaster nor painting will hold, and the painter should in no case guarantee work on such walls. Such walls must first be insulated, which can be done by many approved methods. That which has proved best is the insertion of horizontal lead plates to serve as insulators or the construction of air wells in the walls through their entire height.

Freestone requires less wetting than a brick wall. On the wet ground the largest holes and depressions are filled by throwing mortar into them and permitting the ground to dry for a day or so. Then the stone is roughened, and after again being wet, a (1-2 cm.) thicker plaster coating of a coarse and a fine plaster is applied, which is allowed to dry for a longer time before being painted over than in the case of the mortar on brick walls. Very wet plaster easily comes off freestone. Over this a coating of milk of lime may be put if a very light coat is desired. It is best to remove damp stones or those showing bloom. Tufa stones are often damp. Sooty stones must be "cleaned off" by a stonemason. Thin plastering permits only of a fresco painting in small successive plaster areas. For this reason freestone is more frequently painted on in secco, especially with casein, which is worked into the still wet milk of lime, as in secco painting.

The preparation of the mortar. A mortar trough is required in which to mix the mortar, a hoe, a flexible trowel, a smoothing board or plane (the best is made of elder wood; also an iron plane can be used, but not one of felt), a straightedge, pick-hammer, broom, plumb bob, and pail. For practice in fresco one can plaster a very shallow wooden box (picture box), or wooden or galvanized iron frames in which galvanized wire mesh is stretched. Also on tiles, bricks, and the like experiments can be made.

The slaked lime and sand should be first mixed without the addition of extra water and promptly well worked together. It is, of course, more convenient for the plasterer to add water at once, but then it will be exactly as with wet sand, the sand particles will be no longer enclosed with lime, but with water.

The wall must be soaked until it will take no more water, and all individual plaster coats must likewise be thoroughly moistened. This is important for the life of the fresco. The mortar, however, must not be applied too wet, because very wet mortar loses in body and cracks. Plasterers have the habit, which they bring with them from their trade, of throwing a handful of gypsum, cement, or soda into the mortar. This, if permitted, may ruin a fresco, therefore vigilance is in order. Efflorescence and bad setting of the plaster are the inevitable consequences.

On a wall which has been repeatedly wet and gone over with a sharp broom, and which will absorb no further water,

1. *the roughcast* is applied.

For this purpose one takes *3 parts coarse sand, washed and dried and mixed with one part lime.*

This coat can be a little more liquid than the later coats. If it just threatens to run off a tilted trowel, its consistency is about right.

From a distance of about 50 cm. the mortar is thrown vigorously on the wall so that it splatters, with a twist of the wrist which requires some practice, until the plaster coating becomes from 1 to 1½ cm. thick. It is best to apply the mortar from bottom to top. The roughcast is also best applied somewhat from the left, that is, thrown obliquely to the right-hand side and not straight in front of one, because otherwise one is apt to receive the mortar in one's face, and because the mortar forms blisters more easily and, above all, does not hold so well as when thrown against the wall obliquely. Throwing on the roughcast with force will avoid air bubbles in the mortar which may burst open later on. The roughcast should be rough so that the following plaster coats can get a good hold on it. The next plaster coating may be applied at once to the roughcast when this no longer gives way under pressure of the finger, but merely takes its imprint (about 20 minutes). If one waits longer, 12 hours or even several days, as has often occurred, then the roughcast must be scratched to get rid of the crystallic film which will form. Only with freestone must one wait longer, about 12 hours. If this were disregarded, the top layers would hold only mechanically to the intermediate

limeskin, and with the action of frost they would crack off, an effect which is not infrequently observed on frescoes made with badly prepared plaster. Each new layer must be applied only after a preceding dampening, which is best done with a plasterer's brush and after a good previous brushing.

2. *The equalizing coat* is likewise composed of *3 parts coarse sand, 1 part lime,*

but it is kept a little dryer than the roughcast, so that it threatens to run from the tilted trowel, but does not actually do so.

In thickness it should be the same as the previous roughcast: 1 to 1½ cm. This second plaster coating, which serves as an equalizer for the production of an even wall surface, is put on by means of a straightedge, which is applied horizontally from bottom to top with a light pressure. It is then worked with the trowel. This second coat must remain rough and must not be smoothed. It is best to apply all plaster coats from bottom to top.

3. *The coarse painting coat* (rough plaster). *2 parts finer sand or marble grit and 1 part lime*

are mixed, as previously. When the second coat no longer gives under pressure of the finger, but only allows itself to be slightly dented (after about 20 minutes), the coarse painting coat is applied, perhaps 1 cm. thick. This likewise must be leveled off only with the straightedge if still another coat is to be applied. Marble grit gives to the plaster a peculiar substantial charm.

If this rough plaster is to be painted on, it must be finished with a wet plane. Many artists prefer a somewhat rough ground, especially for work out of doors. According to Dr. Eibner, a fine coat well put on gives off more limewater to the surface; in other words, the colors set better on it. Marble grit in place of sand lightens the colors as well as the ground.

4. *The fine plaster* [intonaco] [2] is applied only after wetting and brushing the preceding coat, and consists of:

1 part fine sand or marble dust, 1 part lime.

[2] The term "intonaco" applies to the actual painting ground in fresco, hence is equally applicable to the rough plaster when used as the final coat. [Translator's note.]

The ground is applied and smoothed with the wet plane. The plane is directed from bottom to top, being applied so that the top part of the plane is inclined outward, and with a light pressure on the under edge the plaster is smoothed out with a circular motion. A plane covered with felt is not good, because it absorbs too much water.

Many painters do not smooth this last coat very much, because they prefer to paint on a somewhat rough surface. There are old plaster coats which are very smooth and which at the same time have stood very well. A Tirolean fresco painter told me that he smooths the rough plaster, which he keeps somewhat more compact and not too fluid, extensively and carefully. He figured on 2 hours to the square meter for this process, which was started immediately after the plaster had set sufficiently. Such ground, for which he used fat lime, became very hard, permitted of a long painting period, and also became very solid throughout. A good wetting of the wall, good, old slaked lime, dry, sharp sand, and the application of all coats wet in wet are the essential requirements for the permanency of a fresco ground and, finally, for a good "setting" of the colors. If one for any reason whatever is forced to allow one plaster coat to wait for the next, it must be roughened and well wet before proceeding with another coat. Plaster made with very fine sand is regarded by many painters as a disadvantage. Dr. Eibner maintains, on the contrary, that the capillary attraction to the surface of the limewater is encouraged by such fine sand. Only very coarse plaster is regarded by fresco painters generally as not permanent. Plasters composed of fine sand laid over the second coat and more or less smoothed are certainly more profitable and form the rule. A single plaster coating of considerable thickness would not be permanent; it would easily crack off. One must work in layers one over the other. The top layer of plaster composed of finer sands must, according to experience, be kept very thin, 3-5 mm., in contrast with the coarser layers, which should be considerably thicker. The "paddling" of the mortar according to the instructions of ancient writers has not proved profitable. Such mortar easily cracks, and the color does not hold well everywhere, because water comes to the surface in spots and the color cannot get a

grip there, exactly as when the edges of the plane are pressed in when smoothing. Perhaps "paddling" is a technical term incorrectly translated and to be better explained as a prolonged smoothing of the plaster. A limewash does away with the dangerous gathering of water in the depressions caused by tools, but makes the colors very light.

The usual proportion of sand and lime is in nearly all recipes in the first coats 1:3; this proportion dates back to the ancients. In many recipes this proportion remains even for the last coats, while in others the last coats are made richer in lime and leaner in sand, according to the old painting maxim: fat over lean. There are old plaster coats on which a pure, thick lime coating lies over the rough plaster, often several millimeters thick, which has become very hard. It is probable that such layers were smoothed down for a long time and thus hardened. Marble dust or fine marble sand is likewise to be found in such rich upper layers. Together with lime it formed the chief material in ancient plasters. In Byzantine and later plaster walls were found tow, straw, or even cow hair to make the mortar hold together better and lessen the danger of cracking, which nevertheless did occur. Such materials must have been allowed to soften in lime paste for a few days previous to being used. The Athos book describes the preparation of such plaster, which today, however, is seldom used. In vaults, and also sometimes on ceilings, materials of this kind are still sometimes employed. For outside walls plaster coats of this type are not suitable.

On ceilings and in vaults the mortar is used less wet, also less thick, and a day is permitted to elapse before beginning to paint. Then the coat is scrubbed vigorously to remove the skin of carbonate of lime. After this limewash is applied, and one paints into this.

Cracks. Very fat and at the same time wet plaster cracks easily, exactly as if wet or loamy sand had been used. Too thick layers applied at one time likewise may crack, as also may otherwise good layers on walls of uneven surface on account of the unequal thickness of such plaster. In themselves such immediately developing cracks are not very dangerous. In case of necessity, they can be brushed over with some milk of lime and the edges

pressed together while the ground is still moist. They may often be observed on old frescoes.

The adhesion of the colors is in general better on somewhat rough grounds; for this reason a rough ground is usually chosen for outside frescoes, and also because it is optically more pleasing and has a livelier effect, and because less of the color is carried off by rain and dust than when applied to very smooth coats. Nevertheless there is great difference of opinion on this subject. Old, smooth plasters have often kept remarkably well, which, to be sure, leaves the question still unanswered whether they were painted in pure fresco or with casein on the damp plaster. Dr. Eibner describes such plaster, which he found on the Hummelhaus at Augsburg, which dates back to the 17th century. A 5% addition of casein increases the weather-resistance, but it makes the colors grayer. Much casein has a tendency to make the colors sticky while painting.

It is not advisable to mix mortar and keep it a long time in storage, because naturally the limeskin forms on it. It must at least have previously been well worked together again or forced through a sieve. For best results only enough is prepared in advance for from one to two days.

The length of time in which one may work depends on the thickness of the plaster coats. The total thickness of all the layers comes to about 4 cm. In Pompeii plaster walls have been found almost twice as thick. The thicker the different coats, the longer painting is possible. If these are applied properly and in suitable thicknesses, one can paint wet in wet, according to the weather conditions, 5-6 hours or more, even for days. It often happens that for convenience or by reason of ignorance the mistake is made of applying the last layer wet and only perhaps half a centimeter thick and then painting on it, when all the other underlayers were applied a long time before and were therefore dry. One or more limeskins in that case have formed inside, which lessen the strength of adhesion of the last coat. On such a thin layer one naturally can paint for only half an hour and only on very small areas at one time. Work under these circumstances may become exceedingly difficult and consume as much time as one would otherwise require for two square meters of figure

work done on the right ground. The whole process of applying the plaster coatings must be directed, on the one hand, toward increasing the new formation of calcium carbonate, which is the binding medium of the colors, and, on the other hand, toward slowing up its formation, so that the length of time in which one may work is increased, which is obtained by the rapid placing one over the other of the plaster layers wet in wet and by a certain thickness of the different coats.

PREPARATIONS FOR PAINTING. One would do well to check up carefully on every phase of the preliminary design at the spot where the fresco is to be carried out, in order to make sure of the illumination and the necessary strength of the colors. On vaulted ceilings one will often be compelled to make distortions intentionally—so that the effect will be convincing when seen from below. A model of the room which permits one to study the relationship of the picture to the surrounding architecture also makes matters a great deal easier for the fresco painter.

When the last plaster coat no longer gives under pressure of the finger, but may easily be dented, one may begin the work of tracing or "pouncing." For larger works it is essential, for smaller works at least very helpful, that, before starting work, one make a full-scale drawing or "cartoon" of the projected painting. For very large-size frescoes the cartoon is cut into squares, and similar squares are outlined on the wall by means of vertical and horizontal lines. One then begins at the top of the composition by lightly pressing in the contours of the cartoon with the handle of a brush. By this means the outlines are incised into the soft plaster. After the cartoon has been transferred in this way, it stands out in very low relief on the wall. The contour catches light and shadow and in this way has a vitalizing effect upon the design. Not uncommonly this impression of the contours is regarded as the one distinguishing mark of the genuine fresco; but that is erroneous. In the first place, smaller works are often painted directly and without such a preliminary step, and, in the second place, secco painting on "buon fresco" underpainting obviously may also show the incised contours. For very fine work one also uses the pouncer and pounce bag in order to make the cut contours visible with charcoal dust. There are also frescoes

which consist of joined square tablets which do not have incised outlines. Along with the cartoon which controls the design, for larger works a color sketch in opaque tempera or gouache is made. One must here take pains to see that the same permanent colors are used as in the fresco itself. The ground must always be kept clean. Since the time for work is limited, the preparations must be made in such a way that there will be as little delay as possible, and that there will be no need for changes. Upon the freshness and immediateness of the execution essentially depend the charm and the proper "setting" of the fresco colors. By exhaustive preliminary studies one must have the work so clearly in mind that it is approached without a sense of anxiety but spontaneously and in a free and easy manner with the sensation of assured success. Here and there on old Italian wall paintings one finds a red chalk drawing, which made its appearance when the top plaster fell off. Here the effect of the composition was tested, and then, carelessly enough, the plaster was not removed, but new plaster was laid over it. Because of the hard limeskin which formed between them there was but little mechanical adhesion, and through lack of resistance to weather conditions, as in so many recent works, the top coat of plaster scaled off in large sections.

The colors. In fresco work the color scale is a limited one, because colors which are sensitive to alkalis must not be used in lime. To determine whether a color is lime-proof, a sample is shaken in a glass with some slaked lime and water and allowed to stand for a few days. It is quickly discovered in practice that only good artists' colors are permanent in fresco and not house painters' colors or those used in calcimining. House painter's ultramarine and English red frequently contain gypsum, which prevents their "setting" in fresco and may cause efflorescence. Cremnitz white is excluded, since in lime it turns in a short time to brown lead. A well-known fresco painter once told me in dead secrecy that he added Cremnitz white to lime. Caution is in order regarding such "secrets." Zinc white could be used, but it is unnecessary. In spite of this, zinc white is used with the argument that, when mixed with lime, it shows fewer changes when dry than does pure lime. Zinc white decomposes very rapidly in the

open. The ripe, "buttery" lime, as it is taken from the pit, forms the one absolutely ideal white for fresco, and it is binding medium and color all in one. One reads not only in old recipes, but also in those of recent times, of all kinds of methods of preparing a serviceable fresco white. Egg shells are cleaned, crushed, and ground, treated with vinegar, and dried in the air, or lime is dried, ground, and likewise treated with vinegar and dried in the air, etc., the "bianco sangiovanni" which Cennini describes in great detail. Chalk, gypsum, and even clay are recommended, although these two latter jeopardize the "setting" of the fresco. All these are not only unnecessary but harmful in pure fresco, even if a great many painters swear by them. These media do not possess the dual advantage of pit lime, color strength together with binding strength, but they must first be bound with lime before they can hold to the ground. They can be used only in fresco secco, and even there they are unnecessary. Good, well-seasoned pit lime is after all the best white material.

Of yellow colors all ochers, even raw sienna, may be used in fresco. Cadmium yellow must be tested in lime; the darker sorts are more reliable. Chrome yellow changes as rapidly as white lead; only chrome yellow orange remains unaltered in lime. Naples yellow holds up well. Zinc yellow will not stay put, according to tests; it wanders as much as 30 centimeters away toward the areas which remain wet the longest. Yellow ultramarine must be tested.

Red ochers, from the iron oxides to caput mortuum, may all be used; in the case of English red, only the better sorts which are free from gypsum; vermilion only after testing for resistance to light and lime, and then only in inner rooms; likewise minium only for inside work. Terra di Pozzuoli and other volcanic earths are natural cements, and they set quickly and very hard. Colors put over them set poorly. This was already known in antiquity. Brick dust in various tones, a material which Böcklin often collected for tempera painting, is reputed to be a valuable and permanent red. Madder lake cannot be used in wet lime. Cadmium red is very useful, but only indoors; out of doors it turns brown. As a substitute for vermilion the coal-tar color helio fast red has become well established. Ultramarine red and ultramarine violet,

in themselves not very yielding colors, can be used here with the same limitations that apply to ultramarine blue. Cobalt violet must likewise be tested for its behavior with lime. Ultramarine blue is but little affected by lyes and therefore can be used in lime. Since, however, it is easily attacked by acids, it should not be used in the open in places where coal is burned in large quantities, as in large cities, for then it completely loses its blue color and becomes a whitish gray. On the other hand, it holds up well in the open in the country. To be sure, I found, even in Tirolean mountain valleys far removed from every industry, ultramarine which had turned entirely white in wall pictures. In this case this was very probably due to adulteration with gypsum, as in the case of house painter's ultramarine, unless the clay itself had decomposed in the ultramarine. Cobalt blue is very useful, but not Prussian blue, which disappears very quickly, leaving only a rusty spot. Mixed tones of Prussian blue, such as green cinnabar, must naturally also be excluded.

Oxide of chromium transparent and opaque are excellent for use in fresco, as are also the green earths in the better qualities. Poorer qualities often show rusty spots. Veronese green earth already in ancient times was one of the most valuable fresco colors. Today there are many synthetic green earths, which in fresco often dry out completely white. Of ultramarine green the same may be said as of ultramarine blue. Cobalt green is satisfactory. Emerald green and other copper colors do not hold up well in fresco.

Umber, burnt green earth, and burnt sienna can be used as brown colors. Umber, if not of the highest quality, is apt to appear sooty. In the open a disturbing change of this color to a sooty brown has frequently been observed. Many fresco painters therefore exclude it from their palette. Burnt sienna frequently becomes dark when applied. For black, ivory black and vine black can be used; graphite, however, seldom. Ground charcoal is said to give a permanent, often very serviceable, black and a fine gray when mixed with lime.

In the case of coal-tar pigments, they must be tested with respect to their stability in light as well as in lime. Names such as "lime blue" or "fast blue," "fast red," and "fast violet" are by no

means guarantees of the permanency of these pigments. According to Dr. Eibner, more than thirty coal-tar colors are usable in fresco, and Dr. Hans Wagner of Stuttgart declares there is not a single one that can be trusted.

The colors are always ground fresh with limewater that has stood for some time and has become clear again, and not with cloudy limewater. This is also best for washing out brushes while working; water alone reduces the adhesion of the colors. The use of rain water or river water, as is prescribed in many recipes, is therefore not advisable, in the first place, because the binding strength of the limewater is lacking, and, in the second place, because, owing to impurities present, rust spots may develop in the fresco. Distilled water would perhaps be better. These directions go back to a period when our modern water-supply systems were unknown. For larger areas, for flesh, atmosphere, etc., it is practical to mix the colors in advance in jars, but without the addition of lime, because otherwise when dry both jar and color are lost, whereas here one has only to add limewater. Some painters, when mixing colors on the palette, add a little lime to all of them about the size of a hazelnut, in order to increase their binding strength.

Many colors, such as black, especially lampblack, take water poorly; such colors, and also Veronese green earth, are first ground with a little alcohol, after which they take water readily because the surface tension (the tendency to form drops) of the water is removed.

In general all colors dry out lighter in fresco; still the difference, with the proper method of painting and a correctly prepared ground, is by no means so marked as is often believed, and it can be taken into account from the beginning, as is done with gouache and unvarnished tempera. The colors lighten gradually, and this may continue on properly made grounds for about six weeks. Certain colors become particularly light, such as green earth, light ocher, and, above all, ultramarine, which, therefore, on old wall paintings is frequently underlaid with ocher in order to tone down the color, which would otherwise appear to jump out, as, for example, on the Romanesque wall paintings in Regensburg.

An especially charming effect is obtainable in fresco through

the juxtaposition of lighter tones. Their vaporous, iridescent charm cannot be obtained in any other technique. Strong contrast heightens this effect. I know of Gothic frescoes in which very light variations of yellow ochers and burnt ochers are opposed by areas of pure black in a most effective and charming manner. The effect of colors in space is to be taken into account, the tendency of warm colors to advance, etc.; harmony and contrast must be preserved at all times. If a color, such as blue, is too strong in its effect, an attempt must be made to soften it; care should be taken, however, that in doing so it is not made too heavy by overpainting. By means of interspersed details, such as stars in a blue background, border patterns, fluttering ribbons, tree trunks, and other decorative details, too obtrusive color areas are suppressed. In the Romanesque frescoes at Regensburg a large, simple effect was obtained with the fewest colors. The figures were in the main given a luminous effect with ocher and red and painted over a very light glazed blue as a background, thus creating an alternating effect of cold and warmth. The strong ocher contours finally enhanced the decorative effect of the form.

A great deal depends on the moment a color is applied. Colors which are put on late usually become much darker. Colors painted on areas which already have started to "pull," or corrections which have been applied several days too late, dry in a manner which cannot be calculated. The darker tones frequently appear "hot," and lighter tones may dry out almost white. Especially is this true of ultramarine. It has been reported of Michelangelo that at the outset of his career as a fresco painter he experienced many failures—the colors of one picture he said had gone moldy on him—and Leonardo gave up the fresco of the battle of Anghiari for similar reasons; and the assumption is not unjustified that colors were put on too late on a dry ground. Particularly tones mixed with lime under these conditions give an effect of "moldiness." A uniform lightening is quite unobjectionable and, as already stated, when the proper technique has been employed, is not so noticeable. The worst is the jumping of some colors out of the total effect, particularly when some colors in the light areas are mixed with lime and others are glazed. Some painters grind the colors with skim milk. A very small addition is quite

helpful with poorly setting colors like the ultramarines and the blacks, not, however, a large amount, because the setting of the fresco is thereby checked, and the colors will scale off or become streaky if water touches them. One must also guard against the forming of milk drops. Glue sometimes is also added, especially with a dark, poorly setting color like black. Casein, however, is better. With deep shadows and quiet surfaces one must be very careful in the use of limewater, since with corrections and repeated working over such surfaces easily become "cloudy." Many colors set poorly; orange cadmium, chrome yellow orange, cerulean blue, Naples yellow, cobalt green, and black in particular have this disadvantage. They should be applied as early as possible to encourage their adhesion. Colors applied too thick incorporate poorly with the wall. The color appears to best advantage in thin layers, especially in the case of darker colors, which in thick application, in addition to poor setting, are apt to produce a heavy and solid effect, as in water color. (One must not confuse these disadvantages of thick color application with the impasto of colors mixed with lime.)

It is the custom in fresco painting to use bristle brushes, among which the round ones are especially suitable. For smooth, fine grounds one may also use hair brushes; for the drawing of contours and for fluid lines the very long-haired sable brushes are suitable. When one works with lime, the brushes must be cleaned at once after the conclusion of the day's work, otherwise they quickly become hard. If one wishes to use brushes in fresco which have previously been used in oil colors, they must, after having been thoroughly washed in liquid soap, be placed in limewater so that the hairs are completely saturated with it. Before starting to work the brush is well pressed out, and only the tip of it is used to take up color.

The best palette for fresco painting is a white-lacquered tempera palette provided with indentations and compartments for the colors. It must be cleaned at once after use, otherwise it will be impossible to remove the lime color.

THE METHOD OF PAINTING IN FRESCO. In this material one may also work quite freely if one has command of the technique. One is by no means so handicapped as is often be-

lieved. The limitations imposed by the material are even in some respects an advantage, in that the painter must have a very clear idea of his artistic intentions before he starts work and must concentrate on simplification of form and color.

Since the ways and means are many, they can only be touched upon here by way of example. After the tracing of the outlines, any loose grains of sand are carefully brushed from the surface. Places which are uneven are first smoothed with the ball of the hand covered with tracing paper. One may then boldly and sharply draw in the outlines of the design with a warm color like ocher or red with an energetic emphasis upon intersecting lines, after which the individual areas created by the outlines are given their local color in a light and sketchy manner. One need not be afraid to run over the outlines with the local colors, and the latter may at once be modeled into a plastic effect. This is just one of many technical possibilities. Also effective, for example, is a contrasting underpainting—light green or blue for flesh, and the immediate loose setting into this of yellowish or light reddish tones, so that the undertone often works through, even out and beyond the form to which it chiefly belongs. The color should be liquid, but must not run down in drops, as the tracks thus made are very difficult to efface. One next heightens the color, with every stroke improving the form, and then sets in the lights. The strengthening of lines here and there to give them life is now in order, and finally the accentuation of the high lights and shadows concludes the process. While wet the whole painting should appear richer and deeper and more saturated. It is very important that one leave open the possibility of strengthening toward light and dark, in order to be able to harmonize the different parts of the picture.

It is practical to begin painting at the top of the picture, so that the lower half is not soiled. One should never begin with the painting immediately after the application of the plaster, because the colors would disappear in the wet ground. The same thing occurs in the case of lime which is too fresh. One can paint only until such time as the plaster begins to set, when the brush stroke is retarded and the color becomes hard to work. Whatever then is not completed must be removed, which is done by cutting it

away with the trowel or spatula obliquely toward the outside. Before fresh plaster is applied, one must be especially careful to wet the edges thoroughly. After some practice one can easily smooth out the well-wet seams with the spatula. These should, if possible, be located at the boundaries of light and dark, in other words, at as inconspicuous points as possible. Lime plaster dries first at the point of juncture; one should therefore on the following day begin to paint at this point. The eventual drying out of the colors may for comparison be very closely ascertained in their values by laying them on a gypsum slab, etc. The colors when first applied must look deeper than they are intended to be. Large surfaces, such as skies, are best painted at one time, out of a pot, because it is impossible to remix the tone exactly the same, and the projecting parts of figures are cut out if they cannot be painted at once. The procedure is the same in the case of gilded areas, which should be completed before the painting begins.

Another way is to begin with a light strengthening of the contours in ocher tones and then apply the local tones of the flesh flatly in a water-color-like manner, after a short drying deepening the colors and strengthening the form while painting from light into dark, leaving the lights open and glazing as in water color. This wash method, in which the contours are strengthened at the end and deep accents set in, is especially suited to surfaces smoothed down with the plane. Contours in fresco have the peculiarity of accenting the flat effect of the painting and must be handled with this idea in view. With the wet brush one can fuse and soften the colors. One must lay on and treat everything flatly, even strive for definite areas in flesh tones.

This loose wash technique has the additional advantage that no small areas in the painting are likely to be overlooked.

Others, after the drawing of the outlines, lay in the shadows uniformly and powerfully, next putting a local color over both light and shadow areas, and finally setting in the high lights and deepening the shadows. This method was employed by the old masters with many variations. Optical grays and a loose effect resulted, as the shadows were active through the local colors. Cennini laid down the rule that the shadows be made with green earth. Knoller used black and sienna. Frequently draperies are

divided into three tones prepared in advance, which is of great practical value in fresco.

A "buttery" lime permits of very opaque application and in this respect very closely resembles oil colors. On frescoes of the rococo period lime lights were very frequently loaded, and they have lasted remarkably well. Since the lights dry out very light, they usually give the inexperienced fresco painter no end of trouble. And yet their handling is so extraordinarily simple! Knowledge of the craft and of the material is, of course, essential. The lights are mixed thick like a paste out of lime putty, and likewise the local color of the surface on which they are to stand. When applied, they must not depart in brightness from the local coloring of the light areas, as does a light in oil color, but the light must equal the value of the local color, and merely be applied more opaquely; then the effect will be right when dry. One should not expect to see the effect of the lights immediately, as in the case of oil colors. The lights become soft and hazy if the background was sufficiently wet; on half-dried ground that "pulls" they appear hard. One can even set them in in a light half tone so that they will appear soft. A little of the half tone should be allowed to stand between contour and lights so that the figure will not have a cut-out appearance.

With the sponge large, simple effects can be obtained over extensive surfaces. With a damp, well-pressed-out sponge the strongly set in outlines and single tone values are brought together and unified. In this way softer, more harmonious tones are obtained than with the brush, and then with a few strong accents the work can be quickly completed.

Many mistakes in fresco painting must be charged to the fact that the painter of today is so largely influenced by oil technique and unconsciously carries over the requirements and special character of this technique into the unfamiliar world of fresco. This accounts for the painting of fine nuances in flesh, which have only a spotty effect. Clear tones are obtained by underpainting in cool, light tones in definite areas and gradually proceeding to warmer tones.

It is obvious that one must proceed uniformly throughout the picture, either employing glazes or impasto entirely in both lights

and shadows. Dark colors are best painted in their true tones, in a fluid but not flowing manner, area by area; and they are at once given strong, deep accents. One may also underpaint in gradations of neutral, opaque grays, laying over this a semi-opaque painting in local tones. It is always best to apply the pigments thinly, particularly the earth colors, in order that they may set well, which need not interfere with their opaque use, since sufficient lime for this purpose may be added. It is best to paint all lights opaquely and very light objects over a limewash. There are painters who for works out of doors use only the thick, stored-up pit lime as heavily as possible and mix color with it, using as little water as possible. This method insures the color's having a certain sheen and permanency. One may also paint alla prima in the full strength of the colors by employing at the start strong contrasts and afterwards refining and balancing them against one another. A very free and broad working method is quite possible in fresco. Since there are always the incised contours to fall back on for a control of the design, one need not fear the loss of the drawing if one has sufficient self-assurance, and one may carry the flesh tones over the contours in a broad, fluid manner, even spreading and fusing them with the fingers, and by a final strengthening of the contours and shadows obtain definiteness and yet softness. One may also, however, employ hatching, deepening local color, etc., in this way. Contours in contrasting colors heighten the color effects. Large dark surfaces are best painted without limewater, so that no cloudy discoloration may develop. Dark colors should be applied as early as possible, so that they will have time to set. But a characteristic of all these methods is that one must paint easily and freely and not disturb the ground with the brush (otherwise the limewater will cause whitish patches to develop); neither must the color be "tormented" if one wishes to avoid dirty, dark, and heavy tones. Limewater frequently exudes on places which are lower than the rest of the wall surface, and the color comes off in such places, as it does on walls which were not brushed off with the feather duster or paint brush after the transfer of the drawing by pouncing. Hard edges may be fused with the wet, pressed-out brush, without limewater, to avoid spots.

If the ground begins to "pull" or whitish, dry spots appear, or if the color becomes so thick that it is no longer possible to paint fluidly, one must at once stop painting. To continue painting under these conditions would result in incalculable changes. If one should continue working on the next day, or if one should make changes in the painting, it would appear to be falling to pieces when dried. If a section has not been satisfactorily realized, it is best to knock it off and paint it over again.

A painter told me once that he preferred painting on a ceiling when the ground had been applied on the previous evening. He would on the next day first roughen the ground in order to break up the limeskin and then energetically cover the ground with milk of lime. This method somewhat approaches fresco-secco painting. If one works high up on a scaffold, it is necessary to view the progress of the work frequently from below. Sometimes changes are necessary because figures must be foreshortened owing to the distance, or because their color may appear too strong or too weak.

One cannot pay too much attention to simplicity of handling and to the preservation of the picture plane, so that the decorative effect will not suffer from a distance. Too strong an emphasis on details will destroy the unity of figures; they must form a single area, a single color surface, despite all detail, and they may be pulled together by accents of light or shadow and made to appear soft by angular contrasting sharpnesses of the surroundings. Pulling together with the damp sponge followed by renewed attention to drawing results in a quickly obtained broad effect.

If an area is overmodeled but still sufficiently wet, this can be remedied by vertical or horizontal hatchings over the local tone with opaque gray, whereby the appearance of a flat surface is again established. Dark, thickly applied colors appear heavy and also "set" poorly. Not infrequently a cause of poor drying is that the painter while working washes out a brush in plain water and, instead of pressing it out, continues to paint with a full, wet brush. Limewater here is better.

When painting on a ceiling, it is a good idea to surround the handle of the paint brush with a paper cuff or funnel-shaped rub-

ber, so that the color cannot run down on the hand and into the sleeve. Brushes with very long handles are useful in cases where distance is necessary for the control of the painting.

Brushes, palette, and jars must be cleaned immediately after use; otherwise it will be next to impossible to remove the lime colors.

The more slowly the mortar hardens, that is to say, the thicker the layer of mortar and the wetter the ground, so much the longer is it possible to work on it and so much the better will the colors set. Mortar loses in volume when its water content evaporates and becomes more porous; it then more easily absorbs carbonic acid. With the evaporation of the water the absorption of the carbonic acid increases, bringing about a hardening of the fresco. While this process is going on, the fresco is soluble in water; one must therefore not make the mistake of exposing it too soon to the rain. It should remain covered for at least a month. The apparently rapid drying of the surface may easily lead the painter to think that the picture is completely dry.

The originally sponge-like and porous mortar eventually becomes hard. It takes several years, however, for a fresco to harden through. From what has been said it follows that it would be a great mistake to dry a fresco with artificial heat, as, for example, was done by the Danish painter Mathiessen, who used coke ovens for this purpose. The absorption of carbonic acid which takes place under these conditions extends only to the top skin and not into the underlayers. Additions of sugar, egg white, fatty oils, soap, and the like are often made to the fresco ground, but they are dangerous, because they may interfere with the "setting." On the other hand, a very small addition of casein to the mortar for outside works, as also of skim milk, is to be recommended. This should not exceed 5%, otherwise the ground will be sticky. Milk and casein give to a fresco a grayish appearance and also increase its resistance to weather conditions. In place of limewater, scientific authorities recommend baryta water (20 gm. of caustic barite to 100 gm. distilled water, preserved in well-closed flasks); the flasks must have glass stoppers, which should be greased, otherwise these will be difficult to remove. The mixture must be shaken frequently. After all the barite has completely dissolved, one may add a few more crystals of caustic barite. A

small amount of sediment should form. This medium is said to have about 20 times the binding strength of calcium carbonate. Baryta water is also used for grinding and thinning the colors. In practice opinions regarding this differ very considerably. It is asserted by some that the high degree of binding mentioned is not even approximately obtained, but that blackening is inevitable; and these prefer to stick to limewater. The spraying of a fresco with limewater by means of a fixative blower in order to be able to continue painting longer is a dangerous practice, because spots may easily develop; but if great care is employed, this device may render good service.

I know of a case where a fresco painting which was repeatedly sprayed with clear limewater has actually held up very well for several decades in the open. To be sure, excellent raw material (quartz sand) was used in the plaster. Other painters hang dripping wet cloths over the finished areas in order to be able, if desirable, to make corrections or to keep out the sun. One must see to it that the wind does not beat these cloths against the wall, because this is likely to cause spots. If lime is accidentally spattered into the eyes, it may cause painful sensations. The application of sugar water and thinned milk will afford relief.

RETOUCHINGS should not be attempted on a fresco until it has completely dried. This will take at least four weeks. About this time the fresco begins to solidify. Retouchings which are applied earlier than this, even when they are as exact as possible, will not look right later on, because the fresco continues to get lighter until it is thoroughly dry. The fresco painter should try to get along without corrections, because, out of doors in particular, every retouched spot is likely to be a source of trouble.

Some colors cannot be used for retouching because they dry in a manner that cannot be calculated. It is customary to use casein, and the color must be applied by means of hatchings, not flatly, because otherwise the casein tone has a heavy effect in fresco. Wax-potash emulsion mixed with dammar varnish has proved to be exceptional for inside works. Wax ammonia is perhaps better than wax potash, because the latter is soluble in water. I have mixed the very thick (like soft cheese) emulsion, which was prepared with very little water, with powdered color by rub-

bing these together with an old round brush on the palette, and applied the mixture in a stippling manner. Zinc white is used for white. These retouches optically fall in completely with the fresco. In the open it is best to avoid corrections altogether. It is always better completely to repaint an unsatisfactory piece.

POMPEIAN WALL PAINTING. The Roman architect Vitruvius has described for us the plaster used by the ancients. Six coats in all made of lime with first coarse and then finer sand in the upper layers were put on wet on wet. The last three coats in place of ordinary sand contained marble sand and marble dust. Thus they became very hard. The last coats were carefully smoothed; the very last, in fact, was given a mirror-like polish. According to Vitruvius, six coats were necessary to insure the high polish of the last coat. The mortar of the different coats was well worked together for a considerable length of time. Any one of the different coats was thicker than those used in present-day fresco.

The Pompeian wall technique has long been a much-discussed, even disputed, subject. Berger first saw in it an encaustic technique; later he believed it to be stucco lustro [imitation marble], in which the high gloss was obtained by the addition of soap. Keim insisted it was pure fresco, and he proved that a high gloss may be achieved in fresco by means of certain additions and by polishing the different coats under pressure.

In Pompeii may be observed today paintings on white ground as well as on colored red, yellow, black, or blue grounds. The paintings on white ground were always regarded as true fresco. Raehlmann and Eibner by microscopic examination have proved this to be the case. Paintings on colored grounds were mostly secco painting, but frequently also done with casein. Resin colors or encaustic have nowhere been encountered. Through the later conservation of the walls with wax the casual visitor is easily misled into pronouncing the paintings wax paintings.

By painting over the colored grounds with thin layers of lime with some filler, optical grays resulted which were active in the shadows, and later lights were strongly developed with the same material.

The paintings on white ground were first outlined, and then lightly, by means of hatchings over light washes of the local colors, the forms were plastically developed and finally completed with a few accents and a strengthening of the outlines. In the shadows the lovely apple-green Veronese earth was frequently used. These paintings in part have a very polished, smooth surface; often, however, they are painted in a heavy impasto laid over the polished ground, particularly in the red panels. Keim has demonstrated that painting in buon fresco on a very smooth surface is possible because the very heavy coats retain moisture a long time, particularly when rendered more solid by paddling. Coats of this type cannot be put on very wet, otherwise they will shrink, and cracks will develop. When Keim made his experiments in Pompeii in 1911, despite the tropical July heat under a sheet-metal roof it was possible to paint and have the colors set on his plaster after a period of fourteen days. The difference between the wet and the dried colors was astonishingly small. Because of the fact that the ancient fresco remained wet and paintable for so long a period, joins were rarely necessary.

Black was always applied with glue, or perhaps with casein, because it set poorly. According to Raehlmann, pigments in Pompeii were frequently cut with marble dust. He also discovered a layer of pumice-stone powder and white of egg underneath some of the paintings on colored ground. Perhaps this was used as a means of producing a high gloss. Malachite green was used both in true fresco and also in tempera. Egyptian blue (lapis lazuli), however, was used only in secco painting.

The durability of the Pompeian mural paintings is not so absolute as is widely believed. In the museum at Naples there are copies in oil of Pompeian originals; they were made because the originals were fading very rapidly. The six coats of Vitruvius are by no means found everywhere at Pompeii; in many instances cheap work was done, perhaps only in glue color [distemper]. I have made many tests of pieces of walls which had been discarded, and have found that the colors promptly came off if only very lightly rubbed with a wet finger. It is undeniable that under favorable conditions wax, resin, fresco, tempera, and even glue

color [distemper] have survived as remnants for several thousands of years. However, I do not believe that we should draw generally applicable conclusions from this fact. Ludwig [the Munich painter] has told me that he once, together with Böcklin, attended the excavation of some fresco remains on the Forum at Rome. When first brought to light, the colors appeared as if they had been painted only recently; after a very short time, however, they turned gray, and eventually were nearly destroyed by atmospheric influences.

Very glossy and very smooth fresco paintings existed until recent times in upper Italy and in southern Tirol. Our former director [of the Academy at Munich], Ferdinand von Miller, has told me that on his castle Karneid [in southern Tirol] he gave to a frescoed wall a mirror-like surface by merely ironing it with a hot iron without any addition to the plaster. The different coats were troweled solidly and finally rolled with a bottle. The attending plasterer insisted that no time was to be lost between this last operation and the beginning of painting; but that apparently depends entirely on the particular lime used. A certain dolomitic limestone has been shown to set very slowly, but very hard.[3] A high gloss was obtained in this case.

Professor Dannenberg reports, on the contrary, that at Stettin, where he reconstructed frescoes in the Pompeian manner, a high gloss was obtained only by the addition of skim milk to colors which were very finely ground in lime (which, of course, makes this a casein technique). He has perfected an electric iron which, if vigorously and skillfully applied, will give great luminosity and body to fresco painting. Experiments by Professor Franz Klemmer conducted at Nymphenburg Castle have demonstrated that also through cold ironing a fresco ground may be given a gloss resembling marble. This process was carried out a day after the fresco was completed.

[3] Ray Boynton, who has executed many fresco paintings in California, also believes that, because of the natural difference in lime, the practice of different craftsmen in the use of lime have been considerably modified by the locally available material, as, for instance, in Mexico. [Translator's note.]

II. FRESCO-SECCO PAINTING

Fresco-secco painting is painting on dry plaster in contra-distinction to buon fresco. In secco painting all sorts of technical combinations and modifications are practiced. Sometimes the underpainting is true fresco and the painting is finished in secco. Nearly every painter in this respect has his own peculiar method. Secco painting is simpler than buon fresco, the plaster being less of a problem, since it can all be put on at one time; or one can even paint in secco on already-existing old plaster.

The wall, of course, must not be damp from within, because on such a wall no type of painting will last. If this basic condition is neglected and a painter guarantees his work, he may be held liable for damages. I know of a case where a casein painting on a wall was destroyed within a month; the cause was damp tufa stone. A simple way to test a wall for moisture is to hold a sheet of gelatine against it by means of a lath. If there is moisture in the wall, the gelatine will curl up in a few minutes. If there are holes in an otherwise good wall, the holes will have to be moistened and filled with fresco ground, but never with gypsum, because the latter continues to "work," and the color over it will fall off. Old plaster walls will have to be carefully examined for their firmness. Loose calcimine washes will promptly come off if painted over with undiluted casein. Hollow places in a wall are traced by tapping the wall with a wooden hammer. Doubtful plaster must in every case be removed. Moistened ground should not turn red litmus blue; if it does, only colors used in buon fresco can be used. Otherwise one may use indoors nearly all the colors used in tempera painting. Old, dry plaster must first be roughened with a steel brush in order to remove the skin of carbonate of lime, to which the color will not adhere.

The ground is thoroughly moistened, and a limewash is laid over it. One may then paint into the wet or on the dry limewash either opaquely or in a glazing manner. A slight addition of thinned skim milk is frequently recommended. Soaking the ground with oil is not advisable, because the oil will cause it to turn yellow.

Old walls patched with gypsum are dangerous to paint on. A limewash laid over them is a good precaution, but it will not prevent the destructive action of the gypsum and the subsequent scaling off of the colors.

According to Theophilus Presbyter, one may paint on thoroughly moistened lime plaster with colors mixed with lime.

Lime used as white in secco painting was slaked, dried, and powdered several times. The caustic lime thus became a neutral carbonate of lime which no longer would burn the tongue. It was then possible to mix it with organic colors like madder lake. This white, the "bianco sangiovanni" of Cennini, naturally no longer had any binding power, and it had to be applied with egg, casein, etc. Ground egg shell, clay, and chalk served the same purpose. With these it was possible to paint on the wall with colors not suited to lime, such as madder lake. Today we have in zinc white, and perhaps also in the best grades of lithopone, a very good white for secco painting. Titanium white is as yet too little tested. White lead, of course, must be excluded from true fresco because it is blackened by hydrogen sulphide. Lime, of course, may be used, but only with lime-proof colors.

If one wishes to use on dry lime plaster other than fresco colors, for example, Prussian blue, it is first necessary to ascertain if the wall has lost its caustic properties. Moistened red litmus paper when pressed on the wall must not turn blue.

The differences in appearance between wet and dry color in secco are, as in the case of tempera, more easily controlled than in fresco. A gypsum slab quickly exhibits a color in its dry state. The painting may in parts be pulled together with a sponge, and a soft, harmonious effect may be achieved by means of powerful outlines and light and dark accents set in while the surface is still wet.

Retouches are possible within a few days.

Casein painting. (For the preparation of casein see page 218.) Casein prepared fresh daily is the material prescribed for secco painting indoors on walls or ceilings; and even in the open in protected places it is durable. Additions of oil, resin, etc., are better omitted. Combinations with wax-soap emulsion are suitable only for indoor work. Very fresh lime, either in fresco ground or in a

still wet limewash, enters into a weatherproof combination with casein. The color sets quickly, and spraying with formalin is unnecessary; as recent experiments have shown, this makes the color brittle. Casein painting on a wet fresco ground or into a wet limewash has a somewhat grayer effect than fresco, but it becomes very hard.

Tests are advisable to determine the degree of thinning desirable in each case. The color should set completely in a few days.

Painting into wet limewash results in very soft and airy, but at the same time opaque, effects, while more glaze-like effects are obtained by painting on a dry ground. An addition of lime to all colors is to be recommended.

As compared with fresco, casein colors look grayer on the wall, particularly in middle tones. They are very effective, however, in flat areas. Skim milk as a painting medium in fresco has the same effect as casein. A thinning with water, however, is advisable, because otherwise it becomes very sticky. Out of doors this technique is yet to be tested.

Lime casein was the material used in the many well-preserved 18th-century ceiling paintings on our upper Bavarian and Tirolean peasant houses. They were painted either into still moist fresco plaster or into a limewash. Many wall and ceiling paintings of that time are so-called "casein frescoes."

The casein colors were ground stiffly in water and used with very much diluted casein (at least 4:1 water). The lime at first is somewhat alkaline, but under the influence of the atmosphere turns into carbonate of lime, which is not injurious to colors. It is different with the lyes of many caseins of the trade, which contain caustic soda or potash in addition to other undesirable additions, such as glycerin. How harmful such caseins can be is evidenced by the fact that paintings carried out with this material have been completely destroyed within half a year, even though apparently well protected. The painter concerned told me that the color layers appeared as if they had expanded and contracted like an accordion. This is the typical result where hygroscopic media are used. Tube tempera colors of the trade must also be excluded from walls because of the danger of hygroscopic additions. Soda and borax solutions of casein here lead to efflorescence.

A casein painting should be completed in not more than two or three separate working periods. If it is carried out in many super-imposed layers, the color is likely to scale off, as also where too much medium and too little pigment are used. Casein in many respects is a kind of glue color and behaves somewhat similarly.

For corrections and retouchings casein is used a great deal. In using it for such a purpose, the color must be applied by means of hatchings rather than in solid areas, otherwise, particularly in fresco, it is apt to have a heavy appearance. It is best to paint from light into dark.

Painting with egg yolk on dry walls was formerly a common practice. Egg yolk and lime combine very solidly. Cennini describes this ancient technique. The wall was covered by means of a wet sponge with diluted egg yolk, a color being sometimes added for a tone. The colors were ground to a stiff consistency with a little water and mixed 1:1 with yolk of egg. An improvement on this technique is to paint on true fresco ground just when it begins to pull or into a wet limewash. It is also an advantage to add to all colors a little lime. In this way very vaporous and at the same time solid painting of great charm is rendered possible, in effect very close to real fresco, whereas, as compared with fresco, pure egg color as a glazing color has a harder appearance and is less in harmony with the wall surface. With the aid of the sponge large areas can be covered easily and loosely and then promptly brought together. This type of painting turns practically as hard as stone. Indoors it is absolutely reliable, but out of doors only where sufficiently protected.

Encaustic painting is burnt-in wax color. Inscriptions on Doric temple façades testify to its early use. On these temples it was employed in plain, single colored areas, usually as blue or red backgrounds behind figural and ornamental sculptural decorations. On Trajan's column in Rome remains of wax colors have been found used in the manner indicated. These facts, however, should not be cited as an argument for the probable durability of this technique in northern countries, and especially not for outside work. Ordinary glue colors and similar materials under favorable conditions have survived splendidly from Egyptian and Pompeian days.

Pliny calls wax painting a technique alien to walls (*alieno paric-tibus genere*). Encaustic wax paintings have never been found in Pompeii either on indoor or outdoor wall surfaces. The vermilion panels of Roman wall decorations, according to Vitruvius, were coated with wax. As a form of easel painting encaustic played an important rôle in Greece and Rome. The wax was heated over coal basins and mixed with pigments, and then, while still hot and liquid, applied to the picture. The colors were fused with hot spatulas, and were finally burnt in with hot irons held very close to the surface of the picture.

Attempts to revive this ancient technique are not uncommon, because the splendid qualities of wax are well known to artists. It does not turn yellow or oxidize; moreover, it retains its body and is impervious to water, and it produces charming optical effects which have attracted artists of all times. Through additions of all sorts of substances, however, the fine qualities of wax have often been impaired. Fernbach in 1845 made public his recipe for "Pompeian" wall encaustic consisting of wax, oil of turpentine, Venice turpentine, amber varnish, and India rubber (!), and honestly believed that he had rediscovered the old Pompeian wall technique. Unfortunately, it has since then been revealed that there never was any encaustic painting at Pompeii.

Dr. H. Schmid of Munich has recently revived this ancient technique and facilitated its employment through the perfection of several heating devices. The picture, as well as the palette and brushes, must be warmed.

The colors, mixed with wax, are kept heated on the palette. The heat must be very carefully regulated, because too much heat causes wax and pigment to separate. Electrically heated spatulas allow of spreading of the colors, which are finally burnt in. For outside purposes Dr. Schmid, I believe, adds resin or some balsam; indoors nut oil is employed to render the colors more easily workable.

Dr. Eibner calls wax an ideal "weather medium."

Any final judgment in regard to outside encaustic wall painting is as yet impossible. Satisfactory experiments are contrasted with others less fortunate, which, however, may have failed for

technical reasons. Some deny that encaustic is suitable for outside walls, and even indoors they are convinced that it will not last. Perhaps the so-called Punic wax is here more suitable because of its higher melting point.

In my own opinion, easel paintings in encaustic wax, if carried out on lean grounds, are durable beyond a doubt.

Wax soap. Wax emulsion was already used by the ancients (see page 227 under tempera). It may be thinned with water, as in any other tempera, or mixed with glue, or, better yet, with casein. Such a medium has a fine mat effect on the wall. When rubbed with a cloth, it takes on a real gloss. It lends itself also to encaustic treatment. Wax ammonia in this case is better than a potash emulsion, because the latter attracts moisture. Zinc white may be used here. This technique is useful only indoors.

All sorts of technical combinations are here possible. I once painted large-scale figures with tube oil colors on a dry plaster wall. The time available did not permit of real fresco. The figures were outlined with casein black, and the color areas were painted in liquidly, as in water color, with oil of turpentine. All color not immediately absorbed by the wall was taken up with a rag. The shadows were strengthened by means of hatchings (to keep them loose) with thinned casein black. Afterwards lights were added with lime. These paintings have lasted well, and they are as luminous as a fresco. It is true that the plaster ground was of exceptionally fine quality and covered with a clear limewash.

COLD LIQUID WAX. Wax melted in oil of turpentine or liquid balsams and combined with pigments was used extensively in Egypt on walls and as a protective coat over paintings. Such pictures have naturally a mat effect. When polished, they acquire a soft gloss; if treated encaustically, a high gloss. Retouchings and corrections were made with the same material. The more oil is added to the wax, the less satisfactory is the wax mixture.

This technique was employed in many variations.

Mr. Gambier Parry's spirit fresco [practiced between 1840-1860] was a kind of resin-oil color applied to well-dried walls which had been previously soaked with a mixture of paraffin, oil of lavender, oil of turpentine, and copal varnish, which was also used as the painting medium.

Rottmann is said to have started his landscapes under the arcades of the "Hofgarten" at Munich as frescoes and then finished them with wax-copal varnish. The same thing has been stated of his mural paintings in the New Pinakothek, which, as a final process, were treated encaustically.

PAINTING IN OIL on a plastered wall is optically not very effective. It is perhaps useful when the color is employed lean or mixed with wax. Fatty oils over lime, if used too abundantly, turn very yellow. In the 14th century in Germany, according to Cennini, painting in oil on walls was a very common practice.

It has been stated on authority that Leonardo's "Last Supper" at Milan was originally painted with oil colors, but that very soon it suffered serious damages. Reports of Armenini and Palomino testify that in their day [16th century] the disadvantages of oil on the wall were well known.

Oil paintings on canvas mounted on the wall with casein or white lead mixed with linseed-oil varnish never have the optical charm of paintings done directly on the wall.

GLUE-COLOR PAINTING is very useful for decorative work. About 40-50 gm. of Cologne glue are soaked in water and slightly warmed. Then pipe clay or barium sulphate, also chalk, but not gypsum, is poured into a weak glue solution. This is the basic material with which the colors, which are first stiffly ground in water, are combined. Pipe clay (kaolin) has the greatest covering power in glue color. Without this basic mixture all glue colors look hard and glassy. The glue-water, to be right, must run easily off the brush. After the color has dried, it must not be possible to wipe any of it off with the fingers. If too much glue has been used, the color is likely to show spots or even scale off, especially when too many coats have been superimposed. Three successive coats are regarded as the maximum. The lowest should have the greatest glue content. The upper ones should contain a little less, otherwise the color will crack. Although glue color as such is easily soluble in water, spraying it with a 4% formalin solution will render it nearly insoluble. Wax soap is often applied to glue color for the same purpose. Brushing will give the color a half gloss.

Glue color yields very light, airy tones, which, however, if

varnished, change much more than tempera colors. If a color needs to be corrected, this should be done only after it dries. To match a color, it is best to moisten it for comparison. Glue color is best mixed in quantities in pots. The interior decorator first gives the walls a coat of soap; this facilitates the application of the color. Calcimine and soap combine solidly. Too much soap, of course, is injurious; it takes the color badly and, besides, kills it. Parts which have scaled off can be gone over only very lightly. Despite the solubility of glue colors, Pompeii apparently abounds in glue-color paintings.

THE CONSERVING OF MURAL PAINTINGS. The objective of the care of paintings is to remove the causes of damage and to refrain from all "improvements" and "beautifications" which may destroy the character of the original. The conservation, not the restoration, of the original state is the problem. This is much more difficult than the practice of old-time traditional restorers, who overpainted entirely too much, and who more often than not substituted their own handiwork for that of the original. The modern conservator modestly takes his place behind the work of art.

To determine whether a painting is a true fresco or painted "a secco" is not always so simple. Dilute hydrochloric acid dissolves lime with effervescence, hence also fresco. But secco colors may also contain lime, or, as has been shown to be the case by Raehlmann in Renaissance paintings and also at Pompeii, they may contain marble dust, which also effervesces.

Layers of tempera colors, when tested with hydrochloric acid, in general remain in the form of thin, separate sheets. Even where incised outlines are missing, fresco may be present. Fresco does not dissolve in water, but glue color and tempera used incorrectly will. On the other hand, casein, egg, and wax will not dissolve in water, nor in a pure soap solution.

Casein is recognized, when heated, by its odor of burnt horn; organic substances, such as one finds in tempera media, glue, and organic vegetable pigments, and also in coal-tar colors, leave ash. Wax is easily recognized because it melts and has its own peculiar odor when heated. Alcohol dissolves resins, but not gums, glue, casein, or egg. Sulphuric ether (ethyl ether) dissolves resins,

waxes, and oils, but not glues or gums. Lime remains unchanged when heated, Cremnitz white turns yellow, zinc white changes temporarily to lemon yellow. The technical analysis of old paintings is very difficult, and even an expert may make all kinds of mistakes. Old pictures in the course of centuries have not infrequently been treated with every imaginable substance, and these later additions are not always so easy to detect.

If one suspects the existence of a painting under an old limewash, this is best removed by means of a hammer covered with leather, or, better yet, with a wooden hammer. One must proceed very carefully and apply the hammer only for a short time on any given area. Spatula-like instruments will here also render good service in lifting off the limewash. Some areas come off more easily than others. A coat of strong casein will often aid in pulling off the limewash. Extreme patience is required for this delicate operation, and even then mere fragments are sometimes the only reward one has for one's pains.

CAUSES OF DECAY arise often from technical errors in the original painting. If, for instance, separate plaster coats come off in flat layers, one may be certain that some lower coat was allowed to dry in between, with the result that the next was unable to get a good hold on the skin of carbonate of lime. Freezing temperatures always attack frescoes at these points and destroy the plaster ground. Poorly slaked, lumpy lime which slakes in the picture and thus keeps on "working" cracks the plaster because it requires more space. Lime containing gypsum effloresces; it also continues active and increases in volume, thus forcing off the plaster. It is clear that fluctuations in temperature and humidity caused by sun, rain, or wind, depending upon the location of the fresco, will be the cause of more or less rapid deterioration. On a wet wall neither plaster nor color will hold. Fugitive colors bleach out completely in the sun. Cheap colors containing extenders, as used by house painters, for instance, English red or ultramarine containing gypsum, will show efflorescence. Hygroscopic substances out of doors are carried off by water.

The principal cause of the early deterioration of many wall paintings is poor and insufficient ventilation. Especially is this true of ceiling decorations on which moisture has condensed.

Often air wells will have to be constructed inside and back of walls. Dr. H. Wagner has reported a case where ultramarine was completely destroyed within two months because the plaster ground could not dry owing to poor ventilation. I know of two separate ceiling decorations in one large hall of which one is in a very bad state and the other without a blemish. The answer is to be found in the attic. One decoration is situated under a leaky roof, while the other is protected by a masonry vault.

Damp walls must be dried. In old rural churches a layer of clay in the foundation is often the cause of moisture's making its way into the walls. Removing the clay at the base of the wall and filling the space with coarse gravel will often remedy this condition. I remember the case of a fresco in an open pavilion where the surrounding area was covered with tar and then plastered. The moisture in the wall then tried to escape through the painting and seriously damaged it.

Many injuries result from unjustified restorations. One has absolutely no idea of what is constantly being smeared on paintings, and how difficult these substances render conservation.

The cleaning of mural paintings. First it should be ascertained whether the color is firm and not crumbly. Dirty color, if solid, is cleaned first with a piece of rye bread held in both hands and rubbed lightly over the picture surface. This may have to be repeated. If the results are not satisfactory, the surface of the fresco is tested very carefully with a well-pressed-out moist sponge for any colors which may be soluble in water. If the color is solid, and particularly if the limeskin is uninjured, one may without hesitation clean with water, since the fresco is insoluble in water. It is best to use boiled or distilled water so that no water containing carbonic acid attacks the skin of carbonate of lime. In cases of very heavy and insoluble accumulations of dirt caused by greasy candle soot, I successfully experimented with a mixture of acetic ether (ethyl acetate), distilled water, and a thinned solution of a good grade of soap, all combined in equal parts. Before using this mixture, it was considerably diluted with water. This cleaning mixture has proved very useful to many restorers and artists. It will not attack lime. In very obstinate cases,

the troublesome area is covered several times with this medium, which is allowed to stand on it for a while.

Oil laid over fresco is often difficult to remove. If the skin of carbonate of lime is solid, soft soap applied with a sponge will dissolve the oil color, and after a little waiting the fresco can be washed off. Soap mixed with lime is a still more vigorous expedient, therefore caution is here in order. Remnants of oil remaining on the fresco will, after drying, look white and turbid. Finally the fresco should be washed with distilled, lukewarm water. Panzol [a trade name], a salve-like mixture of wax and solvents which in this form remain active longer, may be used as a removing agent. Absolutely inadvisable is the removing of oil color with the blow torch, because it darkens the fresco.

Murals painted in media soluble in water, such as glue or tempera, obviously must be cleaned by a dry method.

Enormous damage has been done by washing murals with hydrochloric acid. There is not the slightest doubt that it cleans, but at the same time the fresco is destroyed! The acid destroys the limeskin of the fresco, and calcium chloride is formed, which is both soluble in water and hygroscopic, and, furthermore, has not the solid appearance of lime and makes the fresco appear insubstantial and even transparent.

Many valuable works of art have thus been ruined, for example, the great ceiling painted by Knoller in the "Bürgersaal-kirche" at Munich, which, before the final disaster overtook it, was soaked in 1862 by a commercial firm of gilders with paraffin. That such a substance destroys the essential charm of fresco should be clear, not to mention the fact that, because paraffin does not dry, it attracts dust and soot. It is, indeed, a fatal error of many restorers to believe that casein paintings and "casein frescoes" are not injured by hydrochloric acid. It is true that the effects are not obvious at once, but the lime plaster is naturally destroyed in this way, and humidity quickly causes the exposed casein to decompose and to turn black.

I recently heard of another Knoller painting which had turned black in an unusual manner. In Neresheim [a cloister in Württemberg] the very large pictures in the cupola were restored in 1828. The restorer had used white lead with a watery medium

(glue or honey). Glue color is always affected by dampness, and black patches, mold, etc., develop, especially with the help of hygroscopic substances like honey, crystallized sugar, and glycerin. When the pictures were restored in 1903, the paintings had turned black, and they felt like fine velvet. Lukewarm water applied with a sponge removed the "repairs," since the old painting underneath was as hard as glass.

A barbarous custom formerly much practiced, which was responsible for the destruction of many frescoes, was to clean them with sandpaper. This naturally destroyed the limeskin. After this drastic treatment they were repaired, "restored," and "beautified" to one's heart's content; and when these "improvements" looked too new, a brick was used to rub down the painting and give an effect of age. These violent practices are by no means so outworn. Those who employed them were honored and praised, but they deprived us of practically all that was left of Romanesque frescoes in Germany. It is unfortunately still necessary to fight such barbarous methods, because they are still practiced secretly despite much improvement in the situation. Governmental agencies on the whole are showing a laudable zeal in doing the right thing. Today pretty generally conservation is the policy. Attempts are made to correct the causes of damage, and one does not presume to restore a partially destroyed valuable fresco in such a manner as to make it appear as if just completed by its original creator.

Efflorescences on frescoes are not uncommon. Moist walls, lime containing gypsum, caustic lime remaining from dashed on, imperfectly removed cement plaster, cheap colors containing gypsum instead of artists' colors of high quality, and impure sand are all causes, as are also gypsum and soda in fresco plaster. These efflorescences may cover the entire surface of the painting and cause both color and ground to fall off. Caustic lime in cement through the influence of the atmosphere turns into neutral carbonate of lime, and it may be removed from the surface of the fresco with distilled water and a wad of cotton—but efflorescence usually continues! Gypsum, sodium sulphate (Glauber's salt), potassium sulphate and carbonate, and calcareous earth developed

from caustic lime are the main causes of efflorescence, which popularly [but erroneously] is called "saltpeter." [4]

The only remedy for efflorescence which has its origin deep in the wall is the removal of the plaster. If a wet wall is at fault, the cause of the moisture must be removed. Muddy, cloudy-appearing areas in a fresco painting may result from "tormented" colors and "disturbed" ground. On old frescoes disintegrated resinous films of colophony or shellac often are present. Wax solution or poor casein may cause a veil to form, which may be carefully removed, if the ground is solid, by using a solution of soft soap, alcohol, or oil of turpentine. All coatings with substances such as white of egg, resin varnish, and wax must be avoided. Turbidness of appearance which has its origin in the plaster is not removable.

Tempering and fixing a fresco. If there are areas in a fresco which threaten to disintegrate or come off in powder form, they may be fixed with pure, clear limewater. A very thin solution of ammonia or casein is frequently used and fixed with a 4% solution of formalin, which later on hardens. This, however, is being disputed in the case of outdoor frescoes. It would be best to experiment first on a small area and cover up the rest of the picture during the test. 2% dammar in benzine is useful only indoors. Fixing with water glass is not to be recommended. Sodium silicate forms, which causes efflorescence; it also disintegrates and changes the optical effect of the fresco.

The character of the fresco should not be changed by the fixing medium. Solutions of paraffin or wax in fatty oils change the effect of a fresco. Thinned Zapon varnish has been employed indoors, also very much thinned wax soap.

Repairs and replacements in walls. Deep cracks and holes must be well moistened and filled with fresco plaster into which broken and moistened fragments of bricks have been introduced. The edges must promptly be cleaned with a sponge. Gypsum mortar must never be used for these repairs, because it continues to work, increasing in volume and thus causing the color to fall off.

[4] Saltpeter, strictly speaking, is potassium nitrate. [Translator's note.]

Retouches. In the case of valuable works it is best not to attempt corrections, additions, or overpainting, but rather to maintain the faulty areas in a neutral color tone which harmonizes with the general tone of the painting. The restorer in such cases should not glory in his skill in making his additions appear to be parts of the original. As has already been stated in discussing true frescoes, it is best to apply retouches on frescoes inside of buildings with wax-potash emulsion and dammar varnish thinned with water (see under fresco). Repairs made in this way fit into the old picture so perfectly that after a few days they are scarcely any more recognizable as such. One must keep the medium thick and not fluid, however, and it is best to daub it on with round, rough bristle brushes and with dry pigments. On outside walls casein is used, followed by a spraying with 4% formalin.

It is dangerous to retouch wall paintings with commercial tempera or water colors. I know of a case where a new, very good ceiling decoration was considerably damaged in this way. Flies in large numbers settled on some colors, particularly on the places which had been retouched, and soiled the picture. One might assume that the flies had a special preference for certain colors—however, it was substances like honey, syrup, and the like which were the attraction. Incidentally, such places suffer very much owing to the permanent solubility in water of such repair material, which eventually becomes crumbly and falls off.

REMOVING FRESCOES. Already in antiquity frescoes were occasionally removed, a fact which has been proved by discoveries at Pompeii. The ancient plaster was very firm, so that whole sections of the wall could be sawed out. In the case of recent transfers, such as those, among others, carried out by A. W. Keim, the plaster was cut at a certain distance all around the picture and a wooden frame fastened around it. Many strips of strong paper were then glued to the surface of the picture with starch paste so that no part of it could fall off. As an additional precaution the face of the picture was covered with a wire netting which was fastened to the wooden frame. Starting from the top, a piece of the fresco was sawed away from the bricks, and an iron band carefully put behind it and screwed to the frame, and so on until the whole back was firmly held to the

frame. Another method of removing a fresco is to cover it completely with pasted strips of paper; if the room is then heated to a high temperature, the fresco skin with the color springs off and can be rolled up. The painted layer is then placed on a new ground and the layer of paper carefully softened. However, all retouches are lost in this process, the picture afterwards has a much duller appearance, and a good many qualities are lost, especially glazes and ocher colors; opaque areas are best preserved.

Still another method calls for coating the fresco surface with thick glue and scalded pieces of canvas coated with glue, which are unraveled at the ends, always so that the upper strips of linen (or paper) lie over the edges of those underneath. At the top a wooden roller is then fastened, and an attempt is made slowly to roll off the picture from above, while at the same time carefully loosening the plaster. It is self-evident that all these methods require a great deal of practice and patience, as does also the process of loosening the picture together with the top plaster coat from the wall by a sustained, regular tapping of the parts to be removed.

Today also transportable frescoes are painted. Galvanized wire mesh is stretched inside of shallow wooden boxes, and the plaster coats are applied to this as one would to the wall. One then may paint in fresco or secco, and all sorts of technical variations are possible.

MINERAL PAINTING [stereochromy]. Quartz sand fused with alkalis produces a glassy substance, water glass, which is capable of absorbing water and thus becomes liquid. Water glass, so to speak, is a kind of mineral glue, which binds and adheres. Only potassium and not sodium water glass can be used for painting purposes. Potassium water glass fused with lime or powdered chalk is said to yield a waterproof water glass. With slaked lime, magnesia, and zinc oxide it forms a silicic compound which hardens and becomes insoluble in water.

On this principle was built the technique of stereochromy by J. Fuchs and Schlotthauer, later improved upon by A. W. Keim and introduced as mineral painting.

Water glass decomposes when allowed to stand exposed to the

air; it must, therefore, be kept well covered. It is often used for commercial paints, and also on metals. It is hard to apply with the brush, and the colors easily coagulate; hence they are first ground in milk. The choice of colors is still more limited than in fresco.

Completely dry cement-lime mortar serves as a ground for Keim's mineral painting. The skin of calcium carbonate must, with a fixative of water glass, be transformed into an insoluble silicic compound. The whole process depends on obtaining the greatest amount of silica formation, which causes the colors to adhere closely to the ground. The colors contain additions of magnesia and zinc oxide and must be applied wet in wet on wet grounds. The pigments are mixed with distilled water and kept covered with water. The colors should penetrate deeply into the ground. Painting into half-dried ground will not set. For the most part one can paint only in glazes. If this rule is not observed, the colors will become heavy when fixed. Colors and ground must be free from gypsum, otherwise the colors will congeal.

The well-dried painting is fixed by warming and carefully spraying ammoniac-potassium water glass over it in such a way that no drops will form; and this is repeated several times. Lightly glazed places require less fixative than opaque places. No surplus fixative must be allowed to remain on the wall. The color on the painting must no longer rub off. Free potassium is afterwards washed off as potash with water. The most difficult part of mineral painting is the proper fixing, upon which the whole permanency of the painting depends. One should paint during damp weather and fix during dry.

Mineral painting has proved itself in many instances. Failures are probably due in most cases to technical errors.

Cement and concrete are still today very unreliable materials to paint on. Cement is hydraulic lime. It sets also under water. Cement mixed in certain proportions with sand and gravel produces concrete. Cement, like lime, needs an admixture of sand, in fact, more than lime to make a good cement plaster. On very smooth cement plaster color holds very poorly.

So-called Portland cement is most frequently used; it contains

as much as 75% caustic lime and 25% clay. Frequently there are additions of gypsum and magnesia. There are types of cement which set very fast and others which set more slowly, in from a few minutes to twelve hours, depending on the temperature of the air. Indoors cement hardens more slowly. It is generally presumed that cement plaster and concrete cease to be active after two years, and that then no further efflorescence is caused by caustic lime or gypsum. Still I have seen this occur after a much longer time.

One may remove the efflorescence on the surface with ammonium carbonate, using stiff brushes and rinsing afterwards with water. This, however, does not prevent further action from within.

Keim's mineral color is said to have lasted very well on concrete. Oil color is destroyed on fresh concrete through saponification. Casein has also been employed on cement plaster. But with all these techniques the danger of efflorescence is everpresent. According to Dr. Wagner of Stuttgart, the following colors are usable on cement: the yellow and red ochers, the iron oxides, including caput mortuum, Naples yellow, certain ultramarines, oxide of chromium brilliant and also opaque, the green earths, and manganese black. Black iron oxide would perhaps be permanent. Zinc white or lime is here used as white. Wax color has not yet been sufficiently tested on cement. One should never, as is the custom, add soda to concrete or cement plaster, as it will come to the surface and cause trouble.

Gypsum walls may be painted on if completely dry with tempera or glue color, but only indoors. Gypsum walls are sized with glue-water and a small addition of alum. Alum 1:10 in water is soluble. After drying, the alum crystals which appear on the wall are wiped off. In the open gypsum is not weatherproof, and it destroys color laid over it. Lime with gypsum sets apparently quite well, but Vasari already remarked that gypsum effloresces and destroys the color. Lime plaster is more dependable.

Graffito. The last plaster coat of a fresco ground is colored before being applied. While still moist, it is brushed over twice with limewash. When the plaster begins to pull, the design is pounced on, and on parts of the design the limewash is scraped

out so that a decorative, two-color effect results. Ornamental and figural designs covering entire façades were at one time executed in this manner. The outlines must be cut obliquely to prevent rain from collecting on the cut edge.

Vasari reports that burnt straw was used to color the mortar. It is absolutely essential that the color be well and evenly worked into the plaster. A small amount of casein or skim milk may be added. Today sometimes several layers of the plaster are colored, and different fresco and casein colors are used in the different layers.

Portland cement, which sets slowly, is also used in graffito plaster. In fresco, of course, such cement is not useful, as it sets here too quickly and would allow too little time in which to work.

Finely broken natural-colored stones, such as slate, basalt, and marble, are much used today as additions in plaster. They must be thoroughly mixed with it, otherwise there will be disturbing spots. New decorative possibilities have in this way been developed in graffito by Professor Lois Gruber of Munich, who claims extraordinary durability for these plasters. Cement in this process is subjected to a special treatment. The plaster coats are as much as 7 cm. thick. The experiments being conducted at present may also clear up the much-debated use of cement in fresco ground.

CHAPTER IX

TECHNIQUES OF THE OLD MASTERS

Although I regard the technical study of the old masters as a very profitable activity, these discussions are not intended primarily for copyists. Even less are they to be regarded as a kind of historical dissertation on art.

My main idea has been to show to the creative painter how others before him have succeeded, so that he may receive in this way fresh incentives to creative work of his own and perhaps independently discover new ways and means more readily to solve his own problems.

This chapter then has not for its aim a comprehensive and complete presentation of the working methods of all the old masters, but contains merely a broad statement of typical examples.

Thus the technique of the early Florentines serves to illustrate the tempera technique; the technique of the Van Eycks the mixed technique—a combination of tempera and oil colors; and the technique of the Venetians and of Rubens the use of resin-oil colors on a rational foundation. In each case the discussion is sufficiently broad in its scope to give a complete picture of the technique in question.

Today most artists work independently of one another, but in the days of the old masters each artist was a link in a chain, a part of a tradition. Knowledge and ability increased from generation to generation, each master adding something of his own. In the workshop the apprentice became intimately acquainted with his materials and easily learned through performance all the tricks of the trade.

In those days a painter could take time to mature; competitive exhibitions and the feverish haste of today were unknown. Today every artist is expected to turn out a new "hit" each season in the manner of a vaudeville performer.

In the old days a picture was built upon sound knowledge, accompanied by a well-disciplined use of the materials.

It is a form of self-deception, or perhaps merely a convenient excuse, to say that the materials of the old masters were better than those of today, and that the splendid preservation of many of their pictures is to be attributed to this factor. To be sure, through the great care which they exercised in the purification of their oils and in the grinding of their colors the old masters acquired a very different knowledge of their materials, which must have contributed considerably to the excellent preservation of their works. But where we today possess unobjectionable pigments, the old masters had frequently to employ fugitive colors. I need mention only their verdigris as compared with our oxide of chromium. That the old masters were able to meet such difficulties testifies to their reliable craftsmanship.

But most of all must their success be attributed to the building up of their pictures in accordance with the laws of the materials. The old paintings in every stage of their development possessed very logical and in themselves complete qualities, and look as if they had been developed and completed according to a plan thoroughly understood from start to finish.

We shall see what infinite pains were taken by the old masters in the selection and preparation of their materials. It strikes one as curious, to say the least, when one hears modern artists insist upon their favorite superstition that originality and personal expression are better safeguarded by the use of a free and easy technique untrammeled by any regard for the laws of the materials. The painter of today must become more conscious of his responsibility for the permanency of his work than is unfortunately the case. Many a painter of today lives to see his own handiwork go to pieces in his lifetime because he abused his materials. Before one can become a master, one must first have been a disciple. Those who do not believe this will pay the penalty sooner or later. There is no short cut to becoming a good painter, to quote Reynolds. To a beginner the technique of the old masters must seem very mysterious, and even the experienced painter and the technical expert are bound to commit many errors in judgment. It is, curiously enough, much easier

to study technical problems in the minor works of "schools" than in the works of the masters themselves.

Frequently a painter who has suddenly become interested in the technical procedure of the old masters hears of the existence of some old treatises on painting and thinks that the matter has thus become very simple. He jumps to the conclusion that all he need do is discover how this or that artist painted, and, presto, his problems are all solved! But, if he looks more carefully into these treatises, he will, unless technically well trained, carry away with him an overwhelming sense of confusion. The value of all these "sources" is, in fact, very conditional.

All sorts of recipes are here thrown together. In the very early works materials are largely discussed which today only a house painter or, at best, a church decorator would use; there are recipes for gilding, the preparation of gold size, etc., and how, for example, by means of saffron painted on tin foil one can imitate the appearance of gold leaf, and there are recipes for miniature painting, for plain house painting, the polychrome treatment of statuary, and so on, in short, anything and everything, and the injudicious will take a recipe the use of which is not clearly indicated and unwittingly try it on his canvas, with, of course, very disappointing results. Also these source books contain a great deal which will not stand the test of critical examination. It is therefore in general advisable not to place too absolute a confidence in advice merely because it is old. Such of the old pictures as were not soundly executed have long since disappeared, have completely perished; only the best have survived. Time here also has exercised a natural selection.

These old painters' manuals have been copied again and again, often by incompetent persons who did not understand the technical expressions and often mutilated their meaning. Some recipes no doubt were deliberately kept secret to increase and protect the importance of the guilds. Many additions were made later by others. Added to this is the difficulty that in these writings the terminology varies considerably and is very different from that of today, with the result that the interpreters of these treatises quarrel among themselves as to their meaning. Professional terms

no doubt existed even then, and by a person who does not understand them they are apt to be translated literally, often with the most comical results. If one stops for a moment to consider how a person not acquainted with artistic terms would translate literally such expressions as the "sinking in" of oil colors or the "jumping out" of a tone, one will have an idea of what has happened when attempts have been made to translate some of these early painters' books.[1] Additions by other hands are not uncommon, and sometimes the genuineness of the entire manuscript is doubtful. The times in which they were written are similarly obscure, and dates are often more or less arbitrary. From all this one gets a vivid picture of how much or how little a painter is likely to profit from these works, excepting perhaps those of Cennini, Theophilus, and De Mayerne. The least reliable are more recent works, which largely offer stones in place of bread and doubtful aesthetic dissertations instead of reliable discussions of craftsmanship. E. Berger's *Beiträge zur Entwicklungsgeschichte der Maltechnik*[2] very interestingly relates the history of these "sources."

Raehlmann has made valuable discoveries through his microscopic examinations, particularly in determining the character of old pigments and in part also of media, and has thus validated many practices which have grown out of experience. These researches, however, are still in their infancy, and they do not as yet present a complete picture of every phase of the technique of painting. This is similarly true of the chemical analyses of very old pictures, which have not been wholly convincing in their results.

If, for instance, a ground was strongly absorbent and was covered with a varnish glaze, the chemical analysis of the ground is bound to give false results. Furthermore, old pictures were often painted over by others, old layers of oil in the course of time come to resemble varnishes, glues are altered by tempering, and many pictures were later impregnated from the back with foreign

[1] Different examples have necessarily been substituted for those given in the German text. [Translator's note.]

[2] Only available in the German language, see bibliography. [Translator's note.]

substances. There are certainly enough reasons for making mistakes.

What is of importance to a practical painter is to discover those materials and the laws for building up a picture which will enable him to get with certainty and not by accident the same results as some old master in question.

The present-day generation of painters, who have practically burnt behind them all the bridges connecting them with the old masters, must often wonder how the latter could build up such rigid technical systems and why they followed them so religiously when oil color offers such attractive and simple means of covering up all mistakes. The truth of the matter is that these technical systems never remained the same for long periods; the different techniques developed gradually, generation after generation adapting them to its particular requirements. They were passed on, to be utilized freely by men of genius, while at the same time enabling the less gifted to produce respectable, craftsmanlike, and enduring works of art.

Through changing times and techniques, however, one basic idea persists: systematic construction, with a concurrent division of treatment of form and color as two distinct phases of the process. In the foundation, the underpainting, were concealed all the evidences of labor, detailed drawing, modeling, and the heightening with white which was necessary to give to the superimposed color luminosity and power and clarity. Rapid-drying painting media were always used. The old masters believed it to be very essential that the individual layers of the picture should come to rest as soon as possible and cease "working." Today, as everyone knows, the contrary is the practice.

There was a system, a schematic procedure, if you will; but it does not follow that a system must be used unintelligently and without spirit. Furthermore, it must always be remembered that, in the case of the old masters, we are dealing with preconceived, clearly thought-out pictorial projects, where every phase of the picture is developed almost according to a schedule, to carry it to the highest perfection of form and the greatest clarity and luminosity of color. It cannot be denied that our methods today

are not so simple, neither do they lead us so directly to the realization of our artistic aims.

THE TECHNIQUE OF THE FLORENTINE PAINTERS OF THE TRECENTO AND OF THE *TRATTATO DELLA PITTURA* OF CENNINI (Tempera Technique)

In *Cennini's* treatise the style of Giotto has been preserved for us, who gave it to Taddeo Gaddi, who in turn passed it on to his pupil Cennini.

Here we find for the first time a full description of the technical growth of a picture, which is not the case in the earlier manuscripts, which are mostly a heterogeneous collection of all kinds of recipes.

The easel pictures of the Byzantines had a dark, muddy character, the result of the incorrect preparation and excessive use of oil varnishes. The ground contained soap and oil "according to individual preference," which naturally caused still further darkening.

The oil varnishes in themselves were dark, burnt, almost black, and very thick. It was impossible to apply them with a brush, and they had to be rubbed in with the ball of the hand. Pictures were put in the sun to dry, and little difference was made between quickly and poorly drying oils.

The painting was done in tempera, a very glossy mixture of glue, lye, and wax, but also in egg tempera. In the flesh parts the picture was built up of prescribed colors, greenish in the shadows contrasted by red, on a principle handed down from antiquity. The pictures were hard in color and "fell to pieces." By means of dark-colored glazes, probably asphaltum glazes in the manner of Apelles, an attempt was made to create harmony.

Mural painting was the source of inspiration, and the easel picture showed a similar flat treatment. Nearly all painting was weighted down with gold and gold imitation.

All painting was in accordance with a fixed canon, and no one, largely for religious reasons, was allowed to deviate from it.

Of the many contemporary manuscripts which shed light upon

the painting of the southern countries, the following may be briefly mentioned:

In the *Lucca manuscript*,[3] dating from the 8th century, are to be found recipes for colors, directions for the extraction of pigments from plants through the use of lyes and precipitation with alum, information in regard to gilding, lettering in gold, gums and emulsions. There is also mentioned the "pictura translucida," which requires tin foil as a basis and is then glazed over with resin-oil color and treated with oil stains. *Heraclius,* also in the 8th century, gives us white-of-egg-alum for miniature painting and lettering, besides information in regard to oil color. The *"Mappae Clavicula"* from the 13th century also contains recipes for miniature painting, gilders' recipes, a recipe for a wax color with glue for use on both wood and canvas, as well as directions for mixing colors and for the use of castor oil as a varnish over tempera and glue paintings.

In the *Hermeneia* of Dionysius, the painter's handbook from Mount Athos, the date of which is very difficult to fix and which some have placed very late (11th-17th century), we also find many of the restricted rules of Byzantine painting, including a recipe for a gypsum-glue ground to which soap and oil were added. There are also recipes for gilding and a detailed and systematic description of the painting of flesh. The recipes were especially applicable to wall painting. In the Athos book ground for canvas is made from glue, soap, honey, and gypsum, "according to preference," and is then painted on with egg. The varnishes mentioned are spirits of wine varnishes and yellow-colored varnishes, which were probably employed in the "pictura translucida," in the imitation of gold, and in tempera painting. Finally, there are recipes for a kind of wax painting and for a medium with a high gloss consisting of glue, wax, and lye mixed in equal parts.

Pictures by Duccio di Buoninsegna and his school in Perugia very plainly show the dark green imprimatura, the "proplasmos" [4] of the Athos book, which was laid over the entire white gesso ground of the picture and showed through everywhere. Over this

[3] In the Cathedral Library at Lucca. [Translator's note.]
[4] Preliminary organization into plastic form. [Translator's note.]

in two or three successive layers the "carnation," consisting of white lead, ocher, and vermilion, was laid on in such a manner that the "proplasmos" remained effective toward the outlines and in the shadows, producing a modeled effect and gradations of optical grays. On top of this came the red of the lips and cheeks, while the eyebrows, the pupils of the eyes, and deep folds were set in with black and caput mortuum. Draperies were always painted before the flesh.

This was called the Cretan or Greek manner. Egg yolk and the glossy color "cera colla," which acquired gloss through rubbing, are the authentic media of this period. The very early Russian icons are painted with egg yolk with strong heightening with white and in the antique color contrast of green and red in the flesh. Ocher tones predominate.

Giotto was the great liberator of art from the limitations of the rigid Byzantine tradition. His teacher, Cimabue, had introduced the egg tempera of the Greeks into Italy. Giotto's works, according to the accounts of his contemporaries, must have made a profound impression. They appeared almost terrifyingly realistic, so true were they to the spirit of nature in their clear and luminous color, their free movement, and their power to suggest space.

Cennini in his *Trattato della Pittura* describes for us the technical aspects of Giotto's art, which long exercised a dominant influence. There is a good translation [in German] by P. Vercade.[5]

The ground for easel paintings, according to Cennini, was prepared very carefully, and great care was taken to see that the panel was free from grease. The panel was first given several coats of glue size and then covered with canvas. Next a gesso ground was laid on in many thin layers, the materials for this being most carefully prepared. The brilliantly white panel was finally scraped very smooth.

There is no better way of preparing a panel, and we can offer today no improvement upon this recipe; but the same cannot be said of Cennini's recipe for putting a ground on a canvas. The

[5] There is also an English translation by Lady Christiania Jane Herringham. [Translator's note.]

canvas, in fact, was drenched with hot glue, and over that starch, sugar, and gypsum were very thinly applied with a spatula so as to fill only the pores. Over this came an oil-color priming. No wonder pictures on canvas of this period have survived only in very few instances. Gilding was also fully described by Cennini in the most painstaking manner.

Painting on canvas in those days was done in tempera. As a medium for grinding colors and as a painting medium egg yolk was used mixed with the juice of young branches of the fig tree and diluted with water. The milky fig juice was probably intended to dilute the egg yolk or perhaps also act as a preservative much in the same way as vinegar is used today in the trade. Cennini issues the warning that the use of too much egg is fraught with danger. He also remarks that the yolk of "city hens" is lighter in color than that of country hens.

The colors were first ground very fine in water and then combined in equal amounts with yolk of egg. Such hand-ground color naturally possessed much greater body than the present-day machine-ground color.

Draperies and architecture were painted before attention was given to the flesh parts. The most striking color, as, for example, a red, was used at the start, so that the final effect was at once achieved in its full strength. To increase the luminosity of the red, it was painted over white.

The painting was preceded by a clear and accurate drawing, which was lightly gone over with a mixed green tone. This was followed by a toning of the entire surface of the picture with Veronese green earth, and the light areas were twice flatly modeled with white. The green mixed tone of the contours (verdaccio) consisted of black, white, and ocher. The shadows were strengthened with Veronese green earth. Accents in the mixed green tone were put in to increase the expression of the eyes, the nose, and the mouth. In the painting of the flesh three tone values of the local color were employed. Sinopis mixed with white was the tone used at the start ("cinabrese"), a light, vermilion-like red, a natural ocher from Asia Minor, today unfortunately no longer available. The darkest tone was made of sinopis with very little white, the middle tone of equal parts of

both, while the lightest contained a considerable amount of white. The green underpainting had a similar, but a little more finished, character, somewhat like a drawing made on green toned paper and heightened with white. The three red tones were put over this underpainting, being used in the lights, transition tones, and shadows in accordance with their respective values, but always in such a way that the green undertone remained active in the shadows in visible contrast with the reddish light areas. The darkest tone was chromatically the strongest, because it had to compete with the strong green complementary tone of the underpainting. This was true also, though in a lesser degree, of the middle tones. In the lights, however, where, owing to the greater use of white, the contrasting green was lacking, the red chromatically had to be very weak.

The painting was begun with the red of the lips and cheeks, which was applied very boldly, since the darkest of the flesh tones was required to be lighter by half. The colors were then blended and applied one over the other several times in succession. Finally the high lights were set in with almost pure white, and the deepest shadows with red-black or pure black.

The draperies were treated similarly in three graded tones. This use of three graded tones is very practical and has been continued for centuries.

The ancient tempera technique was very tedious as compared with modern painting in oil. Great care had to be taken not to paint too wet, the brush had to be well squeezed out, and yet the color had to be liquid. There was always the danger that the lower layers would be dissolved if they were not gone over lightly and quickly enough.

The individual tones could be gone over successfully only by means of "hatching." The light areas were somewhat easier to manage; they remained practically unchanged, being laid over a white underpainting. All water-color techniques, of which tempera is one, require a light ground, so that the color over it will have luminosity; therefore the shadows offered the greatest difficulties, both from the standpoint of clarity and modeling. The arbitrarily fixed scale of three tones was therefore quite helpful, since one could always return to them without much

difficulty. Without this technical formula it would have been quite impossible to recover the value of the shadow tones without creating a spotty effect, because in tempera they dry not only quickly but lighter. Shadows in all water-color techniques, including fresco, had to be kept relatively light so that they would not look heavy and sooty.

As an intermediate varnish for easel pictures parchment glue (made from the clippings of goat skins) was used.

After the completed painting was dry, it was covered with varnish.

A liquid varnish (vernice liquida) made of linseed oil and sandarac is mentioned by Cennini, but this sandarac in all probability was different from the sandarac resin of today, which is not suited to tempera.

Boiled oils reduced to half their volume are also mentioned, as well as oil thickened in the sun, of which Cennini says, "There is nothing better."

All the varnishes had a warm, reddish tone, which gave a certain warmth to the relatively cool tempera pictures. The varnishes were rubbed in with the hand in order to achieve the finest distribution. This method was practiced by Italian, Flemish, and early German painters.

Colored varnishes are often mentioned in early books on painting; their effect must have been that of a glaze.

Some parts of the picture, such as the draperies, were later painted in oil, likewise applied in three tones, while the flesh parts continued for a long time to be painted in tempera.

Oil painting was already practiced in Cennini's day on walls and on panels, and he especially mentions that it was much practiced among the Germans. There is a tradition that Giotto occasionally painted in oil.

Tempera pictures have a cool and solid, but also a colorful, appearance. The shadows are relatively light, they do not jump out of the picture, and the total impression is of diffused daylight.

There is a very striking difference between these Italian pictures and those of the early Germans, in which glazes in the main, alongside of a few opaque passages, determined the character of the picture. This is likewise true of the early Flemish

pictures, which combined solidity of effect with transparency. In general tempera pictures constructed of body colors laid over a white, toned ground are easily distinguished from other techniques, and they have somewhat the appearance of a fresco.

Here also the technical process was a prescribed one into which neither whim nor accident entered, but which amounted strictly and logically to a law of picture building which took advantage of all the technical possibilities of the material and carefully avoided all technical errors. The durability of these tempera paintings is extraordinary and unsurpassed by the products of any later technique.

This technique was taken over in its entirety by mural painting, and is to be found there practically intact.

Plaster composed of two parts of sand and one part lime, which was allowed to stand for a few days, was laid on the wet wall, and on this the design was outlined with ocher and traced with red chalk.

Since another coat of plaster went over this, it is clear that this drawing only served the purpose of gaining a clearer impression of the design, particularly its effect from a distance. It is certain that a pounced drawing was made from it. Not infrequently the plaster coat laid over it has come off, since evidently the skin of carbonate of lime was not always removed.

On the last coat the drawing of the contours was carefully carried out with the mixed green tone and the picture developed according to the method employed on the panel picture.

It is a curious fact that occasionally in the white grounds of old Italian easel pictures are to be found deeply incised outlines such as are usually supposed to be the distinguishing marks of buon fresco, for example, in pictures of the school of Milan and those of Raffaelino da Carbos.

The methods, of course, varied with different masters according to their individual aims.

Fresco paintings in green earth were very frequently executed on walls. Also paintings were often finished in secco over a fresco ground, and sometimes with materials which caused their later destruction. On the other hand, Vasari mentions explicitly a fresco by Ghirlandajo in a chapel which had collapsed and ex-

posed it to the elements which nevertheless remained in a good state of preservation. Vasari makes a point of adding that it pays to paint frescoes according to rule and not to patch them up afterwards in secco.

Egg was the medium employed in *secco painting*. Egg yolk was thinned with water and applied with a sponge, as in gilding, where Veronese green earth was also used as an undertone. Some painters made use of the whole egg. Giotto's influence was felt all over Italy and far beyond into southern France and Spain. Characteristics very similar technically to those of the early Florentine period are found in the early masters of Cologne, such as the green underpainting of the shadows in the works of Meister Wilhelm. Probably they may be traced in both instances to Byzantine sources.

The technique of the early Italians as described by Cennini has repeatedly been experimented with by painters of later periods, and the results have not infrequently been conclusive of its many advantages.

THE TECHNIQUE OF THE VAN EYCKS AND OF THE OLD GERMAN MASTERS (The Mixed Technique)

In the long run the tempera technique was not capable of satisfying the artistic and technical requirements of painters, and, according to the testimony of Vasari, many attempts were made in Italy and Germany and elsewhere to improve it. But tempera painting in the old manner continued to be practiced (at least in Italy, for in Germany, as Cennini reports, painting in oils on walls and on wood panels was already being practiced), although artists everywhere were conscious that tempera lacked a certain softness and sparkle, that the colors were difficult to fuse, that the method was laborious, chiefly by means of "hatching," and that the pictures were sensitive to shocks and to moisture.

In Italy, to be sure, one had already begun some time before to paint certain parts of a picture, such as the draperies, in oil, while the flesh parts continued to be carried out in tempera.

We read of the failure of Baldovinetti, who naturally produced nothing more than a very poor omelet in trying to combine hot

Vernice liquida with egg yolk. But this serves to illustrate the direction which experimentation was taking. Tempera, it was generally felt, should have greater binding power and produce a richer and more saturated color effect, and should also be easier to work with. When one stops to think how simple, after all, it is to make an emulsion, one wonders that it took so long a time to discover it. But it is always the same in such matters as with the egg of Columbus.

Tempera painting, as we have learned, gradually took second place in Germany (and in England); perhaps climatic conditions there favored the use of oil in painting.

We learn about the earlier German tempera painting from a book by *Theophilus*, the monk of Paderborn [Westphalia], who under the title *Diversarum artium schedula* wrote the first systematic work for the use of painters, a work which is at least a hundred years older than Cennini's treatise. It goes back to Byzantine sources and contains recipes similar to those found in contemporary painters' manuals of the southern countries. Here again we learn about panels and how to size them and cover them with canvas, how to prepare grounds made of glue, gypsum or pipe clay, and casein glue, how to paint over tin foil, and so on. But most important is a recipe for tempera. Cherry gum served as a vehicle, while light colors were applied with the watery residue of beaten white of egg. Underpainting with green in the shadows is also mentioned, as well as heightening in the light areas with white and the use of reddish tones in the flesh.

Especially noteworthy here, however, is the fact that intermediate varnishes were laid between the separate color coats of the tempera—mixtures, moreover, of oils and resins and colored varnishes, i.e., glazes; in short, what we have here is a mixed technique. Regarding the special properties of the different oils one was still in those days very much in the dark. Theophilus reports that linseed oil does not dry well! He had first used his oil press to press out olive oil and had then, without cleaning it thoroughly, used it for pressing linseed oil. No wonder the linseed oil would not dry!

He ventures the opinion that oil perhaps might do for paint-

ings which would afterwards permit of being dried in the sun. Waiting for the oil to dry, he said, was a nuisance, because it delayed the putting on of the next layer of paint. This, of course, must have been annoying to a painter in tempera, who was accustomed to an immediate drying of the colors.

Figures and draperies were already at that time painted occasionally in oils, but no distinction was made between the different types of oil. The varnishes were thick and dark and had to be rubbed on with the ball of the hand. For that reason the "liquid varnish," vernice liquida, had a special reputation.

This was the condition of the soil from which grew Van Eyck's discovery.

Obviously, after what has been stated, there can be no talk of Van Eyck's having invented oil painting, since centuries before his time oil had already been employed as a painting medium.

Very probably Van Eyck's "invention" is not based upon the discovery of a heretofore unknown material, but rests upon the logical and effective employment of materials already known.

According to an often-repeated legend, Hubert van Eyck had put a varnished picture in the sun, as had been recommended by both Theophilus and Cennini. Unfortunately, the panel cracked, and as a consequence he looked for a varnish which would dry in the shade. After many experiments, as the story goes, he discovered linseed oil and nut oil to be the best drying agents.

The white, solid gypsum grounds were retained, but Armenini (1587) reports that the Flemish had added 1/3 white lead to the gypsum. (In those days zinc white was unknown.) Canvas was mounted on the wood panels, but often only over the seams. Egg yolk or tempera made with it was the medium. It was a laborious process, and the results dry and unpleasantly hard in appearance. In this manner did the Oltramontani (the Flemish) paint, according to Armenini. The moderns [the Italians] had completely renounced the painful and laborious methods of the Flemish and adopted an exclusive oil technique in their place. Paolo Pino writes: "Let us leave guazzo [gouache] to the Oltramontani (the Flemish), who have lost sight of the right road. We, however, will paint in oils."

Vasari states positively (but mistakenly) that since 1250, in

fact, since Cimabue, all painting, on canvas as well as on panels, had been executed exclusively in tempera, which accounts for the fact that he ascribed to Jan van Eyck the invention of oil painting. He says that, after many attempts, he finally discovered that linseed oil and nut oil dried best. By boiling these with other admixtures, he invented the varnish to which all the artists of the world had looked forward. He also discovered that pigments ground in these oils were very durable, did not suffer damage from water, and, further, possessed gloss and fire without additional varnishing. But their most marvelous quality was the ease with which they could be fused as compared with tempera colors. Oil painting and boiled varnishes, however, had been well known for more than 100 years before the Van Eycks.

The above quotations [from Armenini and Paolo Pino] would lose all meaning if Van Eyck had practiced a pure oil technique; but although the differences in the techniques in question are here clearly indicated, it is continually being reiterated that Van Eyck's was nothing more than an oil technique involving the use of boiled fat varnishes.

There are plenty of Flemish pictures on which one may observe a very solid tempera underpainting in white or gray. It is alleged of Van Eyck that his underpainting (the so-called "dead color") was more complete than the finished pictures of other painters. Tempera underpainting in monochrome or in suggestions of local color, as we know from experience, greatly facilitates finishing by means of resin-oil glazes and increases enormously the luminosity of the colors. Van Eyck knew only too well from experience the advantages of a tempera underpainting as compared with one in oil. The rapid and solid drying of tempera alone satisfied a universal requirement of that period. The lean character of tempera allowed superimposed varnish-oil color to show to its highest advantage. The water medium permitted of a very precise treatment of the drawing, and the gray or white preliminary underpainting did not detract in the least from the special charm of the color.

There was the further advantage that tempera did not dissolve when covered with oil, while a neutral underpainting in oil would not be without this danger, not to mention other tech-

nical disadvantages, such as slow drying. It is unreasonable to believe that the old masters would voluntarily have surrendered the well-known advantages of tempera in these respects.

The ease with which oil color could be fused was of importance only in the overpainting. In underpainting this quality, as well as the gloss of oil color, was of no advantage. It is also not improbable that the underpainting was done in casein glue, which, as such, is insoluble in water.

In striking contrast with the painting of today is the heightening with white of Van Eyck and all earlier technicians. A passage in Carel van Mander's [1548-1606] *Schilderboek* [artist's book] which, curiously enough, has always hitherto been overlooked states that Jacques de Baker [1530-1560] deserves everlasting fame because he painted the light areas in the flesh not with white alone (followed by a glaze), but at once with white mixed with flesh color. If this means anything, it would seem to indicate that before De Baker preliminary heightening solely with white was the common practice.

Filarete [1400-1469] describes this procedure of heightening with white. Over the imprimatura [a colored undertone] all parts of the picture were to be heightened with white. This statement was not clear to writers until they learned to understand the nature of heightening with white. White used thinly over those parts which function as shadows, but applied heavily over light areas, results in gradations, the optical grays, all achieved by the use of white. Filarete continues: "If you have human figures, houses, or animals to paint, first model them with white lead." "If you have heightened all parts of your picture with white lead," we read further. Over this came the local colors, development of the lights with white and local color, and strong accents in the lights and shadows.

The old tempera did not permit of heavy application. Egg yolk color easily came off when used too thickly. It is not improbable that Van Eyck greatly improved tempera through the discovery of an emulsion. This was, so to speak, in the air, as may be seen from Baldovinetti's unhappy experience, and also when one remembers in this connection the current report that in Italy and Germany and elsewhere great efforts were being made to im-

prove the tempera technique. Tempera, of course, became much harder as an emulsion; it also had more body, it combined well with oil and resin varnishes, and yet it could be thinned with water even to the point where it resembled pure water.

The tempera brush stroke is the clearest and most definite, as was pointed out in the chapter dealing with the mixed technique. No other medium, in fact, allows of such a clear stroke if set into a thin oil or varnish glaze.

A tempera emulsion does not change when varnished, if properly used, which cannot be said of pure egg tempera.

No doubt such an able practitioner as Hubert van Eyck would soon discover this, and all the more probably because the idea of a mixed technique of alternating layers of oil and tempera was already known at the time of Theophilus, that is to say, two hundred years earlier.

The old egg tempera had the disadvantage, if gone over, of being easily dissolved, even down to the ground.

Through the use of an ocherish oil- or resin-color imprimatura, that is to say, a thin and meager glaze over the drawing, or a resin ethereal varnish or Venice turpentine over a tempera or glue imprimatura laid over a solid gesso ground, heightening with tempera white was possible without the danger of subsequent unfavorable developments. It became very hard, and, even if used with much water, it did not dissolve the ground.

On the imprimatura the use of white in many carefully differentiated degrees of thickness for light, shade, and middle tones resulted in a certain plastic development of form. A fundamental principle of this technique is that white must be used, no matter how thinly, over every part of the imprimatura. Otherwise, if a new resin-varnish glaze is put over that part of the imprimatura which has received no tempera white, the upper coat of varnish will tear off the lower.

I hold to the opinion that the so-called discovery of Van Eyck amounted to a rational use of his materials, to a logical construction of his pictures on the basis of a gradually acquired knowledge of these materials.

It must be clear that the enamel-like fusion of the overpainting in a picture, the clarity of the depths, the softness of the model-

ing, and the saturation of the colors could have been achieved only through the means offered by oil painting, and not with some kind of tempera, no matter how rich in oil. To attempt to obtain these effects with tempera would be only a waste of time, as anybody knows who has ever tried it.

This whole technique was designed to meet the demands of the time for a more versatile material. Which material allows of the most precise brush stroke and provides a solid foundation which dries immediately, can be painted over at once, and at the same time possesses a certain leanness? Surely tempera in these respects vastly surpasses oil; and these are all advantages which count in underpainting.

On the other hand, which material produces the greatest luminosity in the shadows and permits of ready fusion, a precise setting down of colors, and a quick and easy recovery of mixed tones? Undoubtedly oil color, especially when oil is used in combination with resin varnishes or balsams and sun-thickened oil. The earlier dark and thick oil varnishes could not meet these requirements, and it is well known that Van Eyck was dissatisfied with the tempera varnish, which he called a brown sauce. On the other hand, light varnishes, such as the "white varnish of Bruges," were already known at the time of the Van Eycks, and one has a right to suppose that this varnish was either a mastic turpentine varnish or a balsam like Venice turpentine. Probably Van Eyck's invention was not made overnight, but was a gradual development. In the beginning he also very likely used dark varnishes and thick, boiled oils. At any rate, the early paintings of Van Eyck are known to have darkened and yellowed more than his later ones and those of his followers.

Cennini already remarked that sun-thickened oil which had a varnish-like character was superior to all other oils, and I think that it was very probably used with resins and balsams as a glaze over a tempera base. This glazing process must have been especially sympathetic to Van Eyck, because he was originally a glass painter. It is also reported that the medium he employed had a pungent odor, which points to turpentine ethereal varnishes, and not to egg media or oil varnishes. Glazes of this type produced

very clear and beautiful colors, great translucence of the shadows, and a pleasing softness.

Glazes alone, however, were not the exclusive means; heightening with white and strengthening of the drawing were further employed.

It was as simple as it was effective to use tempera white over these lean resin-color glazes and in that way create a new basis for further glazes, which were used to improve form and color. To represent form as exactly as possible was the aim of this art, as of the old masters in general. The finest details, such as single hairs and bits of jewelry, were easily rendered in this mixed technique, and with black or any other color as well as white one could in tempera achieve the utmost in draughtsmanlike precision without the danger of these effects undergoing change when varnished.

The work could be put aside and taken up again at any time—it possessed gloss without being varnished, which the painters who used tempera exclusively and the illuminators were quick to notice, and as Vasari specifically states.

A high degree of luminosity was achieved by means of the pure white and solid ground, the heightening with white over the transparent, warm imprimatura, and the clear varnish glazes to a degree never before known in a technically very simple manner simply by a rational use of the distinctive qualities of the separate techniques.

The color, upon drying, at once becomes insoluble in water, while tempera painted into varnish becomes as hard as stone. All these are the traditional characteristics of the Van Eyck technique. If this technique had been based exclusively on the use of oil color, it would be difficult to understand why it should have created such a sensation and why it was regarded as an innovation, because oil painting and the use of resins boiled in oil had been known for centuries, and glazes since the time of Apelles. If these new paintings had not been executed in the manner described, they would not have survived in such a splendid state and in such clarity of color, but would at least have turned very brown.

To prove beyond the peradventure of a doubt which is the

one and only Van Eyck technique will probably never be possible, although there are on the market today several so-called "only genuine" Van Eyck colors, and several Van Eyck techniques are advertised. If one stops to consider for a moment, to take a modern case for comparison, what a confused picture one gets of Böcklin's [1827-1901] technique from the writings about him by Flörke, Schick, Berger, and others, one is bound to become very skeptical regarding the value of recorded recipes. Each person simply writes from his own point of view, and it is always open to question how well such a person understands the craftsmanship involved.

To the painter of today all these technical matters are a source of great difficulty, particularly when he lacks every sort of early technical discipline. One reason, and a very important one, is that with homemade tempera and oil color, such as Van Eyck used, the combined technique becomes child's play, while our tube colors of today frequently contain additions which make difficult a successful combining of oil and tempera.

What should here above all interest a practical painter is the discovery of a material which without much trouble and without special tricks will enable him to paint pictures equal in merit to those of the old masters. All historical effusions on art and all recipes contained in old manuscripts, as compared with this, must take second place. That it is possible to create paintings in the manner and of the quality of the Flemish masters has been demonstrated by numerous experimental studies and original paintings by artists, paintings which, moreover, despite the most careful attention to detail, possess the greatest possible luminosity and clarity of color and will in all probability retain these qualities.

The technical procedure in its logical development would probably be somewhat as follows:

1. The preparing of a solid white gesso ground.
2. The transfer of the drawing by pouncing and a drawing of the contours with India ink or tempera black.
3. The imprimatura made with an oil color containing a little red or yellow ocher in ethereal varnish. All superfluous glaze would be removed with a rag. The imprimatura should be lean and barely show a gloss. It should have a texture like toned

paper, and the outlined drawing underneath should remain visible through it.

4. Either into the wet or on the dry imprimatura heightening with tempera white, beginning in the high lights of the flesh, at first by means of hatchings, but more broadly in the draperies. This process is best divided into several successive layers.

5. When this heightening with white has been sufficiently carried out, a resin-oil-color glaze thinned with varnish or balsam or sun-thickened oil is applied. This must be very lean and very finely distributed.

6. If certain forms should still be deficient in plastic expression, tempera white may again be employed to correct this.

7. Another glaze as under 5, into which resin-oil color may be painted semi-opaquely. The glazes may now also be strengthened in the shadows wherever necessary; in this way intermediate values are created in a very simple manner.

The parts heightened with white must, of course, always be lighter at the beginning than the ultimately contemplated values, otherwise the superimposed glaze will not be clear and luminous. Glazes are best worked with the ball of the hand or with the fingers, as was customary with the old masters. Each oil-color glaze must also be put on in a very thin film; heavy color here would be the death of the luminosity of the picture.

The paintings of the Van Eyck period were all highly colored. A red, a blue, or a green was used pure, and after drying was modified by means of glazes. Very frequently colors were given variety by the fact that the tempera white used in the underpainting was itself varied by additions of a little Naples yellow, gray, or green, etc. When a glaze of a certain red, for instance, was laid over this differentiated white, it itself showed interesting variations. All one need do to be convinced of this is to experiment and see how on slightly differentiated tones of the underpainting one and the same red-colored glaze results in many different color nuances; they may be cold or warm, violet-red or a fiery yellow-red. Direct mixtures of cold and warm colors were avoided. In general, colors were laid one over the other in layers and were not mixed with one another. In this way simple

and always easily recoverable effects were produced very different from those obtained with directly mixed colors.

Beginning with the shadows, accents were set in with black and suggestions of the local color, and finally the sharpest high lights and the most precise details were put in as finishing touches in both light and dark.

Soft brushes were used, and any hardness was modified with a large, soft brush of the so-called "blender" type.

At the very last tones as thin as a breath were spread over the glazes, for instance, white over light to modify excessive warmth, and other tones to strengthen dark accents or emphasize the form. All these tones must be extremely thin so that the tones below them are not lost, but merely gain in refinement. In this way physical substance takes on elusive mystery, and harmony and contrast are uniformly established throughout the whole picture. These last technical refinements are naturally of a very delicate nature and are only very rarely seen today on old pictures. [Being very susceptible to injury, they have frequently been lost in the process of restoration.]

In the course of a single century the Van Eyck technique was simplified into a nearly pure, chiefly glazing, alla prima technique. Pieter Breughel still employed heightening with white and permitted this to be active in the overpainting, whereby his color acquired a very loose effect. In Naples there are two tempera paintings by Pieter Breughel the Elder. Hieronymous Bosch painted alla prima at one sitting. The paintings of Jan Scorel, on the other hand, look as if constructed entirely of glazes. The later masters in part used red imprimaturas.

The tempera-oil technique is capable of many modifications and may easily be altered to suit individual requirements.

Obviously it is not a technique for quick studies, but only for systematically constructed pictures; and it is exactly in this manner that it was used by the old masters. It is not for everyone, because it presupposes a thorough disciplinary training.

This technique was introduced into Italy by Justus van Gent and Antonello da Messina, and we may observe its effects there in the increased luminosity of color in the paintings of Giovanni Bellini, Perugino, and other contemporary masters.

Leonardo da Vinci enriched the art of painting through his half-dark, a special kind of illumination which gave to forms a deliberate importance in terms of light and shadow. The effects of the "dead colors" he used for very fine gradations from light to dark (sfumato).

Leonardo was devoted to technical experimentation, particularly in oils, and many of his canvases have suffered because of an excess of oil and the use of arsenate of copper in the shadows. He was always on the alert for new discoveries, and it was inevitable that some of his technical experiments should turn out badly. The meticulous Flemish technique was preserved in many variations until it was replaced by the broad manner of the Venetian school.

In Germany the Flemish technique spread as rapidly and assumed as many variations.

The old German masters, like the Italians and Flemish, maintained shops similar to those of present-day church decorators. Not only pictures of very uneven artistic merit were produced in them, but also of marked differences in technical quality, depending on the quality of the materials used and the efforts bestowed. This, of course, was governed largely by the price paid and the purpose to be served. Much of this work was even carried on by journeymen. All kinds of work were also undertaken, the chromatic embellishment of statues, gilding, and even plain house painting, in short, anything and everything which would give to an apprentice a first-hand knowledge of the materials and teach him their use. Out of this, of course, there grew a knowledge of the materials of which today the average artist no longer has an adequate idea. The earliest German pictures were undoubtedly also carried out in tempera, but soon draperies, etc., were executed in oil.

Oil, according to Cennini, was used by the old Germans already at a very early period on walls and panels. Oil painting on walls, traces of which are to be found in the lower Rhine countries, of course could not last long. The panel pictures were very uneven in quality, sometimes very crude. The color had almost the character of house paint, and they were characterized as "very ordinary pictures." At the same time a shop might turn out

real masterpieces. This was the case in all the shops everywhere, not only in Germany, but also in Italy. Raehlmann discovered through his microscopic examinations that oil occupied a very secondary position among the old Germans; tempera or resin-oil color was the most popular medium. We have today all sorts of pictures of that period, some painted very heavily in the flesh parts over white or light gray dead color on a warm imprimatura, as in the case of the pictures of Michael Wohlgemut, others, the works of later masters, showing the use of glazes.

The influence of the Flemish technique is best exemplified in the works of Dürer. Here we find the carefully prepared white gesso ground,[6] the careful drawing, and a chiefly ocherish imprimatura. Heightening with white is also unmistakably evident in several of his works.

The principal difference of these early schools as compared with the methods of our own time lies in the slight intermixing of the different colors. The white body was the basis, which was colored through the superimposition of many alternating layers, but the colors themselves were not intermixed. Intermixtures of cold and warm or complementary colors, which have a dead effect, were especially avoided. Thus the color was preserved in all its charm and was subject to but slight changes.

Dürer demanded of painting the most painstakingly definite drawing of every detail, and insisted that there should be no compromise with this demand.

In a letter to Jakob Heller dated August 26, 1509, he writes: "I know that you keep your panels very clean and fresh, so that they will stay that way for 500 years, because your panels are not made in the usual way"; and farther on in the same letter: "I can turn out a prodigious quantity of ordinary pictures in one year, so many, in fact, that no one would believe it possible that they could be the work of one man." What were these "ordinary" pictures like? Perhaps a drawing in outline tinted with oil color? We see that Dürer himself made very strict distinctions, and it is

[6] Dürer writes from Italy of a white panel which he hopes to finish scraping within eight days. The following year, 1507, he reports that he had turned a panel over to a specialist for grounding and toning (imprimatura). From: Guhl, *Künstlerbriefe der Renaissance.*

not thinkable that his finest work was merely oil painting. In this connection it is also very significant that later copies of Dürer's works which were undoubtedly painted in oil have turned very yellow and are not to be compared to the originals.

There are many who believe that Dürer merely glazed over a clean ground, and that the fine execution of his works resulted largely from the fact that he ground his own colors. All kinds of works are credited to Dürer, when, like all masters of his time, he employed others in his shop. Once he wrote to Jakob Heller that he had composed the wings of an altarpiece and that, while he had had these underpainted by someone else, he intended to apply himself personally to the middle panel.

It is undeniable that the fact that he personally ground his own colors and purified his own oils contributed largely to Dürer's excellent technique. The liquid quality of the nut oil in which the colors were ground and the precise brush stroke which it permitted were especially of the greatest importance.

I am convinced that a repeated under- and overpainting, such as Dürer describes (page 341), if carried out in liquid oils, could lead to nothing but a dark brown gallery tone. With so many superimposed layers of oil the brush stroke would lose that crispness which is a marked characteristic of Dürer's pictures, as well as those of many of the old German masters. It is simply not possible to achieve the fine quality of these brush lines in anything but a water medium. To be convinced of this, one need only study the heavy, opaque lights in the jewelry or the fine lines of the hair, which are executed with a technical ease impossible to achieve with oil color. No matter how skillful one may be, if one attempts the same thing in oil, the result will more often than not be merely a formless spot, and then it will all have to be scraped off and done over. Oil of turpentine and oil of spike are here of no avail; they merely cause the brush stroke to spread and, furthermore, dissolve the underpainting.

There is only one medium which permits the execution of such details in the Dürer manner, and that is tempera diluted with water and painted directly into wet or on dry oil color, or into resin-varnish glazes.

Whatever requires draughtsmanlike details can be accomplished

easily in tempera, and any painter who has ever tried it will admit that this medium at least approximates much more closely in its effects the Dürer originals than does pure oil color. Dürer knew well the danger of yellowing to which oil color was subject. This is brought out in one of his remarks, namely, that only his own varnish would do for his paintings because all others would spoil his panels by causing them to yellow. He knew of a "white varnish," i.e., a resin ethereal varnish made with essential oils.

We are always thinking too much of oil color as we use it to-day, but we can well afford to presume that so able a technician as Dürer and others knew how to weigh the advantages of one technique against another and how to combine them profitably and skillfully.

One need only look at the old copies of Dürer's apostles at Nüremberg, which are beyond any doubt oil paintings, or at the restored areas in Dürer's pictures to recognize what is oil color and what is not.

From Dürer's own letters we learn with what care this master proceeded, and how he placed the highest importance upon ground and colors. In a letter to Jakob Heller in 1508 he wrote that he had finished underpainting the wings of an altarpiece, which were now being completed. The center panel he had underpainted with two especially good colors, so that he could now set about finishing it. And he goes on to say: "I have it in mind to underpaint some four, five, or six times," and again: "I have painted with great industry." And in 1509 he writes: "I have used the very best colors I could get, especially good ultramarine,[7] . . . and since I had prepared enough, I added two more coats at the end so that it would last longer." With our present-day material such a technique is unthinkable. Most assuredly no one could maintain that a picture constructed of so many under- and over-paintings in the oil color of today would last.

[7] Raehlmann maintains on the basis of his microscopic examinations that Dürer often used a copper blue when he believed he was using genuine ultramarine. This color and the genuine lapis lazuli, exquisite tempera colors, as Raehlmann calls them, were used in the form of a fairly coarse-grained powder in egg tempera by Italians, Flemish, and Germans.

It is different with a technique in the manner of the Van Eycks, which Dürer adapted to his own purposes. Here all colors were glazed over a carefully graded white. Incidentally, the sharp water-tempera brush line is easily recognizable on Dürer's pictures, especially on the "Baumgartner altar." He writes further: "After a year or two or three I intend to varnish them with a new varnish which is not known to others, so that a hundred years will be added to their life. I will not allow anybody else to varnish them, because all other varnishes are yellow, and they would spoil my panels." This proves that he knew of something different from the customary oil varnishes, that is to say, boiled-down oils and resins dissolved in hot oils. He probably knew of a resin ethereal varnish or balsam, such as was also known to the Flemish painters.

Dürer is said to have used nut oil which he filtered through screened coal. It is true that nut oil permits of a very fine and precise technique. In some pictures of Dürer's where parts of the color have come off, the white ground is visible. A warm, ocherish imprimatura is very easily recognized, also the drawing with black water color, and one can distinguish a special treatment of the draperies intended to produce optical grays. The red cloak of the apostle John is underpainted with yellow and white to create a fiery red, while green is similarly underpainted with a yellowish white to make it luminous. The fine, opaque brush lines representing hair, jewelry, etc., were not painted on the white ground, but on the underpainting. Parts of the head of the apostle Paul which are rubbed off very plainly show the heightening with white over a transparent local color. The brush stroke is sharp and precise, and the white shows no yellowing.

Dürer sent a portrait of himself to Raphael which was painted on very fine cambric and was equally visible from both sides. The lights were transparent without opaque white; in fact, it was painted and modeled entirely with water colors (according to Vasari).

The Isenheim altar by *Mathias Grünewald* very plainly shows the use of resin glazes, but at the same time the substantial character of tempera white in the light areas combined with the finest fused effects. Oil color here would have long since been lost

through saponification. Pictures by *Hans Baldung* reveal the same technical construction based upon heightening with white as do so many pictures of other contemporary masters. Van Mander writes that Holbein built up his pictures very differently. When he wanted to paint a beard or hair, he first painted the total effect in correct light and shadows, and then put in the details liquidly and perfectly, whereas the others built up their pictures by beginning with a drawing, followed by successive and alternating glazes over forms developed plastically with white. On a picture by Holbein, Raehlmann discovered with the microscope unmistakable evidences of an emulsion. He maintains that tempera can be proved to have been used in oil painting as late as the 18th century. Later on the solid white grounds and the subtle manner of execution were lost. We soon find practically nothing but strongly browned and darkened pictures, which plainly show the typical characteristics of pictures painted exclusively in oil.

THE TECHNIQUE OF TITIAN AND OF THE VENETIAN SCHOOL (Resin-oil Color over Tempera)

The technique of the Flemish painters, which at first had also found enthusiastic followers in Italy, was later abandoned there, ostensibly because of the many difficulties it presented. Armenini (in 1587) speaks of the "painfully dry and harsh" work. He says that oil painting is now being practiced. Here is an indirect proof that the Van Eyck technique could not have been merely oil painting.

Furthermore, very different problems awaited the artists in the rapidly rising city of Venice. The power and wealth of Venice had to be glorified in grandiose canvases of tremendous size. These new problems inevitably called for entirely new technical means of expression. The Flemish technique created for a loving and intimate concentration upon form and color was not suited to work on a grand scale.

But here the old was by no means ignored; it was merely logically developed and adapted to the new aims, and the experience of centuries was not thrown to the winds. In place of highly perfected and diversified local colors which were to be viewed

closely in connection with details, the picture was now conceived as one harmonious whole aiming at striking pictorial and decorative effects, masses of light and shadow independent of objects being projected over the entire canvas. In place of the glaringly white grounds on wood panels, dark grounds were preferred, gray or red to deep black-red tones spread upon canvas with resin-oil color, presumably on a gypsum ground (bole grounds). Bassano and Veronese at least are reported to have complained that gypsum grounds had come off when they were applied too thickly. The canvas for such large formats as Veronese used had to be especially strong. Coarse hemp canvas was used, but one must remember that the loss in volume of the paint coat and also of the ground is the reason why the texture of these canvases is so conspicuous today.

On these dark grounds heightening with white was practiced to a very considerable extent. Gradations were made with admixtures of gray or green earth. The egg tempera of the Van Eyck technique would not have been suited to these impasto underpaintings, especially on such relatively unstable supports as canvas. Stronger binding media had to be found. In what direction this was accomplished is shown in a manuscript in the Marciana Library [16th century]. One part thickly ground oil color was mixed with equal parts of tempera color. This tempera color was ground stiffly in equal parts of water and egg yolk. Such a white becomes extraordinarily hard, and it is possible to use it very opaquely; used as a scumble, however, it yields soft, veil-like tones, besides drying very quickly. Once dry, it is practically insoluble. It may be laid into a wet varnish or a glaze, which is especially important in a technique which is based upon glazing. One gets an immediate picture of this technique in its underpainting phase when one thinks of a plastic modeling of form on a black slate with white chalk. First the outlines are drawn, the light masses are then brought out with the chalk, and the dark ground tone of the slate is everywhere drawn upon to render the shadows. Half tones are created by fusing with a fingertip the edges of the light areas with the background. The whole scheme of the underpainting was built upon three values, lights, middle tones, and shadows, the lights being heavily loaded and the middle

tones derived from the ground. If the half tones were covered over too much later on, the richness and the loose effect of the optical grays would be lost, and the picture would appear harsh and gaudy. In this, as in the Van Eyck technique, heightening with white may be repeatedly alternated with glazes.

Glazes are, of course, profitable and effective only on a very light ground, because all glazes darken. In the further development of the picture, therefore, the shadows were lightly gone over with thin white or gray, or white with a little green, whereby very broad and pictorially effective glazes were made possible.

Vasari relates of Titian that his pictures at the beginning of his career, while he was still employing the old Flemish technique, were painted with unbelievable industry and attention to detail, and that they were effective both from a distance and close by. Later on his colors were put on broadly, and the picture looked complete only from a distance; but the figures appeared as if alive. His later manner of painting, in which he suppressed all details and aimed at a broad, pictorial effect, was probably due to defective eyesight (farsightedness) in his old age.

It is characteristic that he would not resort to a detailed drawing or underpainting, because it disturbed his imagination and thus interfered with his painting. He constructed his pictures for purely pictorial effect out of contrasts of light and shadow, and he used very few colors, like all great colorists. One anecdote relates of him that he used brushes as large as brooms, and when the visiting Spanish ambassador asked for an explanation, he is said to have replied that he did this in order to paint differently from Raphael and Michelangelo, because he did not wish to be an imitator. And so in the course of a very long life he developed a free and personal means of expression. It is certain that the severe technical discipline of his early youth stood him in good stead. According to Vasari, in his young days Titian also painted a good deal in fresco.

"*Svelature, trenta o quaranta!*" (glazes, thirty or forty!) is a traditional exclamation of Titian's. But this should not be understood to mean that he constantly put new glazes over the entire picture. The light body of the underpainting, perhaps a yellow-

white as a basis for a fiery red or a green-white for a cooler red, was glazed with a strong color. These glazes were, where necessary, partly wiped off or blended with all sorts of colors in adjacent areas. Analogously colored reflections, often of breath-like thinness, or new scumbles with white to take from color its coarse, material effect, were resorted to, and in this way he created that suggestion of mystery which constantly engages the eye anew and never tires it.

Another saying of Titian's, "Make your color dirty!" is only to be correctly understood if one compares the exactions of the preceding Van Eyck technique with the new aims of Titian. There the pure, clear, beautiful quality of each color—Van Eyck had not been a glass painter for nothing—here the subordination of color to a large, mysterious, dominant tone. Titian was the inventor of the broken neutral tones which today play such a decisive rôle in painting.

It was the breaking of these clear, beautiful, sharp, individual colors with contrasting hues, the dulling of a brilliant red by means of a green, or also by means of other colors, to which the above exclamation refers, and not to the use of "dirty" glazes. Titian was opposed to alla prima painting. It seemed to him unsuited to an exhaustive representation of human values. Often he allowed his pictures to stand untouched for months, and then promptly, under a fresh impulse, sacrificed without hesitation all that seemed to him superfluous to the main idea of the picture. Although a picture was completed, he would continue to add many refining touches. Out of the broadly and boldly constructed framework of the picture heightened with white he would modify a light here and there with his thumb or deepen a shadow or perhaps strengthen a color, always, however, keeping in mind the large, total effect of the picture. Sometimes, as his pupil Palma Giovine reports, he used his fingers entirely to the exclusion of brushes. All this is best exemplified in the picture "The Scourging of Christ" in the Pinakothek at Munich. The same solid body in the underpainting may be seen in the portrait of Pope Paul III at Naples, which appears to have been very simply finished in resin-oil color over a very practical tempera base. Its fine, substantial quality, which plays up the glazes so suc-

cessfully, was seldom obtained by his imitators. One becomes conscious of this when one compares Lenbach's copy of the so-called "Sacred and Profane Love" with the original.

Pictures which have so much inner light of their own are effective anywhere, in light or in semi-darkness. Titian's followers neglected to their own disadvantage the possibilities of heightening with white on a dark ground.

Without doubt resin-oil colors, mastic, sun-thickened oil, linseed oil, or the nut oil much used at that time and balsams like Venice turpentine were all employed in glazing. Brown and reddish imprimaturas are found in the earlier works, as, for instance, in the "Madonna with the Cherries" at Vienna. When this picture was remounted, it was discovered that Titian had altered the original design. It is superfluous to point out that a great and free spirit like Titian's was equally free and bold in matters of technique, and during the long course of his career he adapted these to his purpose, without, however, sacrificing basic principles.

In the pictures of his disciples Titian's technique is more clearly demonstrated than in the works of the master himself. For example, El Greco's pictures give us much valuable information in regard to Titian's technique.

For purposes of illustration, the probable development of El Greco's picture "The Disrobing of Christ" in the old Pinakothek at Munich is here described. This picture has already several times been very successfully reconstructed according to this technical procedure.

A very luminous brown imprimatura is recognizable in several places in the picture. It is possible to reproduce this luminous ground only with a glaze laid over a white ground. It may be applied as an oil color thinned with mastic, or in varnished tempera. The drawing may be made directly on the white ground with black tempera color, or with white chalk on the brown imprimatura. A mixed white made of yolk of egg and white lead with equal parts of white lead in oil proved to be the medium best suited to express the solidity of the colors of the original. Beginning with the sharpest high lights, the white, which was prepared fresh for each working period, was spread out, largely in a scumbling manner, in semi-opaque layers into all the light areas. No

painting medium was used for intervals and shadows. In this way the total effect was constructed of optical grays, which everywhere allowed the imprimatura tone to assert itself. This process was repeated, the light masses being strengthened in the direction of more light and greater impasto, while the shadows also were not overlooked, in order to maintain a balance between light and dark. The drawing was also carefully preserved. It is well in this process to add a little yellow ocher to the white so that the effect is not too cold.

The large relationship of the masses must be clearly maintained, and the picture in its totality must be much lighter than the original. It would be artistically very ineffective to heighten only the light with white, because the shadows in the final picture would then appear only as dead, colorless, dark areas.

After the picture has been given a light intermediate varnish, the local colors are set in with large brushes to play against one another, and the contours are easily and deftly drawn into them.

The red of the mantle of Christ is strongly painted with madder lake in mastic or dammar varnish and refined with loosely applied reflections. All the colors are set down similarly, but in every instance lighter than in the original. Once they are as dark as those in the original, they must be regarded as finished. If a form or the degree of light somewhere in the picture is deficient in expression, the mixed white is again resorted to.

Next the shadows are uniformly deepened, drawing and modeling constantly improved, softness and harshness balanced against each other, and all the elements of expression continually reexamined.

The picture is then allowed to dry thoroughly. Now over the picture, which is still too light and in parts too glaring, is put the final glaze, a blue-green tone which gives to the picture the effect of a nocturnal scene. Perhaps El Greco used a copper color for this; we achieve the same effect with oxide of chromium brilliant and cobalt blue, using a fairly large brush. By means of a rag glazes may be variously modified. The glaze takes from those parts which are too light or too harsh the effect of being isolated and draws them harmoniously into the greater unity of the whole. It also takes from colors their material quality and lends them

mystery. But into this glaze the final alla prima painting is laid as effectively as possible, strong accents in the lights and shadows which give the picture finality and conviction.

Sometimes transition tones are created with the fingers, in the manner ascribed to Titian. None of these transition tones in the flesh or the draperies is made directly; they are rather the result of an optical effect produced by allowing the undertone to function through the overpainting. Only in this way is it possible to achieve the airiness and lightness of the colors of the original. All painted grays look heavy alongside of optical grays.

From the standpoint of craftsmanship, it is very important that the technique be managed with three clearly divided tone values, one for the high lights, another for the middle tones, and a third for the shadows. It is a basic condition of this technique that no color layer be dissolved by a successive layer, as may occur in painting with oil over oil, otherwise the luminosity of the picture will be destroyed. Tempera white over a resin-varnish imprimatura and resin-oil-color overpainting fulfill these requirements.

Goethe, in his final chapter of the "Italian Journeys," states that those pictures which had been painted with transparent glazes on a dark ground laid over a white priming became in time rather lighter than darker.

Tintoretto's pictures, Goethe remarks further, had already darkened considerably. The reason, he observed, was that Tintoretto without any preliminary underpainting painted directly alla prima on a red ground and set the final color directly on the canvas. When the color darkened, there was no light from within to balance this defect. Goethe adds that a red ground was particularly harmful when only lightly painted over, when often only the high lights survived.

Goethe's judgment here was, indeed, technically sound. When a paint core plastically developed by heightening with white is lacking, an alla prima technique on a dark ground is illogical. Such pictures have a drowned look; they have sunk away because there is nothing to support them, as is amply illustrated by the many Titian imitations and copies of later times, the painters of which aimed straight at the final effect without benefit of the luminous white core underneath.

In alla prima painting on red bole grounds, which were used to expedite work (fa presto!), the shadows were gone over thinly, and the lights were in a heavily loaded impasto.

The pictures of *Luca Giordano*, the "fa presto" master, plainly show a strong use of white in the light areas over the dark bole ground, while the shadows were only very thinly gone over with it. Saponification of the white caused by oils (lead saponification) often completely destroyed these thin, veil-like underpaintings in the transition and shadow tones. Originally, no doubt, they were quite effective, but the dark bole ground has "grown through," and is mistakenly averred by those who confuse the cause with the effect of this change.

The evil was made worse by the manner of going over the red values of the shadows with some complementary green like verdigris, which in itself would probably have turned black, but now also completely canceled the chromatic effect of the color underneath.

There are also, however, alla prima paintings on bole ground in which the principle of the light, solid, preliminary underpainting with its charming gradations was effectively employed. This is particularly true of the light red grounds which transformed the light grays put over them into the sparkling mother-of-pearl tones so effective in the flesh tints, and which also contributed to a plastic effect. This is in keeping with the facts of nature, where the skin in thicker and thinner layers reveals the blood underneath in varying degrees of intensity. In the picture transitions and shadows had similarly to allow the red ground to shine through in differing degrees; otherwise the color would appear too heavy.

Gradually, however, the painter's craft lost in esteem and was relegated to a position of inferiority. It was argued that the artist was a gentleman who need not concern himself with the menial tasks of his high profession, that art was a noble lady who had nothing in common with her stepsisters, the crafts. Volpato actually wrote in this vein, and his words have been copied and his sentiments repeated from his day to the present.

The good painting grounds of the old masters were forgotten, paintings were executed on canvas covered only with a glue size,

and sometimes even with fatty oils on canvas without any sizing or priming whatever. The consequences were inevitable.

Veronese's pictures on canvas had sometimes suffered, according to Volpato, because the gypsum ground was too heavy; where the ground was thin, he said, the pictures had lasted well.

Goethe reports that he had seen very large pictures by Tintoretto and Veronese into which portraits had been pasted.

Marco Boschini reports that Veronese covered his entire canvas with a green middle tone (gray-green?) and developed his picture out of this; also that he used blue colors "a guazzo" (in glue or tempera) in oil paintings, a precaution which also Van Dyck employed to counteract the yellowing of oil colors.

El Greco transplanted the Venetian technique to Spain, where already Italian recipes of Cennini, Alberti, and others had laid the foundations for painting.

Pacheco and *Palomino* have described Spanish painting techniques. Pacheco describes gypsum grounds on panels after the manner of Cennini; they were primed, however, with oil paint, and his recipes for flour paste for canvas are by no means unobjectionable. He also tells of a half-chalk ground of glue, linseed · oil, and pipe clay, which also was painted over with white lead in oil. Glue painting is supposed to have been practiced in Seville as a kind of preparatory training for oil painting. Palomino writes of the sizing of a canvas as a sufficient ground "when you are in a hurry," and of the use of verdigris with varnishes and also with black. This use of verdigris was the main cause of the darkening particularly of the shadows in Spanish pictures. In general the Spanish recipes followed closely the Italian.

Velasquez developed in a free manner a technique suited to his alla prima method. He employed brown and red, also gray grounds, and retained the gray underpainting also in his alla prima technique. His finest picture from a technical standpoint is his papal portrait [Innocent X] in the Doria Gallery in Rome, on which with heavy liquid resin glazes, probably over a light gray tempera base, he painted with opaque colors alla prima and thus obtained the highest degree of pictorial effectiveness.

In *Goya's* pictures the evidences of good craftsmanship are also seen to advantage. Most of his pictures are presumably painted on

light, yellow-red bole grounds laid over pure white primings. On these he worked freely with white, achieving a peculiar charm of mother-of-pearl tones by the subsequent use of superimposed varnish glazes. Individual colors were never forced beyond the general tone of the picture. His sketches are sometimes merely in grisaille [gray in gray] over white grounds and lightly glazed with varnish colors.

Tiepolo was the last of the great Venetians. His oil pictures possess the characteristics of fresco, which he well understood. Contours play an important part in his pictures, contrary to the general practice of this school. His colorful grays were finely differentiated on the red or gray undertone, and his textural effects possessed an extraordinary charm of color.

Next comes a period of tedious correctness and schematic concepts, good craftsmanship is progressively neglected, and finally the good tradition is entirely lost.

THE TECHNIQUE OF RUBENS AND OF THE DUTCH PAINTERS (Resin-oil-color Painting)

It is from the manuscript of their friend De Mayerne, the physician, that we gain much valuable information concerning the technique of *Rubens* and *Van Dyck;* but there are also in this manuscript many additions obviously made by other hands which must therefore be accepted with caution.

The red bole grounds had become very common at the time of Rubens and were employed generally as the basis for alla prima painting, without any appreciation of the value of a strong underlayer of white. Rubens, on the other hand, went back to the thick white gypsum grounds and apparently even to the structural technique of the Van Eyck period, which he modified to suit his own purposes.

Wood he pronounced the best support for smaller paintings. The thick and glaringly white gypsum ground he covered with a silvery gray, slightly streaky, neutral tone, obviously a mixture of powdered charcoal, some white lead, and a tempera or glue medium (at least the same results may be obtained in this manner).

This primary coating must be applied quickly; one should go over the surface only once with a broad brush or a sponge, and, if possible, avoid going back over it, otherwise the coating will be uniform and uninteresting. The light streaks in it enliven the ground and give looseness to superimposed form. They may be studied to excellent advantage in the sketches for the Medici cycle in the Pinakothek at Munich. In complete misunderstanding of Rubens' artistic intent, it has been remarked that this undertone is so carelessly and rapidly applied that one can see the brush strokes.

That the ground must have been non-absorbent is evidenced by the fact that in these sketches and paintings it remains uncovered in many places. Had the ground changed upon being varnished, it would have had an altering and disturbing effect on the appearance of the entire painting.

The canvases of Rubens do not show the streaky gray undertone, but were given an even coat of a darker gray, which was very probably a kind of half-chalk ground laid over a chalk ground. This toned ground must likewise have been non-porous, for it is present everywhere as an uncovered transition tone or covered only very thinly.

Regarding the interpretation of the De Mayerne manuscript in so far as it deals with binding media, there is wide variance of opinion.

We are again concerned here only with what is of practical value. We must let the paintings speak for themselves. In other words, by what means is it possible to obtain the same effects which we find in the paintings of Rubens? Only this question concerns us here. With oils used alone as painting and grinding media it is impossible to achieve the characteristic, often very opaque and then again infinitely thin, application of color. In the first place, with oil alone the paintings would inevitably have turned very yellow and brown, and then the finely distributed layers of white would have become bodiless or have disappeared owing to saponification. The paintings, however, are still clear and luminous and have very evidently yellowed but slightly.

There is not a doubt in my mind that color ground thickly with nut oil (or also with linseed oil) was, in the main, used with

Venice turpentine (with or without mastic) and an addition of thickened nut or linseed oil, because only in this way can all the technical characteristics of Rubens' art be obtained without difficulty.

At the same time one must not forget that the colors of the old masters were not ground in the same manner as our modern tube colors, but more fluidly, and for this reason were applied quite differently; and, above all, they were ground fresh every day.

The color of Rubens was probably given the right consistency on the palette by adding painting medium with the spatula, whereby it became more uniform in application than present-day colors, to which painting medium is added by dipping the brush into the palette cup.

Regarding oil of spike, Rubens expressly declares that oil of turpentine is much superior, which is absolutely correct from a technical standpoint, because oil of spike causes the brush stroke to run and, owing to its solvent action on lower layers, has an after-darkening effect. It also remains sticky in contrast with oil of turpentine.

Venice turpentine dissolved in petroleum or oil of turpentine was rejected by Rubens, according to De Mayerne, for use as a final varnish, and justly so, because it has not enough resistance to water and soon becomes brittle. The best painting varnish is made with sun-thickened nut oil or linseed oil (as additions to mastic varnish or Venice turpentine). The meaning of "varnish" in old painting books is even more obscure than it is today.

It is important here to point out to what extent a painting medium may influence the technique of an artist and his manner of expression, how only this and no other possible material can exactly satisfy his requirements.

The principle of Rubens was in the main to apply the light with much body, but to keep the shadows thin and transparent.

"Begin by painting your shadows lightly. Guard against bringing white into them; it is the poison of a picture, except in the lights. Once white has dulled the transparency and golden warmth of your shadows, your color is no longer luminous, but mat and gray.

"The same is not the case with light areas; there one can set in

the color as one thinks proper. They have body, still one must keep them pure. Good results are obtained if one sets down each tone in its place, one next to the other, lightly mixing them with the brush while taking pains not to 'torment' them.

"Then one can go back over the surface thus prepared and put in those accents which are always the earmarks of great masters" (after Descamps). "Paint your high lights white, place next to them yellow, then red, and use darker red to carry them over into the shadows. Then fill the brush with cold gray and go tenderly over the whole until it is subdued and softened to the desired tone. Since flesh is of a soft nature, we find pearly reflexes playing on its surface, and for the most part they are visible where the colors are tenderest" (Burnet after Rubens [?]). These utterances attributed to Rubens are unsubstantiated, and therefore to be accepted only in a general way.

A record, however, has been preserved of a conversation with Van Dyck in which Rubens remarks that at least the last layer of the shadows must be transparent, and also of Rubens' advice to Teniers, whose paintings had lost their earlier warmth owing to thick painting (also in the shadows): he was told he should paint the lights heavily, but keep the shadows thin, otherwise the undertone would have no purpose, that is to say, it would not aid in the final effect. This refers to the optical grays which were developed when the half tones of the underpainting were only lightly covered and showed through. They give to a painting the lightness characteristic of the works of a master, and, for lack of them, the paintings of the schools look hard by contrast.

Rubens' painting media were very thick in contrast with those of Van Dyck. It therefore becomes clear why, as De Mayerne informs us, Rubens often dipped his brush into oil of turpentine while painting—but not in order to paint with it!

His media were so rich that his paintings did not require varnishing for a long period of time, and it is certain that therein is to be found the principal reason for the remarkable preservation of his paintings. He also gave the advice not to paint on places which had sunk in without first bringing them out. Cf. page 186. His rivals among his contemporaries decried his technique, which departed so radically from the traditions of the

times and obtained such startling effects, as being unsound, and prophesied that the paintings would perish with their master. If any technique, however, has given convincing proof of its correctness by its splendid preservation, it is the technique of Rubens.

His method of working was perhaps as follows:

On the white, non-porous gesso ground laid over a wood panel and covered with a faintly streaky, light gray coating the drawing was set in loosely with ocher tones, the ground tone being only wiped on lightly, beginning with the shadows. The transition tones, which were intended to give a cool, mother-of-pearl effect in the finished painting, were set in lightly with pure gray, a mixture of black and white with perhaps even a trace of ultramarine or Veronese green earth, but in such a way that the uneven gray undertone was not lost or deprived of its character.

This underpainting, which is uncommonly thin, is very probably made with a tempera or glue color and takes the place of the old imprimatura. It shows the same free, loose character as the ground, and not the more evenly covering quality of oil color. The contours are set in only lightly and vaguely, without anticipating too much the further development of the picture.

Over this comes a thin coating of ethereal varnish or balsam, in which the form is fluidly built up. In this coat the colors seem to float softly, yet definitely. The resinous and balsam-like painting media, such as Venice turpentine combined with thickened oil, give to the color its peculiarly soft, hazy quality, which is not a result of blending the color with the brush, as E. Berger suggests.

The shadows and the drawing are now strengthened with full ocher tones. Over the light areas are laid light, half-covering tones, such as white and red or white and yellow, which are spread in the thinnest possible layer even over the shadows, but have a cool and grayer effect on top of the warm ocher tones. These half-covering tones give a flat effect and have a smoother and more enamel-like surface quality than the underlying layer of tempera. As long as strong and opaque colors are withheld, especially red in the flesh, one still retains the possibility of improving the form and can easily hold the picture together in

color and continue to develop it further. The lights were now strengthened, and by means of very thin but at the same time opaque overtones the gray of the transition tones was given a mother-of-pearl iridescence which misguided copyists have vainly tried to reproduce with blue, oxide of chromium, and violet. It is almost incredible what charm of color is developed through such thin layers of mixed white and ocher, white and red, etc., over a clear, not too dark or sooty gray.

Such extremely thin layers of color cannot be obtained by the use of oil of turpentine. They would in that case "drown" in the underlayers; they would not stand up, and their enamel-like effect would be lost. It is precisely a thickly fluid painting medium like Venice turpentine with thickened oil which permits of the finest distribution and at the same time enables the colors to stand up.

The ground tone was preserved everywhere and drawn upon for the final effect; this gives to Rubens' originals the harmony which is lacking in the products of the schools, in which, through too strong a covering of the half tones and shadows and over-modeling, hard and gaudy effects are often produced.

In the further course of the work the light was covered with a heavily loaded impasto, as is evident in such authentic works as the "Massacre of the Innocents" in the Pinakothek at Munich.

The mixing of the colors was always unusually simple. Cold color tones lie in layers over warm color tones, even in painting done at one sitting, and so a muddying of tones is avoided. The "alla prima painting" of Rubens and other masters must not be confused with the alla prima painting of today. The color tone was developed from the simplest tones, such as white mixed with red, light ocher, and Naples yellow with white, which were laid one over the other and never mixed together as is done today. Clean brushes for each color were an important requirement. All definiteness in the drawing of details and all strong color came last, when the form, modeled in thin color, appeared well established. Thus the principle of heightening with white is here modified in a clever manner and made to serve the particular aims of plastic pictorial expression. Starting from a general under-

tone, Rubens worked toward light, and also strengthened in the opposite direction toward transparent shadows.

The strong color tones of the accessories, such as the red of a drapery, are glazed over modeled gray tones made of a mixture of black and white with green earth and some of the local color. In this manner the color remained clear and attained its highest luminosity at the end.

The greater or less sparkle of this red or of an atmospheric blue, in short, of these determinant, colorful tones, naturally influenced the whole harmony and appearance of the painting. The flesh was harmonized with them, made grayer or more fiery, softer or harder, as might be required for the total effect. At the conclusion of the work the most brilliant color effects were obtained in all freshness by means of shortened alla prima painting on a systematically prepared underpainting. Finally came the strengthening of the shadows and the before-mentioned accents in light and dark. In the shadows tones occur which correspond in appearance to a mixture of Cassel brown and gold ocher. The reflections, in order to have a luminous and plastic effect in the warm, transparent shadow masses, had to be applied with fiery red. H. Ludwig, incidentally, believed, as he told me, that they were not vermilion, but strongly calcined (burnt) sienna. One finds in copying that one can manage without vermilion, and that the effect of vermilion can be obtained by contrast. At the last came still additional glazes over certain parts of the painting, for example, over the blue of the air, or extremely thin white and ocher glazes over the flesh parts.

The paintings on canvas exhibit a cooler general tone as compared with the paintings on wood panels. The darker gray ground is made use of by being very thinly covered in the shadows and half tones, while the light is repeatedly and more opaquely covered. In this way the optical grays were developed, which are found on all the canvas paintings of Rubens. Intervals are often scarcely covered, and the tone frequently appears greenish, an effect which is probably due to yellowed varnishes.

The light gray, non-absorbent ground represents here a logical development and an ingenious simplification of the principle of obtaining grays through heightening with white over a dark

ground. His pupils were often called upon to develop the white impasto in the light and the sketchy blocking in with warm colors of the shadow masses, while the master himself frequently painted directly alla prima on the gray ground. The gray preliminary painting is recognizable in many of his works, notably in the portraits. The "alla prima painting" of the old masters, however, in most cases has as a basis a lightly sketched in drawing heightened with white. Only the last skin is alla prima. Especially profitable is the study of the backgrounds of the Rubens originals in contrast with the paintings of his school. In the first, since all detail is worked out of a general, subdued harmony and is merely strengthened, the figures do not appear to be sharply cut out of the background, as in so many of the inferior school paintings. In the wonderful little figure of Cupid in the painting "Meleager and Atalanta" in the Pinakothek at Munich one can admire the use of optical grays in the transition tones and observe how this figure, developed only through thin, semi-opaque layers of white and ocher and white and red over light gray, rises from the background, so to speak, as out of a mist, and how through the outline put in last in a liquid manner it is made to stand out from the background, in places almost identical in color with the transition tones, and yet form with it a harmony in its relationship to the whole.

Briefly and schematically, the method of Rubens may be described as follows: on a gray, cool ground a warm, ocherish tone lightly applied, over this light gray or colorful restrained modeling in certain areas, then warmer shadows and general strengthening of color and contours through emphasizing of details, in short, cold and warm following each other.

There exist copies made by Rubens of paintings by other masters, such as Titian or Velasquez, but they are all freely conceived and executed in Rubens' peculiar manner.

In his landscapes, such as the one with the rainbow in the Pinakothek at Munich, one may again observe the light, ocherish tones over the silvery gray ground, with which the whole was easily brought to a perfect glowing, warm effect. This was toned down by a transparent gray overlay, in which the opaque lights seem to float, but in such a way that the many subsequent thin

layers of warm and cold do not kill one another, but all work together. In the "Drunken Silenus" the effect was also built up out of the warmest ocher tones, the gray or gray-green being set only into the transition tones of the underpainting, while over the warm, ocherish white underpainting of the light were set the resultant grayish mixtures of red and white, the semiopaque, liquid, fused tones which carry the light, mixed of white and Naples yellow. If a cold gray, as in the transition tones, had been used anywhere (under) in the light, it would have a discordant effect, so logically and clearly is the whole built up. Warm and cold follow in strict alternation: warm shadows, cold transitions, warm light, and cold reflexes imbedded in the light masses.

According to Reynolds, the human figures in Rubens' "Battle of the Amazons" are heightened with white in the underpainting. Böcklin held the same opinion, and expressed the belief that the small "Day of Judgment" was not painted by Rubens, but by Teniers, because of the heaviness of the shadows.

To avoid the yellowing of his painting "The Allegory of War," Rubens, in a letter to Sustermans, recommended setting it out in the sun. He feared that the flesh tints and light areas might have turned yellow when the painting was shipped in a box.

It is sometimes asserted that Rubens applied yellow-colored final glazes over the shadows. I could never find any evidence of this, but it is not improbable that later-applied oil varnishes through yellowing have given rise to this opinion.

Van Dyck, in contrast with Rubens, preferred very thin oils as painting media.

Nut oil, slightly heated with white lead to increase its drying power, in combination with mastic melted 1:2 in oil of turpentine, was his grinding medium for colors; for grinding white he used nut oil alone (according to De Mayerne).

He preserved all his colors in a dry state and ground them directly with his medium; only white was ground beforehand in water, and, after it had dried, ground again with nut oil and preserved under water. Van Dyck took special precautions to see

that the white lead was thoroughly washed before use (in order to get rid of the sugar of lead).

Venice turpentine, dissolved 1:2 in oil of turpentine while warm and preserved well covered to keep the oil of turpentine from evaporating, was mentioned by Van Dyck as a retouching varnish to be applied warm. All areas covered with it must be painted over, otherwise the varnish will have a displeasing appearance and is liable to become sticky (the warm application permits of a thinner coat). Present-day Venice turpentine varies considerably in its degree of fluidity, being often so thick that it no longer flows. The thinning must be done in such a way that the material is easy to brush on, hence it varies in each case. The application must be very thin and at the most only lukewarm, otherwise the underlying layers may dissolve. (For best results the application should be of normal temperature.)

"Linseed oil is the best," is stated in another place by Van Dyck, "better than nut oil, which is fatter, and better than poppy oil, which easily becomes thick."

All painters, he said, should strive to obtain a colorless, lean oil, since too fat an oil changes all colors.

Blue and green he frequently applied to oil paintings with gum-water (tempera?) in order to avoid the yellowing caused by the use of oils. Applications of onion and garlic juice were believed to make the color adhere better (that is a mistake, they do not improve the adhesion, but merely prevent the trickling of the colors, which are taken better). He discarded the amber varnish of Gentileschi and replied to De Mayerne's question whether this, since it was too thick, could not be thinned with oil of turpentine and thus made useful—no, that was impossible. Oil of turpentine evaporates during the work and hence serves no purpose.

The dictum: "Endeavor as far as possible to complete your picture alla prima, because there is always plenty left to do afterwards," is attributed to Van Dyck as well as to Rubens.

In the beginning Van Dyck employed the light gray, slightly streaky grounds of Rubens, but later he used solid gray grounds, on which, beginning with a brown drawing and making use of the optical grays developed through modeling with white or

with some of the lighter tones of the overpainting, he heightened and completed the painting alla prima. The optical grays are especially apparent on the "Lamentation of Christ" in the Pinakothek at Munich.

There are numerous evidences, however, on the gray ground painted over with brown of a slight heightening with white, gradually decreasing toward the shadows, which insured a certain plasticity of form and was painted over alla prima. He warned against bringing red lead into the ground, because it would crack and spoil the colors. This is obviously in reference to bole grounds. Honey, he said, would make the canvas slack and bloom like saltpeter. His attempts to use fish glue in the ground were unsuccessful. The glue in part flaked off, he said, and in a short time killed the colors. Later Van Dyck came under the influence of Italian art and of Titian in particular. His underpainting becomes opaque, even in the shadows, which were previously transparent down to the ground. The tones become correspondingly duller, less beautiful in color, and, in contrast with the works of Rubens, darker owing to the gallery tone, the browning of the oils, and perhaps also because of the umber underpainting. Van Dyck's influence determined the technique of many painters, particularly those of the English school.

The great masters of the English school, *Reynolds, Gainsborough, Lawrence*, and others, employed white to a considerable extent for purposes of preliminary modeling and in that way obtained the most charming effects. It is a question whether this white underpainting was tempera or, which is also possible, a resin-oil color which was ground shortly before use. (Thus, for example, 2 parts dammar or mastic varnish and 1 part linseed oil.) Such color also dries rapidly and thoroughly. It must contain sufficient pigment so as not to have too much gloss when dry.

Reynolds often before portrait sittings underpainted merely the space for the head heavily with white, in tempera or resin-oil color. It is evident from this that one can vary the principle to suit one's taste.

Daniel Shegers, the flower painter, made use of Strasbourg turpentine (from the white fir) and thickened nut oil as a paint-

ing medium. There is no medium with which it is possible to obtain even approximately the fusion and enamel-like softness of tones which are obtainable with the oleo-resins and thickened oil. In order to facilitate an understanding of this technique, I give here the history of a copy which a young painter executed in the mixed technique after a flower piece by Rachel Ruysch. It was his first piece of work in this manner, but, despite this, so very successful in the right choice of the material and in color character that it excited general admiration. It was no tiresome patchwork, but, despite its perfection of detail, appeared as if cast from a mold.

The following are the notations of the painter in regard to his experiment. Oak panel, covered with thin, fine canvas. Over this a pure gesso ground in eight very thin layers. Then a coating of dark caput mortuum. Over this a second tone of ocher and some chalk. Both tones were painted on with egg yolk. The drawing was then transferred by pouncing and the outlines traced with thin India ink. The modeling was then done with Cremnitz white ground fresh daily in egg tempera, beginning with the highest lights, the colored ground being used as a tone value. (The ground shines through the semi-opaque white tones, thus producing the "optical gray.") After sufficient modeling with white the background was painted on, lighter and cooler, however, than the original. For painting medium 2 parts Venice turpentine were used 1:1 in oil of turpentine and 1 part sun-thickened linseed oil. Now followed colored glazes over the individual flowers and other forms, beginning with the middle tone, with the same painting medium as used for the whole picture. Thereupon further heightening with white in tempera in the wet glaze and a sketching of the exact details in the tempera white as well as in resin-oil-color glazes. The tone of the background was now strengthened to the desired effect. The shadows of the objects themselves were then strengthened and rendered more precise by drawing. Reflections were applied with egg tempera and white. This procedure was repeated where necessary. Then a heightening of the highest lights with tempera white and also with Naples yellow. Finally the shadows were strengthened by deep accents with resin-oil color. Each flower was divided into three tones,

light and shade set into a middle tone. Final varnish glazes were added with a little green earth.

Brouwer's paintings show the influence of Rubens' technique in their golden tone and their thin, transparent shadow tones. One might believe that his panels were hardly primed, but such is not the case. Here, as in the case of the Dutch landscape painters, the oak panels were probably given a relatively thin priming; but in the course of time the ground, owing to saponification, has become transparent. Otherwise the grain would have become disturbingly prominent.

The paintings of Vermeer van Delft and Ter Borch show the same principle of picture construction and the same use of resin- and balsam-containing painting media in conjunction with thickened oils. Without these the fusion and enamel-like quality of their color would have been simply impossible to obtain; oil alone would yield only a sauce in comparison.

Caressingly soft are the tones in many of Vermeer's pictures, such as the "Allegory of Batavia" in The Hague, and at the same time they possess great definiteness and sharpness.

Vermeer's paintings show the finest gradations of luminous tones despite strong local color effects. The color glows in broad, simple masses, and not in scattered details. Unique are the high white dots set like pinheads in his lights, which produce an unusually lively effect. It is obvious that there is Venice turpentine in his color; this is evident in the whole surface and enamel-like fusion of the color, but also in the susceptibility of his paintings to damage by inappropriate cleansing media. Ter Borch to a large extent made use of the law of neutral tones over a warm brown ground in order through the use of economically applied lights to increase still further the tonality of his works and give them firmness in place of weakness. And he proceeded in the same way with the strengthening of the shadows.

With the scantiest but well-calculated means, with cold and warm blacks, with variations of gray-yellow and contrasts of cool gray, and the sparing use of strong color, the little masters of Holland obtained the most beautiful effects.

Gerard Dou, to be sure, with his unbelievable scale of flesh tones mixed in advance on the palette, was a forerunner of that

schematic, pedantic school of the middle of the 19th century, whose members scorned to look at the model at all, because they knew beforehand exactly what tone, for instance, should be used on the neck or anywhere else; and if it chanced to be different in nature, they were not concerned with this "accident."

Alla prima painters like Frans Hals show clearly the technical influence of Rubens. Thickly fluid, resinous painting media with brown, warm tones glazed over gray ground, with over these cooler, opaque tones applied with the same painting media, characterize this style.

It would be erroneous to believe that this painting set down so impulsively was alla prima in the present-day sense of the term. Everywhere may be seen the preliminary gray underpainting, which gave just such a spontaneous method of painting the necessary foundation and solidity.

The alla prima painting of this period retained the principle of warm and cold one over the other, as one may observe in the gray ground, the warm underpainting, and the subsequent modeling with white or gray. Over this preliminary effect were laid glazes of luminous, warm tones with resinous painting media, which were painted into while wet with white and gray color, with finally a setting in of strong color accents to give the painting harmony and freshness. One can, as a matter of fact, paint pictures in this manner in a very short time and at one sitting, pictures that look as if many glazes had gone into them and an immense amount of work. Very frequently there is hidden under apparently pure alla prima painting an underpainting of water color or similar material, carried out in a few tones and probably executed by apprentices.

REMBRANDT'S TECHNIQUE

is a subject which is always certain to arouse the interest of large numbers of painters.

One must bear in mind what had preceded him. The brilliant hardness of local colors, which was opposed to a broad, single light effect, he rejected in the interest of illumination, and thus he avoided the danger which threatens the ruin of so many

paintings, the tendency to associate strong local colors with strong light; for strong light and full color are not compatible, in fact, one excludes the other.

Only an unremitting, intensive study of nature enabled Rembrandt with all his genius to achieve his results, and recklessly he subordinated all artistic means to his purpose. At times he painted such opaque pictures that they gave rise to the witticism that one could lift up his portraits by the nose, and when someone remonstrated with him for painting so heavily, he answered that he was no dyer, but a painter.[8] It was not necessary to smell a painting, the odor of paint was injurious, he said to people to whom the paintings did not seem completed and who wanted to examine them at close quarters. At another time he said that the picture was completed when the artist had realized his intentions.

Sandrart tells us that Rembrandt was not afraid to question the rules of art, perspective and the utility of antique statues, Raphael's proficiency as a draughtsman, even the worth of the academies so necessary to our profession, and to oppose them on the ground that it was all-important to hold only to nature and to no other rules. No doubt he must have caused much shaking of heads, but naturally all this is to be taken with a grain of salt, for Rembrandt was a passionate collector of antique statues. He merely turned against the dullness and emptiness of dry rules.

Regarding the painting of the "Resurrection" by Rembrandt in the Pinakothek at Munich, he wrote in a letter that it had been his intention to give to the picture the greatest and most natural mobility. Houbraken tells the story that, in order to give a pearl the proper effect, Rembrandt painted out an entire figure. The pictures of his early career are hard and cold and show a painstaking fondness for detail. Heightening with white is plainly evident, as in the portrait of Anna Wymer in the Six Museum at Amsterdam. In his "Simeon in the Temple" at The Hague the strong colors still quarrel with one another. They are painted on brown with an underpainting of white. In the grand portrait of

8 This and the following item are taken from the work: *Rembrandt*, by Karl Neumann (Munich, F. Bruckmann).

"Jan Six" (Six Museum) white stands over the most glowingly luminous golden glaze, which varies from gold ocher to a deep, transparent brown. The heightening with white is indescribably charming in its gradations, which partake of the local color. The optical grays are especially fine in this best-preserved painting by Rembrandt. It would have been absurd to attempt to paint such grays directly. The picture is painted very liquidly and unmistakably with resin media, Venice turpentine, thick oils, and mastic.

It must always remain a matter for regret that precisely Rembrandt's masterpiece had to be the cause of so much vexation and hostility and at least partly of his later misfortunes. But it is explainable on a human basis. Exactly as in present-day group photographs, all the members of the "Night Watch" wanted to be as much in the foreground and as clearly defined as possible; but Rembrandt subordinated their individual portraits to the larger artistic idea of the picture, and so many heads vanished in half tones in order to avoid the tiresome sameness of evenly illuminated heads as in portraits.

It is a great treat, a truly fine dish for the artistic gourmet, to study closely the wonderful texture of the light masses in the "Night Watch," which is like fine lace and precious jewels. The opaque places, to be sure, owing to repeated restoration in the course of time, have suffered in so far that today they have taken on a polish which originally they certainly never possessed and which must have deprived them of much of their original textural charm. Despite this, however, the truly beautiful handling of the material in the light areas, such as the lieutenant or the little girl in yellow, has the most profound effect on a sensitive eye. Naples yellow [9] is an important color with Rembrandt, as with Rubens, which he used in the sparkling lights of jewelry, in shimmery gold draperies, in the green of trees, as well as in the lights of the flesh. In the "Night Watch" a light blue-green is to be found, probably a mixed color, perhaps Naples yellow and smalt.

By purely pictorial means the utmost in the plastic modeling

[9] According to De Wild, it is another lead color, massicot.

of objects in contrasts of light and shade has been realized in this painting, in which the opaque structure of the light masses is contrasted by transparent depths glazed over lighter gray and opaque middle tones. In this way the effect of material substance is achieved in the highest degree.

If one investigates the details more closely and observes how the luminously bright yellow of the little girl is held together and, despite its obtrusive brightness, kept in its proper place in the painting through contrasting depths, one will be seized with admiration for the power of Rembrandt's plastic technique. To follow the outlines of such light masses, to feel how they often vanish in half light, in other places stand sharply against dark areas, or elsewhere expand into these, and always create the right effect in the painting, is to realize the wealth of his artistic powers. A few sparingly applied, scintillating lights in the ornaments tone up the entire light mass. The rich yellows of the uniform of the lieutenant are carried across by the warmer yellow and the "friendly" yellow-red and brown of the surroundings in many gradations to the black of the captain. Through these warmer surroundings, as in the case of the light masses of the girl, they are rendered cooler despite their luminous yellow, and thus a "hot" effect is avoided.

One might write a special chapter regarding the white used by Rembrandt. Out of clear contrasts of a gray-white and a yellow-white (in other words, a cold and a warm tone), which I believe were mixed in advance, it was laid on in layers, one over the other. One must have seen how, for example, in his "De Staalmeesters" the white of the broad collars flows together with the flesh tones and without hardness passes over into the texturally wonderful black of the draperies to understand what a splendid artistic performance this is. Technically it was possible to obtain this effect only by means of a uniform preparatory modeling in white and gray throughout all parts of the painting. One can, moreover, observe these lighter preparations quite clearly in certain small areas on the heads and hands. Through thin, semi-opaque, and vibrant glazes the separating local colors were applied over the gray body of the underpainting, but in such a way that the undertone always continued to exercise its

effect throughout the whole picture, and into these glazes, prepared with varnish and thickened oils, were set the strong accents in light and shade which determined the final character of the painting. The fringes on the glove of the man sitting on the right outside (often falsely designated the treasurer) are unbelievably realistic; upon closer examination they are found to be scratched into the fluid color with the handle of the paint brush!

Unification of the light effect, the holding together of the masses of light and shade, and the subordination of all individual colors to a single dominant tone was the guiding principle of his work. The subject never overwhelms the artistic form. He constructed a painting purely out of pictorial means. He created a half-dark such as was never obtained before or after him. No longer, like Leonardo, did he seek beauty, but individuality, of form.

Together with the manner of his treatment of light, he enriched the pictorial means of expression by the charm of his color technique, in which he alternated the application of the most opaque tones with half-covering and the finest glazes. His paintings were not produced hastily, even if in some instances it may appear so, but always with the utmost forethought in the preparation and underpainting, which he developed in many intermediate layers, thus welding together, so to speak, the final effect.

Out of a complete knowledge of his craft he created a new masterly and free technique, different from and more versatile than present-day pure alla prima painting, because he used all the varied possibilities of oil color in his work. His technique is a truly spiritualized handicraft, and to trace this in his paintings is always a thrilling experience.

He employed chiefly pale gray, light grounds, with over them an ocherish, warm drawing of a golden effect. He enriched this effect by creating, in a sort of abbreviated underpainting, an optical gray out of the ground by means of half-covering and glazed tones. Yellow and brown in many gradations, such as yellow-gray, yellow-red, brown-red, etc., with a slight admixture of other colors more opaque in the light, in the shadows glowingly warm, result in that congeniality and harmony of "friendly" colors of which his pupil Hoogstraten speaks. On the

other hand, the cold contrasting tones, gray-blue, gray-green, etc., which seldom increased to strong blue, were sparingly set in, and even they were permeated (because they were painted or wiped on wet in wet) by the warm harmony.

His painting media were strongly resinous in quality; in this respect he resembled Rubens. With freshly ground, thick color, perhaps prepared with Venice turpentine, mastic, and sun-thickened oil, which dries hard in a few hours, may be obtained technically very similar effects, that is to say, very opaque colors combined with glazes. His opaque colors give the effect of floating in the varnish glazes.

It was a necessary requirement for the proper effect of the picture that the lights should be preserved as they were set in, and that, above all, there should be no loss in body. This he obtained with his thick resin varnishes and thickened oil. On the paintings of later, inferior painters who followed in his footsteps, as, for example, Edlinger, one may clearly observe a wrinkling of colors too rich in oil, a drying together of originally opaque layers. Let one compare with this Rembrandt's lights on jewelry, which in themselves have the material effect of precious jewelry and with their sparkle tone up the other parts of the painting.

Today quite unjustly Rembrandt and other painters are reproached in scientific works on painting technique because of the large use they made of resin in their pictures. In no other way would it have been possible for Rembrandt to obtain the effects which he had in mind. He had to choose these media. After all is said, there is no color easier to regenerate than just this resin color—though, to be sure, none easier to ruin by mechanical interference. But that does not argue against Rembrandt, but against the restorers.

The great Brunswick family portrait represents the high point in his creative career. It is a real holiday for any painter to see this work and also the roomful of Rembrandt's masterpieces at Cassel.[10]

[10] The more than forty Rembrandts at the Hermitage, Leningrad, should here be mentioned, although Leningrad is not so easily visited as Brunswick and Cassel. [Translator's note.]

Dark is the basic tone of his paintings, and darkness occupies a large area in them, in contrast with the pictorial scheme of Rubens. But how full of life is such darkness! Beginning with the most glowing middle tones of brown and yellow, they are gradually deepened through glazes and accents and made so unutterably rich in values! With a breath of cool color the warmth is balanced and relieved of its burning quality. With spatula and brush he worked freely and broadly, and in his later works extremely rapidly, being in this respect far ahead of his time, and set the colors over, not into, each other, so that one might believe from the freshness of the effect that they were painted only yesterday. It is certain that he also underpainted much in tempera and carefully prepared his paintings. His pictures are often covered with brown glazes. Here he used asphaltum more logically and therefore more effectively than Makart and his contemporaries, who used this dangerous color in the underpainting, where inevitably it caused damage.

One of the most instructive examples of Rembrandt's technique is his sketch in the Boyman Museum at Rotterdam: "The Peace of Westphalia." The painting is executed in light and shade with transparent brown, which in part is separated into cold and warm by overlying gray. The middle section of the picture, representing a group of horsemen, is heightened almost solely with white in various gradations and of a strong impasto in the light areas. The local color is only very lightly wiped over this.

In "De Staalmeesters" [in the Rijks Museum, Amsterdam] the heightening with white over the ocher tone is likewise clearly visible. The red carpet is also heightened colorfully over gray and wonderful in tone owing to the glowing light on one small spot, an effect which is similarly repeated in the "Jewish Bride." The unity of his work is amazing in the mutual penetration of light and color through all the tones of the painting, especially also in the reflections.

A comparison, purely from the standpoint of artistry and craftsmanship, comes to my mind before Rembrandt's paintings. Titian, Rembrandt, and Marées, three outstanding painters belonging to different periods, are definitely related in matters of

technique. All three made the fullest use of the painter's means in the very broadest sense. Through the use of fluid and fiery varnish glazes over heavy, opaque undermodeling in white or gray they created the greatest possible material contrast between the heavy light masses and the somber, mysterious dark areas, which charm ever anew the fancy of the observer. All three painted in many layers one over another, not alla prima, and worked long at their pictures. All three sought the effect of the body in space as the essential thing and built up their pictures with the fewest colors, which never transgressed the limits of a unified effect, the large, dominant tone.

Thus Rembrandt created his magnificent color harmonies out of the "friendly" colors of yellow ocher to brown and brown-red by merely balancing transparent, glazed tones with the dull effects of the same tones mixed with white, and conceived them all in a sense as variations of the one dominant tone. We know similarly of Marées that he built up his effects with the fewest and simplest colors, and the same is true of Titian. The material charm of the paintings of these masters was almost never obtained by their pupils, no matter how much they may have learned by minute observation from their masters. The finest flower of craftsmanship, of course, cannot be imitated. The feeling for it is rare, and only in very few is this highest technical capacity to be found.

"Take the brush in hand and begin," Rembrandt would say to a pupil lacking in self-confidence, and: "The painting is finished when the painter has expressed what he wished to say."

We see from the examples cited of the techniques of old masters that spiritual freedom rested on a basis of sound craftsmanship. A plan carefully thought out from the ground up was the inspiration of these works of art, which in their perfection, their unity, and their completeness of expression often appear so incomprehensible to us.

If we wish to attain to similar powers, we must again build on the foundation of craftsmanship.

The achievements of modern painting, the study of light, air, and color, should, however, by no means be deprecated. It must be the task of a modern painting technique to insure that these

achievements are also given permanent and convincing means of expression in painting. Every period requires its peculiar means of expression, and a one-sided admiration of the old masters is of no help to progress. Modern methods of painting make the greatest demands on the material. It is no easy matter to prescribe basically sound rules for modern painting. Toward this end much patient work is required, in which science and practice must be united.

The aspiring painter can, however, learn from the early works of the great masters that the most careful execution does not hamper, but forms the basis from which real artistic freedom arises. One must once have carried out something in a very exact manner in order afterwards to be able to paint freely and broadly, one of our best painters once said to me. One should not be influenced by the currents of fashion, and their temporary successes must not deter one from learning everything one can about art. Technical ability, after all, is the best assurance of success.

CHAPTER X

THE RESTORING OF EASEL PICTURES

This chapter dealing with the restoring of paintings has been included not so much with the end in view of training future restorers, but because many painters are occasionally called upon to restore paintings and often for lack of knowledge may commit blunders, and, furthermore, because many painters later adopt the business of restoring as a profession. In fact, by far the greater number of professional restorers have come from the ranks of painters! My object, then, is merely to give a survey of the processes of restoring which may be of assistance in avoiding the grossest errors. Hence only that will be touched upon here which can be accomplished by the simplest means as they stand at the disposal of every artist.

Thus the very promising experiments with the quartz lamp and the successes achieved with X-ray photography cannot be discussed here. If these experiments enable us for the first time to see into the depths of pictures to determine the method of overpainting, etc., it must always be remembered that, apart from the advantages thus to be derived from the phototechnical side, still the greatest reserve in judgment, as well as experience and technical artistic knowledge, is necessary.

A painter, however accomplished, cannot without special knowledge hope to restore a painting successfully. This is not to be accomplished through a casual patching up and an approximate matching of colors.

A good restorer must thoroughly understand the art of painting and know how the paintings of the various old schools were built up. True, he must be able to paint, but at the same time he must also know when to forego this pleasure. He must above all be conscientious, have a profound respect for the works of others which he is commissioned to restore, and apply himself to his task with great patience and without regard for time, with the aid of skill and scientific knowledge.

374

"Restoration" is a very poorly chosen term, and, strictly speaking, it signifies something which cannot be done. The genuine restoring of a painting is obviously something which is possible only to its original creator. What is then in question is always in reality but a substitute for restoring.

Conservation should be the chief task of the curator of paintings: to ascertain the causes of damage and remove them, thereby insuring to a work of art the longest possible span of life. An old painting should be treated like a document, which every custodian is not privileged to alter as he pleases. For then his successor would have the same right, and soon everything authentic about it would be hopelessly lost. One should never attempt to make a new, "more beautiful" painting out of an old one; an old painting should be permitted to show its age. These views of Pettenkofer's should be shared by every restorer. Even today, however, more than fifty years since they were first given utterance, we are still unfortunately far from witnessing their general adoption. Although there should be only one course open, that, namely, which is based on a scientific and practical understanding of the problem in hand, restoration is frequently practiced at the restorer's own discretion, with the result that something quite different from the original is often produced.

This applies also to galleries, and it is only in very recent times and in a few places that the ideas of Pettenkofer have been practically carried out.

No one today would think of restoring an old work of architecture in such a way as to make it appear to have come down uninjured from the hand of its original creator. No one would dare so to restore an old statue—but an old painting—why not! And still the obvious impossibility of this is clear enough.

Wilhelm Tischbein (who painted Goethe) wrote: "The harmony of pictures created by time is very easily swept away. If an ignoramus begins to work on them with soap, lye, or alcohol, not only is everything delicate in them destroyed, but also all glazes, and nothing remains but a skeleton and a spoiled picture, which no longer gives any pleasure. Very soon we shall have no more well-preserved pictures, because so many clumsy, inexpert persons tinker with them and destroy them. One can really not

protest too often and too loudly about this, because it destroys whatever few good pictures have been left to us."

For lack of a training school, the individual restorer is forced to obtain his knowledge wherever he can. The great majority are not lacking in skill, but they often lack a thorough knowledge of the materials. No one deplores this state of affairs more than the intelligent restorer. Irreplaceable art values often have to be intrusted to persons who simply do with them as they see fit, and the history of restoring records, as a consequence, many examples of ruined paintings. No wonder if many restorers eagerly search for recipes and anxiously guard them as deep secrets. Secret devices of all sorts are recommended, and media whose composition is unknown to those who use them and whose effects therefore cannot be calculated. Confidence in "authority" here still reigns supreme, and every successor on the strength of his particular authority decries the methods of his predecessor and removes the latter's efforts, with the result that valuable paintings suffer lasting damage.

For a time, after Pettenkofer had given to restorers his processes of regeneration, one might have expected a science of restoration to develop. But today, after half a century, not much progress has been made, although the science and practice of painting together could very probably create today a sound foundation. Not in secret, no, but in the open, should paintings be restored. Happily I recently found these ideas being carried out in the Frans Hals Museum in Haarlem, while formerly it was this museum in particular which had to be criticized so severely and so often in the professional press because of the washing of the paintings of Frans Hals intrusted to its care.

Here we can be concerned only with presenting the larger aspects of restoring as it should be carried out, and the simplest methods as they stand at the command, not of the professional restorer, but of the average painter.

The procedure in restoring may be described as follows:

The value of old paintings and their genuineness are not always so easily determined. Forgeries are frequent and often very cleverly executed with the fullest use of all the technical devices and with pigments often prepared after the recipes contained in old

painting books. Moreover, when it is recalled how often in the course of centuries old paintings have been copied and, what is more, in earlier times so convincingly in the technical manner of their period that the changes in these copies necessarily correspond to those which have taken place in the original, one is bound to become skeptical. It is advisable to examine such paintings very carefully and to study exactly the old, original methods of painting. Only too often, however, the opposite occurs, and the paintings are forced to undergo as severe tests with fire and water as those practiced in the times of witches. Thus a painter friend of mine once told me a tragi-comic history of a very beautiful portrait which he believed to be a Rembrandt and which he turned over to several authorities for an opinion. These authorities were unanimous in declaring the painting to be very excellent, but they were not in accord as to whether or not it was a Rembrandt. Then one of the "restorers" proposed the "alcohol test"; "if the picture can stand it, it is genuine," he said, and he threw into the face of this portrait a large dose of alcohol. And, behold, after a short rubbing, considerable parts dissolved, the shadows in particular disappearing down to the ground, and the experts promptly came to the conclusion that it could not have been a genuine Rembrandt. The valuable painting was naturally destroyed. Now, sensitivity to alcohol can certainly not be a criterion for determining the genuineness of a Rembrandt and his school, rather the contrary. For the resins and balsams which he and his school used are precisely the kind which dissolve rapidly in alcohol. Unfortunately, such occurrences are not so uncommon as one might believe. But retouches cover a multitude of sins.

The first thing to be done when one undertakes the restoring of a painting is to prepare an exact statement, in fact, make a complete record in writing, of the damages, preferably, whenever possible, in the presence of the owner. For it is not impossible that the client, after the completion of the restoration, may no longer clearly recall the former condition. A photograph taken before, during, and after the process of restoration is, in the case of valuable works, a very necessary and important document. Regarding the nature of the restoration one should likewise keep

a written record, which can at least become useful for reference. A good magnifying glass is necessary for the examination of delicate works.

One should first determine whether the ground, for example, the canvas, is undamaged, and whether it has folds, is brittle, has decomposed, or is, perhaps, perforated with holes; and, furthermore, whether it has patches glued to the reverse side.

In the case of wood panels, one should proceed in a similar manner. Here we are interested in finding out if the board has warped, is worm-eaten, or contains moldy wood.

Surface dirt is easy to detect.

It must next be determined whether the color layers themselves are still intact or whether splintered areas or blisters are present, at the same time observing closely whether in other apparently solid places the adhesion has weakened or the ground itself become loose.

Chemical changes may, in the case of more recent paintings, be the cause of the destruction of areas in the picture, but this seldom occurs (as, for example, the blackening of emerald green and cadmium mixtures). The striking through of certain colors, such as asphaltum, can easily ruin the appearance of a painting; or the problem may be a yellowing, browning, or blackening, or perhaps a bleaching, of the color layers. Madder lake and yellow lake, especially in mixtures with green, often fade, as in the distances and trees of old Dutch paintings. With the aid of the quartz lamp it is possible in many cases to recognize certain pigments. Thus zinc white appears a bright greenish white, while white lead appears brown. Forgeries can often be detected with certainty in this way. The X-ray is frequently used today to search for signatures and to determine whether or not a picture has been painted over. However, these processes are still in the experimental stages. Chemistry is still unable in many cases, particularly with regard to the binding media of very old paintings, to reach any definite conclusions. Old oils, for example, owing to their becoming resinous, come to resemble varnishes and cannot with absolute certainty be distinguished from the latter.

The final varnish, particularly in the case of resin ethereal

varnishes, may develop a whitish discoloration due to the weakening of its molecular cohesion.

Oil varnishes, through strong yellowing, browning, or becoming opaque, may ruin the effect of a painting in the worst possible manner.

Special pains must be taken to see whether parts of a painting were not changed by earlier restorers, for example, by retouching or overpainting, or whether the painting was affected by being mounted on new canvas. In sunlight retouches and overpainting can more easily be detected. Signatures and oftentimes writings on the reverse side, gallery notations, etc., must likewise be recorded exactly if they are to be covered over.

First one should attempt to repair any damages to the support and replace with putty any missing places. After this the picture is cleaned and "fed," next come the retouches, and last of all the final varnish.

Wherever possible, the restorer should prepare his own materials, purify his own oils, apply his varnishes himself, and, above all, grind his own colors. Only in this way can he guarantee his work and its permanency with a clear conscience.

DAMAGED SUPPORTS AND THEIR REPAIR, relining a canvas, restoring wood panels. The cause of many damages to old paintings is that they are mounted on an unsuitable frame, which frequently is not a stretcher at all. In this event one must, when the picture is not intended to be relined, as also in the case of dents and bumps, attempt to get rid of the damages by a very careful ironing on the reverse side. With fairly new, still sound paintings, a very weak going over (not wetting!) of the creases from the back with a well-pressed-out sponge will help matters. In all cases one should immediately afterwards slightly tighten the wedges.

If the frame was not sufficiently beveled, one often finds that the inner edge of the stretcher has pressed through to the front. This damage is one of the most troublesome to repair. Relining is, after all, the only remedy. A sudden strong tightening of the wedges may cause tears in a painting, especially also in the case of new canvases which were painted on folding frames and later permanently mounted on a stretcher. Fissures in the glue

size can in many cases be eliminated by thickly applying with the spatula a half-chalk ground over the entire back of the painting. In the case of older paintings one will, instead of this, resort to relining. Of a painting by Reynolds it is known that he thickly painted the back of the canvas in the place occupied by the head with white ground. It is commonly thought that this was done to absorb oil, but I rather believe it was to eliminate troublesome creases and glue fissures in the canvas.

Damaged canvas was formerly often removed thread by thread, and even the ground was rubbed off. Berger still recommends this in the new [German] edition of *Bouvier*,[1] published in 1910, in the case of the presumably harmful striking through of the bole grounds. These are the light-red to brown-red or very dark black-red grounds toned with iron oxide and burnt ocher or sienna which were used as middle or transition tones and which, for the reason that they were thinly covered, created the warm, local tone of the painting and permitted unusually fast work. Owing to the thin covering of the shadow parts and the later shining through of the white lead as a result of its saponification due to oils, and, furthermore, owing to the removal of the resin glazes by clumsy restorers, these red grounds have often come through in a disturbing manner (see page 350). This gave rise to the erroneous belief that the bole grounds had "grown through."

I have in my possession a book published by a restorer in 1834 in which it is recommended that paper be first pasted over the face of the picture. Then the picture is laid on its face, and a uniform ridge of wax of a finger's breadth is kneaded all around the edge of the back of the canvas. This low-walled tank is then filled with either hydrochloric or nitric acid, which is allowed to remain standing on the canvas until every thread is completely eaten away. If the action of the acid is too slow, it must be strengthened. Later the acid is poured off and the picture rinsed several times with water. This gentleman informs us that his main reason for writing this book was "to stop the practice of

[1] Bouvier, P. L.: *Manuel des jeunes artistes et amateurs en peinture* (Paris, 1827; Strasbourg, 1844). *Handbook of young artists and amateurs in oil painting* (New York, 1845). [Translator's note.]

restoration by incompetent persons." One becomes curious to know what the incompetent ones did. Largely such proceedings were, and still are today, veiled in secrecy. Chalk ground on wood was softened with hot water, after the face of the picture had been pasted over with thick paper, and lifted off the panel by means of the spatula. Often wood panels, after being planed down to a thin layer, would be removed by acids in the manner described above for removing canvases. Even metal bases were removed in this way.

But all these methods are as unnecessary as harmful. If a canvas has been damaged, another should be stretched underneath. In the case of new paintings that would also be the best protection for the reverse side, better than if one covered the back of the painting with an isolating medium or glued on tin foil with shellac. The most deplorable method is to soak the reverse side of the canvas with oil or an oil and wax mixture, because this will make the canvas really brittle, and the appearance of the painting is bound to suffer. Nevertheless, this method is still very much in vogue. One can best see the damages done by holding the canvas to the light.

Very much damaged or brittle paintings on canvas full of holes are glued to new canvas. From the back of the old canvas must first be carefully removed all unevennesses, knots, remnants of glue, glued-on patches, and the like. For this purpose a piece of broken glass is useful. Patches can often be pulled off quite easily. Every knot and every little unevenness on the back later becomes painfully noticeable on the painting if it is not previously removed.

The old canvas is attached to a new, well-stretched, strong canvas which has previously been many times sized with alum glue. A good strong linen is to be recommended. To be avoided are half linens, because they do not stretch uniformly. A good adhesive is white colophony, dissolved 100 parts in 30 parts oil of turpentine, with the addition of 10 parts beeswax and 20 parts boiled linseed oil. Likewise rye-flour paste or starch paste, 100 parts well mixed with about 20-40 parts Venice turpentine, produces a serviceable adhesive. The paste, however, must be so thick that it gives out no water when placed on blotting paper.

Many paintings, particularly those produced between 1750 and 1850, are unusually sensitive to water. The canvas of such paintings can in a moment shrink about 5 cm. or more to the meter. The old, dry color cannot follow this movement, bulges up like a roof, and falls off. Therefore care should be exercised with watery adhesives. Colophony alone, dissolved only in oil of turpentine, sticks very well temporarily, to be sure, but soon becomes splintery. The adhesive may then fall away like wood dust from worm-eaten wood. Boiled linseed oil ground with Cremnitz white to a stiff paste, thicker than tube color, with the addition of some color resembling that of the priming in the painting, produces a very strong adhesive which in time becomes very hard. With all such adhesives care must be taken to see that the smallest possible shrinkage takes place. Therefore as little water and oil of turpentine as possible must be added. India-rubber adhesives have also been used by a few restorers.

It is strongly advisable, before beginning work, to coat the painting with copaiva balsam thinned with oil of turpentine. Places which are flaking off, which might be lost, are covered over with many layers of white tissue paper which has first been coated with copaiva balsam. The majority of restorers here use glue or paste coatings, which can be dissolved again only with water and are therefore dangerous to use.

The coating of copaiva is intended to prevent the penetration of water from the paste into the canvas. Therefore one should also coat well with it the backs of old, especially rotted, canvases. Mastic varnish may also be used.

The glue is applied with the spatula both to the back of the old painting and in the same way to the new canvas. It should be as thick as a salve. See that the ground takes it evenly and well all over.

The overlap of the new canvas should amount to at least 5 cm. on all sides, so that a later tightening can be easily accomplished. At the outset are driven in, but only half way, longer tacks than are commonly used, which facilitates the subsequent tightening. In the case of larger paintings, it is often necessary to continue the stretching for several weeks. Several persons must also assist in the transfer of very large paintings to a new canvas, for this

part of the work must be carried out accurately and rapidly.

The two pieces of canvas are then lightly pressed together, beginning in the middle and working toward the corners; a soft cloth is used for this purpose, and any folds should be carefully smoothed out toward the edges. With a warm iron, for example, a flatiron whose edges have been polished down, iron first on the back, then also on the front. I prefer a piece of heavy sheet iron into the back of which is riveted a covered handle, because this can be worked well under the stretcher frame.

Naturally one may also mount a painting on a new canvas without its first being stretched by placing it on an even surface, for example, a marble table. Extreme care must be taken not to allow the iron to become too hot. The face of the painting is coated with wax—1 part white beeswax dissolved in 4 parts oil of turpentine—to facilitate the ironing. The iron also is coated with it, and it must not be so hot that it sizzles. The color would easily stick to a dry iron if the painting were not waxed. The hot iron should be kept on one place for only a very short period, until the two canvases hold together and the old canvas is smoothed out. In the case of blisters, lumps, or creases longer warming with the iron is necessary. After coating with the wax, iron carefully on the face of the picture, continuing patiently until the uneven place disappears. Iron until the iron begins to get cold, using a light pressure, never keeping too long to one spot, while applying a counter-pressure from the opposite side by means of a waxed "wood plane" (a smooth board with a handle). The adhesive melts under the heat and penetrates into the old and new canvas. Under excessive ironing it may force its way through the latter, which, however, is of no harmful consequence.

The iron must be kept clean. Over an open flame the wax salve becomes sooty. One should always test the temperature of the iron on something other than the canvas.

In the case of very hard, blistered paintings, which are very difficult to smooth, it may happen that the adhesive, owing to too hot ironing, will be partially sucked up and leave hollow areas. The old canvas is then carefully lifted from the edge and fresh adhesive introduced with the brush. If this should become

necessary after several days, when the painting already adheres tightly, the back of the new canvas is opened by two right-angled cuts, more adhesive is introduced, and the edges are then brought together again. Very opaque places must not be ironed hot from the front. They would be flattened out in the process. Sprinkle the surface with the finest sawdust until covered evenly and well, then press the wood plane upon it and iron from the back. Very hot ironing will melt oil colors and finally burn them.

If there are stitches on the old canvas which do not permit of being smoothed down on the reverse side, then the new canvas must be cut out here and the stitches allowed to lie free; otherwise they will press through to the front of the picture.

If any of the adhesive should come through to the front through tears, it should be removed at once. The ironing wax and the dirt clinging to it can be easily removed with cotton wadding and oil of turpentine. Here the coating of the old painting with copaiva balsam before beginning the ironing proves to be very useful in the later cleaning process. Coatings of linseed oil or linseed-oil varnish, and above all fatty oils, should never be used. By a light scratching with the finger nails one can determine whether there are still remnants of wax on the painting. The wax must be completely removed.

Professional restorers have all sorts of devices which lighten the work of relining. Here we can be concerned only with the simplest devices enabling a painter to do satisfactory work. Oftentimes it is possible to mend a hole in a canvas by applying a patch to the back. Frequently, however, folds will form later around the patched area. Such a patch must be scalded (hot-pressed) beforehand and dried, no watery mixture being used as an adhesive, but the above-described mixtures of colophony and wax or boiled linseed oil, thickened oil, and resin varnishes which were used for ironing. Half-chalk or oil ground material provides an excellent medium for gluing such patches. The patch can be laid in the half-chalk mixture and thus soaked with it. It is then taken out and scraped off with the spatula without using any pressure. The place on which the patch is to be placed is also coated with the same ground material. With the wood plane a light counter-pressure is exerted from the front while applying

the patch. The patch then is ironed out by using only a slight amount of pressure and smoothed from the middle toward the sides. The edges of the patch must be frayed. The application of patches, however, must always be regarded as only a makeshift. Hard, blistery places in the old canvas must be softened by repeated treatments with copaiva balsam and a gentle, repeated ironing before one applies a patch or resorts to relining.

Boards which warp must be braced on the back, that is to say, supplied with dovetailed strips of wood in both directions; these, however, must not be glued in, particularly those which run against the grain, so that they can follow the movements of the wood. A warped board must not be allowed to get wet on the back, and it must not be straightened by force. More and more weight should gradually be applied. Against the woodworm Leonardo da Vinci already recommended coating the back of the board with sublimate (mercuric chloride). Exposing a picture to benzine vapors in a well-sealed box has here proved very effective. Formaldehyde is said to be equally satisfactory for this puropse. Watery substances like mercuric chloride applied to the back are dangerous, since they may dissolve the ground. There are today many highly-advertised remedies which are likely to be more destructive than woodworms themselves. Recently Blaugas [named for its inventor] has been used to fumigate whole rooms with allegedly permanent success. On the painting "Vinum bonum" by Böcklin in the Schack Gallery, the worm holes were filled up with an asphalt-like substance, which in the warmer season came to the surface of the painting and there caused small ugly spots.

In cases where the color is brittle, the front of the picture must be covered with various layers of thin paper and copaiva balsam, in order that it may not break off. After the work has been completed, the paper layers are carefully removed with oil of turpentine.

Blisters in the color and ground layer on wood panels are coated over with wax dissolved in oil of turpentine and carefully ironed down. When that does not help, they are carefully pricked open and some resin varnish introduced with a fine syringe or a brush, when they may then be ironed down.

For copper plates see page 43. Büttner, in the case of damaged copper plates, attempted to take off the painting by removing the copper through an electrical process. Color usually will hold very well on copper plates if they have been correctly prepared. Sometimes the color, however, loses all hold and gradually peels off. To prevent this, thinned mastic varnish which penetrates underneath the color skin may be useful. To take bumps out of copper plates nearly always involves loss of parts of the paint surface.

When pasteboard has been painted on both sides, it is often split in order also to be able to use the reverse side. By means of long, broad spatulas this is often accomplished without much difficulty, but this is by no means always the case.

THE USE OF PICTURE PUTTY. Where the priming of a canvas has fallen off in some places but the canvas itself is still intact, such places are filled with putty. In case the canvas is damaged to such an extent that it must be relined, this must be done first. In this case one should use only a putty which does not become very hard, for the putty must not become harder than the paint, or the puttied places will not hold. Furthermore, care must be taken to see that such a putty loses as little of its substance as possible; consequently it must be very rich in body and must contain the smallest possible amount of evaporating constituents, such as water or essential oils.

The half-chalk ground material, comprised of glue and chalk, zinc white, and boiled linseed oil, makes an excellent putty, to which, as in the case of colored, such as bole, grounds, one may add suitable colors. In general putty should be tinted as closely as possible to match the area in which the repairs are carried out, for only in this way can the same color effects be again built up. The putty, then, must not be applied in a watery, thin state; it must be thick and evaporated in advance to such an extent that it can be molded like bread crumbs into pieces the size of a pea or even smaller which can then be conveniently rubbed into the missing places with the finger. A preliminary but only very slight moistening of the broken-off ground places with copaiva balsam may be of advantage. The putty is permitted to set for a few moments; a cotton pad or small rag is then dipped into copaiva bal-

sam thinned very slightly with oil of turpentine, well wrung out, and used to press the puttied place smooth and also to clean at once very carefully the soiled edges of the old color layer. If the putty were permitted to dry without first being smoothed, it would be very difficult to smooth later, and soiled parts of the painting could be cleaned only with much trouble and attendant danger.

Many add to the putty some wax dissolved in oil of turpentine and, in the case of very smooth paintings, carefully iron these places.

The putty always shrinks somewhat in drying. One must have patience and possibly make a second or third application until the puttied place is even with the picture surface. An addition of mastic or dammar varnish to the half-chalk ground in place of boiled linseed oil is better for rotten canvases which for one reason or another do not permit of being relined, because this putty does not become so hard. Gypsum in the ground instead of chalk offers the possibility of scraping the putty after it has dried. If one has to repair a painting on which very many small adjoining areas have come off, then one would, particularly in the case of places which are covered with complicated details, even when one restores the color of the ground, have unusual difficulties none the less, because the many individual puttied parts would stand out too brightly, and the harmony of the old parts of the picture which lie between, which may often be very small, would be difficult to maintain. There are restorers who in such cases cover the entire picture with ground material and then wash off the parts which are intact; but, while this saves time, it is not advisable.

For such purposes it is better to make a colorless, transparent putty, prepared with freshly precipitated hydrate of alumina and mixed with thickened oil and thick varnishes. Hydrate of alumina is made by dissolving aluminum sulphate or alum 1:10 in water and slowly stirring potash or ammonia dissolved in water into the solution. The clay is precipitated as a white, gelatinous mass, which is allowed almost to dry. Before completely dry, however, when the substance is still somewhat gelatinous, it is mixed with very heavy, thickened oil and very thick dammar varnish. This

putty is applied with the spatula, but the edges must be cleaned at once, because this putty hardens very quickly. The use of boiled linseed oil or oil varnishes has the disadvantage that the putty not only becomes very hard, but also very yellow. With this transparent substance sections of a painting which appear to resist every attempt at restoration permit of again being rendered smooth and solid, and in this way even the very smallest parts of the old paint surface can be preserved.

Additions of glycerin, soap, honey, and similar substances are for picture putties just as unnecessary as in the case of grounds. A smearing of the place to be puttied with oil is not recommended. Bologna chalk, thick varnish, and thickened oil likewise produce a transparent putty. Büttner recommended filling up cracks with shellac powder and a suitable color, and permitting alcohol vapors to act upon this. Personally I prefer the putty described above.

When larger pieces of a canvas are missing, one can glue hot-pressed pieces of canvas of the same weave into the old stretched canvas. If the texture of the canvas is of importance in the painting, the pattern may be pressed into the last layer of the putty before it sets.[2]

CLEANING. The first superficial cleaning is done by a dry process. One carefully dusts off the painting with a feather duster or soft cloth and removes the dirt by rubbing with bread crumbs or with kneaded rubber. But it is seldom that a completely satisfactory cleaning is obtainable in this way. Then a wet cleaning is undertaken. This wet cleaning is very frequently the cause of the worst damages to a painting. There is no cleansing medium that is not a potential source of danger. Therefore the restorer must not only be skillful, but must also have at his command the necessary knowledge of the properties and effects of the materials used. How very unsatisfactory conditions are in this respect has already been suggested above.

[2] Goethe tells in the "Italian Journeys" of the patching of old canvases by means of canvas of the same pattern and texture. This practice was formerly very common. In the process one must see that the grain is the same and that the threads run straight, and then construct the ground in a manner analogous to the original.

Water, for example, is apparently the most innocent cleansing medium. Its use is therefore recommended in the majority of books, often even expressly required at regular intervals; and in pretty nearly all galleries paintings are still washed with water. Only concerning the quantity of water is opinion divided. While some recommend water without limitations and use soap in addition (since this is always used in washing), afterwards rinsing the painting off well in order to get rid of the remains of the soap and rubbing the painting dry with a chamois skin, others rub the painting with damp cotton wads and only with what they estimate to be sufficient water to dissolve the dirt, which is naturally difficult to determine. A freshly painted, undamaged painting will suffer fewer damages by careful treatment with water, and not until it has been cleaned repeatedly will any bad effects become noticeable. The oil-color layer is, however, in the case of a fresh painting by no means so impermeable to water as is generally believed. The varnish layer is attacked by dampness without a doubt. Old paintings often give the appearance of being quite intact. If, however, they are examined more closely with the aid of a magnifying glass, they very frequently disclose a fine network of minute cracks. The water penetrates into these cracks, no matter how quickly one goes over them, and permits the glue of the ground or the underpainting to absorb the water. The glue increases in volume and may force off the overlying layers of color. I well recall the case of the paintings of the court painter Stieler which were washed in preparation for a special exhibition. Although before the washing they were in an excellent state of preservation, they soon afterwards were covered with cracks, and small areas of the color turned up at the edges like saucers. In recent times I have had the opportunity of repeatedly observing the ruinous results of the washing with water of old paintings. The canvas shrinks, and the color buckles up like a roof and breaks. Washing from the reverse side is especially dangerous. Paintings of the 18th and the first half of the 19th century are most susceptible in this respect. It is a mistake to believe that a painting can be ruined only by water applied to the surface and not from the back. Especially are the chalk- and gypsum-ground

paintings of the early German and Italian schools endangered by such "water cures." Moreover, certain colors in old oil paintings are soluble in water, as Leonardo and Palomino already stated (according to Dr. Hesse). I myself made similar tests with umber and ocher. Indian yellow, verdigris, carmine, and zinc yellow are all partly soluble in water. If influences of temperature, such as excessive heat, also enter into the problem, then the damages may assume the nature of a catastrophe.

That one cannot always trust old recipes just because they are old is shown by the following from the De Mayerne manuscript: "Thoroughly rub and soap the oil painting with soft soap and a sponge. If it is very dirty, let the soap stand on it for a while. Afterwards wash with urine and rinse with water, throwing it vigorously against the picture. In the beginning the water must be warm; later it can be thrown on from a bucket."

Naturally it serves no purpose to place the paintings in an upright position during the process of washing. Even if the picture were hung from the ceiling face down, the water would be drawn into the fine cracks by capillary action, and not, as one might think, run down. Just as senseless is the method of rubbing down the painting with sterilized cotton wadding, because the painting itself is neither free from germs, nor can it be freed from germs in this manner. The rubbing down of the painting with sliced onions still appears to be the least harmful cleansing medium; slices of potato are not so good, because the potato starch may dull the picture. In either case, however, moisture may enter into the fine cracks of the picture surface.

Many restorers seek to "reanimate" the varnish by dry rubbing the washed painting with a chamois skin, which, however, results only in an optical illusion. The painting will no doubt shine after such a polishing, as would any smooth surface under the same circumstances; but that the coat of varnish by this means gains in cohesion or durability is a fallacy. This "polishing" naturally in no way contributes to the strengthening of already loosened parts of the painting, especially when color layers have curled up on the cracked edges. The swelling of the glue often causes the cracked parts of the painting to curl up at the edges like saucers,

which affects very unfavorably the appearance of a picture and may cause the paint to break off completely.

To me it seems a contradictory state of affairs when in galleries the dampness of the air is carefully controlled by a hygrometer and at the same time the paintings are washed with water.

In the meantime my misgivings in regard to the washing of old pictures have been shared and even supported by scientific authorities. Since, however, curiously enough, the advice of neither artistic nor scientific authorities is followed, but only "professionally trained" restorers are consulted, washing is continued in all calmness of spirit. Perhaps I am mistaken, but I am decidedly of the opinion that our old paintings are too valuable treasures to be used for experimental purposes, no matter how completely individuals are convinced of their efficiency. For there are no authorities in the field of picture restoration. Everyone here is and should be only a student.

It is certain that there can be found less dangerous cleansing media than water, which, to be sure, has the advantage of being very convenient and cheap. In view of the artistic values involved, however, these considerations should not determine the choice of the material.

Probably repeatedly fractionated petroleum products of high boiling points, which have no similarity to kerosene, not even in odor, would present a less objectionable and safer cleansing medium than water. Science would certainly long ago have solved the problem of cleansing media if it had been appealed to for a solution. It appears that recently in decaline a substance has been found which makes the use of water unnecessary (see page 121).

There are countless cleansing media, which are largely the secrets of different restorers. One would not believe it possible if one knew of all the substances that are used on paintings! The sharpest lyes, acids, and solvents are heedlessly employed. Media of unknown composition, so-called "patent" media, with which anybody without previous knowledge can clean his paintings, are openly recommended. Such cleaning often succeeds only too well, right down to the ground, and the restorer in such cases covers up his sins with retouches. Not infrequently such places

appear to the unsuspecting public as more beautiful than the old.[3]
No lyes, salts, or acids should be employed for cleaning; they
remain permanently on the painting and attack it, as, for example,
potassium hydroxide, potash, etc.

Unvarnished tempera and gouache paintings, like water color,
should be cleaned only with bread crumbs or kneaded rubber.

SOLVENT MEDIA (CLEANSING MEDIA) are:

Oil of turpentine (q.v.) mixed with copaiva balsam 5:1 is a
solvent and cleansing medium which works weakly on old, but
strongly on fresh, paintings, especially when (in a water bath)
it is moderately warmed.

Benzine, benzene, toluene, and xylene, used in the same way,
are more powerful.

Tetraline and decaline are mentioned on page 121.

Alcohol, spirits of wine. Absolute alcohol (100% pure) is a
very strong solvent for resins. It even dissolves many copals. So
be careful! Even very old coats of color which contain resin dis-
solve in it very rapidly. Ordinary alcohol is weaker in its effect.
Also with alcohol an addition of copaiva is very advantageous, in
order to render its effects less dangerous.

Methyl alcohol, wood alcohol, is a powerful solvent for resins.

Amyl alcohol is likewise a very powerful solvent; its vapors
are poisonous.

Trichlorethylene is a very strong, hence dangerous, cleansing
medium, whose vapor has effects similar to chloroform.

Carbon bisulphide is poisonous, as likewise is its vapor; it evap-
orates easily and is a powerful solvent for resins. It mixes with
the oils.

Acetone combines with water, oils, and alcohol, and readily
dissolves resins and oils.

Chloroform is a powerful solvent for resins and oils. All these
solvents are colorless liquids of characteristic odors.

The essential, semi-volatile oils, like their balsams, have a sol-

[3] In all seriousness some restorers today claim that they have a cleansing
medium which removes only new color additions, but stops when it comes
to the old, genuine parts. All they need now is a bell which rings auto-
matically when the old color is reached, and their wonder medium will
be complete.

vent effect upon the resins (oil of spike-lavender, oil of cloves, elemi oil, copaiva oil, rosemary oil, etc.).

Ammonia considerably increases the solvent action of alcohol, oil of turpentine, etc. It should be used only in very small amounts and never without copaiva balsam, with which it combines to form a soapy mass.

Acetesol is an especially powerful cleansing medium for oils and resins.

Water and soap conceal many dangers, even if they easily remove the surface dirt; their action has been described in detail above.

Potassium hydroxide, potash, soft soap, etc., clean, to be sure, but only too well. Afterwards they can never be entirely removed from the painting. Therefore their use as cleansing media is prohibited.

Egg yolk has a moderating and favorable effect as an addition to solvent media; likewise copaiva balsam.

Additions of oils in order to soften the action of the cleansing medium are obviously contrary to sound sense, because cleaning is often intended to remove the effects of oils which have turned yellow or even brown. Despite this, this bad habit persists, and also the practice of rubbing cleaned pictures with linseed oil.

How should a cleansing medium be used on oil paintings? Above all, very sparingly and carefully! Because, before one knows it, one may be through the color layer upon the bare canvas. One should always test first the weakest solvent medium, in this case oil of turpentine with copaiva balsam 2:1, and always first on some valueless object, before one goes to work on a valuable painting. A cotton pad is slightly dampened with the mixture, pressed out, and passed lightly over the painting with a circular motion, touching only briefly on one place and not returning to it for some time. One must not expect to see the effect take place at once, nor clean one place as thoroughly as possible, because one never knows whether the other places can be cleaned to the same extent. Therefore one should always bring the entire painting to a certain degree of cleanness and then go over the whole of it again. A person who possesses no patience should leave restoring alone. Areas painted in a heavy impasto, particularly in white, demand

special care in order to remove the dirt from the depressions. This is best done with an old but clean bristle brush, daubing or rubbing with a circular motion.

After the cleaning, which should not be continued too long at one time, there follows a very thin coating of copaiva balsam 1:1 with oil of turpentine. With the next cleaning many places will then easily dissolve which on the previous day refused to soften. It is only after all other media have failed that one should resort to stronger media, such as an addition of alcohol, first of all, however, only wood alcohol, and this mixed one part to one part of oil of turpentine and a half part of copaiva balsam. Now considerably more will dissolve. In very difficult cases an additional half part of ammonia is used, or absolute alcohol, or one of the strong solvent media mentioned above. Here extreme care must be taken, and one must not linger on any one spot too long. A place is overcleaned only too easily and long before the color becomes visible on the cotton wad!

It would be decidedly the simplest method to advise against the use of all strong solvent media. But in the most difficult cases the weaker media are not always equal to the task, and, finally, any cleansing medium can be dangerous in unskillful hands.

In order to prolong the action of rapidly evaporating essential oils, alcohols, etc., one applies the cleansing medium to stubborn places in paste form by making it into a paste with chalk, egg yolk, or wax-turpentine solution, hydrated clay, etc.

Pictures painted with resin varnishes or with many resin glazes are particularly subject to damage by cleaners. Very difficult to restore some day will be modern paintings whose colors contain additions such as copaiva balsam. Likewise pictures with an asphaltum underpainting are easily damaged by cleansing media. Poppy-oil color by itself or with resin varnishes is rapidly dissolved by the use of alcoholic cleansing media.

Thus paintings of the Rembrandt school can be easily cleaned down to the ground in a few minutes, particularly in the often very thinly painted shadow parts. The proof thereby obtained of the resinous nature of the painting media is all too dearly paid for. Tempera paintings and tempera underpaintings resist these media better.

Only the experienced restorer knows how far he may go, and he should rather allow a light patina to remain than injure the original parts of the painting.

Gold ground is cleaned with a mixture of ammonia with oil of turpentine, copaiva balsam, and alcohol, which is carefully applied by being daubed on with a cotton wad.

Gold bronze over gold leaf is easily removed with chloroform, also with alcohol.

Of overcleaned and scoured paintings there are plenty. In the case of many paintings only the white underpainting in tempera is genuine, which has successfully withstood all attempts at cleaning. Everything above it has been added by other hands.

Here and there pictures are met with which have literally been soaked with some non-drying fatty oils and have become smeary all over. Vaseline oil, butter mixed with olive oil (!), wax with rapeseed oil, and the like are the common offenders. In fact, once I had put in my care a valuable picture whose gold frame had been soaked in oil, and as a result broad, greasy margins had formed all around the picture. It took me a whole year to repair this damage. Warmed talc free from water and light spar were applied to the front and back. Later, by a further sprinkling of these oil-absorbing ingredients and by light ironing more fat was removed, and finally there was the onerous task of removing by means of oil of turpentine and cotton wadding the last traces of all that made the picture look muddy.

YELLOWED OIL PAINTINGS

The yellowing of paintings is principally caused by fatty oils, especially linseed oil, but also in fewer cases by poppy oil or nut oil. White lead in linseed oil is most prone to yellow. Other substances which turn very yellow are the oil varnishes, such as linseed-oil varnish, copal, coach, and amber varnishes, and also certain mastic or dammar varnishes of the trade which contain additions of fatty oils.

Very thick applications of color, and especially white laid on with the spatula, often exhibit a strong tendency to turn yellow, due to the oils coming to the surface. If an oil painting which has

dried only on the surface is kept in the dark (especially in damp warmth), it will turn yellow.

Even over-fat tempera may yellow; if unvarnished, this condition can be improved by the repeated application of white blotting paper soaked in hydrogen peroxide. This operation should be carried out in a well-lighted, warm room. It is dangerous to try to bleach any paintings in the sun, particularly paintings executed on wood panels; strong light is in most cases quite sufficient for this purpose. The wrinkling of oil paint is caused by an excess of oil and cannot be remedied.

Oil varnishes which have turned yellow must in most cases be removed. They lie like a dim yellow glass over the picture, and in the course of time may even turn very brown, so that the whole appearance of the picture is ruined. It is very seldom that such varnishes can be removed and then only with the greatest difficulty and not without injury to the color layers, for they will resist even strong solvents for a long time. One is nearly always here forced to use alcohol, which is tempered by adding a small amount of copaiva balsam.

Resin ethereal varnishes which have turned yellow owing to the addition of oil can be rapidly dissolved by many of the weaker media, and under certain conditions even rubbed off dry.

Only resin varnishes made with oil of turpentine should be used in restoring and for varnishing. Whatever damage they do is easy to repair. Furthermore, they do not become so hard as oil varnishes, which in old paintings is a decided advantage. Resin ethereal varnishes such as mastic or dammar, and balsams such as Venice turpentine, succumb in time to the influences of moisture, but can be replaced without injury to the painting.

The object of the varnish is to render a painting equally visible in all parts and to protect it from the influence of harmful gases and dampness. The resin ethereal varnishes accomplish this better than the oil varnishes. The varnishing of the paintings is a necessity in order to protect the color layer, especially from dirt. Occasional rubbing off with a cloth (see under cleaning) is not sufficient.

Damages to the varnish due to injury in transport. The varnish covering of new and old paintings is not infrequently damaged

through unsuitable packing. If the box was not well sealed (with pasted paper strips) and free from dust, and either varnish or color is still sticky, then dust will collect on the picture. One can, however, with the finger rub off most of the dust particles from the affected painting after it is dry. A common mistake is to lay cloths or papers over the painting when the varnish is not yet dry, which then stick to it. In this case one proceeds with the restoring in the same way as above, only in obstinate cases a trace of egg tempera must be used to aid in the removal of the paper or cloth. Scratched varnish can in most cases be repaired by a very thin coating with copaiva balsam. Otherwise one must employ a light "Pettenkofer" treatment [q.v.], and in both cases varnish afterwards. Paintings which have been rolled and stored for a long time can often be unrolled only by force. In the process they are apt to crack, and the paint to splinter. It is best to leave the canvas roll for a few days in a damp cellar and not open it until this can be accomplished easily. Pictures must never be rolled up in any other way than with the painted surface outwards.

The "turning blue" of the varnish, which incidentally also takes place with balsams, has not yet been satisfactorily explained. Moisture in the varnish or on the picture surface appears, however, to be one of the chief causes. It is most annoying on dark, smooth, and glossy parts of the painting. Rubbing down such affected areas with wet cloths seldom does any permanent good. The best method has proved to be an over-varnishing with a fairly fat resin ethereal varnish, mastic or dammar with 2-5% castor oil. Linseed oil or other fatty oils should not be added because of the danger of yellowing.

Richter-Binnental, a restorer, reports success with a mixture of 2 parts rectified oil of turpentine, 1 part copaiva balsam oil, and a few drops of oil of lavender applied thinly with cotton wadding to the parts which had turned blue.

THE DISINTEGRATION OF RESIN ETHEREAL VARNISHES. Exposure to dampness over a long period of time may bring about a destruction of the varnishes. They become whitish and muddy and lie like a mealy powder on the surface of the painting. All sorts of attempts at cleaning are made by the owners of such affected paintings. Thus I saw at one time a drawing-room-

ful of Lenbach's paintings, the lower half of all of which, or as far as the faithful servant could conveniently reach, appeared to be covered with mold. The varnish was destroyed and thin areas in the color layer rubbed off. The lady of the house explained to me that she could not understand why the pictures looked as they did; they were dusted every day, she said, and frequently rubbed off with a damp cloth; and she was quite astonished when I told her that this was precisely the cause of the damage.

Many colors which contain clay, such as ultramarine, ocher, and umber, may, owing to the decomposition of the clay, cause the destruction of varnishes. The so-called ultramarine disease is such a phenomenon. In ignorance of the causes, one formerly soaked such places with fatty oils, which only aggravated the evil. Hygroscopic substances in the ground or in the paint layer, such as glycerin in many commercial canvases or in tempera tube colors, likewise soap, sugar, honey, etc., hasten the destruction of resin varnishes. External causes, such as continued exposure to dampness, especially, however, damp or still fresh walls, also bring about this destruction.

Pettenkofer's regeneration process.[4] Pettenkofer discovered the simple solution of the problem of how to restore their transparency to such disintegrated varnishes. He showed that these varnishes had lost their cohesion, and that their muddy and powdery appearance was due to physical processes. Air penetrated between the fine varnish particles and caused the white discoloration, just as a glass sheet ground to a powder appears white (one may think also of water turned to foam) without the glass having changed its chemical composition.

Pettenkofer's method of regeneration was to place the painting in a box containing alcohol vapors; the resin thus is fused and again becomes transparent. To carry out the process, a very absorbent material is fastened to the cover of the box, care being taken to see that no threads hang down and that the absorbent covering nowhere touches the painting lying on the bottom of the box, because in such places, on pictures painted with resin-oil

[4] See: Max von Pettenkofer, *Über Ölfarbe.* Braunschweig, Friedrich Vieweg, 1860.

colors, the color is dissolved at once down to the ground. Naturally also none of the alcohol with which the absorbent padding is soaked (the best is denatured alcohol) must be allowed to drip down on the painting. According to my own experience, it has proved much better to lay the painting on the bottom of the box than to fasten it to the top, because with rapidly softening paintings (such as pictures painted with resin) the color easily loses its cohesion with the ground and, owing to its weight, forms blisters. A preliminary rubbing of the painting with copaiva balsam aids materially in the process of regeneration, for copaiva balsam has the exceptional and important quality of gradually bringing the old dried-out and brittle "linoxyn" skin of the fatty oils into a state of fusion, and it has the same effect upon resin varnishes.

A disadvantage of the Pettenkofer process is that the regeneration of resin varnishes or of pictures painted with resin is, to be sure, quickly and easily accomplished, but that often deterioration sets in again very rapidly. Here also science could perform a service by trying to improve this process of regeneration. According to information given the author by the director of the Haarlem Gallery, the Pettenkofer process has not proved entirely satisfactory. He said that in collaboration with a chemist he had discovered a much more efficient process. But I was unable to learn more about this. As long as science can offer us nothing better, we must stick to the Pettenkofer method and copaiva balsam as the one effective fusing medium for disintegrated resin ethereal varnishes and resin-oil colors.

Büttner's "Phoebus," according to the claims of its discoverer, should make all old paintings like new and far surpass the Pettenkofer process. The medium contains liquid petrolatum, which never dries; it enters through the fine cracks into the painting and can never again be entirely gotten rid of. It would in any case be better suited to the greasing of harness than to use as a regenerating medium. Nevertheless it is used very frequently, even in art galleries. It is, to be sure, inert, but that does not mean necessarily that it is good for paintings. The fact that it is inert is no reason for assuming that it has the specific property of loosening the "linoxyn" skin of old oil paintings. It is simply

grease which never dries and which therefore constantly attracts dirt. But of course a painting can always be restored again!

By a simple, but often-repeated, treatment with pure copaiva balsam thinned with rectified oil of turpentine 1:1, I have obtained surprisingly gratifying results with paintings which often had become practically unrecognizable. But one cannot, even here, expect immediate results. These very thin coatings must be applied successively and gradually until the painting regains its full clarity. Once, in the case of a painting which had become almost unrecognizable and was thickly covered with dirt, I succeeded in restoring it entirely to its original freshness through repeated treatments with copaiva balsam and oil of turpentine. The treatment was continued until even the deepest shadows had regained their full transparency, and after that the copaiva balsam was partly removed with a cotton wad and oil of turpentine, and the dissolved dirt with it. Finally the painting was given a coating of resin ethereal varnish. The painting has lasted perfectly now for 15 years and is absolutely clear and luminous. In hundreds of other cases since then this method of using copaiva balsam has given satisfactory results. But time and patience are essential; simply going over the painting once would produce no results worth mentioning. Scientific authorities frequently argue against resin-oil colors and against poppy-oil color; they claim that their use makes later restoration difficult. The exact opposite is true. With a simple "Pettenkofer" treatment I was able to close completely deep cracks in poppy-oil paintings. One must not, however, continue the treatment too long, otherwise the paint at the edges of the cracks will stand up, owing to the expansion of the color layers.

I once examined a creditable painting of the Rubens school which, because it has been much damaged, had been relined a few years previously by a restorer. The picture was heavily varnished and had a high gloss. But from the many cracks there exuded a mealy white powder which disfigured the entire painting. Obviously colophony had been added to the paste used as an adhesive, and it had separated from this as a result of disintegration. A "Pettenkofer" treatment appeared dangerous, because the painting was covered with many retouches, and a

change of their color through softening was to be feared. (Later darkening frequently takes place in that case.) Furthermore, the great size of the painting was a problem. I treated the painting repeatedly with copaiva balsam and oil of turpentine, warmed it by a weak ironing, and achieved completely satisfactory results after several weeks' work. I applied a thin final varnish with mastic and 5% castor oil and repeated this in due time.

Removing old varnish. It is an old practice of professional re-storers to remove the varnish from paintings. Ethereal varnishes are removed by going over the painting, immediately after the "Pettenkofer" treatment, with a brush dipped in water, which has the effect of disintegrating the varnish. After drying, a whitish dust is formed which is easily rubbed off. Naturally in this process all glazes and the resin color itself are frequently removed with the varnish. The varnish of old paintings is occasionally covered with all sorts of other, usually fat, coatings. According to old accounts, it was the custom in Italy, and certainly also elsewhere, to rub down the church paintings with bacon rind before im-portant holidays. Glues and gums are also often to be found on old pictures. Attempts were made to "clean" the paintings with sharp lyes, nitric acid, and sand, which frequently resulted in greater damages than ever before. Just as harmful were soaking with hot linseed oil and fatty oil coatings in general in order to bind the colors again when these, after the lye treatment, dis-colored cotton wadding.

Such varnishes are best rubbed off by the dry process by taking a grain of mastic or a mastic "tear" and powdering it on the layer of varnish with the finger. In this way the varnish is attacked on one spot at a time. True, in such a process the varnish glazes of old paintings are often apt to come off as well, for no one can say where the final varnish stops and the glazes begin. It need not be especially emphasized how unnecessary and dangerous in general all these manipulations are. Oil varnishes like amber, copal, and coach varnish, and varnishes in general containing oil, are very difficult to remove, since the dried-out oil skin can be dissolved only with very strong solvent media. Pure alcohol and ammonia have already been mentioned as being such powerful media. Chloroform is able to soak into and dissolve such old oil layers,

but with such procedures there is always lost a considerable part of the color layer and the glazes. The removal of the varnish should be undertaken only in cases of extreme necessity, when this is actually dirty, disfigures the painting, and cannot be gotten rid of in any other way.

THE COLOR COAT. Brittle paintings in danger of disintegration must be given new adhesive power by applying copaiva balsam or resin varnishes before they are relined. Often the color layer appears to be intact on the surface, while its physical connection with the ground is impaired. Here also coatings of copaiva balsam thinned with rectified oil of turpentine may help. Chemical changes of the color (in more recent pictures) caused by cadmium yellow mixed with emerald green cannot be remedied. If one wishes to paint over them, such places must first be varnished. Faded colors, particularly red and yellow lakes, are not uncommon in old paintings. For the reason that they were glazed with resin varnishes, they often become the prey of unskilled restorers. One also often encounters disintegrated colors on old paintings, especially bright yellow tones (like orpiment). The old masters did not have bright yellow tones of the sort we possess today, such as cadmium. They no doubt knew of the dangers of certain colors, and they knew how, for example, verdigris could be rendered less dangerous by not mixing it with other colors, but using it as a glaze between two layers of varnish.

On pictures of the old German masters one not infrequently observes decomposed, island-like patches in the darker, especially brown, thickly applied tones of resin color, in appearance like the crusty bark of a tree, and reminding one in particular of weathered pitch on pine trees. This is the result of climatic conditions. I have found this disfigurement even on relatively new paintings. Nothing can be done about it, and it is best to leave such paintings as they are.

The darkening and blackening of a picture due to an excess of essential oils and balsams cannot be remedied, but surface yellowing can be reduced in part by exposing the painting to the light. Yellowing in spots is treated by applying blotting paper soaked in hydrogen peroxide. Disturbing spots which cannot be removed frequently appear on pictures in which too much siccative has

been used. A resoftening of the color layer takes place, particularly in the case of poppy-oil color and colors to which copaiva balsam oil has been added, and especially on dark places oversaturated with binding medium. It is best to expose such pictures to the influence of light.

The turning up of the edges of cracked color layers is always caused by the repeated effects of dampness, as, for example, frequent washing with water. These spots are smoothed down with a thick ethereal varnish, mastic or dammar 1:2 in oil of turpentine and an equal amount of wax solution 1:1. In difficult cases one must add glue which has been soaked for a day in water, to the amount of about ¼ the mass of the wax varnish (without water), and rub the previously slightly warmed varnish on the grinding plate into a stiff putty. By warm ironing with the edge of the iron or a wood plane the edges are imbedded in this putty. One must iron each place until the iron is cold, and perhaps even repeat this several times. The superfluous putty is removed in the cleaning. A coating with copaiva balsam before beginning work is very advantageous.

Wrinkling of the color surface, a secondary phase in the forming of a skin, which is attended by the shrinking of the color layer, is caused by an over-abundance of fatty oils like linseed oil or hemp oil. To be sure, it is not dangerous, but it may produce a displeasing optical effect, and it cannot be overcome. On paintings of the second half of the past century the improper use of asphaltum caused much damage, as did the excessive use of siccatives. Ugly spots often disfigure these paintings. I once saw a painting which had been thickly underlaid with asphaltum, probably with very much siccative, while over this lay a smoothly surfaced coat of pure Cremnitz white. There is no more senseless way of preparing a ground. Naturally all the color started to slide when the painting became warm at the exhibition, where it was hung over a radiator, and it developed heavy folds. Nothing will help here except turning it upside down and letting the color slide back into place.

Blisters in the color layer must be ironed, after first being rubbed down with wax solution; likewise places which have become detached. Saucer-shaped patches which stand up from the

canvas are usually a result of 'moisture which has penetrated into the glue grounds, and they are difficult to press into place.

A previous rubbing with copaiva balsam before ironing and a brushing with wax is to be recommended.

Cracks which go very deeply into the color coat are frequently encountered in modern paintings which were painted with a disproportionate amount of binding medium, siccatives, or even balsams like copaiva over underpainting which was not thoroughly dry. One may first try the "Pettenkofer" process. Repairing should be resorted to only when the inner, still soft color layers have dried. The unequal expansion of the various layers may also be the cause, likewise repeatedly painting over still wet color layers, especially in the case of poppy-oil colors. Very often also the excessive driving in of the wedges is the cause of cracks in modern paintings. At other times the cause lies in the color itself, as in the case of madder lake (q.v.). The fine hairlines of old paintings, the "craquelure," one should not attempt to repair. Many restorers cover them by coating the entire picture with chalk-glue solution and then wiping it off. Typical oil paintings show particularly in the glazed areas the characteristic concentric oil cracks, like spider webs. Old chalk ground or tempera and resin often show lattice-like cracks. The crack formation can, however, with one and the same material be different according to the thickness of the application of the ground and the proportion of pigment to binding medium. Peculiar parallel cracks are exhibited by the background of the Döllinger portrait by Lenbach in the New Pinakothek in Munich, which can probably be traced to a copal painting medium containing paraffin. In general, places painted with white on old pictures are for the most part better preserved than the glazed portions. This is especially noticeable on paintings of the later baroque period.

The removal of repainted areas. Frequently one observes on old pictures overpaintings of a later period which are conspicuous through differences in color character as well as in artistic rendering.

The delusion that the old masters possessed a "gold tone" (which in reality was chiefly the result of yellowed varnishes containing oil) enticed many restorers in the second half of the

past century into creating such "gold tones" artificially with colors like stil de grain, etc.[5] Today these paintings appear "hot," even "burnt."

Often additions were made to paintings, or they were arbitrarily cut down. The later baroque era was particularly enterprising in this respect and always too anxious to try new stunts. The removal of overpaintings always remains a very dangerous undertaking, because one can never know for sure whether a piece of the original painting is underneath. Frequently the removing of such overpaintings is done in a spirit of discovery, in the hope of finding a genuine Titian or some other old master of the first rank underneath. For the most part, however, faulty places are found under the overpainting, and the restorer is forced more than is desirable to make additions of his own. Frequently also at a later date canvases are painted over by the original artist. In the case of pictures of even moderate value it should be absolutely mandatory that the painting be photographed in the various stages of restoration, especially, however, after the removal of the overpainting and before the application of each new retouching, so that later one may know exactly what is original and what is not. With repeated overpainting, which also occurs, this is especially necessary. In sunlight much better than in ordinary light it is sometimes possible to recognize the old painting under the overpainting. The X-ray and the quartz lamp are here also especially useful. Signatures naturally must be treated with especial care; in the process of cleaning they make their appearance at unexpected places. Unfortunately they are not infrequently forgeries, and they usually exhibit a tendency toward high-sounding, expensive names. The stubbornness of such signatures in resisting solvents proves nothing with respect to their genuineness. Unvarnished, lean tempera on lean ground, for example, can become very hard in a few hours.

"*Feeding the color coat.*" Oil color in time loses its flexibility. It turns brown (the gallery tone), becomes brittle, and can lose its cohesion under certain unfavorable influences of temperature to such an extent that it can be wiped off like a mealy powder,

[5] This practice is not uncommon even today. [Translator's note.]

as is observable on coats of paint in the open. It was formerly the custom to coat such brittle places with oil, especially linseed oil, and to soak the painting from the back in the same way. That these media cannot have the desired effects has already often enough been demonstrated. Goethe mentions in the "Italian Journeys" that many old paintings had been spoiled by coating them on the back with oil in order to give them a "juicy" effect. I myself have observed paintings anointed in this manner with a mixture of linseed oil and wax. Pettenkofer in 1869 said (*Über Ölfarbe*) that this method of soaking a picture with oil was "degeneration" rather than "regeneration." The old, dried-out oil skin ("linoxyn" skin) is not softened by fatty oils. Coatings of copaiva balsam alone have the power of gradually dissolving this skin and thus again giving the painting clearness and depth. (See Pettenkofer's method of regeneration.)

Quite unsuitable are media containing vaseline or paraffin oil. They never dry, and act like grease on leather. They can never again be entirely gotten rid of; the dust settles on these pictures, and they easily "sink in." The "linoxyn" skin is just as little dissolved by them as by fatty oils. As yet we have nothing better than copaiva balsam.

RETOUCHING is the most bitterly fought-over phase of the technique of restoration. In the main two opinions are here directly opposed to each other. According to the older view, faulty places should be repainted in such a manner that the most practiced eye could not recognize them as such and that the painting would appear to have come down to us undamaged from the hand of the original master. This method is almost always insisted upon by private clients and by the art trade. In opposition to these, Pettenkofer in his work *Über Ölfarbe* upheld the point of view that an old painting should be regarded as a valuable document and be kept in as good condition as possible, but was not to be arbitrarily "improved." Conservation instead of restoration was his slogan. It is perfectly clear that only in this manner can an old painting transmit truly to the observer and to future generations the original conception of the artist. We should therefore allow these faulty places to remain recognizable as such, standing in simple, neutral tones or in the color of the imprima-

tura. This method should be particularly employed in the case of valuable paintings, especially in galleries. It seems to me, in fact, to be the only permissible course, but unfortunately it is not always followed, though it is increasingly being adopted. I saw in the Hamburg Art Museum a painting by the master Francke in which very extensive faulty places had been filled in only with an imprimatura tone. The genuine old places thus became intensified in their effect. Similarly I saw in Breslau a painting by Pleyden-wurff conserved according to this idea, and likewise pictures of the Nördlingen master Herlin in Rothenburg ob der Tauber. A magnificent example of recent conserving technique is the Milbertshofen altar near Munich. Such work is incomparably more difficult than the popular method of retouching and then fitting the original to these retouches. There is no other way of giving to future generations a true and unspoiled picture of earlier painting. This applies particularly also to fresco painting.

There is a middle road, according to which the retouches are put into the painting in the correct color, but made recognizable by a special method of handling, for example, by hatching, and thus remain differentiated as additions. V. Bauer-Bolton would have the retouches made recognizable by permitting the putty to stand a little deeper than the surrounding picture surface.

If one is forced by a client to apply retouches in the exact color of the original, the first requisite, according to my idea, is that they be so put on that they are easy to remove without harm to the genuine old parts of the painting. This is possible only with resin-varnish color, which can easily be removed with oil of turpentine. Such color also does not suffer the later changes of some oil-color retouches. Its transparency and saturated effect most closely approach the appearance of old color. Copaiva balsam and oil varnishes, such as amber or copal varnish or coach varnish, must not be used, nor the fatty oils by themselves. One must never use tube color of the trade for restoring purposes. From the standpoint of scientific restoration such color is a trade secret, the composition of which is unknown, and the behavior of which the restorer cannot guarantee. When a painter like Böcklin could grind his color fresh every day, then a restorer can certainly do it much more easily. For he requires—or should require—only a

very small amount of pigment, and in addition only very few colors, enough of which for the day's work he can grind in a few minutes, if necessary, with the spatula. In this way he has a material which compares favorably in every way with the colors of the old masters and can be worked in a similar manner. Such color is quite different from our present-day tube colors, which are created for different purposes, for which they are quite appropriate. The color is ground with mastic or dammar varnish 1:3 in oil of turpentine, and up to half the amount at the most of fatty oil is added. With very finely drawn work, like that of Dürer, a few drops of nut oil added to the mastic will be of service. The defective place may be rubbed over beforehand with mastic varnish, but this must be extremely thin. Pure oil retouches afterwards change color to a great extent. One can often observe such places on old paintings, from which one might be tempted to conclude that the restorer had been color-blind, so black have bright tones often become. Only very little pigment is here required, for the painting of the old masters was carried out in successive layers, many color valuations being developed out of a few colors by the method of laying them over one another. It is very advantageous to put in the puttied places in the same general tone as that of the old painting, be it white, gray, ocherish, or red, etc., because in this way optical effects comparable to those in the painting will result. One must not mix the colors in the modern sense of the term, nor perhaps paint the retouches alla prima, because in a short time such color would turn very dark.

One paints from light gradually into dark, with the fewest, but purest, colors laid one over the other, and guards above all things against mixing warm with cold color. Thus, for instance, in a picture of the Rubens school, in the light area occupied by a nude figure one should first very lightly stipple over a silvery gray putty with a very meager color without gloss. One should not strive at once for a finished effect. Above all, one must not set in at first too strong colors, which must then be broken. Such color would later turn very dark. An alla prima painting of one color into another, even where the color tones blended most exactly, would be the worst thing one could do. In a short time the set-in area would change in contrast with its surroundings, usually

appearing considerably darker and blacker. Working in layers and allowing for their thorough drying in between, laying one color over another without resorting to mixing, would be the way to achieve an optically convincing and lasting effect which will fit perfectly into the old picture. First the effect of light as such must be established, then one may carefully add color in small amounts: thus, in the case of the above-mentioned example, over white mixed with ocher perhaps white with Naples yellow and other warm colors, but applied so thinly that the gray of the ground is not lost; and finally extremely thin white and red in the flesh, which must have a fresh appearance and not be unfavorably affected by overpainting. Exactly in the same manner are built up the transition tones from cold tones, green earth, black with white, etc.; and they must also be kept clear. Warm colors added to warm colors intensify each other and remain pure, and cold with cold colors likewise remain clear, but, mixed together, they weaken each other and have a dirty effect. In the shadows more glaze-like, warm tones are added, and afterwards often gone over thinly with opaque tones. Through such a gradual process of building up the retouches are completely fitted to the original. Over the, as compared with the original, still lighter color foundation follow then the final thin glazes, likewise in varnish color. Frequently one will here have to use in dark places the warmest tones obtainable, such as Indian yellow with Cassel brown and sienna, madder lake, etc. The mixed technique can often be used here to advantage.

Very dangerous is the commonly practiced "retouching" of small injuries and accidents or even hair cracks, which is done with a very small, pointed hair brush under a magnifying glass. The charm of many a spirited painting is in this way sacrificed to tedious correctness. But since America wants slick, smooth paintings, this method has become quite popular.

It is absolutely inexcusable when the restorer, because of the relative simplicity of such a method or because it is in keeping with his conception of the old masters, changes the character of a whole painting or parts of it to fit his own retouches, a method to which enough old paintings have already been sacrificed. For instance, the world-famous painting by Frans Hals, "The Regents

of the Company of St. Elizabeth," in the Haarlem Museum, according to information furnished by the directors, was "cleaned" by a Berlin disciple of Professor Hauser. Accidentally the heads in the process became a little chalky. They were then "harmonized" according to the approved method with Prussian blue and gold ocher, and naturally with linseed oil, as was the custom of the Hauser school. And the black of the draperies fared in the same manner. The remarkable part of it all is that at the time of Frans Hals there was no such color as Prussian blue! By the restorer every piece of color should be held sacred. To conserve correctly is by no means easier than to restore.

That retouches carried out in resin-varnish color can afterwards easily be cleaned off by careless restorers must not prevent conscientious restorers from continuing to work in this medium. For the primary requisite of restoring is that retouchings remain capable of removal without damage to the painting. Coatings of copaiva balsam or use of the "Pettenkofer" process also restore their transparency to these retouches, exactly as they do to varnishes. Pure oil varnishes and pure oil color, on the other hand, are difficult to remove and only at the risk of damage to the painting, and they are less capable of regeneration.

Tempera paintings (varnished) which are painted with egg, casein, or wax and therefore have become very hard are very resistant to cleansing media. The cleaning proceeds as with oil paintings. Great care must be taken in the case of artificial tempera and especially with modern tube tempera colors. These pictures, like oil paintings, must be cleaned without the use of water.

Unvarnished tempera can be cleaned only with bread or kneaded rubber.

Missing places can be restored in egg tempera by the same procedure employed in retouching oil paintings, by painting, namely, from light into dark.

Pastel restoring, see page 253; water-color restoring, page 263; restoration of wall paintings, page 304.

Final varnish. One frequently finds, after varnishing, that dust particles or threads have gotten into the varnish, and that they produce very annoying effects, especially on smooth surfaces. If it is found impossible to remove them from the wet varnish with

the tip of a fine brush, then they may be rubbed off with the finger after the varnish has dried.

When the retouches have thoroughly dried, the painting is given a final varnish; but this should be delayed as long as possible (see varnishing). One should never use anything but mastic or dammar in rectified oil of turpentine, about 1:3, to which in the case of brittle or hard painting 2-5% castor oil may be added in order to increase the suppleness of the varnish. Pure castor oil does not turn yellow. Entirely unsuitable are all fatty-oil varnishes, like copal varnish, coach varnish, or amber varnish, and likewise all mastic and dammar varnishes melted in or adulterated with fatty oils, as well as spirit varnishes. The danger has already repeatedly been pointed out that such oil-containing varnishes turn yellow, and especially that oil varnishes become dim and dirty and can be removed only with difficulty, whereas mastic or dammar turpentine varnish, in case it had actually disintegrated, could be easily regenerated by the Pettenkofer process. Mat varnish can be used where desired (pages 210 and 237).

Protection of the back. The destruction of the painting, even the discoloration of the varnish, results very often from causes traceable to the back of the painting (for example, dampness of the wall).[6] A coating on the back with fatty oils or mixtures of fatty oils with wax is by no means a suitable remedy. The canvas turns brown, becomes hard and brittle, and looks as if scorched. Moreover, the appearance of the painting itself may even be affected, as in the case of paintings on chalk ground, which become sauce-like in character (see also under faulty grounds). The back of wood panels, provided they are dry and even, and also the edges, may be given a good coat of varnish or wax dissolved in oil of turpentine.

It is a frequently-observed fact that under the wood of the stretcher bars the canvas is perfectly preserved, while on the exposed areas of the back it is nearly rotten. I found this clearly demonstrated once on a canvas of the year 1520, where the areas

[6] One must, therefore, never hang valuable paintings on outside walls, just as one would not place a piano against them. [This, of course, applies particularly to brick and masonry structures, and not so much to frame buildings.]

under the stretcher bars which were untouched (and unsmeared!) were almost as fresh and pliant as when new. Also tags glued on the back, such as gallery notations, ward off injurious effects, but show on the front as clear spots in muddy surroundings, as was illustrated once on a painting by Salvatore Rosa in the Pitti Palace at Florence.

Very valuable lessons may be drawn from all this. In the case of smaller paintings, a wooden cover which fits the space inside the stretcher bars and is fastened with clamps or screws will offer sufficient protection from the back. With larger paintings I fastened four such coverings on the back of the cross frame. This is necessary with paintings exposed to special atmospheric influences, like sea air, but also to damp walls.

Even a strong paper mounted on the back of the stretcher bars will render good service. In the case of recent paintings, mounting them on another canvas covered with an oil priming will serve well.

To serve as a protection against possible damage, there are offered today by the trade all sorts of preparations to apply to the backs of pictures. Although highly praised, however, none of them is to be recommended. There are preparations resembling hardwood-floor wax, which may completely change the optical appearance of the picture and turn it brown. Tin foil is not useful, nor are priming coats of any kind. The best procedure, after all, is to leave the back of a canvas alone.

The picture on either a canvas or a wood panel must be allowed to move freely in the frame; otherwise, for example, in the case of a wood panel, it may crack and pull the frame out of joint.

If two parts of a panel have separated, the pieces are laid on a larger single board. The edges are cleaned with a piece of broken glass, covered with casein, and promptly put together; the margins are then cleaned with a dry rag. Against the long sides of the picture are laid two wooden laths, one of which is at once screwed down close to the panel and the other at a slight angle to allow the placing of a wedge. This wedge is carefully and tightly driven in, and the picture is allowed two days to dry.

PRESERVATION AND CARE OF THE PICTURE

Pictures should be kept at as even a temperature as possible. Above all, sharp changes of temperature must be avoided. Thus, especially at the beginning of the cold season, when the heat is turned on, special precautions must be taken. [Unregulated] steam heat has proved to be the most dangerous. Paintings which have been preserved for centuries without any particular damage suddenly suffer the worst sorts of damage in steam-heated rooms. Whole patches of color stand up and break off, especially in the case of paintings on boards. The fault is the reduction of the normal humidity, which causes the wood to warp. Unglazed clay jars filled with water and placed on or near the radiator, which permit evaporation of the water, have proved beneficial. Pettenkofer maintained that paneled or fiber-covered walls were preferable backgrounds for pictures because they absorbed moisture from the air.

A moderate, even temperature for paintings is vital. For this reason one must not place paintings in the sun, because the rapid warming and subsequent cooling may cause damage. Paintings underpainted with asphaltum may, when exposed to the warmth of the sun, slide and afterwards crack. Even changes in color may occur, as in the case of vermilion and the lakes (bleaching), or a resoftening of the binding media. The prolonged opening of the windows in spring during a thaw after a period of extreme cold has, as one may learn from Pettenkofer, already been injurious to many paintings and caused first moldiness and later decomposition (ultramarine disease and rotting of the varnish).

Keeping the paintings under glass is a recently much-practiced method. But it is by no means certain that it offers advantages to old paintings and does not more often hasten their decay. Paintings which in heated rooms hang near a window or door are, owing to sharp changes in temperature or the effects of the sun's rays, very apt to crack.

The air should be able to circulate behind the paintings, and for this reason they should not hang flat against the wall, but

should project a little at the top, which also improves their visibility.

A law governing the processes of restoration is projected in many quarters. It would doubtless be a fine thing if it could be made internationally effective. But when one reads that by supposed authorities copal varnish is still recommended for oil paintings and linseed oil as a cleansing medium, as well as the washing of pictures, one becomes skeptical. The necessary preliminary condition of such a law would be the working out of entirely unobjectionable methods of restoration and conservation.

BIBLIOGRAPHY

Berger, Ernst: *Beiträge zur Entwicklungsgeschichte der Maltechnik.* Dr. W. Callwey, München, 1901.

Eibner, Dr. A.: *Malmaterialienkunde.* Verlag J. Springer, Berlin, 1909.

—— *Über fette Öle.* Verlag B. Heller, München, 1922.

—— *Entwicklung und Werkstoffe der Wandmalerei.* Verlag B. Heller, München, 1926.

Pettenkofer, Dr. Max von: *Über Ölfarbe.* Friedr. Vieweg, Braunschweig.

Raehlmann, E.: *Über die Maltechnik der Alten.* E. A. Seemann, Leipzig, 1910.

—— *Farbstoffe der Malerei.* E. A. Seemann, Leipzig, 1914.

Vanino, Dr. L.: *Die Haupttatsachen der organischen Chemie.* Verlag F. Enke, Stuttgart, 6. Aufl., 1933.

Wagner, Dr. Hans: *Die Körperfarben.* Wissenschaftliche Verlagsanstalt, Stuttgart, 1928.

APPENDIX

CHAPTER I

P. 4, l. 1: approx. one to two yards long.

P. 4, l. 10: approx. a yard square (39.4 in.).

P. 5, l. 9: approx. 2 in. or more to the yard.

P. 7, l. 12: approx. a yard or more in dimensions.

P. 7, l. 21: at least 1 in. larger.

P. 13, l. 34: 70 parts (1.9 oz.) to 1,000 parts (1 quart). 1:14 by weight.

P. 14, l. 6: One quart of glue size will cover about seven square yards.

P. 14, l. 10: the quart of water.

P. 14, l. 14: 1.9 oz. to 1 quart (1:14 by weight).

P. 15, l. 22: approx. a square yard.

P. 16, l. 21: 1:14 by weight.

P. 23, l. 22: 1:14 by weight.

P. 27, l. 12: 1:14 by weight.

P. 34, l. 24: approx. 1 in.

P. 34, l. 25: approx. 4 in.

P. 37, l. 7: 1.9 oz. to 1 qt. (1:14 by weight).

P. 37, l. 8: 2.6 oz. to 1 qt. (1:10 by weight).

P. 39, l. 6: approx. ½ in.

P. 40, l. 11: approx. .04 in.

P. 40, l. 14: approx. one pound of glue to a quart of water.

P. 42, l. 1: 2.6 oz. to a quart (1:10 by weight).

CHAPTER II

P. 51, l. 26: approx. a yard long and about 5 in. wide.

P. 64, l. 8: approx. 12 inches away.

CHAPTER III

P. 105, l. 6: .2 in. deep.

P. 105, l. 35: 392° F.

P. 106, l. 33: 212° F.

P. 118, l. 36: 421-424° F.

P. 119, l. 17: 140-320° F.

P. 119, l. 18: 356-518° F.

P. 119, l. 20: 518-752° F.
P. 120, l. 25: 122-158° F.
P. 121, l. 7: 42° F.
P. 130, l. 31: 194° F.
P. 130, l. 32: 221° and 248° F.
P. 132, l. 28: 149° F.
P. 132, l. 29: 212° and 302° F.
P. 136, l. 6: 1.5 oz. of borax to 4 oz. of shellac in 1 qt. of water.
P. 141, l. 10: 149° F.
P. 142, l. 22: 113° F.
P. 142, l. 31: 122-176° F.

Chapter V

P. 214, l. 22: 158° F.
P. 217, l. 28: 5.4-8.8 oz. to a quart of water.
P. 219, l. 5: 1.4 oz. casein . . . then ⅓ pt. moderately warm water.
P. 219, l. 7: ⅓ oz. ammonium carbonate.
P. 222, l. 11: 392-554° F.
P. 225, l. 7: 1¾ oz. of paste.
P. 225, l. 8: a little more than ⅓ pint.
P. 226, l. 1: 4.4 oz. rye flour.
P. 226, l. 2: approx. ¼ cup warm water.
P. 226, l. 4: ½ cup cold water.
P. 226, l. 6: 1½ cups boiling water.
P. 226, l. 7: ⅝ cup boiled linseed oil.
P. 226, l. 8: ½ cup cold water.
P. 226, l. 9: ⅝ cup boiled linseed oil.
P. 227, l. 6: .9 oz. white, cleaned beeswax.
P. 227, l. 7: ⅓ pt. boiling water.
P. 227, l. 8: ⅓ oz. ammonium carbonate.
P. 227, l. 16: ⅙ oz. potassium carbonate or soda.
P. 236, l. 28: 2 oz. borax and 4 oz. powdered white shellac in 1 qt. of water.

Chapter VI

P. 244, l. 24: .8 oz. tragacanth.
P. 244, l. 25: 1 qt. of water.

Chapter VIII

P. 273, l. 29: approx. ⅔ of a yard.
P. 275, l. 18: 20 in.
P. 275, l. 21: .4-.6 in.
P. 276, l. 11: .4-.6 in.
P. 276, l. 22: .4 in.
P. 277, l. 13: to the square yard (approx.)
P. 277, l. 33: .12-.2 in.
P. 279, l. 24: about 1½ in.
P. 279, l. 30: .2 inches thick.
P. 279, l. 38: approx. two square yards.
P. 282, l. 23: as much as 12 inches away.
P. 292, l. 33: .7 oz. of caustic barite to 3.5 oz. (or ½ cup) distilled water.
P. 303, l. 20: about 1.4-1.8 oz. of Cologne glue.
P. 314, l. 22: approx. 3 in. thick.

Chapter X

P. 382, l. 3: about 2 in. or more to the yard.
P. 382, l. 32: at least 2 in. on all sides.

INDEX